D0936368

NONBINARY

NONBINARY

A MEMOIR

GENESIS P-ORRIDGE

Abrams Press, New York

PROLOGUE
HOW DO WE SHORT-CIRCUIT CONTROL?

I thought it had to be fake.

William S. Burroughs's name and address was right there, in the middle of a magazine called *FILE*.

There it was in an "image bank request list" section in the part of the *Yellow Pages* devoted to correspondence art. One artist could request an image from another artist living thousands of miles away. And now, right before me, soliciting "Ideas and Camouflage in 1984," was Burroughs's home address—in London. I was sure he lived in America; not to mention this was 1972, and 1984 seemed a long way off. Convinced it was a joke, I nevertheless wrote to the address telling Burroughs just where he could stick his camouflage and instructing him, Allen Ginsberg, and any other Beats to STOP pretending they knew me just to gain contemporary credibility.

A few weeks later, an old souvenir postcard of Morocco arrived through my letter box and fell to the cobbled floor beneath an axe and hammer clipped for defense on the inside of the bloodred front door of the Ho Ho Funhouse, the communal home in Hull I shared at the time with my guerrilla performance art collective that was also a band. On the back, a greeting signed by William S. Burroughs telling me that he had enjoyed my recent letter and that he would love to meet up the next time I was in London!

"Just call me up and I will pay for a taxi over here from wherever you are," he wrote, adding his phone number.

Whoa! He wrote back!

This was so much more than just a thrill.

Naked Lunch had changed my life, *The Third Mind* was my bible, and I was even more eager to read *The Wild Boys*, which was just about to be published. His "cut-up" technique of writing, which he had developed with the artist and writer Brion Gysin, was heavily influencing my music at the

time. The idea of chopping up the tedious everyday narrative and creating new, unexpected meanings, even prophecies, was fascinating.

The first time I met him, he was living in Duke Street, St. James's, London. I had no idea what to expect. Would he be cantankerous Old Bull Lee of the Kerouac sagas, where I had first heard of him, or the thinly disguised biographical character William Lee of *Junky*? I was excited to discover the REAL person.

After hitchhiking from Hull in East Yorkshire all through a miserably rainy, blustering night, I had crashed with my friend Robin Klassnik, sleeping on the floor of his artist's studio at 10 Martello Street, Hackney, East London. I was woken by Robin with a cup of tepid instant coffee heaped with white sugar.

"You know some really annoying people, Gen," said Robin while I tried not to grimace at his foul brew.

"What do you mean?" I asked groggily.

"Some stupid idiot has been phoning all morning claiming to be William Burroughs and asking for you. So I told him to fuck off and not call again," Robin proudly announced.

"Oh shit! What time is it?" I asked.

"Eleven A.M. I let you sleep; you looked tired."

"Robin, that wasn't some stupid idiot pretending to be William Burroughs," I said, rubbing my face and then staring up at him in happy disbelief. "That really *was* William Burroughs. I hope he'll still see me after your tirade."

Back in Yorkshire, I lived in a commune and stole whatever food I could, supplemented with broken biscuits that rescued a watery cup of tea from disgrace. I scavenged bruised vegetables and fruit off the road after the local farmers market closed and brought home meat that was donated by the local Freemasons Temple. The kitchen ladies there would leave fish, steak, and chicken—left over from the masons' lavish banquets—by our door for our "poor cats," but we destitute humans got first choice.

I wasn't used to traveling in taxis, but William was paying. I expected him to be quite financially comfortable. He was a famous writer, after all. I've since learned that no matter how many people know your name, it

still has zero to do with having a healthy bank account. I anxiously walked around the block several times because I was early, and I had this notion that he'd be upset if I was a minute early or a minute late. I'd built him up in my head to be a hyperintelligent, never-suffer-fools-gladly type and that he'd be waiting, silent, to be impressed by me. I had a bad case of the exam shakes.

As I nervously walked up the narrow stairs, listening to the faint echoes of my Doc Martens boots in the dark, austere stairwell, I was convincing myself that he'd see how dumb I was instantly and chuck me out, humiliated and clearly inferior.

I knocked on his door.

He opened it before my hand was back at my side, no chance to compose myself. And there he was, a living legend, neatly dressed in a suit, his eyelids half-closed, the convex bags under his watery eyes an unhealthy pink.

He looked smashed, and it was only a little after noon.

"Genesis," he said, the last syllable drawn out in that famous voice.

Oh, God, this is real, I thought. *It's really him.*

We politely shook hands. Nothing like the revolting wet-fish handshake of Philip Larkin, I thought again, calming myself by making small comparisons. Burroughs ushered me into his surprisingly small apartment, squeezing past a life-size cardboard cutout of Mick Jagger.

God, I hate fucking Mick Jagger! I secretly thought, followed by, *Careful, you only just got here and you're being negative.*

The volume on a shitty colour TV was turned up high in front of the one window, and thick green curtains blocked out any daylight. William sat down on a grubby armchair. He took a long sip of Jack Daniel's and told me he'd spent his day just changing channels with the remote.

I'd never seen a colour TV before.

He picked up the remote, changed a few more channels as if he were searching for something underneath the white noise.

"I've been doing this all morning," he said, changing to another channel. "Sometimes it helps if I close my eyes and just listen to the noise. Turn the volume all the way up."

And so it began. He started to talk in that infamous hypnotic monotone, that underwater junkie voice of his. It originated in his throat, a long,

sustained, rasping growl reaching a dry mouth and becoming a nasal St. Louis whine. I'd expected him to put me on the spot. Test me. Challenge my intelligence to ensure he wasn't wasting his time. Or, more likely, make some excuse and politely suggest I leave after a few minutes, having decided his pen pal was less interesting in the flesh.

Instead he asked me if I'd like a drink, and when I said yes, he walked over and poured more Jack Daniel's into two glasses. I noticed his shoulders were slightly stooped. He sat back down, and for nearly a minute we didn't say anything. He was looking me over, but not in an unfriendly way.

"So you're a musician," he said.

"I'm in a band called COUM Transmissions," I said.

He took a sip, and the faintest of smiles spread across his face. He looked so tired, it was as if his skin just wanted to slough off his face.

"You're in our songs," I told him, taking a sip of the whisky. "I use your cut-up techniques when I write lyrics. I'll read something in a newspaper and just splice the words together."

"Then you're on the right track," he said.

He picked up the remote control, and for moment I thought I'd already lost him, but he changed a few channels on the television, stopping on a grainy image of a football match, and then turned it off.

"It never would have occurred to me if I hadn't read *Naked Lunch*," I said.

"Can you reach that book on top of my desk," he said, lifting one trembling hand and pointing at a leather volume filled with strange bits of paper.

I picked it up and started to hand it to him.

"No, open it," he said.

I opened the book, and the first thing I saw was the photograph of a flame-throwing soldier cut out from a magazine and glued right next to a girl kneeling in front of a box full of puppies, which was cut and glued so that it fit neatly against the gleaming wing of an airplane.

There it was, right in front of me, the same technique that had inspired me to leave behind all the tried-and-true ways of doing things.

I turned page after page in the book, some of the collages so freshly glued that a piece of newspaper fell out of the book. I apologized and started pasting an image of a bloody corpse back where it belonged.

"You're being too careful," he said, taking a long sip of whisky. He tossed me an old magazine. "Find an image you like and stick it there instead."

I turned a few pages of the magazine, ripped out an ad for Harrods, and patted it onto the dots of glue.

"Now you're learning from the master. But I'll have to ask you to do something in return," he drawled.

My mind sketched out several possibilities. The one thing about William that would forever be true was that I never knew what was next. That was the most amazing thing about him. He was a living example of cut-up technique.

"What is it?" I said, closing the book of cut-up collages, rubbing a bit of glue between my forefinger and thumb.

"You can get me another drink," he said, holding his glass high in the air. "And one for yourself as well."

"I still have a little," I said sheepishly.

"To meeting interesting people," he said, nodding at me to finish what was left.

"I thought you'd have kicked me out by now," I said, finishing the rest in one wincing gulp.

"I think you'll last a few more minutes," he said. "I'm quite optimistic about that."

I stood up and took his glass, briefly touching his long fingers. I felt him watching me as I walked over to the makeshift bar, pouring us the next round of drinks.

"I had a dream with you in it, Genesis," he said as I turned and walked towards him, handing him back the glass. "But you looked completely different."

I began to laugh, but he wasn't smiling. He was completely serious. I sat back down and then we began to talk about all the other things I was dying to ask him: *Naked Lunch* and censorship, the upcoming novel *The Wild Boys*. He gave me a signed advance copy.

I was thrilled to be talking with Burroughs in depth like this. My wildest dream was coming true, unfolding in real time. And I was getting drunk. Not as drunk as him, but enough so that I scraped against the wall on the way to the toilet.

We were interrupted for only a few minutes when his Irish lover, a muttering piece of Piccadilly rough trade named John Brady, walked in and was quickly shooed away. William took another slug from the second bottle of whisky and suggested I go with him to dinner.

We walked to an Angus Steakhouse, a tired-looking chain restaurant right by Piccadilly. As we entered, William nodded to the three Latin waiters, all about five feet high, standing in a row against the wall as if in front of a firing squad. They acted as though they'd been expecting him. All wearing clip-on ties and identical red aprons.

"Hello, Meester William," they all said in unison. "Your table is ready."

I immediately felt I had slipped into one of William's routines in *Naked Lunch*.

There were just two other customers there. It had the atmosphere of a funeral home that just happened to also sell dinners.

William recommended the steak, so I obliged him and ordered it, too, even though steak was the only thing on the menu.

"With peas," he said in that monotone, every word he spoke exactly spaced out, like freight cars crawling across some midwestern plain.

"I'll have peas, too," I said to the waiter.

It turned out that William ordered the same meal every night. He had it down to a science. Eight bites of thin leathery steak. Twelve buttered peas, no more. The tines of his fork tapped against his plate as he trapped them.

"I used to eat at the Moka Bar on Frith Street," he said. "But they were always rude to me, unfriendly, so I had to curse the place."

Then William proceeded to tell me how he had cursed it using his cut-up magic technique. First, he walked back and forth past the Moka Bar, again and again, with his TEAC cassette recorder slung over his shoulder, making a recording of all the ambient street sounds.

Honking horns. Shouts from passersby. The tinkling of a bell as a shop door opened. A dog barking somewhere. The sound of a distant jet overhead.

Once back home, he began to "cut in" by randomly recording what he called "trouble noises." Ominous, negative sounds recorded from his TV. Gunshots, police sirens, warfare, bombs exploding, buildings being demolished, screams of fear, loud swearing, crying, fire engines. Once he

had cut these sounds into his original ambient recording, he went back to Frith Street. He played his edited trouble tape as loud as possible while he again walked up and down past the notorious café.

William had also taken a photograph of the row of buildings with the Moka Bar in the middle. He made a print, sliced out the café with a razor, and burned the removed rectangle image of the Moka Bar while gluing the remaining two parts of the photograph back together in his journal minus the café. Placing a curse correctly required extreme attention to detail.

But it paid off. Within weeks the Moka Bar was closed and suddenly out of business, never to reopen. The building became a ghost, dooming any business attempt to instant failure.

Somewhat anxious about his ability to curse anything at will, I concentrated on my steak, sawing another piece off, my lousy English dentistry struggling. I was picturing William S. Burroughs walking up and down a street fifty-odd times, wrapped in his overcoat, trilby hat on head. A huge cassette recorder strapped to his chest, holding a microphone up like a Geiger counter, intently recording noises on a seemingly ordinary day. And then I smiled to myself because I realized there wasn't a single other person on the face of the earth I'd rather be eating a shitty steak with.

"I hope they're nicer to you here," I said.

"Well, here, Genesis," he said, chasing the twelfth pea to the side of his plate, "they are always nice to me."

I watched him lift that last recalcitrant pea to his mouth, then delicately put the fork down, just so.

"I like your scarf," he said. "What's it made from?"

"Ferrets," I said.

"I know them well," he said, reaching towards me to touch the fur. "I used to be an exterminator in Chicago. We used them to chase and kill the rats."

By the time we finished our meal, William was wearing my ferret scarf. He paid the bill, and we made our way slowly to the door.

"Goodbye, Meester William, sir," the waiters chanted in high-pitched union again.

"Good night boys," he replied, a little flirtatiously. His eyes were slipping around, making unfocussed, looping patterns like off-kilter ice skaters.

Both of us were pretty unsteady on our feet by now. We had demolished almost two full bottles of Jack Daniel's. He had had far more than me, and I became thoughtful as we returned to Duke Street.

What do I do if William makes a pass at me? What is the sexual protocol in these situations? I had had only one male lover at this point of my life . . . These flutters of excitement in my stomach confused me. Had this been his intent in contacting me all along?

I need not have concerned myself at all. William had far more portentous matters on his mind in regard to my future as we trudged along in the last light of the day, moving as if we were underwater.

He turned to me at the front door to his building and smiled, a wonderfully sincere and warm smile. Then he spoke, gently but firmly, my ferrets still around his neck.

"Genesis . . . ," he said.

"Yes, William," I answered.

"Genesis . . . your task from now on is to tell me . . . HOW DO WE SHORT-CIRCUIT CONTROL?"

His question that drunken afternoon resonated with me because it had already haunted me.

By age seventeen, I had a revelation that life and art were inseparable. Indivisible. To really know what was going on around you, you had to locate "control" and those entities with a vested interest in maintaining their tight grasp on it. And then you had to take it apart as best you could. You had to cut it up. Break it into pieces and reveal the ugly interior.

Once you decide to devote yourself to this cut-up technique, it joyfully contaminates every aspect of your life. A kind of truth virus. And, for me, it remains the only reliable filter through which to observe this earth and the overriding culture with any hope of accuracy.

As our species grows more homogenized, riddled with insipid stereotypes, diminishing returns, and increasingly uninteresting ideas, cut-ups become an ever more essential tool to smash this status quo to pieces, cherry-picking only the functional, exciting remains to take into any future world. The tape experiments I compiled almost a decade later were my deepest connection to William. I followed him from London to the Bowery

to Lawrenceville, Kansas, with a Nagra tape recorder, always in search of ghost voices behind all the white noise that shrouds us. There are hundreds of hours of recordings. They are the hissing magnetic blood that kept our relationship energized and ongoing.

I still hear his voice so clearly, and that question posed in his monotone.

How do we short-circuit control?

How do we drain the power sources of the forces that are ceaselessly trying to keep us in their grasp? Even those forces within ourselves?

There's a picture of William I took at the end of that evening. He's wearing my ferret scarf and we're standing inside his apartment. He's leaning towards me unnecessarily as I snap the photo, as if the world's weight were tilting behind him. His cheeks are flaccid, eyes drooping.

He's clearly drunk.

He's clearly trying to numb some inner force.

How do we short-circuit control?

<div align="center">* * *</div>

Nonbinary is the first time we've chosen to reveal the story of our provocative life in full. We're battling chronic myelomonocytic leukemia, and it will win. Two years, they say. More, we hope. Or less.

We'd like to stay, because it's fascinating here. But as far as we can tell, having a physical body is a luxury we don't often get, and too many people squander that luxury.

We've not squandered it.

We've utilized it to the maximum we could.

When you've got a terminal illness, you think about what your legacy might be. Our only answer is, we would hope that it would inspire people to see that they can live a life totally as they would like it to unfold. We've never believed in an audience, really; our work has always been built upon finding out how to knowingly include them. This book is no different.

Our influence on modern music is an open secret. We helped create industrial music with our band Throbbing Gristle, and then, at the height of the band's fame, simply walked away. There is nothing more dull as a

song sung the same way twice a day in which one lives on automatic pilot. It's always been our mission to fall through the cracks of stale tradition and habit every hour of life. To find the places and sounds no one has dared to think of. To have real faith in oneself in an age when the white noise of conformity has never been turned up higher is no easy task. But everyone has the potential to do it.

It's no coincidence that our creative process nearly killed us on several occasions. Surviving in this relentless, grueling landscape is brutal. It can deplete your optimism, reduce your strength. But in choosing the hardest artistic path of all, penniless at times, attacked by politicians, exiled from London, we also managed to attract like-minded iconoclasts such as Timothy Leary, Brian Eno, John Waters, and Trent Reznor. Risking everything, we found not only a family of thousands of devoted fans and friends that stretches around the world but also our late, truest love, Lady Jaye Breyer.

Through the example of our life, set out in this book, we hope to inspire future generations to discard all inherited value systems, social conditioning, and familial loyalty for its own sake, and to come to realize that gender is a red-herring distraction as an issue. The real issue is how to reclaim our right—and the determination to embrace that right—to build our own unique identity and be the writer of our own self-chosen life narrative, free of intrusion or interference.

For us, there has been a conscious choice never to be stuck: not in any one place, in any one song, in any one musical genre, in any one definition of sexuality. It's been our daily mission to subvert. Charmingly and seductively, but to subvert nonetheless. As a result, *Nonbinary* isn't for the faint of heart or the squeamish, because the delight of this memoir is in the details, both somber and joyful. Our genuine hope is that this book gives readers with even the most modest artistic ambitions—and who may have fantasized about what it would be like to live this kind of life—the strength to pursue such freedoms and personal growth.

Our desire is to inspire a new underground we all know exists, a new generation of nonconformists hungry to read about a genuine and often-attacked artist who has been reluctant to tell the whole story up to now.

As a chameleon and cultural engineer who exploded genre after genre, whether industrial music, acid house, the occult, body piercing, or the ultimate canvas of our bodies as Lady Jaye and ourself sought to become one, we've always sought and fought to answer Burroughs's challenge: *How do we short-circuit control?*

1.

I was born in the shadow of war, without the light of peace, during the early evening of February 22, 1950, in number 10 Kensington Avenue, Victoria Park, Manchester. I was born at home, which was a common practice back then.

My mother told me that in her post-labour delirium she asked the midwife, "What is it?"

This was long before ultrasound or other technological ways of KNOW-ING in advance the biological and assumed permanent gender of babies in the womb. Although some women still swore blind that a house key suspended over a womb with a cotton string was as infallible as a pope.

So, despite her birthing story sounding more like a working men's club joke than what actually happened, my mother swore that the midwife's reply, exasperated though it was, was totally true.

"It's a baby, of course!"

If I had been born biologically female, my name was to be Rowena, which the various books on infant names I looked it up in said means "fame and delight." However, it turned out that I was born a biological male, and so received my first set of legal names without being personally consulted, without a roll of dice nor a cutting of cards. Why, God forbid! Even without so much as a spiritual discussion with our local Church of England parish priest. My parents never revealed their motives for scrying in a book of Celtic names, but, in the end, after much hand-wringing and debate, and a determined avoidance of any deceased grandparent or favourite relative's moniker, they tagged me Neil Andrew Megson.

I'd never bothered to look up what these names mean before but, to my surprise, discovered just yesterday that "Neil" translates as "coming from clouds," a connotation we actually really like.

So here we are, sixty-nine years later, receiving a revelation that my sense of being drawn down into materiality by my birth from an orange place of peaceful, cloudy immateriality and eternity—this deliverance from an orange source—is what my given name actually meant. That source of quaquaversal bliss that I have strived to reconnect with ever since I was sucked away from it is precisely the meaning of my given name, Neil, and for a moment I feel all these threads of my life binding me to mortality at the end of my sojourn within so-called linear time. It's as though birth was a knot in a golden rope that unravels into multiple threads, paths, and choices, and now this same multiplicity of threads will recombine back into another final knot releasing me back into my orange cloud of source once more. I have every reason to believe that this process of knots and threads continues indefinitely, contributing to our sense, at times, of reincarnation and déjà vu . . .

Meanwhile, in the household at 10 Kensington Avenue, my naked flesh "knot" has arrived and been thoroughly washed, leaving me shiny and sterile. Next, naturally, I was held up to be admired and then examined. I am told that my infant penis was declared to have a "perfect natural circumcision," and within a few weeks had been carefully preserved as a photographic example of this, apparently quite a rare penile blessing, to then be dutifully printed in a pediatric medical reference book. I've always wished I had a copy for my archives. Our dogged midwife also measured my body, head to toe, at twenty-three inches long and exclaimed, "He is going to be tall like his grandfather!"

Alas, this was not to be. Not because I failed to grow through some metabolic fault of my own, but because, within a few years, I would be put on daily doses of a new wonder drug, cortisone, a prescription steroid that would stunt my expected growth and in far more profound ways affect the course of my entire life in all the years to come.

On the upside, I suppose that if I'd been around the predicted six feet tall and seen this hallucinogenic world looking down instead of looking up, perhaps you'd never have noticed my resultant more likely conformist ripple of normality in the pool of social conformity. So, in the end, we consider my being vertically challenged and chemically truncated a priceless blessing.

In later years, I asked my mother what she remembered of my birth itself. Her dismissive reply disappointed me: it felt a little uncomfortably close to a form of rejection, even irritation, rather than joy at my arrival. Now I know we were different generations, and hers kept intimacy and biological functions hidden away in a *DO NOT DISCUSS* box. It seemed the mechanics of reproduction engendered more shame than ecstasy. What she said to me several times, when pressed, was this: "Oh, I don't know, Neil; I was too busy having you to think about anything!"

This reply was deftly placed exactly between irritated and dismissive. Clearly it still bothers me, or I wouldn't concern myself with it.

Her first baby died in a miscarriage, followed by the birth of my sister, Cynthia. Then another baby was stillborn. After the stillbirth she was told, "No more babies."

Her doctors told her getting pregnant again could easily kill her.

Despite that dire warning, she did get pregnant again—with me. Her final pregnancy must have been so emotionally terrifying and stressful, with her naturally being constantly afraid she might lose her child again and possibly her own life, too. My due date arrived and nothing happened. I ended up being two weeks late, which must have added to both my parents' fears, even paranoia. She must have been so totally worn-out from the birth itself and all her dread-filled imaginings. Maybe those tensions triggered my asthma, which my doctors concluded was emotional as well as physical?

Still, there I was at last, on the twenty-second of February 1950, dangling upside down. A naked, scrawny late arrival with infinite potential adventures ahead. Were they really lying in wait? All those key moments and options still to come for me? So many potential choices, meetings with remarkable people, conceptual crossroads, and apparently random accidents?

In an odd coincidence, Brion Gysin, who became my mentor and creative "master," said he could very clearly remember being born and he hated it. All the different physical sensations. Like how painful it was being squeezed out from the womb into bright lights and instantly being slapped. He told me he began screaming not because the traditional smack hurt but because inside his mind he was yelling, "Wrong place, wrong address, send me back!"

He even, half jokingly, half ambiguously, said to me more than once, "I hated being forced out of that vagina so much, maybe that is what made me gay, Gen!"

I, too, have often wondered if I stayed inside my mother longer because I liked it there and didn't want to leave the source of all that is. That bliss- and compassion-filled orange space that would take me years of research, psychedelics, and teachings to eventually reach again by my searching and experimenting, but most of all by my force of will, decades later.

My only vivid memory from being an infant is also the feeling that I was unable to express: I felt displaced. All these human beings around me seemed of another species. Close enough to me at times, but I never ever felt I belonged completely.

And this sense of my physical self being disconnected from any bio- logical family, peer group, society or even youth-defined demographic has always been combined with an ongoing awareness that my deeper, private thoughts are best kept to myself. Because if I try to join in with any socially focused behavioral dance or conversation, I will immediately be exposed for the alien brain that I constantly, internally, experience myself as being. Worse, if I speak my true thoughts as that alien being, I will make those around me uncomfortable, possibly embarrassed, insulted, or even a little afraid.

2.

My mother had danced in a chorus line and been an amateur actor before having children. Prior to the war, my father had worked as a semiprofessional stage actor and played drums in a Glenn Miller–style big band. Apart from playing in that big band and also playing drums in a jazz trio, he had one other great passion: motorcycles.

He used to race his motorcycle at Belle Vue Speedway, Manchester, and also took part in motocross, cross-country racing regularly. I still have his 1939 Belle Vue Speedway enamel racing badge pinned to my own biker-style denim cut-off. Speedway racing utilised hard gravel as a surface on an oval circuit. As he told it to me, he had to wear thick, protective leather trousers to avoid scraping his legs and causing nasty open wounds and deep grazes, often caused from having to lean really low down into a corner to maximise his speed as he accelerated out onto the next straight section. He also wore old cavalry riding boots and a leather jacket and cap. I was pretty surprised to hear this and adjust my image of my father from the hardworking, dedicated father with a nine-to-five job, to a teenage tearaway rebel who was seriously addicted to speed and claimed adamantly that he was the first person to go over one hundred miles per hour down Princess Parkway in Manchester when he was just seventeen.

I felt so proud of him learning this. As a result of this shocking revelation, an intensely coloured cartoon of him, swaggering in leather, nonchalantly kick-starting his bike and roaring off into the streets of 1930s Manchester, was playing in my head. But even before I could include a roar of approval from his fellow fledgling delinquents in my imagination, he added another tasty morsel about himself that took me to a whole new level of ultraviolent anime . . .

"I used to have a thick, wooden, cut-down stick slid inside my right boot in case our group got in a fight with any other bikers."

It is probably unhealthy, or a sign of my own personal decadent leanings, but I was so excited to hear about this.

"Did you have fights, then, Dad?" I asked.

"Yes, that's why I carried my stick."

"Wow! . . . What about?"

"Whose bike was the fastest, which looked best, that kind of thing . . . and girls, of course."

Both my parents were very smart, and intelligent. They both won places in good grammar schools on their intellectual merits. My father had worked hard to achieve a scholarship that covered his fees. His father hand-sewed tarpaulins for covering loads on trucks, which barely fed them both. Around the age of fourteen, my father and his sister went on a holiday trip with his mother to London. After an enjoyable time there, his mother put him on a train back to Manchester, telling him his father would meet him at the station and that she and his sister would catch up with him in a couple of days. She never did come home. She kept his sister, Molly, with her. In fact, as was the vernacular in those days, she had run off with another man, eventually moving to a small fishing village called Tollesbury in Essex.

Suddenly feeling discarded, not only was he now motherless and missing his sister Molly, whom he had been very close to, but now he felt like a valueless castoff compared to her.

Worse was yet to come.

Without the extra income his mother had added to the family income, with a father suffering from worsening chronic asthma, my father was forced to quit his education and seek employment. He was just fourteen and suddenly his first-ever job became pushing a tea-break trolley around a large cotton mill, giving out mugs of hot tea to anyone who needed a cup of tea on the tea break—which in England was a big deal back then. British trade unions had fought for tea breaks for years, often going on strike for months at a time, and they remained a bone of contention for years to come.

It was in that mill that he started smoking Player's unfiltered cigarettes, an addiction he continued all his life until three years before he died of emphysema. I still vividly remember the front of a packet of twenty: an old "salty" sailor framed by a circular life belt. By 1969, he was smoking

multiple packs of cigarettes a day. I'd see him at his desk, one, sometimes two, burning cigarettes perched on the edge of his ashtray, another between the fingers of his left hand, and his right hand fumbling to extract another cancer stick from the packet absentmindedly as he focused on a contract. His thumb and first two fingers, as well as his teeth, were deeply stained a dark oak brown from decades of nicotine and tobacco.

Eventually he got a better job at the same cotton mill, shifting from the tea trolley to working as a sales rep. He had begun dating the boss' daughter. He told me his affair with this girl came first, then followed by the promotion, likely because her father, the mill owner, didn't like his daughter going out with a "tea boy" as because he was clearly very smart. And so, with this good fortune, he had quickly leapfrogged his working-class social status to become lower-middle-class and was actually, at one point, expected to get engaged to and then marry this woman.

Then the war came.

In a strange little twist of fate, my father's appetite for velocity got him a place in the armed services when World War II was declared on September 3, 1939, right after Poland had been invaded by Germany. He lied about his age to volunteer as a motorcycle messenger at the start of the war because he'd heard that if you volunteered to sign up as soon as war had been declared, you could then choose what branch of the military you wished to join. His first hurdle was that he was one year younger than necessary to join up, and looked it, too. So he grew a moustache to the best of his body's abilities, but it was thin and blonde, and he certainly didn't feel it was manly enough to convince an aggressive army recruiter. It just wouldn't grow dark! Always ingenious, he used to mainly use mascara borrowed from girlfriends or anything else he could find to stain it black. And so it was, that, after boot camp, my father dutifully was transferred from the infantry and became a motorcycle dispatch rider. He did explain the motivation behind this reckless behaviour: the dispatch rider corps were to be given the newest, fastest model of British bike available. Only the military would get these modern, sleek, velocity-ravenous machines. So, obviously, joining up was his singular option, and his only route to actually getting on those newest wheels.

He never talked much about the war and didn't tell me the rest of the story until decades later. It was past midnight on a Christmas Eve when I finally learned a profound story from his life. My father had drunk a couple of glasses of whisky with me, something I only saw him do a handful of times during his whole life. This fact alone hinted to me that something extra special was in the air, and I was right.

This turned out to be one of so few, incredibly sparse, and thereby priceless, "father-and-son" moments. Moments that, by their very rarity, remain amongst my most precious and are all kept delicately locked in my heart and held, protectively yet gently, as if hugged close for safety like a newborn baby. Somehow I asked him what had happened after he volunteered for the British war effort back in 1939. After a thoughtful pause my father told me this:

"Well, they called it the 'Phoney War,' " he said.

My father had been "shipped out" during the initial lull in anticipation of eventual warfare and a swift victory. His role was basically to ride back and forth with strategic messages, maps, lists of supplies, and any other paper instructions not entrusted to radio communication, transporting them between various buildings, requisitioned farms, even châteaus, that were serving as temporary division headquarters on his fast new army motorcycle.

All had become a pretty pleasant routine. Spring had arrived when seemingly out of nowhere there was a serious panic amongst the officers. The aptly named Phoney War, which began with the declaration of war by the United Kingdom and France against Hitler's Nazi Germany on September 3, 1939, ended on May 10, 1940. The Germans were advancing rapidly with very little armed resistance, and the war suddenly appeared frighteningly real.

After World War I, France had constructed a supposedly impenetrable barrier along its entire border with Germany known as the Maginot Line, after the French minister of war, André Maginot. It consisted of an impressive system of heavy artillery, concrete bunkers, obstacles, trenches, interconnecting tunnels, and weapon installations. It had been a huge undertaking, and it was truly believed to ensure Germany could never break through and

invade France again. Unfortunately, in a brilliant and childishly simple strategic move, German forces swiftly advanced around the side of the Maginot Line fortifications that May 10, 1940, driving forward through Belgium and the Netherlands, and pushing the British army back almost into the English Channel and the French military rapidly into defeat.

An officer grabbed my father. He stuck a revolver in his hands with six loose bullets and announced, "Your orders have changed. You are urgently ordered to go to this location," at which point a crumpled map was shoved in my father's hands, too. "It's a crossroads by a small farm. Once you are there, you are to hunker down and direct any British or other Allied troops to this beach here."

The officer then used his index finger to indicate a coastal location labelled Dunkirk.

"We have destroyed, removed, or replaced any original signposts and even erected some false ones here and there when we had the opportunity to slow down and confuse the enemy advance as much as possible, and to give our own troops as much time as possible to collect at Dunkirk."

The officer then said something which my father said actually did seem to make his blood run cold: "Stay at this crossroads as long as you can safely. As soon as you see any German tanks or troops, get on that motorcycle of yours right away and get out of there. Oh, and don't bother trying to stop the Germans with that gun we gave you. It will just make you a target. Just get away as fast as you can! Understood?"

"Yes, sir!"

My father told me he saluted and walked away to study his map. Once he had figured out where the crossroads were, he grabbed some food rations, water, and his precious carton of army-issue cigarettes and made his way there.

Pretty soon, battered armoured vehicles, soldiers slogging along on foot, ambulances, trucks—everything a retreating army manifests as it withdraws from defeat—was passing by him in ever-increasing numbers, all going towards Dunkirk in an orderly, strategic withdrawal. Don't ever use that dirty word, "retreat."

I got the impression he was at that crossroads at least two or three days. Always nervous. Not really able to rest, as he had nobody to warn him if the Germans were about to be on him when he was asleep. In fact, his habit of smoking sixty to eighty cigarettes a day really began while he was in France in a state of constant tension, riding around totally alone, never knowing if he would be shot by a German sniper or fall into the clutches of an advanced reconnoitre team.

There was a small, ancient grey stone farmhouse on one corner of the crossroads, and its farmyard still stank of manure. He slept in a small animal shed on a pile of straw he had dragged from a hay wagon piled high but abandoned against a mossy paddock wall. On what turned out to be his last morning there, he was leaning next to the hayrick, smoking a cigarette, when a lone straggler appeared. My father called out to him, and within minutes they were sharing early morning hot cups of tea that he had prepared, and thin blue smoke was curling up in coils from their cigarettes.

Suddenly my father grabbed his new friend's arm and told him to shush and listen . . .

"Hear that?" he queried.

"Yes, what is it?" said the straggler.

"Oh shit! It's a German plane!" shouted my father in reply. "Quick, under here."

They both chucked away their mugs of tea and threw themselves under the wooden wagon piled high with hay. Peeking out, my father recognized the plane was a German Stuka dive-bomber, the screaming banshee sirens on its wings a trademark of Stukas as they dove. Deadly accurate at dropping bombs, and rows of heavy machine guns in the wings.

Both men held their breath, even though there was no one to give away their position. Praying they had not been seen, they lay quietly, immobile, listening. Just as my father caught sight of his nice new motorcycle stood ready by the gate, the sound of the Stuka's engine altered. He was making a run at their farmyard, they were sure of it. If it dropped a bomb, they would be blown apart! There was no deadly whistle of a bomb descending, but just as relief was about to flow through them both, the chatter of heavy machine guns began. Glancing out from under their wagon "shelter," they could see

two lines of exploding turf moving in a direct line towards their position. Later they both confessed they closed their eyes and prayed right then.

There was a tremendous cacophony of noise around them as bullets penetrated the hay, making a sound like a scythe slicing through grass but infinitely louder! A storm of terror immersed them as the wagon exploded into knife-sharp splinters all around them. At that precise moment, my father suffered the worst, incredibly violent shooting pains of his life, feeling as though his stomach were being ripped apart by a vulture's claws.

As the sound of the Stuka's propellor receded into the distance, my father was discovered by his newly acquired companion with all his muscles locked, in a fetal position, loudly moaning in agony. As he delicately turned my father over in an attempt to see where any bullets had penetrated him and how bad his injuries were, his task was made more awkward by my father's constant rolling about, squeezing his knees together against his chest, and holding his arms tightly around his abdomen as he tried to ease his distress.

"Wait! Try and stay still," my father was instructed, soon followed by "There's no blood!"

"What?"

"No blood!"

" But . . ."

As much as he could, my father straightened out, and even then neither he nor his new friend could find any blood. A more meticulous search under his uniform revealed no bullet holes, no injuries of any kind, yet he was still experiencing a crippling abdominal affliction.

Several vital things were clear. He could no longer ride his motorcycle out of there to Dunkirk to save himself. He couldn't even walk. The German troop columns would be arriving soon, as they were never far behind the Luftwaffe. His duty to correctly redirect allied troops was accomplished. A miracle of preservation was called for as soon as possible.

Right then, as if on cue, a cosmetically challenged ambulance, worn-out, beaten-up, and obviously in a state of disrepair clearly caused by sustained proximity to conflict, coughed and crunched its way towards their position, its gears and transmission generating a grinding cacophony nearly as loud as my father's distressed screams and groans. Fortuitously, it stopped at the

farmyard gate and a grimy medic jumped down, walking over to the still ambulatory soldier, who stood by my father.

"Do either of you know the way to Dunkirk?" he asked as he automatically examined my father.

The cause of his new patient's extreme affliction remained a mystery, though, and aware of imminent capture or worse, the three of them swiftly agreed that he should be put on a stretcher in the ambulance.

About a mile from the beaches of Dunkirk, there was an almighty explosion next to the ambulance that threw it up into the air. It landed at an angle, resting on a partly demolished concrete anti-tank trap. My father was screaming, having been thrown across the vehicle's interior, and was lying in a crumpled heap. When they had checked on the driver, he was dead, killed by shrapnel. My father's Good Samaritan convinced a shaken medic to help him reposition my father on the stretcher and carry him together the rest of the way to Dunkirk. And that is what they did. Carried him all the way to a chaotic spectacle often described as one of the inner rings of Dante's *Inferno*.

By now my father was delirious and just recalls fragmentary scenarios. Hundreds of boats had come to rescue the British Expeditionary Force from annihilation, trapped on a beach surrounded on all sides except one, which was the English Channel. German emplacements were machine gunning soldiers at will. Mortars were landing constantly. Being on that beach was a form of Russian roulette, but with more bullets added every time the trigger was pulled. There is film footage of men playing cricket, knowing survival was hopeless, as they were strafed by planes and slaughtered from the perimeter.

The idea was that the smallest boats would ferry a few soldiers at a time to bigger ships that in turn would either make their own way back to England if they could, or transfer their contingent to larger, more task-appropriate larger vessels. In fact, despite the carnage, this desperate ploy worked ridiculously well, saving thousands to live, fight, and risk being slaughtered in battle again.

Amongst all this insanity and constant mutilation and death, my father was carried to the seashore and placed on a small boat to take him to a

larger one. As he was being loaded on the boat by his rescuers, a mortar hit nearby. His Good Samaritan, who had saved his life in countless ways, was killed instantly.

Unknown, unnamed heroes passed my father's stretcher from ship to ship. He remembers another ship he had been on getting blown to bits as it returned towards the Dunkirk beach to ferry another load of warriors to safety.

Then he passed out.

Back in England, by now into the third day of my father's affliction, the cause of his intense agony was finally diagnosed. As he had been hiding under the hay wagon, at the exact moment they were machine-gunned, he must have clenched his diaphragm really hard with fear, and two or three duodenal ulcers in his stomach had burst, releasing toxic poisons into his digestive system and eventually his bloodstream. It was the equivalent of having three appendixes burst at once, causing peritonitis and getting no treatment at all. He had gone over three days without any painkillers! At that time, there was only one specialist doctor in Britain who could perform a new surgery to save the life of a sufferer with this condition. Fortunately, he was available and did indeed perform the operation on my father, preserving his young life.

About a week later, my father's father came to visit him in the military hospital. At the entrance to the ward he asked, "Which bed is my son Ronald Frederick Megson in?"

He was given the bed number and walked down to console his son. After only a few seconds at the bedside, he walked briskly back to the nurses and said, "That is not my son! That is some old man with white hair! My son is young and has dark brown hair! You must have given me the wrong bed number. Please give me the correct number."

The nurse assured him that was the correct bed number, and this time went with him to double-check who was in the bed.

"Yes, that is your son, sir," the nurse insisted.

It was only then that he began to understand that my father's hair had turned totally white in three days from the sheer degree of pain he had endured.

My father heard about a year later that the same surgeon who had saved his life had died from duodenal peritonitis himself, as there was still nobody else available who could do that specialist operation at that time except him.

Years later, we were watching the epic *World at War* television series with my father, mother, and sister, and it was the Dunkirk episode. All of a sudden, my father exclaimed, "That's me!" I was able to focus quickly on the small black-and-white screen, and there he was, just for a few split seconds, perhaps less, being disembarked on a stretcher, haggard as he stared intently into the camera before being whisked away into an army ambulance.

In all the years he was alive, not once did my father say he loved me. This did, and still does, hurt. Coupled with his last words to me in a letter—"When will the pain you cause ever end?"—it suggests an emotional rift on his part from when I was very young. Yet I am also unable to bring to mind ever being smacked at any time. He did yell at all of us when he lost his temper—at me, my sister, and even my mother. His rage at those times was so intense, his face contorted, his eyes so wide that his volume and expressions alone were enough to make me cower. This forceful disapproval was so intimidating that it has stayed with me to this day. If someone I love or respect says they are upset by my behaviour, or let down by my failure to live up to their expectations, I still go cold inside. It paralyses me like a rabbit caught in headlights, frozen in fear until it's run down and killed. There's no need to punish me as such: I punish myself over and over. The feeling I've let someone down envelops me, infantilises me, and I can brood over my failure for days afterwards, wishing for forgiveness but never daring to ask for it. The trigger can be incredibly trivial or relationship-breaking, but the paralysis and guilt I go through is uniformly crippling.

Once my father was eventually released from the hospital and back in Manchester, the Phoney War was over and the Battle of Britain had begun. My father was no longer fit for active service, but he volunteered to continue as a motorcycle dispatch rider in his hometown. The infamous Blitz was in full swing, with all major cities and industrial centers being bombed night after night. Air raids on Manchester by the Luftwaffe began in August 1940 as they attempted to cripple the industrial complex around Trafford Park. My mother worked as a telephone operator for Fairey Aviation,

who manufactured Lancaster bombers for the Royal Air Force, which in turn were flown to bomb various cities in Germany to destroy their industrial capabilities. Apart from plugging dozens of telephone lines in and out of sockets, my mother was also a dancer, entertaining the troops and workers in a Rockettes-style line of coordinated high kicks wearing what was, for the time, a skimpy, titillating costume.

My father, still just eighteen, was now charged with receiving and delivering extremely vital messages on paper whenever the bombing cut the phone lines, thereby threatening official orders to antiaircraft batteries and fighter planes, as well as civil defence, town councils, emergency services, and factory production. I asked him once if he was scared for his life, riding his motorcycle through ruined streets, burning buildings, and more falling bombs.

"No," he replied, messing my hair with his hand as he spoke. "I knew if a bomb landed on me, I wouldn't even know. So I didn't think about it that way. Fear does no good. In fact, that's when you make mistakes."

I tried to imagine the apocalyptic scene: collapsing Victorian buildings, burning homes, brick-strewn roads with bomb craters, a hellish cacophony of noise, flames roaring, walls falling into demolished shops, explosions all around and "ack-ack" antiaircraft fire exploding into flesh-shredding shrapnel like accursed fireworks, always accompanied by the endless deep hum of German bombers' engines in the sky. And, of course, the response to that ground-shaking hum, my father's 500cc engine speeding him through it all, night after night, as if the faster he went, the less likely he was to be wiped out by a bomb with his name on it.

One of his regular destinations was Fairey Aviation. On one occasion, after my father had delivered a packet of letters, he was then off duty. One of the men in the Fairey office suggested he go with the other guys to watch some entertainment. My father said yes. On came a line of dancers in a row, arms interlinked, doing a deceptively complicated routine of high kicks and breakdowns into smaller units. One woman in particular really caught his eye. My mother, Muriel Lilian Swindells. I never found out from either parent how they began dating after that first instantaneous attraction. But they did.

In an atypical confession, my mother revealed to me that on one occasion, they broke into a mattress factory with a few friends, most of them couples. They all had a party—all innocent fun, she said—then she and my father fell asleep on a pile of mattresses. Quite soon after they were married on May 15, 1944. My father's very best friend got weekend leave from the Royal Air Force to be his best man. Sadly, he was shot down not long after this, to be listed as "missing presumed dead" thereafter. I could tell his death had deeply injured my father. Obliteration of a potential life is always such a waste. Whenever he showed me albums of old photographs, which included one or two of his friend in uniform at the wedding, my father would go very quiet and sombre, still affected emotionally and clearly touched by the loss of this friend. They must have been close. He never really spoke of any other mates at all that I remember.

At the end of 1945, my father became one of 750,000 demobilised soldiers released back into civilian life after six years of basically avoiding a violent death. Like everyone, he received a small financial grant and a set of demobilisation clothing, which included a men's suit, shirts, underclothes, raincoat, shoes, and a hat. By 1947, 4.3 million men and women had returned to Civvy Street.

During the period after the war, when they were back in Manchester, both of my parents started doing semiprofessional acting, which my father pursued for a while, even into the 1950s. My mother did acting, too, but my father was the one more focused on it. There was one play he did about a soldier who was court-martialled for cowardice that I remember seeing. It was in a big theatre—just a monologue with him on his own, on the stage, and it was amazing.

My father played the drums, in addition to acting and riding motorcycles. As I grew older, I hung out with Hells Angels, Gypsy Jokers, and Freewheelers; I received a drum kit for being accepted to a university; and after I dropped out, I moved into street theatre and performance art. These connecting threads are so specific, almost an echo of my father's creative aspirations for himself, that I have spent significant amounts of time wondering if children receive key individual yet still-unresolved aspects of a parent's karma to continue experiencing through multiple lifetimes towards

an eventual resolution. My father told me several times that he had been forced by circumstances to give up his dreams for himself to support and raise his family instead. Was I, a weakling, a sickly son, fated nevertheless to live out his most precious creative gifts on his behalf (though this was most likely buried deep inside his mind), becoming a form of genetic reincarnation? Was I intended to realize his disappointed aspirations—a karmic avatar, though biologically flawed?

3.

My father's reluctance to discuss the war didn't surprise me, really. All these people were given a halfhearted official thank-you, and, like many, my father also received two "service" medals and ribbons to match. There was no consideration of trauma, nor long-term psychological damage from being exposed to seemingly pointless brutality for years on end. Post-traumatic stress disorder had yet to be identified. Shell shock and catatonia were seen as weakness, as a failure of a soldier's warrior masculinity. At some point, seeing the "enemy" crookedly sprawled in a trail of their own entrails failed to give satisfaction; it could come to seem friend and foe were just fodder for military egos and political manipulations. Therapy was not included in the military vocabulary. Working-class young men like my father were pulled off the streets by jingoism and after a few weeks basic "training" (now there's a loaded word) were expected to simply adjust to murdering other young men who spoke a different language, came from a different culture, and were therefore fair game for whatever weapon you were given to kill them with.

I often wondered then, and still do, how deeply the psychological scars of this "warrior" perversion called war really go in service of a privileged elite?

At the end of the war, rationing ended. Sometimes, though not often, we would be allowed to choose a few homemade sweets. My favourite treats were sticks of spearmint and rough lumps of honeycomb covered in milk chocolate. I still revere the smell and disintegration into flavour of those honeycombs. Things were still cheap, too. Pennies and half-pennies, even farthings, were still all legal currency, so if I was frugal, I could save up enough coins to even buy myself extra. Already I was leaning towards sugar as a major constituent part of my diet.

Sparkling fragments of memory, some sharp enough to draw blood.

Perhaps I was three. It was still considered completely risk-free for a child around my age to play outside without adult supervision. The serial killers Ian Brady and Myra Hindley had not yet stolen that blessed freedom from the young of Manchester. My mother was cooking dinner in the kitchen at Kensington Avenue when a loud repetitive knocking began at our front door. My mother automatically smoothed out any creases in her apron with both hands as she walked to our door, curious. I followed behind her, keeping close to the staircase wall. There was a small space under there behind a small fluted, wooden door. Usually we kept our holiday suitcases in there, but that still left plenty of space for me to crawl behind them and settle in with a torch. My early intuition had me hanging back, almost hidden behind coats suspended from brass coat hooks as I listened intently to the grown-ups' conversation.

"Your son, Neil, is a menace!" was our neighbour's opening salvo in a raised voice I felt sure was intended to establish ascendancy over my mother.

It still surprises me to remember the vitriolic levels of vindictiveness that particular neighbor was able to project towards me.

What? I thought to myself.

"What?" replied my mother loudly, echoing the volume and tone of our visitor.

At that point I noticed the neighbor had by her side her own small son, who looked miserable, as if he'd been crying. We had been playing warships together earlier.

Houses in Kensington Avenue were designed in such a way that their front doors were over on one side of the building. They were constructed in pairs, known as semidetached, with both front doors next to each other with a small rectangle of dark purple ceramic bricks around the outside. Soil filled this space with the intent of growing climbing ivy, roses, or other plants to brighten the street up.

"My Neil is a good boy. What are you saying happened that seems to have got you upset?" enquired my mother.

"Neil made my boy play in the muddy rainwater outside my door and now look at my son's clothes! They're ruined, and it's Neil's fault!"

My mother looked casually at the victim of my evil persuasion and said, "I don't understand: his grey outfit looks fine to me. Maybe there's a little dirt—"

"Grey! Grey!" the woman screamed. "My son's clothes weren't GREY when he went out to play; they were white! Your son is to blame! He persuaded my boy to play in the dirt!"

At this point, feeling unfairly accused that the ruination of this boy's pristine white clothes was my fault, yet also feeling guilty, with my cheeks blushing, I sneaked away, back into our kitchen.

I am sitting on an old electric washing machine in a small pantry. My legs dangle over the edge. I have developed the power of speech and a reasonable amount of comprehension. My mother is telling me something very important. My heels tap rhythmically against the cream enamel.

"I'm afraid we will have to put Sugar to sleep because of your asthma," my mother says, referring to our family's black-and-white cat. "It turns out you are very allergic to cats, and as long as we keep her in our house, she will make you very ill."

I was dumbstruck.

I loved Sugar. I loved running my tiny pink fingers through her fur, which it now seemed she was using as a weapon to try to kill me. I did not want her to die. Apparently it was my fault that she must. And she did. And so began my being blamed for things I didn't do.

Little did I know that this was the beginning of a lifetime of being accused of things that I never did, being scapegoated for ideas that I felt were morally sound, being viciously attacked by various aspects of the "establishment," and victimised and pilloried by tabloid newspaper character assassinations. It seemed to me that my fate was to be continually singled out, isolated, ridiculed, punished, bullied, and unfairly blamed by my birth society in yet another unwelcome golden thread.

Kensington Avenue was a private road, which seemed to mean whoever owned our street had no obligation to asphalt the surface, so it was just compressed earth. When it rained, various potholes filled with muddy brown puddles, looking very much like a scale model of a World War I

battlefield, like Passchendaele. Only two families on the street had a car. My father had one of them. My father's car had those old-fashioned indicators. Little orange glass flags that rose up out of a slot in the body of the car to indicate a turn. How traffic behind saw them, God only knows.

Back at the house, my father had installed a brand-new piece of technology in our front room: a television set. It had a very small screen, no more than twelve inches in picture size.

By the second of June 1953, I had enjoyed my third birthday. My brain, and sense of individual self, had strengthened enough for me to realise that I was lucky to be privy to a very significant event: the coronation of Queen Elizabeth II.

The adults gathered around the TV seemed to be revelling voluntarily in this celebration, surrendering to the pure pleasures that seemed to engulf adults in ways I and other infants never would understand. Several invited neighbours sat quietly in concentric rows on our dining room chairs. These were all people I did not recognize, except for my maternal grandmother, Edith Swindells, who we called "Nanan."

I guess my father was being altruistic and patriotic in having near strangers over.

No doubt there would be pots of tea, sandwiches, and biscuits, but that is not what I remember. I remember sitting on the floor and staring at this mysterious wooden object that had flickering black-and-white photographs that moved. I had no idea what I was watching or any of its meaning. I was just fascinated by the sight of a horse-drawn carriage that seemed to keep slowly moving while thousands of people watched and cheered as a classic, posh BBC voice monotonously droned on and on as if determined to send me to sleep during the first-ever British coronation to be televised live. That voice succeeded, too, in leaving me dozing quietly on the floor with an endless loop of the coronation carriage accompanied by the clip-clop of the horses turning, turning, turning in my infant dreams.

Little did I, or anyone else there that day, know that a lifelong, sometimes direct, sometimes symbolic conflict on multiple cultural and moral

levels would be woven into my life from that moment on. Elizabeth and her cronies would, it turned out, vilify, persecute, harass, censor, prosecute, plague, and scapegoat me on multiple occasions throughout my life thereafter. For fate had decreed, even at this early point in my life, that Elizabeth II would be Professor Moriarty to my Sherlock Holmes.

4.

There was still rationing at the time—so soon after the end of World War II—and I grew up playing in bomb craters and sites damaged during the war. To get sweets, we had to have a little kind of token, and we were allowed meat once a week.

But about a year after the coronation, on the Fourth of July 1954, fourteen years of food rationing finally ended when restrictions on the sale and purchase of meat and bacon were lifted. It is so easy to forget how long the hardships of war had continued in Britain. The shadows of war are long indeed. Despite having been twenty-three inches long when I was born, I was really thin and weighed around half the weight considered healthy for my size. This meant that just as many of my numerous hospital visits were about my abject refusal to eat food as about my affliction with asthma. One doctor even said, "If I didn't know better, I'd say Neil seems to be so revolted by food, it's as if he is on a hunger strike."

There were constant medical concerns about how thin I was. My long-suffering mother had to take me back and forth to nutritional specialists for years. In my adolescent years I was forced to drink a mug of Complan, made with warm milk, every night. Complan was equivalent to Ensure, but was thick—made with a powder that clumped up into lumps that broke apart into vile-tasting dry power when you were cursed enough to bite down. I worked so hard to comply by drinking Complan every night, but it was so revolting. Yet, just to please my mother and get the endless doctors off my back, I drank it every night for the next four years.

Apparently, I rejected nourishment so determinedly that my mother, in her panic to get something—anything—inside me, resorted to tempting me with sugar. Custard, chocolate, honeycomb, blancmange, apple crumble. Basically anything I would accept. Inevitably, she was unwittingly training me to prefer sugary sweetness and to be aware that if I was stubborn long

enough, I would not have to eat the steamed cabbage, mashed potatoes, peas, and beef and carrots.

This struggle with food and eating has never ended. Even now, if I could absorb enough nourishment and vitamins by simply swallowing one pill with some water, I'd be thrilled. I have never been able to muster even the slightest interest in tastes, flavours, textures, or combinations of food. It has always struck me as a demeaning and primitive requirement of my body. A necessity that I totally resent. For years, my weight hovered around 115 pounds. During the late 1970s nearer to 95 pounds. Even in my thirties I remained at 120 to 125 pounds. Considering that I was taking steroids from eight years old every day until the present, it is remarkable how skinny I remained for decades.

I am constantly amazed by how little detail I remember from my early childhood. Entire years are empty, reminding me of how I feel when I visit abandoned amusement parks with their defunct and rusting rides. Time serving as a witness to their encroaching purposelessness. When I do have any fleeting images, fragile as the ash from burned paper floating in thermal air currents, they are mostly devoid of clear, connected feelings. There are not even traces of once-inert anchors. When I am out and about, socialising, usually under extreme duress, I meet people with endless vivid memories: "Best time of my life," "Wish I could have it all over again," they exclaim with a unique case of ravenous nostalgic hunger.

For me, memories of early infant life appear as sparkling fragments, like glitter pouring between my fingers, catching light in unpredictable ways, a jigsaw of primarily visual recollections. There's no way for me to be sure which of them happened first, preventing any order that might give a linear shape to these earliest years. Some, I know, can feel like memories but are really anecdotes shared with me by my mother, yet they are just as valid.

By the mid-1960s, we would discover Gysin's "cut-ups," a creative methodology enabling a far more accurate reflection of so-called consensus reality than any linear structure could impose. In turn, this retroactively liberated me from feeling obliged to formulate any formal sense or shape out of the mess my fractured memories delivered. In fact it confirmed that we experience minute-to-minute existence in overlapping, contradictory

layers, built on a foundation of extreme disorder and fluidity. Yes. Just as it seemed life was chaos, it actually was.

Despite having the only car in Kensington Avenue, my father had very little money to support his family. So he made me toys himself. One Christmas he built me a medieval castle from scrap wood and empty cardboard carpet tubes to make towers, complete with crenellations and a courtyard. It was covered in a modelling paper that replicated granite blocks. There was even a drawbridge with a ramp leading up to it that could be raised and lowered on tiny chains. I liked to imagine this moat filled with sharks and poisonous snakes hidden by brackish water. I had a few knights, cast in lead and meticulously painted.

Most of my cowboys, Indians, World War II soldiers, and even small wild animals were made from lead. To protect their beautiful paintwork, after every time I played with them, I would wrap each one carefully in toilet tissue and then lay them on a bed of more toilet tissue side by side in a wooden tea box. In those days tea was imported in various sizes of wooden boxes that had tinfoil sealing them to preserve as much flavour as possible in transit by sea. My father would get empty boxes from the grocer to use as ubiquitous storage containers.

When I was four, he made me a wooden "tommy gun" submachine gun from a plan in a hobby magazine. He stained the barrel and circular magazine metallic black and the handles brown. I adored that gun. I still sometimes have dreams where I am searching for it in an old home, nagging my father to remember what happened to it, even begging him to create another. Before it disappeared forever into the same dimension as odd socks, I would borrow my maternal grandfather's Iron Cross, hanging on its original Nazi ribbon, and sneak away his defused hand grenade off the mantlepiece, then go outside and play soldiers in the bomb craters and shattered buildings close to our house.

I remember little about my grandad Swindells except he seemed incredibly tall—he was actually around six feet two inches—and he was always in blue-and-white-striped pyjamas. Somehow, one afternoon, I lost his Iron Cross on the "battlefield," and when it was noticed that it was missing, I attempted invisibility—but, of course, everyone knew it was me who had lost

it. My young mind felt sure I would get a severe reprimand and punishment of some kind; yet, much to my surprise, when I owned up, my grandfather was very mellow and easygoing about this loss. I was forgiven, and it was never mentioned again.

Nanan Swindells and Grandad Swindells lived next door, so we tended to see them quite a lot. Nanan much more, as she took on the traditional role of helping with the grandchildren. Although I feel a warmth whenever I picture Grandad Swindells, I'm pretty sure he didn't come by as much, and he had died before I reached five years old. Strangely, I don't remember any anguish or gnashing of teeth amongst my family, no drama—nothing, really. It seemed like one day he was just gone, but I'm sure that's just primarily the inability of a small child to register the import of death. Even so, this absence of overt grieving was my first evidence of the degree to which my parents, and perhaps my relatives, too, failed to express any outward feelings or intense emotions, apart from my father's occasional-yet-memorable rages, of course.

Earlier in her life, Nanan had been a medium and done spiritual readings. She'd go into a trance and speak in different voices and tell people things. Apparently, she'd been very sought after. Once, while doing a séance reading for somebody, the client suddenly started freaking out. When my grandmother came back, she asked, "What is it? What is it?"

The woman said, "I can't go on."

"Why?"

"I can't explain it exactly, but I started to see images of a naked child—a boy, not a baby, a little boy; he was glistening, and he had strange eyes and red hair."

Nanan nearly fainted. She'd had four children: my mother, Aunt Vie, Uncle Neville, and another son named Adrian. Adrian had red hair and had been born blind, so he had strange eyes. He was a sickly baby who died around the age of five or six, from scarlet fever, I believe. My grandmother explained to her client that when Adrian was succumbing to the fever, they tried to revive him by putting him in and out of cold and hot water, to try to shock him back. The fact that the woman had seen that scared my grandmother—so she never did séances again.

Nanan should have been more interesting than she was when I knew her. The other bits I learned of her life were very interesting. She had photos from before she got married where she's in elaborate Russian outfits like the ones in *Doctor Zhivago*. How that fit into her lifestyle, I do not know. Later she dressed in Indian saris. That was because she started taking in boarders after my grandfather died. Apparently she was one of the only landladies in Manchester who would take in foreign students from India. Some of the students were active in the independence movement, and when Gandhi came to speak in Manchester, the boarding students took Nanan to see Gandhi. And because they were activists, she even got to *meet* Gandhi. That's when she started wearing saris and cooking curries. Still, we didn't have a very friendly relationship—strangely, she became really bigoted. Also, she had a thing about how my mother had married beneath her. She didn't like my father and was constantly disparaging him when he was away on business.

My father's father, Grandad Megson, came to live with us briefly. He was dying from severe bronchial asthma, probably emphysema, too, inevitably caused by decades of smoking cigarettes.

One scene in particular is firmly lodged in my mind. An adult, perhaps one of my parents or another relative, informed me that Grandad Megson wished to see and speak to me. I was told he was dying, though I didn't know what that meant, and was led into a small, darkened bedroom. Grandad was in the bed, his cheeks sunken, his eyes wide-open, his chest heaving violently as he struggled for each breath. He feebly gestured with a small hand for me to lean into the epicenter of his frantic wheezing, somehow succeeding in projecting his whisper audibly over the noise.

"You must remember this, Neil. What I am about to tell you is very important," he began.

Pushing himself up even closer to me with his elbow, he continued, "It's a Megson family secret . . . Our side of your family are descended from a Spanish princess. That's why our skin is not the usual Caucasian white but slightly darker."

I was too young to say anything. Yet his words engraved themselves into my memory banks when so many other things didn't. Then he spoke once more to me.

"We come from a lineage of sailors and fishermen. One of them was in Spain and fell in love with this princess. They brought their baby to East Anglia to raise it away from the intrigue and dangers that would threaten an illegitimate child in the Royal Court."

That was it.

I never saw him again.

He died soon after this revelation, before I was five.

Of course, I filed this story away as delirious nonsense whenever I remembered it once I was older. Strangely, many years later, my sister told me that an almost identical scenario, including the royal blood story, happened to her that day, too.

Manchester is a strange town. I've often tried to understand why it's so strong in its impact. I think it's probably because of the industrial revolution, being a port with all the mills. It's linked with Africa and slavery and the cotton fields and so on. Manchester was really integrated into the explosion of commerce and materialism in the West. It also started to decline more quickly than almost everywhere else, so it's on the edge of the curve of what's happening to civilization generally, I think. That's why it has this interesting edge that affects people so psychologically. It has always struck me that it was very symbolic of the decay of the prewar idea of the happy family and the benign government and the generous capitalist. I think a lot of those things were revealed as empty in the early 1950s. When I used to go to school on the bus and see all these empty mills and abandoned steam engines, that really summed up what was going on behind the surface.

In Britain, the North got hit sooner. That's why you've got Liverpool and Manchester supplying some of the most influential music anywhere, out of all proportion to geography. There's something there—it's a hot spot.

Growing up around the cotton mills that were all closed, seeing them all start to decay. Every day, going past the railway yards where they were cutting apart all the steam engines for scrap—just seeing clearly and vividly that the industrial revolution that had made Britain potentially or theoretically great and brought in its prosperity was *gone*.

Economic power had shifted away from Britain.

For me, I saw it literally all the time. I knew the fragility of the most substantial structures—meaning bureaucratic as well as economic or social.

Seeing a streamlined railway engine powering through a landscape, pumping columns of steam in time with an intense metallic rhythm of steel wheels on railway tracks, portrayed a sense of proud, strong, mechanical nobility that I feared I would never ever see or experience again, especially once those potent "iron horses" were scrapped.

I went through a phase as a "trainspotter." I had a fat little book, around eight by six inches and two hundred pages. Inside were black-and-white photographs of all the British Railways' steam engines, and a much smaller section of the most stylish, grandeur-projecting diesel and electric engines. I don't remember exactly when I began this relatively brief obsession, nor where the trainspotter's book appeared from; possibly my father. But I would sit for hours, every chance I got, at the end of station platforms waiting for trains to pull in, chuffing white steam into the damp autumn air. I was always eager to see a nameplate and then tick it off in my book by its photograph.

My father as always had a job that meant he had to visit branches of the company he worked for all over the Midlands area of England. Whenever I was off school for various holidays, he would invite me to accompany him on the drive to Shrewsbury, Coventry, Birmingham, and other offices, then drop me off at the train station with a packed lunch until he collected me for the journey home. I got an amazing sense of accomplishment every time I spotted an engine I hadn't seen before.

It seems crazy now. I was making a note for the grand achievement of SEEING something! In this case, a great big hulking lump of mechanical steam, stinking of coal and oil, clanking and jerking its way past me as I, often shivering with the damp cold, lit up with pleasure simply for watching it go past.

I haven't been touched the same way by modern technologies, except, perhaps, watching that supersonic marvel Concorde taking off and landing on television. But that fabulous, breakthrough machine was scrapped, too. Possibly a Saturn spaceship blasting off into space with astronauts on board has an equivalency, some similar form of direct connection, like the best art brut. I have to confess that zeros and ones supply no hands-on

physical feeling and just don't do it for me in anywhere near the same way. If everything is an illusion, then our senses are sacred. Touching is sacred.

Because of my father's various jobs requiring him to travel all over, usually grabbing sleep in hotels overnight, we often saw him only on weekends. Sundays were for jobs around the house, quiet lie-ins in the mornings with my mother, followed by her cooking the big meal of the week, Sunday lunch.

My favourite Sunday lunches concluded with my father playing a Buddy Rich and Gene Krupa vinyl album he got from World Record Club, one of those scams where if you joined you must buy two albums a month at a huge discount price, but very quickly it became obvious just how very few records on their list were in any way desirable. But it was the only way he could afford to purchase records. Fortunately, my father loved big band jazz. So I got to hear Count Basie, Duke Ellington, Art Tatum's blind piano excursions, Ella Fitzgerald, Sarah Vaughn, Lionel Hampton, and Nat King Cole's jazz vocal tones. I especially liked Frank Sinatra singing "Laura," when his voice was young and warm like a gentle kiss. I am so grateful that my father educated me, maybe obliquely but nevertheless thoroughly, in nontraditional harmonies and improvisations. When I was older, in the early 1960s, while we lived in Aysgarth Avenue in Gatley, he took me to see Count Basie, Duke Ellington, the Buddy Rich Orchestra, and others at the Manchester Free Trade Hall. To this day, I have the some of the programs, tickets, and flyers of those special jazz nights out with him.

Looking back now, what I remember the most about those Sundays is a feeling of comforting warmth, a sense of life slowed down despite the predictable friction and tension of me not wanting to eat. In my mind, there is always a sensation of sunlight, though in actuality that would be rare in the Greater Manchester area. Perhaps the very predictability engaged me, and knowing my family would all be together for this one time a week.

My mother was always worried about my health. In part because she'd been told that she couldn't have any more children. I was seen as the miracle baby that she wanted, so she was super-vigilant of trying to take care of me. When I used to get ill with asthma, which became severe early in my childhood, she put me in this beautiful chair that was turquoise with a mustard cushion, and I was small enough that I could sit with my legs curled up.

She would put me there with a blanket, and give me my favorite biscuits and Lucozade, which was my favorite drink. It had glucose in it, which was meant to be good for people who were sick.

The doctor had my mother make me do these exercises. One of them was to have a card table with a Ping-Pong ball on it, and I had to try to blow the Ping-Pong ball hard enough for it to move. It isn't very hard to blow a Ping-Pong ball, but it took me weeks to be able to blow that ball and make it move. When it finally moved about halfway across, about eighteen inches, it was a really big deal. Not being able to breathe and feeling that you're just not getting oxygen is a really foul feeling. You're drowning; you're drowning with air around you. And that's why you panic. Once it's happened once, you know it's going to happen again, you know how it's going to progress, and so it gets worse because you're waiting for it to progress.

When I was about eight, I was prescribed steroid hormones. It was cortisone, originally. It was a new wonder drug. It worked, but every few weeks I'd still have a really bad asthma attack. I remember I'd never taken pills before, and my mother couldn't find a way to get me to take them. It was a bit like trying to give a pill to a dog. They tasted awful, and I'd spit them out. They really do, even now; it's the most revolting taste. She eventually started to get condensed milk, the thick, sugary stuff, and give me a teaspoonful of that with the pill in—which got me totally addicted to that condensed milk. I would eat whole tins of it.

The gender-based division of roles in our household was unremarkable back then. My mother did housework, shopping, laundry, got us children ready for school, and even helped with homework. My father worked to generate the only income, which necessitated him traveling and being absent a lot.

In 1954, my father changed jobs yet again. It must have been a rewarding step up his career ladder, because it required him to move his family from Manchester to the London area. I don't know how he pulled this off, but my father had arranged to have a house built in Loughton. At that point, it was a very chichi suburb in Epping Forest. However, when it came time to move, the architect-designed home was not finished. So we ended up having to live in temporary accommodation: home became a green-and-cream,

quite large two-floor caravan my father rented and parked in the street outside the building site.

The caravan had a room upstairs with a double-sized bed and closets where my parents slept. My sister, Cynthia, and I slept in a tiny room off the living room, where Nanan Swindells also slept. My grandmother could be really unpleasant at times, tending to see a deliberate attack in any dis-agreement, no matter how petty. Though, in her defense, Nanan had been through a lot. When she was little, her mother had thirteen kids. I think not all of them lived, but enough did that they couldn't afford to feed them all. There'd been some rich woman who wanted a little girl companion for her daughter, because they had just one child. My grandmother was fielded out to be the companion. At a very young age, like four or five, she moved in with this really rich family. They dressed her in nice clothes, as if she was another daughter, and took her to all the nice parties, and gave her piano lessons. I often wondered where she got all these airs and graces from, and that, it turned out, was where she'd got them. She said she'd been really happy with that family. Then one day the little girl had grown up and didn't need a companion anymore, so Nanan got sent back to the poverty of her real home, with no nice clothes, and the other kids resented her because she'd had that opportunity and talked posh.

She continued to say negative things about my father. It came to a head between us one day. I was sick of her always running my father down behind his back, so I called her on it, saying, "You should shut your mouth! If you don't like my father, why don't you fuck off!"

She was in the middle of doing some sewing, so she grabbed her shears and chased me with them—but not very fast. I teased her, "Yeah, you won't catch me!"

She screamed, "You little bastard, you!"

That was pretty much the end of me bothering to try to communicate with her.

Needless to say, that caravan was very crowded. I can recall a very cold winter. Snow and ice outside. My father would drag the chemical toilet to an open sewer hole up the street that was destined to be sealed after our house was completed. We celebrated a Christmas in that caravan. Three adults

and two young children, with icicles hanging off the caravan roof and one small source of heat. Nobody enjoyed being forced to live in it. Only one pleasurable memory floats gently within me. On Sundays, no more *Round the Horne*, the BBC Radio comedy, but as a substitute Cynthia and I were allowed upstairs to romp on the big bed with our parents. No doubt chattering excited nonsense as children do. My father had a hairy chest. Not too much: a nicely centered amount of dark hairs. I called this his "spider's web." I would lie between my parents, feeling secure and totally happy, while with my right hand I would trail my fingers aimlessly through his chest hair, occasionally twirling a clump around my small index or middle finger while I was inventing a bizarre narrative about spiders. Needless to say, twirling was soon no longer satisfying enough to quell my desire, and my fables would expand and branch out to explore more extreme variations on that theme. With my alien brain lost in my dreamworld, I would fail to notice that I was pulling harder and harder on my father's chest hair until he would confess that I was hurting him.

Eventually we moved into our new house. There were very few houses at all in that area, so there was no house number. Our new home was named "AYSGARTH," and it stood alone on a still-to-be-developed street called Stanmore Way. I remember a breakfast area and lots of space with big windows that let in sunlight whenever we were blessed with it.

There was an incredible, ancient holly tree hedge along the front street side of our new property. On the left side and all along the back of our garden was a twelve-foot-high brick wall. Nestled in the back corner was a beautiful brick-and-slate, Elizabethan-era pigsty that had a raised platform for prize sows to suckle their young on above any muck and dirt.

On the other side of the high brick wall that ran along the back of our property were a row of Elizabethan stables, still with their original fired-clay roof tiles. Beyond that was a picturesque duck pond surrounded aesthetically by weeping willow trees in front of a large, very old, classic Elizabethan-looking building that I assumed was a farmhouse but have since learned was actually the more grand Alderton Hall. Our house was built on the old kitchen garden of the hall. Hence the walls and pigsty. Jack Watling, the actor, lived there with his wife, Patricia, and their children Deborah, Dilys,

Giles, and Nicola. Several years later I remember half watching television one day and recognising Jack Watling in the opening credits for a series called *The Power Game*, standing, looking very commanding, as he stared off into the sky in the City of London. Even later, in 1967 and 1968, Jack was Professor Travers in the early *Doctor Who* series, and Debbie was Doctor Who's companion as well.

At that time he was the only celebrity I knew, which gave me a certain energy charge by the association of simply knowing him, even though I knew this was pretty pitiful. Sometimes I would watch his series *The Power Game* with my family. It was centered around games of power that usually take place behind closed doors, in Parliament, in boardrooms and in that very English of locations, gentlemen's clubs, exposing all the greed and corruption attached to corporate politics. A form of class privilege that I would later be confronted with personally and in many ways devote a serious portion of my adult life to exposing and attacking.

Cynthia became good friends with Debbie, and we all soon figured out that if we climbed onto our pigsty roof, we could drop down onto the stable's roof and from there easily climb down via barrels and boxes into the Watlings' huge garden and vice versa. Debbie and Giles had horses of their own, and once or twice Cynthia was allowed to sit on one as it was walked around by its bridle. The raised sow platform in the pigsty made an ideal stage for us all to put on our own plays, creating costumes for wizards and princesses, "goodies" and "baddies." We wrote out programmes rather illegibly, sold tickets to our parents and siblings, and performed embarrassing yet cute shows. Debbie and Giles actually followed in their father's thespian footsteps, becoming professional actors. For me, I found pretending to be another character intensely difficult and uncomfortable.

The Watlings' window frames, at the very least, were not ancient and not original, though. They were metal. I know this because one day we were playing chase around the house and I ran around a corner not really looking ahead, running straight into the corner of an open window, ripping into my scalp. I saw the proverbial stars. Debbie's mum, Patricia, fixed me up, informing me that it looked far worse than it was, as scalps tend to bleed disproportionately to any wound.

On another occasion, playing King of the Castle, I was thrown off the mound of earth substituting as the castle into a massive sea of nettles. Little boys still wore shorts in those days, so I was terribly stung all over my face, arms, and legs. My mother placed me in a bath of cold tap water that she ran through a bag of porridge oats, making it cloudy. An old wives' tale that proved highly effective both for nettles then and my chicken pox later. I even used this remedy for my daughters, Caresse and Genesse, years later when they went down with chicken pox while at Dr. Timothy Leary's house in Beverly Hills.

I loved living at our house in Epping Forest. That was my favourite place of early childhood. There was no gate on our driveway, and no other houses near us except the Watlings.' Across from our holly hedge was Epping Forest. When I was eating my Rice Krispies for breakfast, I would often see deer wander into our garden, and foxes, squirrels, and rabbits. All I had to do was walk across and there were small lakes and ponds to explore, where I would adore finding newts, frogs, minnows, and dragonflies. During the breeding season, I'd collect some pond water in a glass jar with frog spawn in it and wait for them to miraculously develop from an egg with a black dot into a mutant-looking tadpole, and finally a miniature frog, at which point I would return them to a pool. I loved wandering in what felt like my own secret garden. I would slowly lower my fingers into the crystal clear water and be fascinated for what seemed like hours by the light bending and shifting. I would marvel at insects that could walk on the pond's surface and watch, captivated, at the surface rippling, making my hand seem to grow undulating flesh ribbons in the water and appear like a dreamy hallucination.

There were muddy tracks through the forest from our private oasis to the edge of suburban Loughton, though, thankfully, it was after we moved away that ever more building sites encroached on this magical place. Eventually, so much damage was being done that bills were passed to protect what was left from total annihilation.

Years later, I discovered that Epping Forest was then, and has always been, right up until today, a favourite dumping ground of London gangsters, like the Krays and Richardsons, and later the Essex Boys, for the bodies of their murdered victims. Serial killers, too, had a certain attraction to

leaving their prey amongst the trees. Later on in my life I wrote a song called "Epping Forest," about this jarring contradiction between a pristine, primeval, natural perfection reminding one's soul of innocence and uncorrupted beauty, contrasting that with the vile debasement and moral indecency that humanity brings, infecting and shattering Nature's purity.

5.

I went to my first school in Loughton. At five years old I was officially enrolled at Staples Road School.

My mother would walk me through Epping Forest, and in the afternoon back again. I remember that I really took a dislike to my teacher. Though I didn't yet know the word, I felt she patronized me. Talking down to me, as if all five-year-olds were stupid and incapable of logic. In particular, we had a reading period. The teacher would hand out really dumb "baby" books that had one sentence a page in huge one-inch letters, like "Andy likes Jane."

"Jane has tea with Andy."

"They both like cats."

Endless drivel that felt demeaning even to acknowledge. So, whenever it was my turn to read a page, I would just look down, amplifying my natural shyness, and say nothing, except maybe mumble that I was sorry.

Because from infancy I was regularly sick with severe asthma attacks, I often missed school, staying at home instead. Recovering in bed, I would sit propped up against a pile of four or more pillows, trying to breathe slowly through my nose and not panic. At those times my mother would read books with me and encourage me to read on my own as well.

One day I was given a note to take home that requested my mother come with me to the school to speak to my teacher and the headmistress about my progress, or lack thereof. After we arrived in the headmistress's office, my teacher began to explain her concerns about my learning to my mother:

"The school and I are really worried about Neil. He doesn't join in our games in class but seems very remote and withdrawn. Also, whenever we do reading, he goes quiet. I don't think he is able to read at all, and rather than tell me he tries to avoid saying anything. In fact, after talking with the headmistress, we wonder if he has some deeper learning disability."

My mother turned to me somewhat angrily and, for a second, looked like she might shout at me. Then she calmed herself and turned back to the headmistress and teacher. Smiling, yet formal, my mother proceeded to say, "Pass me a book or something for Neil to read from, please."

She was handed a book for beginners, which she politely declined, and then she selected a book from a shelf near her that was targeted for nine- or ten-year-old children. This book she courteously passed to me as she said, "Read this!" in an intimidating, terse voice, contradicting her calm expression.

I stood up, took in a deep breath, and then read a whole paragraph fluently, without hesitation. Then I waited. I really thought all these grown-ups would be pleased that I actually knew how to read pretty well. Wrong!

"Do you mean to say that Neil has been making fun of us on purpose all this time?" said my teacher angrily.

"No, of course not. He was most likely just bored," said my mother. "Neil needs stimulation, just like any child."

Which was, of course, true. What I didn't understand was why my being able to read well and politely being quiet in class made the school staff so angry. It seemed like I was always being blamed for anything that went wrong around me, especially when it wasn't my fault.

When various educators' bruised egos had recovered, I was moved up one level to a class of kids a year older than me.

After two years in Loughton, we moved back up north. My father had changed jobs again. Gone were my enchanted grottos and fairy dells of Epping Forest and my friends, the Watlings. Back was the constant rain and drizzle and poisonous smog of Manchester.

I don't know if my father had been cursed by the building gods, but when we arrived in Manchester, our new house was, yet again, unfinished! Oh no! Not another miserable caravan and chemical toilet! I had to believe that something outside the laws of reason and logic was directing our lives when I was informed that the address of our new, half-built home was 7 Aysgarth Avenue. Now, correct us if we're wrong, but "Aysgarth" is not a common word or name as far as we have ever known, so what mysterious force was at work naming our Loughton house "Aysgarth" two years before

we even knew we'd ever move anywhere else. Was this when we began to make note of phenomena that were evidence, perhaps, that scientific theories and traditional thinking were incapable of being decoded demonstratively?

In fact, my family were not going to live in Manchester proper but on the outskirts, in Gatley and Cheadle, in the county of Cheshire, considered a far better address. A new suburb, growing street by street. But never mind my father lifting our family from his deeply working-class roots to this middle-class status; where were we going to sleep?

Turned out to be in a hotel.

Interior Cleaning and Maintenance Limited was my father's new employer, and they covered our accommodations for quite a few weeks. I think my love of staying in hotels began there. I had permission to go downstairs to the restaurant on my own and order breakfast. I grew to love really crispy bacon and fried bread. I could even be persuaded, once in a while, to eat a boiled egg as long as it wasn't runny.

Eventually, in late 1956, we moved into 7 Aysgarth Avenue, where we lived contentedly until 1964. I had a small bedroom at the front, my sister and parents had the two larger bedrooms, and there was a spare room over the garage—where I first began to play drums.

I really have no idea why this should be, but it was while we lived in the house in Gatley that I first began to have a truly disturbing, recurring nightmare. Certainly I had suffered occasional bad dreams in the past—disturbing enough, as they occurred to wake me up quite suddenly to a feeling of being afraid or, in some abstract way, threatened; despite my not being able to recall any details, the fear engendered was strong enough to send me scurrying into my parents' bed for safety. But this specific new nightmare began when I was around eight years old and, once I began to have it, was the only vividly recurring nightmare I had during my entire childhood.

It haunted me constantly.

Sometimes I'd start to think it had finally left me. Then it would return, invading my rest. It left me nervous of falling back to sleep for years. Eventually a part of me came to feel that "bedtime" was a danger zone, and that there was something in these other realms that wished me harm. I'd wake up petrified and run to my parents' bedroom, afraid to look behind me.

"I had that nightmare again, Mummy," I would nervously tell her, and snuggle my head into her large, soft breasts for comfort as she wrapped her arms around me.

"If you tell me what the nightmare was, it will stop," she always told me.

My mother hated to see me freaked out this way. Once I had crawled into bed between my parents, a forced separation I bet they hated in retrospect, I would try to fall back to sleep.

Strangely, I never had this nightmare when I was sleeping between them. Only when I was alone. It got so bad at one point that I was afraid to open my bedroom curtains in case the outside world had transformed and the monster was out there against my window, waiting to attack me!

I'd often try to lose my thoughts in reading or listen to my small, yellow pleather transistor radio. Anything to avoid falling asleep. Eventually, in the end, I could sleep alone only from total exhaustion. I still suffer from this issue, rarely falling asleep before 6:00 A.M. I watch videos, read, write in my journal, ANYTHING to become so tired that at long last sleep triumphs over my insomnia. Yet, if there is someone else in my bed, I can usually fall asleep as easily as nature is supposed to have intended.

So what was this Armageddon of panic and terror that disturbed my sleep patterns so drastically for ten years or more? As is typical with a vivid childhood recollection, the details are something of an anticlimax.

I am outside on the tiled roof of an average suburban, English-style, brick-built, two-story home. It has been raining, so the tiles are very slippery from a thin skin of slimy green algae. It has recently rained, adding to my risk of losing my foothold. I am trapped on this roof alone. Something abominable has pursued me to this roof. I am unhappily familiar with its ruthless hatred of me. But now I am trapped with nowhere further to escape to. The heels of my feet are pressed into the black iron gutter to prevent me from losing my traction and sliding off the roof. The thing, some kind of malevolent monster, a part-humanoid creature, is down below me on a tarmac path that extends all around this house. More than a house, it is my private home. It is supposed to be my castle and protect me from any and all nefarious dangers. I have yelled and screamed for help. I am still screaming. Then I see extremely long, lizard-like fingers with pointed claws. A dark

grey, scaly skin, thick like a reptile's, covers them. When light catches this flesh, it reflects an electric colour very similar to oil slicks on top of puddles of rainwater. Malevolent rainbows spreading out like the dread inside me, soaking through my body. I am in pyjamas, shivering uncontrollably, drenched from the earlier rainstorm.

The monster starts to try and reach me. Each time this being anchors those claws over the edge of the guttering to haul itself up to the roof, I jerkily pull up my feet. But this makes me begin to slide back down towards the roof's edge. As soon as those malicious talons drop away, after another frustrated failure to attain its prize—me—I put my heels back in the gutter, vigilant until those talons reappear. Then this whole cycle would begin again. On and on it went in an endless loop. In my sleep I was totally terrified. If I woke up, I'd be petrified of falling back to sleep. When I did return to slumber, the whole scenario kicked back in like a video that had been on pause.

This detail-specific nightmare went on for years and years into my adolescence. I even began to wonder if there was some kind of a warning there. Perhaps a message from a source outside time, a zone where past, present, and future all exist in infinite potential. I never saw the rest of the owner of those stomach-turning, razor-sharp hooks. From being a small child when it happened two or three nights a week to my early teenage years in the mid-sixties, this vile presence pursued me.

We look back and wonder what it was. What would have happened if once I couldn't wake myself up and stop my sweat-filled horror and instead was grabbed by my feet and pulled off that roof? Yet we also think about how corny that dream can seem now, not so much a B movie horror script as a D or E movie script.

6.

Memories of Gatley are more numerous than my earliest memories, yet still jumbled up. I keep seeing them as equivalent to smashed bottles, the resultant broken glass shards pushed into peat-rich mud. Sunlight strikes myriad pieces as its scorching, sweltering source, our furnace of life, traverses the sky, sending scattering filaments acting like infinite, bright fibre optics of disorganized memories. Once in a while these strike my brain, capture me for a lustrous moment, then skip away like flat stones on a calm, tranquil lake.

Near our house was an extensive expanse of open land, two tree-dotted fields separated by a hedgerow and an embankment. I loved building secret dens in the fields. I found a spot on the low embankment and dug down into the soft, easily excavated soil. Next I dragged an old piece of corrugated iron roofing sheet from a nearby builder's dump. Once I had the roof over my hole, with thick wooden supports at the corners to reinforce it, I covered the entire den roof with soil. Then I added turfs of living grass, imitating my father's lawn repairs I'd watched. Finally, I piled lumps of tangled branches mixed with thorny branches, probably from a blackberry bush. All that remained was a square entrance hole, into which I could slide a strong, square metal tin, full of soil, in which I'd already got grass growing. This was my secret doorway, and once this "door" was in position, my den was invisible. More than once someone stood right on my roof, then walked across to continue looking for me when all the time I was right under their feet! Inside I had sackcloth on the floor, a small recess cut into the soil for candles, and a few bags of crisps and some chocolate for hunger moments.

All my dens had this main thing in common: I wanted to separate myself from the rest of the world. To disappear into a profound, unbroken darkness. Was it Freud or Jung who would liken this to a drive to return

to my mother's womb? I don't know. But now, looking back, it fits my constant feeling of not belonging to this species, my conviction that I was alien in some way that, as yet, I had no language or knowledge to articulate beyond my drive towards isolation. In true darkness, when the outside temperature matches that of your skin, the body dissipates, all sense of materiality vanishes.

Decades later I would still be chasing this sensation, this conscious disembodiment by choice through rituals with Lady Jaye while on what Terence McKenna called "heroic doses" of psychedelic drugs. There is something about this human state of feeling trapped in a body that both frustrates and motivates me.

As I am writing these vignettes down, trawling through my memories, it feels a bit like archaeology of the self. I see a continuity of urges and consistencies repeating. These are the golden threads. Thinking now about my obsessive dedication to creating hidden, densely dark dens, I wonder if they were a concrete version of the secret, often peaceful den of my purest thoughts, guarded against discovery or observation by others, concealed within my most private thoughts. A representation of my ongoing sensation of alienation, of difference in what stimulated my brain from the lower-middle-class norms surrounding me and manifested in the physical world as this compulsion to create dens. The fact of them being secret seemed to protect me, so just as I kept the details of where my escape holes were, so I chose not to divulge my innermost thoughts and feelings, knowing instinctively to bide my time and wait.

Around 1960, the neighbourhood boys and I were getting a little bored with dens as our secret. I can't remember his name, but a boy about two or three years older than us somehow attached himself to our little group of pals for a few weeks. And in that few weeks he gifted us with a sexual revelation.

We would gather in a hideout near a bridge, where the railway line embankment crossed the river, right by a curve where it ran deeper, and the current was much faster, dark silt and mud giving it a quite ominous atmosphere. Our hideout was a cluster of bushes with thick foliage, and within these bushes was an empty space, almost as if nature had designed

us a perfect secret room. There was even a buttress of earth that acted like a bench inside. From this elevation there was 180-degree visibility of the surrounding fields, but anyone inside was camouflaged, perfectly invisible from the outside, the leaves having a similar effect to a one-way mirror.

I was a latecomer to these gatherings. I think one of my friends suggested I might join in with what they did there and have fun. Fun turned out to be everyone taking their penis out of their trousers and pulling on it rhythmically. I was assured that this would feel nice. And it did. For several weeks my penis did not get hard, but I persevered. One issue was I had no idea what I was hoping to achieve. I have found that most people masturbating have a person they desire in mind that they imagine as they wank. As time went by, with continuous practice, I became aware my penis was filling out in size and becoming harder. Our almost-teenage sex educator advised us wisely to use saliva to lubricate the friction and avoid blisters.

Looking back now, we are most intrigued by the fact that all this was totally non-erotic, and although there would be several pubescent boys wanking at the same time in a hidden huddle, there was never any interest in each other's cocks. It felt closer to a practical class in biology than anything close to sensuality. Very matter-of-fact, but pleasurable enough to keep us focused on the task at hand. Our tutor assured us that eventually, just as he was able to achieve orgasm and squirt some strange, sticky, thick liquid from the hole his piss came out of, so would we. Needless to say, this gave us youngsters something more concrete to strive for. And strive to secrete we did. Although for a long time, without much success.

The older boy also smoked cigarettes in the hideout, and, as boys reaching adolescence will, the other boys tried smoking, too, emulating older teenage daredevils in a classic bid to seem cool. Smoking consisted of short little trifling puffs, inexpertly sucked just into mouths, not inhaled into lungs, and was usually followed by hacking coughing and watering eyes. Not me, though—my asthma saved me from this addiction.

There came a time when a boy called Graham Fielding began to really nag about not being allowed in the hideout. I never liked Graham. He was plump through uncontrolled greed, and a spoiled brat. He had got us in trouble before by giving away the locations of dens or informing parents of our riding our bikes far outside agreed parental limits. I have no idea who surrendered and eventually let him into the hideout, but I know that I immediately had a classic, cold, sinking feeling in my stomach.

Sure enough, two or three weeks later, a message went out to all of us hideout boys to go immediately to Auntie Peggy's house, where all of our mothers were waiting together to talk to us about something clearly very serious.

Now, I liked Auntie Peggy Fielding. She had an open-door policy for all us kids if our parents were out or if it rained while we were playing. And if we were locked out of our homes, she would feed us snacks. In those days, everyone's mum was called "Auntie."

My mind was in a panic. What could it be? It must be a transgression we were all guilty of . . . What had we ALL done wrong? Then it hit me. The wanking sessions! *Oh no! How do I explain that? Was it really so bad that all the mums were gathered to reprimand us?* I was desperately trying to come up with an excuse, a story, anything to avoid a confession. But every extenuating explanation failed to exonerate fear or guilt, and my mind was suddenly drenched in shame. But there was a conflict inside me, too, because there was no doubt in my mind that this indulgence in masturbation was gratuitously pleasurable; I really liked doing it, and felt sure I was getting closer to that weird liquid thing as well: an orgasm.

With my mind in turmoil, I arrived at Auntie Peggy's house. Everyone's mother was there, including mine. There was a heavy, claustrophobic atmosphere. Graham was there, too, and I could swear I saw a gloating glint in his eyes. I knew it! I knew Graham shouldn't have been allowed in our hideout. My mind was short-circuiting.

"It has come to our attention that you boys have been doing something very naughty, something unhealthy," Auntie Peggy began.

No, no, no! I was still desperately searching for an excuse; denial was impossible. Perhaps forgiveness and a pardon were possible? A plea based upon our ignorance might succeed in a pardon.

I looked around, and I could tell we all felt trapped by our lascivious explorations. We were all doomed to suffer a massive public dose of humiliation, scorn, and disgrace. Exposed before everyone for the loathsome, immodest boys we were.

"We know what you boys have all been doing in those bushes. Graham has told us everything."

Of course he had . . .

At this point my thoughts collapsed into abject surrender. There was so much disapproval in the air, and I knew from the "secret" aspect of my learning to wank that on some level, socially, what I had been doing had broken a social taboo. My pleasurable actions with my own body clearly exposed an implied transgression. Yet this contradiction between my gratifying, happy experience internally contrasted confusingly with a generally negative evaluation by the outside world and its behavioural social agreements and had me feeling incredibly confused.

Engrossed as I was in my quandary, I missed some of what was being said. When my conscious mind returned to the present moment I was momentarily lost, then baffled.

My mother was speaking to me now.

"You especially, Neil, with your asthma, should not be smoking cigarettes."

What? My contradictory cascading thoughts suddenly solidified in the beginnings of a big, purely mental smile. They didn't know!

Auntie Peggy and my mother had been talking about smoking cigarettes! That classic expression "A huge wave of relief swept over me" was precisely true right then. I was not to be cursed with a red letter to ensure I was reviled and ostracized by my community after all.

They didn't know!

In a society where no media, family, or educators were making any effort to discuss even the nuts and bolts of sexuality and reproduction, my first contact with this beautiful, intimate domain had been warped and

distorted by an implication of shame. Perhaps the victims of Ian Brady and Myra Hindley would have been more wary and less compliant if they knew the facts of life? And I wonder now to what extent my own relationship with transgressive sexuality and my tendency to explore the erotic unknown using fetishes and rituals began, and was shaped by, the deafening silence about basic sexual knowledge.

7.

The first time I got badly beaten up at school was in Gatley.

The playground at Gatley Primary School was concrete. Whenever it was play time, everyone came out screaming and running around like crazy. I often spent my break times alone near the covered walkway that ran from the double doors to another building. I'd watch groups of kids playing together, already beginning to separate into girly cliques and boyish cliques. Boys were often rough and tumble, physical, or playing games that involved running. None of which my asthma allowed me to do.

It's still a vivid image, the small clusters of children bunched together by gender with so much to share, but not with me it seemed. So I would just tend to mind my own business, stand in the corner, and wait for it to be over. I was standing in the corner this one day, and the bell went off for classes, and I started to walk back towards the corridor.

Suddenly: *bang!*

I was hurled downwards. My whole body shook and reverberated as I was smashed face-first into a concrete step. I saw flashes of light; my brain felt dislodged; I couldn't move. Pain filled every cell of my body, and I didn't know if I was actually conscious for minute.

A teacher came running over and tried to pick me up. Still semi-conscious, I resisted, confused.

There was blood everywhere.

I'd hit the concrete so hard that all the teeth in my mouth came out from the impact. They were dangling by their nerve endings, hanging by a thin strand of skin like a row of tiny Chinese lanterns. So I was taken to the headmistress's office, my vision still blurry, while they called for a doctor. The doctor eventually came to the office and rearranged my teeth, pushing them all back in, one by one, with his thumb before they took me home.

Of course, then they were all crooked and fucked-up. I had to drink through a straw for weeks; I missed six weeks of school.

So what did I do, day in day out, stuck at home? Well, in those days my primary option was reading books. British television consisted of a single black-and-white channel that broadcast for just a few hours per day, mainly in the evenings. There was a small concession made by the BBC for children who would still be at home called, inspirationally, *Watch with Mother*. From 1953 to 1973 its roster of shows could be enjoyed in the mornings and, like clockwork, from 3:45 P.M. until 4:00 P.M. on weekdays only. I hated them all. Nevertheless, when I was off from school, I would often sit in the mustard-and-turquoise armchair and, just to distract myself from my shattered mouth, or my chickenpox, or my constant rocking backwards and forwards to assist my breathing during asthma attacks, I would sit through *Watch with Mother*. Every single episode consisted of the old type of puppets. You could see their strings as the characters lurched and bobbed around.

A little later, when I just turned eleven and was off school yet again, I discovered one of the two most important and influential books that I read during this time: *Seven Years in Tibet* by Heinrich Harrer. It is the story of a German prisoner of war who escapes the British POW camp in India and travels north, crossing the brutal, freezing Himalayas, and reaches Lhasa, where he is befriended by His Holiness the Dalai Lama. Harrer's descriptions of the alien culture, medieval yet vibrant, and their forms of Buddhism, as much fantastic myth as factual marvel, lit my imagination like nothing had before.

Because I was missing so much school, my parents began to pay for a woman tutor to visit once or even twice a week once I turned ten years old, though they could hardly afford it. This was in preparation for the "eleven-plus" examination. The eleven-plus was a national examination that every child in England, Wales, and Scotland was compelled to take in the school year they turned eleven years old. It had been someone's bright idea to stratify children's education from eleven years old, already preparing them for their most likely work occupations after they left school—making every

single child take the same test so you could stream all of them into levels of probable failure to achievement all through their lives.

It was a hangover from the British curse of a rigorous class system that in turn was a bastard child of feudalism. If you failed your eleven-plus, you went to a secondary modern school. Children who went to secondary modern schools were already considered educational and intelligence failures. The curriculum often included subjects that were best suited to "blue-collar" work, including trades such as electrician and mechanic for boys and domestic science for girls, with factory work seen as the most likely option for those who left school at fifteen or sixteen in a classic piece of British self-fulfilling snobbery.

If you passed your eleven-plus, however, you went to a "grammar" school. The curriculum at grammar schools, on the other hand, was focused on yet more national examinations with the aim of separating the brightest from the rest and channeling them towards university. In a very real sense, how well you did on the eleven-plus exam affected the course of the rest of your life.

Fortunately, after doing well on the exam, I not only qualified for grammar school; I was granted a scholarship to attend one of the most prestigious private schools in greater Manchester, Stockport Grammar School, which I attended from 1961 to 1964 and loved. As it happened, I'd tested as one of the top five students in the whole of northwest England. At the same time, the cortisone had begun to alleviate some of my problems with asthma, and I was able to play football with the other kids for a time.

I was ecstatic! And when school started, I loved the medieval atmosphere of Stockport Grammar School, too. I had acquired an official *History of Stockport Grammar School*, a detailed and fascinating account of knight and former Lord Mayor of London Sir Edmund Shaa altruistically founding the school in 1487. I liked to imagine that he had been a Knight Templar and that there were powerful occult secrets waiting to be revealed within secret cubbyholes behind the oak panels one day. It could not have contrasted more with Gatley Primary School.

My new school turned out to be quite liberal for that time. In terms of uniform, all students had to wear the school blazer or a charcoal-grey

suit. It was also expected that we would all wear a school tie, and a white shirt was appreciated, but in no way was that shirt colour compulsory or enforced. As the sixties exploded across youth culture, "mod" variations in particular accented our explorations of individuality. "Winklepicker" and "chisel toe" shoes were de rigueur, with various button-down collars on pale pink, blue, or white shirts my preference. I had a one-inch-wide thin black leather tie and a thin black knitted tie that I still have to this day that I would switch for my school tie once out of school. I was a little envious of boys who had real Italian elastic-sided Beatle boots, and there was great status in having the longest, pointiest winklepickers. My parents could only afford to buy me new clothes via a mail order catalogue, which limited my choices a little, but my brown chisels were just fine.

I studied French and German, choosing to avoid Latin despite it being a key component of ancient historical texts preferred by scholars and dusty library academics. Of course, I adored English literature, with its compulsory autopsies of Shakespeare and Chaucer, and, surprising to me now, I got consistent high scores in mathematics, biology, chemistry, and physics. It's true what they say, that a good teacher can bring the most tedious lessons to life, which happened to me at Stockport Grammar. I was enjoying all my subjects. In contrast, there were several teachers at Solihull School later whom I could not stand, who could bore a pumpkin into a pool of sludge. As a result of their incredible skill at creating tedium around the subjects they taught, I lost interest in all sciences and mathematics and I was forced to drop German, as it was not taught at all.

Stockport Grammar School inspired my future strongly in positive ways. One was being in the choir. Another seemed so minimal at the time that it's hard to believe how incredibly important, and pivotal, this next detail came to be for the rest of my life.

I liked my English literature teacher; he seemed to ooze encourage-ment and positivity when discussing language. On one particular Monday, he set as homework for us each to write a short poem. There were more structural and stylistic requirements than it just be short. It also had to be a metaphor, I believe, and had to rhyme. When our teacher announced this task, a classroom groan went up. Clichéd opinions of poetry had us

assuming that all poetry was impenetrable, boring, elitist, a truly minority activity that was dying out at an accelerating speed ever since "The Waste Land" by T. S. Eliot. He of the wine bottle spectacles and self-absorbed scholarship. In my opinion, revised since then, "The Waste Land" did for British poetry what Marcel Duchamp's "R. Mutt" urinal "readymade" did for contemporary art. Never had so little enthusiasm been expressed for something that became so much.

My mother was always very supportive and encouraging towards my homework in every subject. Seeing my dismay at the prospect of wrestling with words to create a poem, her voice took on a warm, gentle, encouraging tone, relaxing me.

"What is the picture?" she asked. She asked lots of questions. "Where was this? What had happened? Where is the crew? How has this ship changed?"

I had recently begun reading the Hornblower books about the British Navy in the period of the Battle of Trafalgar in 1805 and Admiral Lord Nelson. So I focused in on that illustrious era and I had a breakthrough: to look at events as experienced by the ship. Suddenly, this poetry idea was exciting for me. I fell in love with the rigorous discipline of making every single word essential, carrying not one meaning but a package of meanings. A technique that I later used in TOPY (Temple ov Psychick Youth) "sigils" to deposit a true desire into the deep subconscious mind, reprogramming that mind. Every word was uniquely honed, looked at from multiple, quaquaversal possibilities of meaning. Language became a lifeform, phrases living entities, their base signification as malleable as my imagination. Simple words were flooded with purpose, memories, validity, and infinite connections. They danced, teased, withdrew as if touched.

So my ship came alive. To this day I tend to write lyrics, poems, and songs initially as a stream of consciousness describing an actually active scene that I am watching as if it's a movie. When we would remix a song with genius producer Ken Thomas much later in the 1980s, he would invariably turn to me and say, "What's the movie, Gen?" And we would place a sound of a church bell on the "horizon," a train would go from "left" to "right" in the stereo, and so on. Truly a three-dimensional map of the location and action within a song lyric.

In 1961 or 1962, stimulated and energized by now, I both uncovered and adapted my thoughts into writing my very first ever poem. It was awkward, somewhat stumbling and leaden, but it worked. I felt thrilled in a new way. Words were fun. They were a code for me to speak more precisely, yet personally remain hidden. Redundant as author, my words could speak for themselves. Words had their own voice. We were both conscious entities and would continue to collaborate together for the rest of my life.

An archaic mental block had been pierced. I found my senses tingling, close to a palpable shivering within my mind. Two incredibly crucial parts of my personality, of my being, had interconnected, and the possibilities were endless. Never mind any impossibilities!

After such a buildup, now, inevitably, the poem itself will be an anticlimax, but its importance can never be underestimated. Nor my mother's part in uncovering all this.

> "No Helping Hand"
> The once-great old ship
> That had ruled the high seas
> Now lay like a corpse
> With just memories.
> A broadside had thundered,
> The ship ran aground;
> And no helping hand
> Was there to be found.
> The Vulture-like seagulls
> Now perch on the hulk,
> The plants have completed
> Their strangle-like hold.

The poem was dutifully handed in to my English teacher. Much to my surprise, it later came back and received a grade of 10/10, along with the comment EXCELLENT! On top of this perfect academic score, I was feeling rejuvenated and thrilled by my breakthrough into layers of meaning and how much fun it could be deconstructing the mundane to reveal the

miraculous. Then, to top this off, at the end of that school year, my teacher submitted it to the school magazine and it was published.

I had the bug! The poetry bug!

Stockport Grammar School also had a great music teacher whom we saw once a week. He was hilarious, and his passion for all things musical was infectious. I shocked myself by finding it easy to read music quite quickly. One of his methods was to play a symphony on the record player and hand each of us a full orchestral score.

Then he would assign us an instrument to follow. After a few minutes, he would slam down a book and we'd be asked to show exactly which note or space this was on the score. He would give a sweet to us every time we got it right. He made classical philharmonic music fun.

One day, after a classroom talk with me about music that I currently liked, he asked me to bring in a couple of my favourite records and explain to the rest of the class why I liked this music. I brought in a Rolling Stones record and an Art Tatum jazz piano album. He expressed positive appreciation at both, and especially the Stones.

"It's clear to me, Megson, that you, like me, really love music. I'd like you to consider joining my school choir," he said to me after our listening session was over and the other boys had left for lunch. "Practices are twice a week, usually at lunch break, except near Christmas, when we rehearse more often for a choir carol concert at school and at Stockport Parish Church."

My mother had wanted me to learn the piano. I wanted to as well, but the discipline and incredibly slow progress frustrated me too much. After around three weeks, I would pretend to go to the teacher's house but use the money to buy a hot dog or chips and just wander around aimlessly for an hour. Of course, after about three weeks, the teacher phoned up and I was busted. To my surprise, the only repercussion was that my mother told me she was disappointed. She said she thought I would like piano but, given my disinterest, she would simply cancel the lessons, as there was absolutely no point in me going if I wasn't enjoying it. Now, however, having considered this Stockport Grammar School teacher's suggestion, I did decide to join the school choir.

In the end, though, my most enduring memory of four years at that school is the endless obsession with masturbation. The old classrooms had ancient wooden desks in neat rows beginning at the back of the classroom. These were the sought-after desks that we would scramble for at the beginning of each new period. I often went early from any break to ensure I got one. Once in our seats, out of sight of any teacher's prying eyes, every single boy in the back row would unzip his trousers and slowly masturbate. This bizarre obsessional activity went on day after day. Occasional orgasms were still a somewhat vague achievement, and there was no homosexual element that I was ever aware of at the time. Although there was one boy who had by far the biggest cock and he, indeed, would invite boys to sit on his lap while he gently pumped his erection up and down inside his pants to simulate what he knew of having sex.

What strikes me most is how matter-of-fact it all was. There was no erotic charge, no sexual tension, just a group of young adolescents teaching each other what they could of the plain fundamentals and mechanics of flaccid and stimulated penises. In my ignorant innocence, I never saw any expansion from wanking to even the most minimal romantic interaction between boys. It amazes me now to think about rows of pubescent boys jerking away with the teacher oblivious.

I grew to really enjoy being in the choir. I sang alto. It was there that my lifelong love of harmonies developed. My most vivid memory of being in the Stockport Grammar School choir is when we were invited to sing in Stockport Parish Church for a "Christmas carol service." All those movies and Christmas cards I'd seen all my life came alive. We all had to wear red robes with white robes over them, plus a large, circular, three-inch-thick concertina collar. Some of us walked carrying portfolios of music to be sung, other boys had long brass staffs with religious symbols at the top, and two boys carried a banner suspended between two poles. That reminded me of the Protestant church Whitsun parades I took part in Manchester as a very young boy prior to moving to Loughton. It was all a bit too Roman Catholic to me, but I definitely loved the theatre and attention and having a more elevated function than the congregation.

This was my very first public performance as a singer.

My pal Gareth Wardle sat next to me. We had sweets hidden under our robes, and *Doctor Strange* comics. Those were my favourites, and for years were the only superhero comics I would read. What I loved was that later, as I discovered drugs and altered states, those comics got even more interesting and psychedelic. And then their clumsy but fun esoteric texts and concepts—like "Eternity struggles to defeat Infinity"—gave me hours of stoned fun.

8.

My days of educational contentment at school and friendships with peers like Alan Russell, that in a normal suburban life were expected to flourish and grow into lifelong relationships, were to be broken. Just after I finished grammar school in 1964, my father landed a long-term job in the Midlands.

We would be moving again.

This time I was older and more aware of what moving away could mean. All my friends would be gone, my educational continuity would be disrupted, and once again I would be alone, still going through puberty and hormonal storms. My foreboding at this renewed isolation was intense.

Just as my interest in the burgeoning youth culture and the inspirational tsunami of radically new pop and blues music was taking off, my family moved to Solihull, the most sterile place in England. I had to leave all my friends, my mod aspirations, and, perhaps toughest of all, my sense of belonging good-naturedly to my peer group.

Solihull is a small suburb near Birmingham in the industrial wasteland of England's Midlands. To this day we recall that whole conurbation as a decaying and deprived toxic dump. But in greater Birmingham, Solihull was where you went if you were successful, a classic dormitory town—a middle-class-wanting-to-be-upper-middle-class dormitory town.

There were a few little idiosyncrasies that made the place amusing. For example, apparently Mandy Rice-Davies—who was a key figure in the Profumo affair, a sex scandal that had recently rocked the British government and dominated tabloid headlines—supposedly had the milk run in the street where we lived, Lakes Drive. She would deliver milk. Then she'd gone off to London. The next thing anyone knew, she was involved in this big scandal.

From 1964 to 1968, I attended Solihull School, an elite all-boys private school intended to create the leaders of tomorrow. It had been founded in 1560; Dr. Johnson had attended it, and one of Samuel Pepys's

great-great-great-grandsons was in my class. It was a very up-market school, in the top six in Britain. They had a beautiful church that was sponsored by the Queen, and to celebrate her connections to the school, they added a new residential hall called Windsor House. The students, many of whom boarded there, tended to be children of the rich and politically connected.

Solihull also fed officers into Sandhurst, the West Point of Britain, and we had extensive military training. The school had its own rifle range and an armory with hundreds of Lee-Enfield .303 bolt-action rifles, mortars, Bren machine guns, even a working heavy-artillery piece. I was a first-class sniper, earning a badge emblazoned with a rifle and a star.

My parents could never have afforded the fees at Solihull. But I was granted a full scholarship, and lived at home rather than boarding.

My life changed when I went to that school.

Life went from liberal, fun, and free to oppressive, violent, and destructive.

To me, it was all symbolized by the Queen; even day students like me were assigned to one of the six houses, and I was assigned to the newest: Windsor House.

In cool weather I had to wear a vile grey herringbone wool suit every day, with grey woolen socks and black Oxford lace-up shoes, a white normal shirt, and a school tie, topped off by a peaked school cap. In warm months I was forced to wear a school blazer, black trousers, a white shirt, a school tie, black lace-up shoes, and a cap, or, more ridiculous, a straw boater hat. If anyone in the town saw you at any time—holidays, weekends, after school—in uniform but not wearing your stupid cap, they were ENCOUR-AGED to inform the school. This would earn you a caning and detention at the very least. Hair had to be above the level of the top edge of your ears ALL the way around.

These rules would have been bad enough if I had never experienced a liberal-yet-smart school in advance. But I had. And I knew other disciplinary and aesthetic uniform systems worked just fine and let everyone breathe easily and focus on studies, sports, and special interests without a sense of fear and loathing.

Naturally I was pissed at this new school before I went to my first day of classes, but I had no idea of the horrors to come.

My previous school, Stockport Grammar School, had been a day school only, though we did have school classes all Saturday morning and sports on Saturday afternoon, so it was six days a week, plus homework on Sundays. At Solihull School, we had classes on Saturday morning as well. Saturday afternoon was also mandatory sports. The result in both cases was that we only got Saturday night and Sunday off, and then it was back at classes on Monday. At Solihull, however, Monday afternoon was Combined Cadet Force, CCF. That's where you had to be in the army, the navy, or the air force. I was in the army. On Sunday night, you had to polish all your boots up for Combined Cadet Force or you were in trouble again.

It was amazing we found any spare time. But I did, because I wasn't a boarder. Thank God I wasn't a boarder. About a fifth of its students were boarders, who tended to be the problem children of the rich armed forces officer class, foreign diplomats, or African royalty. Boarders were typically abandoned by their families at a young age of about six years old until they graduated to university or Sandhurst—the elite officer training school.

The year before I started at Solihull, the headmaster had hung himself in his office rather than appear in court for soliciting homosexual favors in a local public toilet and bring disgrace upon the good name of the school. A flock of other teachers resigned after his death as a homosexual ring was exposed that did include a few of the oldest boys, known as "benchers." At Solihull, all boys became benchers at sixteen and were then given the right to punish other pupils at the school. They were the equivalent of the Jewish collaborators in concentration camps who collaborated with the Nazis, except these adolescents did not have the excuse that they were saving their lives as a result. Benchers could make you carry their heavy leather schoolbags. They could give you detentions after school, give you assignments, essays, thousands of lines, degrading jobs . . . They could whip you with a cane as they saw fit, even when they were unfit.

Like many partially formed personalities given almost unlimited power over a prey that was powerless, they abused their power. In the past, sexual

favors had been alleged to have been included in what were called their "privileges." I never saw proof of that continuing, though there were rumors. Basically they were nasty, egocentric bullies whose sociopathic excesses were ratified by the next level of power, the teachers.

I had become used to a rational, reasoned way of education and organization in Stockport. On my first day of school in Solihull, I was reluctant to wear the full uniform. I saw no constructive reason to be so oppressively reduced, except to exert psychological control over us. But I knew my parents were really proud of my scholarship and that they believed absolutely that I was getting the best education this way. So I went to the school.

I entered a playground area and waited for someone to tell me what to do and where to go. A bell tolled and in what seemed an instant everyone vanished through various doors. I followed behind but suddenly found myself stood entirely alone.

I knew I was in a class called Lower 5.2. Through the doors was a quadrangle of buildings with an immaculately trimmed lawn divided by a diagonal path. I could see boys in various rooms all around the four sides and assumed those were the classrooms. I began opening doors, asking for Lower 5.2, and eventually entered the right room.

Roll call was in progress. When I answered, "Here, sir," everybody began pointing and laughing at me. There then followed a few minutes of teacher-led verbal abuse that centered around my English being unintelligible because I had a strong Manchester accent. The core of the ridicule included "Why don't you go back?" and "What is a pleb like you doing here?" And, of course, attacks on my being a scholarship boy, because my parents were too poor to pay.

I didn't respond.

I thought the teacher would have restored order, but he joined in. Not a single boy in my class spoke to me voluntarily in that first year except one: the school bully, named Dave Rook. He taunted me, despite his serious lisp, about the way I spoke.

Suddenly another bell rang and everyone rushed out, shoving me out of the way and laughing at me. I tried to ask my teacher what was happening and he said, "It's a break."

So I looked around, hoping to talk to someone, perhaps begin a friendship. As I walked through a doorway I found myself at the top of a concrete stairway. I wondered where it led . . . *BANG!*

I was smashed on the head from behind and kicked by at least two people as I saw stars.

Someone tripped me up.

I was kicked down the stairs as I curled up to protect my head.

As I lay on the floor, I was kicked over and over by about five boys as they yelled curses about my speech being impossible to understand because of my accent.

I went unconscious.

As I came around, I saw everyone running away. By the time I sorted myself out, still dizzy from being kicked unconscious, I realized I was, once more, alone in the quadrangle. I wandered about, first to my classroom and then about the corridors. All the rooms were empty! It was like a sci-fi movie. Everyone had disappeared.

After a few minutes I saw a teacher—they wore black robes—and asked him where everyone had gone.

"To chapel," he said. "Let me show you."

Then he grabbed me by my sideburns above my ear and began dragging me by my hair alongside him. As we turned a corner, I saw a modern church in the school grounds that was big enough for all the students and staff and a lot of parents, too. As he dragged me by my hair, he shouted at me, "What class are you in?"

I told him Lower 5.2.

"Don't be ridiculous, you're much too small to be in that class," he sneered.

We reached the chapel and he burst through the doors still dragging me by my hair. By now it was agony. He stopped dead, still sneering, and the entire school—the teachers, the cooks, the nurse, the chaplain, and the headmaster and his family—went totally silent and turned around, as one, to stare at me.

"What have you got there?" said one teacher.

"A little boy with big ideas" was the reply. "He thinks he is in Lower 5.2, but he's obviously lying because he is too small."

Another teacher said, "Well, what shall we do with him?"

I tried to tell him I really *was* fourteen years old and in Lower 5.2, but everyone was laughing at me now and enjoying my humiliation.

I was in shock: the authority figures were joining in physical and verbal abuse of me in my first hour at a new school!

Then my captor said, "I'm going to put you at the front with the little five-year-olds where you really belong."

He dragged me down the central aisle in front of the altar and a giant painting of the Christ that covered the whole forty-foot-high back wall and dumped me on a pew amongst the little kids. In that five minutes, that teacher gave permission to everyone in the school to treat me like dirt, to abuse, humiliate, and physically hurt me with impunity. And that is just what they did.

After the service, trying to ignore the catcalls and nasty jokes, I found my correct classroom again. But I was a target. Still on that first day I was grabbed in the toilets by a gang of four more bullies and held upside down, my head shoved into the toilet bowl, and then the toilet was flushed. I really thought they were going to drown me. And almost every subsequent day I was beaten up, attacked. Kicked, punched. When playing hockey, my unguarded legs were deliberately smashed from under me by someone using their thick, hardwood stick across my shins. I thought I would die from the pain. The teacher who served as referee saw but did nothing.

The school was vicious, an appalling nightmare of institutionalized bullying. One boy I eventually got to know was beaten so badly—while being called a "poof" and "queer"—by four notorious and very wealthy older bullies that his appendix burst; he was lucky not to die. His transgression? They'd heard he had written a poem.

There was no one I could tell.

When my sister visited me recently, she asked me about that school, and I told her the truth about the systematic brutality. She asked why I'd never gone to a teacher.

At the time I believed the nightmare would only have gotten worse if I were seen to have informed on the bullies.

She said, "Did you ever go to Mum and Dad?"

There was but one time I mentioned anything at all about it to my mother, but that had been born of necessity—because the school called home about an incident that we'll get to in a bit. Other than that, however, I never told them.

My sister was surprised and shocked, and felt real empathy for me. But even she struggled to understand why I didn't go to my parents. I explained: I simply couldn't tell them—it would have hurt them too much. They were so proud of my scholarship and of my attending such a "good school." And when my scholarship ran out, they managed to keep me there by finding ways to pay. Mom went back to work. They made all the sacrifices to gain me access to this wonderful education, and I didn't want to blow it for them. My mother in particular would've just been confused and devastated. Because it wasn't like it just concerned something that was happening to me. To reveal the system to her would basically have been telling her, "These people that run your country, that you fought for, and suffered bombing and everything else for, are assholes, and they torture children in order get their own way and stay in control."

My parents didn't need to hear the harsh reality, at least from me, and I didn't see why I should be the one to burst their bubble. I also didn't think it would really achieve very much.

Both of my parents have dropped their bodies at this point. My successful education remained something concrete they could be proud of, especially given the media reputation I achieved as my trajectory of dissidence progressed. Who knows how many others stoically put up with vicious cruelty and physical intimidation year in and year out? This institutionalized hierarchy of violence began way back in medieval times when knights were warriors protecting the state, though not their serfs—which would have been most of us, and certainly me. In Victorian times it was seen as strengthening the boy, making him a man, suited for leading roles in business, society, politics, and the military.

Later in my school years, sometime during the 1967–68 year, the schoolhouse gang tried to break into the armory to steal automatic weapons and rifles and boxes of live ammunition that were stacked up in the building. To this day I am not sure if I am glad or sad that they failed to get

through all the padlocks. When they failed, they tried to set the armory on fire, hoping to cause a massive explosion when the ammunition went up. Their frustration still not satiated, they then committed a cardinal sin: they managed to start up a bulldozer and drove it across the cricket pitch, gouging great tracks in it. Cricket pitches are holier-than-thou. Surely, we other students thought, surely *this* will get them some kind of retribution? No. Privilege is exactly that. It raises you above and beyond the dynamic of justice we mere mortals are subject to.

In the end, even the cricket pitch was subservient to the aristocracy of wealth. Nothing was done to them. You'll note I have not even given their school nicknames. For who knows? They may now by prime minister of England, a cabinet minister or a captain of industry . . .

I often say that Solihull School taught me who my enemy was.

9.

Dave Rook grew up to be the worst bully in the school. He was huge, over six feet tall, and continued to single me out to threaten, make fun of, try to get people to laugh at, and, of course, physically brutalize. He would push me in lines, and he would kick me in the back and do everything else that bullies do.

A few years into school and his focused attention, I snapped.

By then I was old enough to have access to a shared dorm room to use during breaks—as you moved through school, you were deemed more responsible, and day students eventually got spaces of their own. The room I was in had an open stove so we could warm up and make tea.

On this day I was finishing an essay for history class that I'd been working on for a week. I had just finished it and was leaning back and cleaning my fingernails with a penknife when Dave came in, pushing people around.

He came over to me and said, "What's that?" and grabbed my essay.

Suddenly he shoved it into the open flames, setting it on fire, and then waved the burning papers in my face.

Somehow, it was the final straw.

I stood up and stuck him with the penknife—straight in the stomach.

Luckily it was a tiny knife, or he'd have been dead. He went white—the first time I'd ever seen somebody truly go white. He stood there, shocked in his school uniform of white shirt and tie as a red stain started to spread.

I thought, *Shit, what have I done?*

Obviously my school career was over, I thought. I would be going to juvenile court.

So I just calmly packed up my things and walked home. When I got there, I said to my mother, "You're probably going to get a phone call from the school because I just stabbed Dave Rook."

I explained the context, saying he'd been tormenting me for years and that I couldn't take it anymore.

To my shock, she said, "Sounds like a reasonable reaction."

"Thank you, Mum."

Then the phone rang, of course.

"It's the headmaster," she said. "They want to talk to you."

"I don't want to talk to them."

"They still want to talk to you. They said you shouldn't assume it's negative. They just want to talk. Will you go back to the headmaster's?"

"No."

After some more back-and-forth, I said, "Only if I don't have to wear my school uniform."

The first thing I'd done when I got home was change into my scruffy jeans and bomber jacket.

They agreed, so I went back to school.

The school was laid out so that the main part was like a square, with classrooms all around it, and it was forbidden for anyone except for the teachers to cross this lawn. Assuming I was in the worst kind of shit, I thought I might as well live with it, so I very deliberately and slowly walked across that lawn that only the teachers could walk across.

Then I went upstairs to the headmaster's room, and someone came out and said I could go right in. Inside, there was Dave Rook, his mum, and the headmaster.

I thought, *Fuck, my life is over*.

But I sat down, trying to stay calm, and they started talking. At first, I wasn't able to concentrate enough to hear the discussion—I was just zoned out. But as I started listening, I realized they weren't being really aggressive towards me, so I started to listen more.

"We understand why you did what you did," I heard. "And Dave Rook's mother is prepared to forget about it if you will pay for a new shirt—because you ruined his shirt."

I was starting to celebrate inside my head while trying to act contrite.

"Yes, I'll pay for his shirt."

And then they made *Dave* apologize to *me* for all the things he'd been doing. It was a moment of true justice, when I actually discovered that people would listen to your story and believe you.

Not long after this, the headmaster called me back in and said he wanted me to be a representative of the students of the school—to tell him what was going on, what was wrong, and what things were happening that he should know about. So I became a sort of student advisor to the headmaster as a result.

The other weird part of it was that Dave Rook stopped bullying people and became my friend. He had a car, a Mini, and he became my chauffeur. He would ring me up and say, "Is there anywhere you need to go? Do you want a lift somewhere?"

And he would take me around.

He was lonely, of course. It was the classic story. He just wanted to be part of something. He was a nice guy underneath it all. And it changed his life for the better, as it happened. So we both came out okay from what could have been a disaster.

I'd basically grown up in a household of three generations of women: my maternal grandmother, my mother, and my sister. My schools from the age of eleven on were all boys. I remember at around age nine watching my mother brush my sister's long hair and feeling jealous and a little angry that just because I was a boy I could not have long hair or discover the sensual pleasure of having it brushed. It only recently dawned on me that this could've had something to do with being in such a split situation—a completely feminized home setting and this ridiculous masculine daytime setting at school.

Privately I wanted to be Twiggy, the skinny girl with Vidal Sassoon-styled hair and adventurous clothes. Then it had to be Diana Rigg, who played Mrs. Peel on the *Avengers* TV show and wore skin-tight leather bodysuits and took over traditionally male roles, fighting and dominating her criminal opponents while Steed, her male partner and boss, was a more effete dandy whose name was another word for a horse, putting his character firmly in the submissive role, topped by Mrs. Peel.

I was never a person who felt I was a woman trapped in a man's body. But I did feel totally trapped in the expectation of my role within "masculinity." All the "male" traits and behaviours that were supposed to be so natural to me. I did a lot of boy things in childhood. Played with toy soldiers, for years. Adored playing soccer; even trained my left foot to make the Stockport Grammar School team. Got my colours for basketball at Solihull; wore my tie. Was a first-class marksman. I loved and desired only girls quite naturally. But I hated being associated with "maleness." The idea of emulating behaviours of so many students at Solihull School was anathema to me. It filled me with disgust.

In 1965, I found my only biologically male role model: Brian Jones. The company my father worked for was contracted to clean entire nuclear

power plants, or to paint all the phone boxes in Shropshire. One of the contracts was with ABC studios in Birmingham. Somehow he received two free VIP tickets to the taping of a TV show there called *Thank Your Lucky Stars*, one of the first weekly pop music programs, on every Sunday. By sheer luck, the Rolling Stones were there to lip-sync to "19th Nervous Breakdown" that week. Armed with my postcard-size VIP pass, I decided to wander around backstage.

Suddenly I banged into Mick Jagger.

"Oh, er, I'm sorry, Mick," I said.

He was very sweet, standing there with a bottle of Coca-Cola in his hand.

I got my wits about me enough to ask, "Will you sign my pass?"

"Sure," he said, and signed it.

Then he said, "Would you like the rest of the band to sign it?"

He took me upstairs to the cafeteria, where it was just the Rolling Stones and me. I spent half an hour there, talking shyly and hanging out. They were all sitting at this table, drinking coffee, still seeming slightly innocent.

Brian Jones had an incredible atmosphere around him. Ethereal, as if he were partly here and partly in another dimension. And he was incredibly androgynous. It had a profound influence on me as a fifteen-year-old. He became symbolic to me of both the exotic idea of androgyny, but also of experimentation.

"Why do you use the teardrop guitar?" I asked Brian.

"Well . . . it's . . . really coooool," he said.

Afterwards, it dawned on me that they were stoned out of their boxes. But I got them all to sign my pass, and it's one of my most treasured possessions of all time.

Then, also in 1965, my English teacher, whose nickname was "Bog Brush" because he had a stinky mustache that looked like a toilet-cleaning brush, asked me to stay behind at the end of class one day.

Oh no, what have I done now? I thought.

Instead of getting in trouble, I was given a tip.

"I think you would really get a lot out of reading a particular book," said Bog Brush. "Try to get a copy of this."

He handed me a slip of paper: "*On the Road*," it said, "by Jack Kerouac."

I was fifteen and had no idea who Kerouac was. But I took the paper home and gave it to my dad. Since he travelled all over the England for his work, I asked him to try to find the book for me. One day he came home and had a paperback copy—found in the bargain bin at a motorway café.

He should never have done that! I read it like nectar of the gods: *People can live lives outside the norm, they can integrate creativity and life, they can take control of the narrative of their existence.*

Names could be changed, bodies adjusted, imagery altered to tell a story or hide a story.

Everything is mutable!

Today we wouldn't feel the same way about *On the Road*, but at fifteen, with very little knowledge of the world or its machinations, it was just incredible. My dad, of course, had no idea the effect the book would have, and I didn't tell him. But Bog Brush saved me with that suggestion.

After reading *On the Road*, I realized there were other people. One was Allen Ginsberg; another was William Burroughs. I started hitchhiking to London every second weekend, lying that I was going with a friend to his grandparents' place in Purley.

When you're hitchhiking and you're fifteen, sixteen, and reasonably cute, you never know who's going to pick you up. There was a man in a Rolls-Royce who kept asking for a blow job, and I said no. Then there was a man who was a firefighter and had just done a check on a Mormon temple and said, "Did you know there are eight floors below the ground because they don't need planning permission for that? And in those eight floors, they've got a big water reservoir, and a library and a school and enough places to live for the entire local community of Mormons, so if a bomb goes off, they can all continue to live and come out again?" And so on. So you get all these amazing stories for several hours—sometimes ten, twelve, fourteen hours—from people you'll never meet again.

The only way I knew to find somewhere to sleep was to go to Piccadilly Circus, where all the junkies and people with long hair were, the hip community. I'd meet somebody with long hair and hope they'd say, "Do you want to crash on my floor, man?"

"Yeah, that will be great."

So I'd go visit places like, say, macrobiotic communes. I'd sleep on the floor, and they gave me brown rice in the morning, and I wouldn't really like it at the time but I'd go, "Oh, thank you."

Then I'd think, *Where do I get books?*

I'd go to bookshops on Tottenham Court Road: no Burroughs, no Ginsberg, no nothing. Then I went to Soho, just because it was the porno area. Lo and behold, in the first shop I went into, there was *Naked Lunch*! Since it had been banned and deemed obscene, they stocked it. I looked a bit more and found Henry Miller and Jean Genet . . . Suddenly I discovered all the books I really wanted were there in the "obscene" Soho bookshops. So I'd buy or shoplift the books, then find a way back home in time to go to school on Monday morning. And along the way meet more people. I'd have an amazingly full and kaleidoscopic adventure attached to each book. And then the book had information that I'd never been able to access before.

I read two or three of Burroughs's books, and I wasn't completely sure of what to make of them, to be honest. I knew they had a very potent effect on me, but I was actually quite naive. I didn't understand all the drug and homosexual references completely—basically a lot of the slang and scenarios were totally outside my experience—but I just felt this incredible potency.

One day in 1965, I was in what was called Mell Square, in Solihull, on a Saturday, where I used to go into a shop with lots of magazines and chocolate and frippery—and books. I walked in and there was a magazine there in a pile that was bright pink and blue and all swirly, with a bus on the cover, called *Oz* magazine. I opened it and all the pages were weird and yellow and had purple writing on it. I thought, *What the fuck is this? This is amazing!*

I bought a copy and discovered it came out roughly every month. From then on I looked forward to each new issue: *Oz* magazine became my bible.

Oz magazine featured stories about Malcolm X and gay rights, all sorts of concepts that had never been presented to me before. There were philosophers and agitprop figures and serious scientists. There were all these people with radical new ideas, and it was just this fabulous melting pot. You

could propose anything, no matter how ludicrous, and people would throw it back and forth. I immediately felt a kinship with these people.

Through *Oz* I heard of *International Times*, the newspaper of the underground in London. In England, there was a group called the CND, the Committee for Nuclear Disarmament. The CND used to have marches, and they got bigger and bigger. From that group, there were people like Alexander Trocchi, an anarchist-communist who wrote *Cain's Book*, and Barry Miles, one of the cofounders of *International Times*. Things were starting to change in London, and they decided they needed some kind of publication out in the world to represent what they were thinking. Offset printing had just started to happen, so it was much cheaper. You didn't need to do all that letterpress; you could just do photographic plates to print things. So it got a lot cheaper, and you could do more interesting designs.

After they started *International Times*, they decided to have a poetry reading in the Royal Albert Hall, an event which is generally considered to be the beginning of the swinging 1960s and Flower Power in Britain. They brought over Allen Ginsberg and invited a lot of British neo-Beat poets. The Royal Albert Hall, much to their surprise, was packed. Sold out. That's when they realized there was actually a movement, that it was more than just isolated individuals angry with the state of the world. So from that day it became a steamroller.

Up to then, through the 1950s and the early 1960s, England had tried to maintain its prewar sense of identity. It was very constrained, very rigid. The slogan of the conservative party, which carried them to victory under Harold Macmillan, was "You've never had it so good."

They were still very proud of the empire—they still had an empire after the war. There was a really deep sense of being constrained and locked into this attempt to maintain a failed class system.

But increasingly, people were looking at things and thinking, *Why is it like this? The world has changed. After the atomic bomb, it's changed.*

That's something else people probably can't imagine anymore, but everybody really thought that we were going to die in a nuclear holocaust. I still remember the Cuban missile crisis and my mother saying, "I probably won't see you again when you go."

She sent me off to school—God knows why she sent me, but she did—and said, "If I don't see you again, I love you."

That's how real it was. We all thought we were going to be destroyed.

There was a film made called *The War Game*, commissioned by the BBC, that was meant to be a semi-documentary about what would happen in a nuclear war. In the end it was so scary that the BBC refused to show it. The people who made the film still wanted the population to see it, so various people sponsored evenings of screening the film. I was involved in screening it in Solihull. People would faint, cry, puke. It revealed things like the fact that when people joined the police, they had to sign a form to confirm they would shoot civilians—even their own family—if ordered to do so. You know, so if anyone had radiation sickness, they were supposed to kill them. That really freaked viewers out, as you can imagine. I'm quite proud of helping it be shown in our town.

All of this contributed to a sort of new, existential nihilism, as in: *How many days have we got?* If the answer is *None*, we'd best make the most of the ones we have. That sense of impending death really fueled the energy of rebellion.

How could things be changed? Was there a way to avoid war?

All of that was really churning, and when you're young and activated, you want to be involved in that. You want to save the world. You didn't want to be burned to a crisp without good reason. That all became part of the mix.

Still, the Beats were the common denominator. Everyone had read *On the Road.* Everyone had thought, *Yeah, I don't need to be connected to the past. I don't need to be beholden to my family. I don't need to get the job they want so I can be comfortable. Why the fuck should I when I could be dead tomorrow?*

Of course, there were no equivalents to the Beats in Britain. There were no really radical poets who were well-known enough to draw crowds like the Beats could. It was the same with the bands. I was pretty disparaging of the Beatles, because by 1964 even my granny liked them. That wasn't much of a rebellion. That wasn't going to change the world.

The Stones were sold as rebels and, for a small moment, appeared to actually be rebellious—and to say, *Fuck you, I don't need to dress the way you*

*want, I don't need to look the way you want, or have sex the way you want.
I can just be the person I truly want to be and you can all go fuck yourselves.*
We got these messages from English people, but none offered a really deep, considered, and worked-out message like the voices from America. The U.S. was simply ahead of us.

Of course, nobody I knew had ever been to America. Now, that's something else to remember: hardly anybody traveled to America, or even Europe. To take a plane somewhere was out of our budget. We had no sense of America other than from TV shows, which I hardly ever watched. My sense of America was from those beatniks, and from the alternative writing, and from the art. For me, the messages just made sense. It didn't matter where they originated or that I had no direct experience of that location. I was getting information from books and alternative magazines: I started to get the *San Francisco Oracle*, from Haight-Ashbury, and *Other Scenes*, by John Wilcock, which originally came from New York and later from different places as he travelled the world. Kerouac, Ginsberg, Herbert Huncke—they saw the United States' social culture of the postwar 1950s as spiritually empty and oppressive in that it didn't allow any space for imagination or radical change. The establishment was still trying to nail down the hatches and make it like it used to be. But it wasn't like it used to be. Tens of millions of people had died, and America had dropped atom bombs on civilians. There was too much disgust towards the system for doing that.

I didn't recognize the landscape of those American books—the big roads, for instance; I didn't recognize that at all. In England, if you went thirty miles, it was considered a long way, and people had a different accent already. Sixty miles and they sounded totally different. So the scale was completely off compared to the U.S. But it was that classic thing of recognizing the *feeling* in people. I read these books and I just thought, *That's how I feel, too.*

I wasn't going to get in a car and drive a thousand miles, because I couldn't. But I wanted to get away; I wanted to move, travel, and evolve; I wanted to experience and soak up everything and anything that took my fancy—those were the important ideas, and they translated despite the distance. I felt I had an absolute right to experience anything I wanted to.

And as time seemed precious. given the precarious state of the world, I felt you should live every day as if it was the last day of your life. You should be proud of the way you lived that day.

As I started to find out about all the things going on in London and the wider expanse of the world—the whole psychedelic revolution chronicled in magazines like *Oz* and *International Times* and, soon, also via underground music like Captain Beefheart, Frank Zappa, the Fugs, and Sun Ra, I was, like, *Yes, yes, yes, yes!*

This is how I want to be!

And there are other people like me! I'm not crazy!

As a result of the *International Times* event at Royal Albert Hall, amongst other things, people also recognized that even if in Britain we didn't have any stars like in America, there were still a lot of us. So why not start trying to do something to make things different?

It became really important to feel I was building myself from scratch and wasn't taking anything on that I'd inherited—because all the inherited systems were corrupt, oppressive, bigoted, or exclusive in some way. You'd look back at history and see it hadn't fucking worked. And if it hadn't work, why keep doing it? We had to change how we did things if we wanted to survive as a species.

And, sadly, that's still the problem. All these decades later, that's still the fucking problem.

But back in the mid-1960s, it was exciting to realize that so much more could be done than we were being told, especially at those rich schools like Solihull, where it was about maintaining the status quo. It was really encouraging—I felt part of some far-flung tribe. And I was determined to find out more.

11.

I was vaguely plotting a life of the "avant-garde" and "bohemianism" from the moment I heard about these words. But I kept it secret. *If I tell anyone, I thought, they'll be really suspicious.*

Then, in my seventeenth year, I eventually met and became friends with four other students at Solihull School: Ian Evetts, whom we called Spydee; Baz Hermon, who later became Little Baz; Peter Winstanley, known as Pinglewad; and Paul Wolfson. They were all a year below me at my school, but they were into poetry and the Beats and the new things that were happening.

We'd all been targets of intimidation and abuse in differing forms and amounts. Spydee, in fact, had been the boy nearly killed after his appendix burst when four bullies beat and kicked him for the crime of having written a poem. So a certain camaraderie initially threw us together simply for the sake of mutual protection from this regime of violence and abuse that I'd been subjected to for three years at that point.

We became a little crew: the only five people in the school who shared similar interests. Every weekend Spydee, Pinglewad, Paul, Little Baz, and I would meet and talk about whatever was going on and play new music for each other. If somebody's parents were out, we'd go to their house and literally stomp around the room reading Beat poetry and excerpts from novels out loud and daydream about doing something similar. We had all discovered the Beats in different ways. Little Baz was more into Ferling-hetti, Spydee was into Burroughs, I was into Kerouac. We were discovering information and sharing it with what became a very tight-knit group, the five of us against the world.

Once everyone in the crew had read *On the Road*, we were, like, "We need to get some hash."

Because obviously this was an important part of becoming a beatnik.

We were infatuated with the idea of another way of being. But we were living in this middle-class, sterile, suburban suburb of Birmingham.

How the fuck do we find hash?

On Saturdays, we used to go to a café above a supermarket and buy a cup of coffee and make it last for an hour or so, and we'd talk about changing the world and write little Beat poems in notebooks. We'd daydream of being footloose and fancy-free. We went every week for a few months, and one day there were two guys there with long hair, really long hair—like, down to their waists. One of them was wearing a really horrible, dirty old raincoat, and the other was more of a classic beatnik.

Our crew looked at one another and whispered, "I bet they know where to get drugs. They've got long hair!"

"What if they're cops?"

"They're not cops. Why would the cops come here? Nobody's got drugs; that's why we can't find any."

In the end, I went over to the table and said, "Um, can we sit at your table with you?"

To my shock, they said yes.

The one who was in the horrible raincoat was called Baz—he became Big Baz—and the other one was Ron Skinner. I hit it off with Ron Skinner, and Spydee hit it off with Big Baz. After a while I guess they sussed that we were sort of stupid but enthusiastic and sincere. And they decided to get us some hash. That's how it started.

I found out later that Ron Skinner lived in a flat that was on my way to school. I'd go down the back of the school playing fields, pass the bleachers, go through a hole in the fence, and then walk across to the main school building. His place was just before the school grounds. I started to get up early, much to my mom's pleasure and surprise, and walk to school—but first I'd go into Ron Skinner's flat. He played me Jimi Hendrix for the first time, and actual blues records for the first time. And he was a painter. He did abstract paintings—I still have the one he gave me. It's one of my treasures. It's gone all over the world with me. That's how important he was.

Spydee later found a connection for hash in Birmingham. He would go into a West Indian area of the city and get the hash and bring it back to us, after our first connection with Ron Skinner and Big Baz.

Once we discovered hash, a few people in the school found out that we knew where to get it, and they would ask us for it. So we would make fake hash. We would get Oxo cubes and digestive biscuits and wrap it in tinfoil, then heat it up so it made this gummy paste that looked as much like hash as anything they'd seen. And we'd sell it to them.

At some point, I got called to the headmaster's office: "We're very concerned about Ian Evetts."

That was Spydee.

"Oh? What's happened?"

"Well, it seems as though he may have been selling drugs in school."

"Really?" I said.

They told me someone got caught with it and told the teachers that it was hashish and that they got it off Spydee.

"Ah, that's not hash," I said. "It's fake."

So they couldn't do anything, because it wasn't illegal to sell digestives and Oxo.

But the headmaster was still really pissed off, he said, "Well, that makes him an embryonic criminal. It's almost worse because he's conning everyone."

They let it go, thank goodness.

Spydee was instrumental in a lot of things between 1966 and 1968. He was the one who was really good at finding underground music. These were the early days of pirate radio in England—broadcasters who were bypassing the official media. The pirate radio stations were on boats outside the zone that's considered British waters. Entrepreneurs bought boats, put out to sea, and played all this new music, making money by running advertisements. John Peel had a weekly program on the pirate Radio Caroline called *The Perfumed Garden*. He was the one who introduced American psychedelic music to Britain. With the exception of Radio Luxembourg, my little transistor radio couldn't pick them up. But Spydee could get all of the others—Radio Caroline and Radio London—so he'd tell me all the different things that

were happening. Spydee was developing a real knowledge of underground music and sharing it with the rest of the crew.

Spydee told me he'd heard a band called the Velvet Underground playing a track in which he thought he'd heard an electric violin. He told me I *had* to listen to the record.

I went to the local record store called Boots, which was actually just a drugstore that had a little record section, and you were allowed to go upstairs and listen to the first track of the record and then decide if you wanted to buy it or not. I asked them if they had the Velvet Underground.

"No, but we're getting it in on Friday."

That Friday fell right in the middle of my exams. The first lot of exams you do in England before going to university. I used to be a bit of a mod, with a Vespa, so I actually did an exam on Friday and then ran out of the class room, got on my Vespa, zoomed down to the shop with money that I'd saved up, ran upstairs, and said, "Have you got that record by the Velvet Underground? It was released today."

They had one copy.

I ran into the listening booth and they put it on: the first track on side two. I just couldn't believe what I was hearing. So I just ran back: "Yes, yes, yes, I'll buy it!"

Grabbed it, went back to school, and carried on taking examinations for the rest of the day, then took my new record home that night and played the whole album. I had one of those old record players where you could leave the arm up and it would keep going back to the beginning, playing it over and over. Of all the records in the entire world, *The Velvet Underground & Nico* was the most directly influential on me: I know it backwards and forwards and even upside down, at all levels of my consciousness. I must have played it thousands and thousands of times. I listened to it for hours, even when I was asleep.

Suddenly everything seemed to be opening up.

12.

There was a fence that ran along one side of the all-male Solihull School grounds, dividing it from Tudor Grange, which was an all-girls school. Needless to say, there was a lot of flirtation that went on over the hedge. My first girlfriend went to that school—but that wasn't how we met.

There was a building next to the track and sports fields that served as a youth club called the Track. On Saturday nights, the Track held discos for young people. Spydee and I would go there on the weekend, and we would hook up with girls—or try. Usually we'd just sort of stand and watch, and occasionally dance. But it was our one chance, really, to socialize with females.

At Solihull School, there was a lot of macho boasting by people who claimed to have "done it." After a weekend, if people claimed they had been kissing a girl at a party, or were possibly going out with her, they would hear nothing but "Did you do it with her?" until lessons began. While most boys around me at school boasted emptily of fantasy exploits, I stayed discreetly silent. I had started out totally ignorant about even the most basic mechanics of sexual activity. My time in Stockport and Gatley had taught me about my penis and masturbation, but in a social vacuum. Scotch John had taken me on an illustrated journey with his photographs of the myriad options of conjoining male and female genitals. But I felt I could not move on to emulate my role model, the Beats, without losing my virginity. Yet my nature was not promiscuous. All my life I've been a serial monogamist, which is my true nature. Fighting against my rather pedestrian dream of one single amazing love was creating tension and stress, but I was determined to get it out of the way once and for all. And now, in Solihull, I was to explore in a fully tactile, sensual, three-dimensional explosion what joyful combinations were possible when actual pussies and penises devoured each other in passionate sex.

Spydee and I were there one weekend and I spotted a girl whose name was Jill Button.

"She's a goer," Spydee reported.

In other words, she was a sexually aware young woman.

And she was cute, really cute.

One weekend, Jill saw me looking at her. Encouraged by Spydee, at the end of the night I walked over to her and asked her if we could go for a walk in the nearby park together. To my surprise, she agreed right away. In fact, she told me she had seen me looking at her and hoped I was actually going to ask her out.

"You don't seem like all these other boys here," she said. "You dress different. You give off a mysterious vibe."

She took me outside and into the park, and we wandered around winding paths, stopping every now and then to spend intense periods kissing. In the end, we came to this little shelter with benches and walls on three sides. We sat for a while, still kissing, and my cock got hard very quickly. She instantly undid my belt and slid her hand inside, gently caressing my hard penis. I put my hand on her thigh near her crotch, slipping two fingers slowly under the silk seam of her panties. As my fingers moved through soft pubic hair, then curled inside her, she moaned. She was so wet, it was a delicious sensation to explore as if I was blind, learning these meticulous details of her warm wet labial flesh with my fingertips. I instinctively found her clitoris and worshipped it with careful variations of moving my fingers as if in prayer. In return she kissed me harder and began squeezing my penis, moaning into my mouth, her teeth occasionally clashing with mine. Then suddenly she arched her back, pushing my fingers deep inside her as she had the first orgasm I had ever experienced in a girl.

Then she said, "I want you to fuck me."

I was suddenly, secretly very scared. What if I messed up or literally made a mess? No matter how afraid I really felt, I was determined to go through with this special chance, so I took off my coat and laid it on the ground in our little outdoor boudoir. Jill lay down on it. She had removed her panties and lifted up her blouse and bra, displaying her deliciously slim body, very Twiggy, complete with short mod haircut. I knelt between her

legs and slowly lay on her as she guided my overstimulated cock inside her. I was so horny and excited. We fucked for only a few strokes before I couldn't help but come inside her. It was glorious and humiliating all at once, though not the amazing sexual revelation or beatification I had hoped for or imagined all these years. In fact, I felt embarrassed that I had been such a lousy lover in the desultory end. Jill saw it differently and was happy with her orgasm; satisfaction for her was happening on multiple levels, and the relatively short electrical discharge of nerves that was orgasm happened everywhere in her body, unlike the penis-centric orgasm of most males.

Looking back, it was primarily the sense of deep connection, of choosing to be vulnerable to each other, an absolute form of trust, that really mattered. She held me in her arms for a while, then I walked her home. Somehow, that vexing hurdle of virginity, though lost at last, was really just thrown away by me. All I felt was emptied.

Later that night and the next day, I freaked out, thinking, *Oh, my God, you didn't use a condom or anything! What if she gets pregnant? Aaahhhh!*

Sex was virtually never discussed in my household. The only person in my family who had ever talked about sex with me was Nanan Swindells, during another period when she was living with us. One day, in a confessional mood for whatever reason, she told me that her husband—my grandfather—had been thirty-two when he married her, while she'd been just sixteen.

I went, "Wow, that's young."

With some prodding, she went on. No one had ever told her about sex before she got married. So she married this man who was six foot three or four and was presumably somewhat worldly-wise. On their wedding night, she said, "He suddenly started touching me."

She went on: "I was scared. I didn't know what he was doing or why he was doing it."

She was that ignorant about sex.

I said, "What happened?"

"Well, he climbed on and he did that thing. I hated it. I hated it. I was scared and I was crying."

"Oh, God."

"The worst part was," she said, "I got pregnant that first time."

It turned out that she had sex with him four times over the course of their marriage and got pregnant all four times. They never discussed sex. He would just climb on and she would scream. It made me understand why she would at other times refer to sex as "that horrible, dirty thing" and be so disgusted at anything to do with sex. Poor thing had been traumatized. How many women went through that? Why were people promulgating ignorance like that? Because ignorance was used as another form of control. And we know who was getting the power as a result.

I felt sorry for my grandmother when she told me that story.

For her, sex was just rape and pregnancy.

Luckily, it turned out everything with Jill was fine. She was on the pill, the great sexual liberator of the sixties. In fact, she started to ring me up, because she said she really liked me. But I said it wasn't going to work.

"I'm too confused about all this."

But we continued to talk, went out and had coffee together. We ended up becoming good friends.

Meanwhile, back at the Track, there was a particular Sunday where Spydee had his eye on a girl with beautiful, natural strawberry-blonde hair, in gentle curls. Not really curly, just perfect. So when the light hit her, it was like she had a halo of gold around her head, which is why I started to refer to her as "Angel" Jane.

Spydee pointed her out to me. But as soon as I saw her, I just went, "Ooh, she's nice."

So I ended up going and asking her to dance, and she said yes. And we became friends and then lovers.

Her father was a retired major in the British Army. Very strict, somewhat distant, very BBC British, typical ex-army type. He worked for an insurance company. Because I was already painting by then, he commissioned me to paint something for the insurance company's head office in Birmingham. So I painted a really beautiful painting of an Aztec blood sacrifice to the sun. People with bloody knives and Aztec headdresses, and everything around an altar for the sacrifice. And they put it in their offices, behind the reception desk.

Her mother was a classic, suburban, scatty mother who didn't really have any attachment to anything. She just played the wife.

Angel Jane and I did the teenage thing of just hanging out, meeting in the evenings, and quickly became very close. Then there was a moment, when I went back to my mom and dad's house one afternoon, and she'd got off school early. We were on the floor, fooling around, and then we had sex.

We had the most incredible sexual relationship. At that age we couldn't go home, because our parents were there, so we'd have to think up ways to have sex. We had sex in telephone boxes, in the woods, on the golf course, in the fog. I can remember, very vividly, her masturbating me in a bus queue while there were people on either side. We had a really intense sexual relationship.

Jane also played violin in her school orchestra. That's how I got my first violin. When Spydee had turned me on to the Velvet Underground, I'd become obsessed, and she gave me one of hers.

I stuck a tape recorder microphone in the violin and started playing it, electrified, in the attic in my house, experimenting with the amplifier so I was recording it as it fed back.

I was absolutely, totally in love with Angel Jane Ray. We went out together for nearly two years, right up until I left to go to university, and Angel Jane joined our crew, too.

13.

After finding *Oz* magazine and *International Times*, I was already getting into the idea of happenings and doing things.

I was very naive. I wanted to do an event, a happening. I thought, *Wouldn't it be nice if instead of there just being trash in the street, it was Beautiful Litter, something positive?* How could you transform what people normally discard or ignore into something special? We wrote words on bits of cardboard and cut them out so we had lots and lots of these words. We would leave them in ashtrays and on the ground, wherever there was litter or trash. The idea was that as people picked them up to see what they were, they were writing a poem. So it was a genuine attempt to get people to look at the world in different ways, a genuine attempt to do something positive.

When we carried it out, the stunt got picked up by the local newspaper. The paper interviewed me and printed a photograph. Unfortunately, when we'd sent out a press release to the paper, we'd claimed it had been organized by the Knights of the Pentecostal Flame. For some reason, they took that as meaning it was a Christian thing. And so instead of it being seen as eccentric and threatening, it was seen as being positive and uplifting.

After that, the local photographer who did all the weddings in the area rang up and wanted to do a portrait of me and Angel Jane. He did two photos of me and Jane, which they put in the window of their shop. And we actually gave talks at a couple churches to Christian youth clubs, explaining what we were trying to do. We even got national press: BBC Radio did a news item about our project, too. It spread in a way I hadn't expected, and I saw how easy it was to do something that might expand and reverberate beyond our immediate environs. We could get press that could just grow on its own, and our ideas could be interpreted, reinterpreted, or even misinterpreted, but not quite how we intended. I started to see the media part of everything—a tool.

When we did the Beautiful Litter happening, Spydee liked the idea but wasn't interested in being involved. In fact, not only didn't he want to take part, he actually wrote letters to local papers saying it was a load of shit. He was always very cynical that way. It was one of the first times I had a disagreement with Spydee; he just didn't like the idea of doing public events.

While Spydee was really good at discovering new music, he didn't want to *make* music. It was me who would then say, "Okay, we like it. Why can't we do it?"

That was a difference between us.

Another way our crew worked towards our goal—creating some kind of future group of people who had an influence on the art world and the world of culture—was to print and distribute our own little magazine, *Conscience*.

I've never let go of that impulse: if you think it's a good idea, don't just talk about it: Actually do it.

We decided making the magazine was almost more important than the content, because it was a sign of actually trying to change something and do something proactive. In addition to our poetry, *Conscience* included articles protesting school rules that were anathema to us. We even succeeded in finally ending the ludicrous traditional rule of being forced to wear caps no matter how adult and fully-grown we might have become. Likewise, limits on length of hair. I was also commissioned to design the first-ever issue of the Solihull School's official magazine in the spring of 1968.

Around that same time I read a book of Bob Dylan interviews, and in several of them, people asked why he had changed his name. Dylan said, "We're born as nothing, a name is what you make of it, and Bob Dylan is a name I wanted to grow into."

It's an old tried-and-tested technique that I've obviously used in my own life. I think the name you get given at birth should be seen as a temporary tag, and it goes with the families and the social groups and the expectations of what we're supposed to belong to; if that tag doesn't fit what you imagine you wish to become, it should be discarded.

Changing names is a really potent form of magic. It's a technique for shedding a nostalgic connection to bloodlines and familial responsibility. Of course, you can also say, "Now I'm going to build my *own* story, independent

of what's been fed to me, what we're told we're supposed to be responsible for, who we're supposed to respect." Take all of that out and then try to build your fantasy person and make it a reality.

Perhaps there comes a time when it's not enough to try to change your behavior.

Perhaps you have to let go of all conditioning and step out on your own.

There was a party, sometime in late 1967 or early 1968. I didn't go for some reason, but at school on the Monday afterwards, Little Baz, Spydee, and Pinglewad were all suddenly calling me "Genesis."

"What the fuck are you calling me 'Genesis' for?" I asked.

"Oh, well, we had this game we played at the party on Saturday night. You know, the one you didn't come to? And we wrote down the names of everybody we know and then wrote biblical names that we thought went with everyone."

"But Genesis isn't a person," I said. "It's a book!"

I didn't like it at all.

In fact, I was kind of irritated, so they teased me even more, continuing to call me "Genesis." But then after a while I thought, *Maybe if I adopt it they'll get bored with it and knock it off*. So I started to sign some poems Genesis Megson and then just Genesis, but it didn't work the way I expected. It basically ratified the name and legitimized it as my identity. Later, when I thought about it, it struck me: *It kind of makes sense*.

Genesis is the first book of the Bible, a beginning. It's a place where you can start to create your own world, your own universe, and populate it with your choices.

So I decided I actually liked it as a name and started to use it all the time.

14.

In 1967, I died.

I'd been on cortisone for about ten years by then for asthma. It was one of their so-called wonder drugs, but they didn't know there would be side effects.

As my teen years wore on, I began to feel I was managing my asthma better. I came to recognize the things that triggered it, and realized that my panicking made it worse. Bit by bit, mentally, I dealt with it. Bit by bit I developed the strength and the will not to panic. Of course, I got vague moments of being out of breath if I had to run very far, or from hay fever in summer, but slowly, eventually, I was able to reduce most attacks down to three nights, down from several weeks, and finally to a point where I no longer had attacks that laid me up in bed thinking I was dying.

At that point, I began to think I probably no longer needed medication.

Then, when I was seventeen, my doctor in Solihull said, "You know, you've not had an asthma attack for a couple of years. You don't need to take the cortisone anymore."

I went, "Oh, great!"

Because I'd thought I was going to be trapped into having to take these pills forever, which limited any fantasies of living on a desert island or in the middle of nowhere.

I stopped taking the pills on a Friday, and on Saturday I felt kind of tired and a little woozy. Sunday I definitely felt as if I was getting ill, perhaps the flu or something. On Monday I thought I was in the midst of an asthma attack but couldn't figure out why: *I don't get those anymore.*

When I'd had attacks in the past, I would sit on the edge of my bed and rock back and forth, and it would help me breathe for some reason. It also calmed me down. I was on the edge of my bed when my mother came up to tell me I had to come down and eat my breakfast and go to school.

"I can't go to school, no way," I said. "I'm not well."

She acquiesced—I'd missed lots of school as a result of asthma over the years—and then went back downstairs. Then she and my sister heard a big thump. When my sister came up to see what the noise had been, she found me on the floor, turning blue. I had gone into a coma.

By coincidence, my doctor had recently moved into a house opposite ours in Solihull. And he was running late to work that morning. My sister, Cindy, ran across the street to get him, which saved my life. The doctor, it emerged later, had only that week read an article in a medical journal discussing something called Addison's disease. The disease, which John F. Kennedy also apparently had, developed from long-term use of cortisone steroids. Because the medication released adrenaline, the adrenal glands stopped bothering to work. Eventually it destroyed the glands, which have two functions: one is the fight-or-flight response, and the other triggers other organs to work, keeping them operating when you're asleep, for instance. If, after the glands have atrophied, you stop taking the cortisone, you go into a coma and die.

The doctor guessed what was happening as a result, and ran back across the road for his kit. When he returned, he jammed a needle into my chest and shot adrenaline directly into my heart. Then they put me in an ambulance, and I arrived at hospital basically DOA.

I remember being in the ER, in a room, on a gurney, floating above everything, looking down, the classic out-of-body experience. There were nurses and doctors discussing who would have to tell my parents I was dead.

I'm not dead!

I don't remember going back into the body, but the next thing I remember is waking up the next morning with an oxygen mask on and things beeping and tubes stuck in my arm. The first thing I did was take the mask off and start shouting, "What the fuck is going on?"

Doctors and nurses ran in, and my mother—who heard the commotion and my cursing from outside the ER—was really embarrassed because she didn't know I could swear like that. Later that morning, a doctor came in and explained what had happened.

"So what does it mean, exactly?" I asked.

"Well, you're going to have to take these pills indefinitely."

"But what does it really mean?"

"This is all new," the doctor said. "You could live a normal-length life or you could drop dead any day. We just don't know."

That really pissed me off. I was attached to the pharmaceutical industry now. If society collapsed, I'd go with it. But it reinforced the idea that I shouldn't put things off. I'd already been thinking that I wanted to live a life being creative. But so many people pressure you to put that off or delay it. *Get a degree.* Or: *Get a job first and write poetry later. Travel later.* Now I knew every day was precious. When the doctor said I could drop dead at any time, that was the moment when I made the choice to do the things that I thought were really important first rather than doing anything to suit someone else.

It was the final trigger, the final motivation.

People never know how much time they'll have on this planet, but in my case I could no longer gamble on having any to spare. To have it made that vivid caused me to lie back and think, *What is it I really want to do with this body and mind, right now?*

It made all the decisions so much easier thereafter.

Does this move me towards my dream self, or not?

If it didn't, I didn't need it.

Nobody had the right to make me wait, to contain me. No longer would I just daydream about the things I wanted to do. Those things became the only things I would do. That was the big decision—*boom.*

There's an old Sufi saying: "Live every day as if it's your last, and that's the day you will be judged upon."

That's how I lived from then on.

There would be no Genesis P-Orridge without that death of Neil Andrew Megson.

15.

Through the end of school, I decided to be nice and polite and carry on being the good scholar I'd been. I just continued to hide my unconventional thinking from my family, like you hide thoughts about sex, like you hide thoughts about drugs.

And it wasn't because I didn't like my home life.

I didn't like society.

My parents were so proud that I went to one of the top ten schools in Britain, whereas my father had to leave school at fourteen because his dad was too poor to let him stay at school. And my mother had only been at school until sixteen, even though she was academically brilliant; girls just didn't stay at school back then. And the war came. To them, all their sacrifices were worth it because I was at that prestigious school. That was the pinnacle for them: they'd managed to get me into this privileged place which would open up a nice, upper-middle-class life, and maybe more: stability.

But it was odd, because they also encouraged me to write poetry. They also encouraged me to do my paintings at home even though I wasn't studying art. So there was always this dichotomy, I think. At the same time, I was living out what my father wished he could have been; unwittingly he was ceding me this other way of being. But I don't think it ever crossed his mind that I would take it that seriously. So I left it where it was. It was a convenient balance to me.

At school, I threw myself into art.

Solihull School eliminated art as a subject because they didn't believe it was a real thing—it was only for young kids in the preparatory school. So I was in one of the very last classes where they allowed art class, don't ask me why.

Luckily for me, there were some great teachers. One was an older and conservative-looking man with a beard, a classic sort of English, Francis Bacon beatnik painter who failed miserably as an artist and was angry about it. He'd come into the school the same year as me, in 1964. One day the older man said, "Today, we want you to paint something to do with how you feel about sport, and using green." So we thought about sport and we painted the whole piece of paper black. And he came up and looked at everybody's paintings, and he said, "Well, yes, there are some people who painted rugby matches and so on," and he got to me and looked at me and said, "Now, why is it all black?"

And I said, being totally honest, "I just see it as a dark hole, somewhere I don't want to go."

That was my feeling about sport—it's just an end to a black void. He asked me to stay behind and I went, *Uh-oh, here we go: detention*. I thought I'd get in trouble. Instead, he gave me a key to the art department and said, "If you ever want to come and use the art department and its resources, you can."

Which was doubly good, because I was always trying to escape the bullies—so that meant that on my lunchtime and different breaks I could go into the art department and do things and not get attacked.

I started to make two different artworks. One of them was a painting using expanded polystyrene. It was based on a man in an Arctic research lab sitting by one of those wood stoves with its chimney going off, trying to get warm, and we broke it down into just shapes. Then we made it three-dimensional and added sort of energy lines between different things. He really liked it. Actually, I really liked it, too—I wish it still existed. I gave it to my sister when she got engaged to be married, as a gift.

The other one was also three-dimensional. It was a piece using things we found around the school: gravel from the driveway, bits of broken wood, plaster, a bit of sacking. I wanted it to be kind of an abstract picture, and I wanted to have nails in it. Originally I put in all these new nails, but then realized I want them to be rusty. So I went to the chemistry department, who were really excited to tell me how to make a liquid to turn them rusty.

This resulted in me getting the first-ever school art prize, in June 1968. They basically invented an art prize for me, awarded at the traditional graduation ceremony. Students who had done well would get prizes, and they would go up on the stage—it was a bit like the Oscars. In addition to the invented prize for art, I also got the headmaster's special prize for "initiative" for starting a protest magazine and changing the school rules through petitions. The whole school, which was about eight hundred students plus all their parents, attended. Everybody wore their school uniforms except me. I had on a brown corduroy jacket, a mod shirt, and a thin black tie. And in my pocket, as a matter of principle, I had half an ounce of hash. It was infantile, and yet it made me feel like a rebel.

I remember when I walked into the big assembly hall, people started whispering, "Oh, why is that person not wearing the school uniform? Why isn't anyone doing anything to stop him from coming in?"

There's a room in Solihull School where they hang wooden shields on the walls listing where students from each given year went to university. Somewhere there's a shield that says I went to Hull University. What it doesn't say is that I chose that university because it was far enough away that I wouldn't be obligated to come home on weekends.

I didn't really want to go to university at all, but I calculated that it was the best way to leave home and do the least damage to my relationship with my parents. Yet I worried they'd want me to come home on weekends like my sister did while she was in college. So I got a compass and a map and drew a circle of one hundred miles around where we lived. Anywhere outside of the circle, I'd have an excuse not to come home. And that's how I ended up choosing Hull University, which is in Yorkshire.

I had carried on being the good scholar, being nice and polite through the end of school. No more. Now the real me was going to flourish.

After I'd been accepted to Hull, the mother of a friend of mine invited me to stay over for dinner after an afternoon of creating batik prints on men's shirts in their back garden. At some stage during the meal, she asked me, "What are you going to do now that you're leaving school?"

In my teenage confidence, I believed I had determined the answer to that question in my hospital bed after my medical death the year before.

With shameless, arrogant conviction, I replied, "I am going to take my daydreams *very* seriously."

I sensed awkwardness, the classic shuffling, a cough or two.

Then my friend's mother turned to her son and said, "Tell your friend he is not welcome in this house ever again. I want him to leave right now."

16.

When I went to Hull University in the fall of 1968, I thought I would be studying anthropology. I wanted to learn all about different ethnic cultures and become a wandering William Burroughs in the jungles of South Africa, or South America, or Tibet—I wanted to go to all those places, find out about other people's beliefs and how they lived. But when I arrived at Hull, I found I was officially enrolled to study philosophy, economics, and social administration. I had somehow fucked up my application. To this day, I don't know quite how I did that, but I did.

It was just terrible. I signed up for a sociology class thinking it might include some anthropology, but it didn't. It was all about the structure of the welfare state. Is it right to move populations to different areas against their will in order to maximize economic strength? Stuff like that. At one point during the class, the professor asked us to decide on a subject to do a big essay on. I wanted to do vagrants, tramps, homeless people, and wrote a little proposal; I was into the Kerouac thing, so they were all homeless saints.

At the next class, the professor called out my name and then said, "Do you seriously want to write about these people?"

I explained that yes, I did—I'd met lots of them, they had amazing stories of how they ended up like that, and many of them were really wise. They were all beautiful people with this amazing knowledge of another way of looking at life.

"These people who you want to write about," she said—and I will never forget it—"are the scrapings from the bottom of the dustbin of society."

"Well, that means I am, too, miss," I said. "Because I get on really well with them."

I never went to that class again.

I took philosophy as well, but again, I had no idea what it was going to be like. In my naivety, I'd thought we'd be looking at comparative belief

systems. Instead the language was so convoluted that I just got lost in jargon. It was like being prodded with thorns. I tried to read it and understand it, but I just couldn't find a way in. It was so alien to me. After three weeks, I didn't go back to the philosophy class, either. I just gave up. And economics was just a nightmare. I was so depressed. I couldn't have made a worse choice than philosophy, economics, and social administration.

But I had a parallel existence at the university.

I lived in a hall of residence, Needler Hall, and I had my own little room. You had a little single bed, a little bookcase, a light, and a desk you could write on. The window looked out onto a garden. The atmosphere was very much like Solihull, and things were run a lot like they had been there, too.

The bell would ring when it was time to go get dinner at the refectory, and if you were late walking into the room, they'd all start banging on the tables with their knives and forks, hundreds of them, bang, bang, bang, bang, bang, and shouting something like "Asshole!" or whatever it was then. Nobody would let you sit down anywhere. If there was a gap on a bench, they'd move so you couldn't sit. This would go on for ten or fifteen minutes. And then the professors and staff would threaten you with some kind of ridiculous punishment—though it can't have been anything much, because I never ended up getting any punishment.

One day when they were tormenting me, I jumped up onto the table and did a dance to the rhythm, and never went back for a meal in there again.

That's how you get a reputation for being the crazy one at the hall of residence.

There were about three older students in my residence hall who had long hair. As was the custom in those days, if somebody had long hair, you just knew they were a freak. Amongst others there was Baz Ward, a king hippie, as I used to call him, and the resident psychedelic artist; there was Doug Houston, the drug dealer, and Paul Frou, who ran a magazine called *Mole*.

At some stage I sidled over to them, and they looked at me and my hair, which was growing, and they said, "You got any hash, man?"

And I said, "Yeah, I do, actually."

They went, "Really?"

I said, "Yeah, I do. I brought it with me."

"Can we have some?"

I said, "Sure."

So we went to somebody's room, and we all sat down and we made a big spliff. You'd make it the length of an album cover, using one as a guide, about twelve inches, with a long piece of cardboard as the filter. So all the students that were actually smoking hash were in this room with me, and I was being very generous and let everybody smoke hash, and they all got higher than I did. They started playing music, so I knew that we had a similar sort of approach to music. Because of that generosity in the beginning, when everybody started setting up their networks to get hash brought in, they always gave me free hash because they remembered I'd given everybody stuff when nobody else had any. So I never had to buy hash again. Which wasn't the plan—it just worked out that way—but I was kind of thrilled with that one.

One time, taking hash, I thought I'd left my body for good. Somebody was going to play at the university—I don't remember which band, for reasons that will become clear. There was a street right near the university where just about every house was a student house. They'd all have different bedrooms and share the kitchen and bathroom and living room, that kind of thing. I went to visit Caroline and another girl called Mary East, who were both in the drama department.

We ground up all of our hash and put it into coffee because we were tired and we wanted to wake up just to go to the gig. Then there was a big lump left, so I ate it. Everything was fine, and we hung about, thinking we didn't want to see the opening bands, we'd just go and see the main band. Then, as we walked back across the fields on the university grounds to go to the student union, suddenly it started to come on strong. Really, really strong. And it threw me out of balance. I thought, *I've just got to go the toilet.* I went and sat in this toilet stall, just to try to get my head together, as I would say at the time. Then I got that classic stupid thing where I saw creatures living in the walls and the door of the toilet. And I thought, *Oh shit, I'm going down some really strange, classic bad trip here.* I tried to think it away but it wouldn't go. And then I started to get even more disassociated: I couldn't feel my skin anymore, even when I touched it.

I decided that I needed to go outside and get fresh air. I went outside the student union, where there was a big, wide pathway to the main road. I started to walk along it. I went out of body, so that I was looking down from above. It wasn't nice. It wasn't fun at all. I was thinking, *This really sucks—you're really fucked up, Gen.* I didn't know what to do, I just didn't know what to do. I just kept walking, and it seemed to take forever because I got time dilation. Then I remembered that across the other side of the main road was the medical center.

I thought, *I'm going there to get something to chill me down.* It seemed like it took me about half an hour to cross that road. I seemed to be starting to cross that road while the body below wasn't there. I was coming in and out of the body, not just always above it. There was this strange kind of loop.

I finally got to the medical center and said to the nurse on duty, "Um, I swallowed an awful lot of hashish and I need to calm down." She said, "Oh, we've had several people in here tonight like that. Take some Valium and just relax in this room with the lights down." And that's what I did. I lay in this sort of twilight zone and just drifted out and gradually drifted into a place that was comfortable.

There wasn't much of anything else besides hash, except very occasionally acid, but it was usually gone as soon as it arrived. We used to do Demerol as a substitute, myself and a couple cohorts. We found out that if you drank Demerol, it was an opioid, and you would get trails from your fingers.

It was still pretty new for the majority of Britain. There were still a lot of cops who thought that joss sticks were actually drugs; if they smelled incense, they thought that was hash. People were still really ignorant about what it was, and it was not spreading very quickly up north. London was where the experimentation was going on with lots of things, including drugs. That's why everyone had to go down to London to get stuff and then bring it back.

There was only a very small number of people doing drugs at the university, mainly the hippies who had been at university a few years already. Then there was myself and probably no more than half a dozen first-year students who were actually using drugs. We were always shocked how many people were completely straight: they'd wear suits and ties to class and do their laundry all the time and watch TV in the student room.

In my dorm room I put silver foil on the ceiling so that when I was high, I'd just look up at all the crinkles and strange patterns and stare at it and trip. With the door locked.

I lived on the ground floor and always went in and out through the window so that nobody knew when I was or wasn't there. Nobody knew my business.

Back then, there were cleaners who did up the rooms like in a hotel. When I took up residence in my university quarters, I always locked my door and said I didn't need it cleaned; then I'd go out the window.

One day, I met a cleaner in the hall, and she said, "Can I come in and clean?"

I said, "Okay, I'm here, so you can come in."

She said, "You know what they've told us to do, don't you?"

"What?" I said.

"They've asked us to look at what books people are reading and what pictures they've got on the wall, and if there's any sign of drug paraphernalia," she said. "We're supposed to write it all down and tell them. They're keeping secret files on everyone. And you're one of the ones that they've been really trying to find out about because you keep your door locked."

Once I found that out, I wrote an article about it in a campus magazine—how the school was spying on us—and it became a big scandal.

Eventually I started a magazine, too, called *Worm*. Brainstorming with John Shapeero and a couple of other people, we decided to do a magazine where there were no editors. The editorial structure consisted of a cardboard box in the student union building. Anything that was put in the box marked *Worm* we guaranteed we'd publish, no matter what it was.

The student union, where I collected submissions and handed out copies of *Worm*, had always been run by very conservative and straight public school boys who were trying to keep everything as normal as possible. They hated the fact that drugs, long hair, and psychedelic music had infiltrated the university. All the things that I thought made it totally worth being there, they were totally against. One of these arch right-wing characters who was conservative in every sense of the word decided to stand to be the president of the student union. This would give him the power to decide how to dole

out funds for societies, clubs, and events. If this guy got in, it seemed clear he would close down all the things we freaks found interesting.

So we came up with a strategy to ridicule the whole process by asking as many people as possible to stand for president. We slipped the application form into every copy of *Worm*. Eventually, between sixty and eighty people submitted the forms to become official candidates. Somebody even put a pig in to be president of the student union, copying the Yippies in America. Every candidate had to give a speech in the big hall where concerts took place. A girl with blonde hair—one of the hippie kingpin's girlfriends—took the pig up to give a speech. To make it more interesting, she was naked. The pig tried to escape, and as she was trying to hold on to it, the pig shat all over her. So the speech was the pig grunting and her, naked, covered in pig shit, which we all thought was fantastic.

Around that time, there was a member of Parliament who gave a speech saying the students who have grants to go to university should not have opinions or demonstrate or say there were things wrong with Great Britain, because taxpayers were paying the money for them to study. His famous quote was, "They are just academic thugs, they are not students." A new friend of mine, a math and physics student named Tim Poston, thought that was such a great phrase that he stood for president and used it as his platform—because he was for everything they hated. So he stood as "Academic Thug."

By some strange quirk of electoral mathematics, Academic Thug ended up the winner and became the president of the student union. That gave him the power to give money to our magazine and put on acid tests or whatever he wanted to do.

Also during my first year, the university held a poetry competition which was judged by Philip Larkin and an Irish poet called Richard Murphy who was the visiting poet at the university. They posted a flyer at student union on how to enter, so I submitted a poem. As I recall, it was called "The Possession of Both of Your Mouths" and concerned a one-night stand and the feelings of emptiness afterwards.

I won the competition!

Philip Larkin, who became the poet laureate to Queen Elizabeth II,

awarded me the prize: a copy of *The Armies of the Night* by Norman Mailer. He was interviewed in the *Times* (London) at one point and said I was the most promising new poet in Britain, which was a nice little tag. He and Richard Murphy really encouraged me to become a poet. They asked me to give a talk to the English department about my work as a writer. So in one department I was just disintegrating and couldn't wait to get out—I was the scrapings of the dustbin—while another department wanted me involved. The English department even offered to admit me to the department, but the social studies department refused to let me go—out of spite. Which meant I was doomed; there was no way I saw to get out of my degree.

My first direct exposure to psychedelic bands came at the university. There was a kind of sleazy character who booked music at the student union. The main circuit for the bands in Britain at the time was university student unions; touring them was a band's bread and butter. At Hull I saw Family, Marc Bolan, Pentangle, and the Nice with Keith Emerson, who later joined Emerson, Lake & Palmer. The Nice were great live. Emerson had a Hammond organ, and I used to wonder how anyone could make one of those look sexy. But he would push it around and jump on it and stamp on it, stick knives in it to jam notes down and stuff; he went crazy. And because they played in our refectory, there was no stage, so everyone stood around the bands, right up close. It was really brilliant.

I knew about psychedelic light shows because I'd seen photos of the San Francisco scene, and my copy of *Country Joe and the Fish* had photos of their light show on it. The Velvet Underground used light shows, too. At Hull, I saw them for the first time. Whenever we went to clubs—as opposed to the student union—to see bands, there were always light shows. One called the UFO Club was where I first witnessed a light show with the oil slides and all that stuff.

Mark Boyle did the first light shows at the UFO Club. He'd first gained notoriety for doing a *Fluxus*-type event in Scotland, at the Edinburgh Festival, which consisted of a naked woman walking along the parapet of a building, high up, while somebody played bagpipes. The performance made national news: *How could this be art?*

Needless to say, we became good friends.

For big events, Mark sometimes called in additional helpers, and I was on call, extra hands when needed—whether it was a political demonstration, a light show, or whatever it might be. At some stage, I was added to the light show crew for a Pink Floyd concert because there were to be two light shows running simultaneously. Before the concert we all had hash coffee, and we ate a lump of hash each, and we all smoked great big joints of hash, and then we got over there and did the light show.

Pink Floyd's song structures—the stuff Syd Barrett was writing—were different from all other bands'. The songs seemed to me to have a loop structure. For example, there's a recording off the first album that's five minutes, and there's another version recorded in the studio that's twenty-odd minutes long. It's exactly the same song, just stretched out. So they could keep it down to five minutes or they could go on as long as they wanted. That's what I mean by loops: they could set up a basic riff or loop and then could go anywhere. They were the main proponents of that in the beginning.

Obviously people started to copy it, but they were definitely the first in my view. It sets them apart from the Beatles, the Stones, the Who; Syd was doing a totally different thing.

It was like discovering jazz.

It was a real earth-shaker.

Pink Floyd had been influenced at that point by AMM and the Scratch Orchestra, which were a couple of the groups in London based around *International Times* that did lots of improvised, abstract stuff. Apparently, Syd had gotten intrigued and influenced by that. That's when he started using steel ball bearings and running them down the strings of his guitar, and using more echoes and effects.

Basically, these instruments made noises, that's all, and you could do whatever you wanted with it, and you could bring in anything else you wanted, and it could still have some kind of sense and meaning. They were using sound effects like birds and insects and boats and so on; it was like being on Grantchester Meadows, where they all used to smoke pot in Cambridge. They were the first people really starting to integrate that. And not just for an effect, but actually as a counterpoint to the meaning. Hearing

Pink Floyd was another moment when things just opened up again. It was a huge disappointment when, later, they got boring.

The band did an incredible improvised piece the night I was working as part of the light crew.

Most bands would do two sets, and usually in between was the drum solo. This particular concert, Pink Floyd all went off and then they came back on quickly, wearing old workmen's coats. They had hammers and saws and nails and bits of wood. They started to build a couple of stools and a tiny little table, and they had a little camping stove with a kettle on it. As they were making the furniture, they must have had contact mics on the floor, because you suddenly realized that they were creating rhythms as they worked. And when they finished, they all sat down on the little stools, turned on a transistor radio, and drank cups of tea off the stove.

That performance was profoundly influential on me.

It was amazing: the rhythms were great, and I was just in awe that they could come on and do that, and have no interest in playing a song. So that was a real breakthrough for me. Seeing and hearing it was stunning, especially when high as a kite.

Oh, my God!

We can go anywhere!

17.

Most of my time I spent with the freaks, the older students who were into hash, psychedelics, and underground culture. I joined in a lot of protests against the university administration. I carried around my violin and a little diary. I still did lots of drawing and painting.

Unfortunately, the arts scene surrounding the university was not as I'd imagined. There were people deciding if they should sleep with a gallery owner—whether that would get them a show. Students tried to impress their professors by giving them blow jobs. I thought, *Hang on a minute, is it really just about sexual favors and money for the people who are already elite and powerful?*

It disappointed me that the world still looked suspiciously like everything I'd hated at Solihull. But near the end of the spring semester in 1969, a performance art collective called the Exploding Galaxy performed at Hull University—and it proved a turning point.

I'd read about the Exploding Galaxy in *International Times*. It had been started by David Medalla, who was a Filipino artist known internationally and part of the kinetic art movement. He made installations of what were called "Bubble Machines," which were basically white wooden columns with holes on top. Inside them was a machine that created loads and loads of soap bubbles—foam. Foam would come out the top and spread and flow down the sides, change shape, and be different amounts of volume. He got quite well-known—he was on TV quite a few times—and his work caught the popular imagination. He'd initiated the Exploding Galaxy in 1967 as a collective of multimedia artists and was significant in the late '60s counterculture movement. He was really into non-static art—art that would have a visible process and made things happen. He ended up wanting to remove the art object and make the artist the art, hence the Exploding Galaxy, where the combination of artists, writers, filmmakers, and dancers

combined was the work, and it existed because of all of them collaborating and being in one place.

One of my friends at Hull, John Krivine, knew a guy living in London who seemed to just travel around Britain, hanging out at universities and setting up things for a while, and then vanishing again. He had come across the Exploding Galaxy in London, at the Arts Lab in Drury Lane. This friend of John's had turned up in Hull, and while he was there hanging out, we told him they should come up and do an event. So he arranged for the Exploding Galaxy to get some money from the student union and come perform towards the end of the spring semester in 1969.

Meanwhile, there'd been a split in the Exploding Galaxy. They were living in two houses on Balls Pond Road in the Islington section of London, and they got raided by the police. The police didn't find anything, but they planted drugs in the buildings and prosecuted them. They did their own book about this called *Planted*, showing what happened. In that moment of chaos, David heard about this woman living in Paris, Sylvina Boissonnas, who had inherited a massive oil fortune from her parents. She'd become a true-blood hippie: she didn't want to have money—she considered it a hang-up. So she started to give it away. She announced that people could come to see her in her apartment in Paris, and she would listen to what their projects were, and may or may not give them money to do them. So David went there with some of the Exploding Galaxy to get money to go to India and study dance in Calcutta. Some people felt that that wasn't multimedia and that that was betraying the heart and the essence of the Exploding Galaxy. David and some of the others went to India with the money. The rest fragmented in London until there were only about three or four of them still living together in Islington. Those are the ones who came to Hull.

When they got to Hull, because they were short of people, they asked around through that guy and Krivine, "Who do you think there is who might want to be part of our improvised, crazy event?" Apparently everybody said "Genesis," so I got dragged into it. I have no memory at all of what I did with them in Hull, but before they left, they gave me their phone number in Islington and said, "If you're ever in London and you want to go and hang out, here's the number."

The Exploding Galaxy was the closest thing I could find to my idealized concept of Warhol's Factory, though the Factory had far more sophistication attached to it. The Galaxy, by contrast, was basically gutter punks with credibility because of David Medalla. But there was a lot about it that was closer to what I wanted: the changing identity and wearing of different clothes, the changing your name if you needed to, and changing your appearance. The idea of continual change and analysis—that was there.

It was something I really craved.

Soon after, I resolved to quit school—disappointingly old-fashioned Hull University that was still unquestioning about male-female structures.

When it got near the end of the school year, I met a guy named Tom who ended up writing a book about how ineffectual the exam system was, how the system should be continual assessment instead because some people are just bad at exams. They just get freaky and nervous and can't do it, but they're actually really brilliant. So grades should just be based on the quality of your work for the whole period of time. This made a lot of sense to me. Tom and I became friends, and when I told him I was planning to leave the university at the end of the first year, he said, "You gotta be careful."

"Why?"

"If you just walk away, they can make you pay everything back that they've spent on you so far," he said. "But if you fail the exams badly, they just chuck you out. So you have to fail badly."

"Oh, okay."

So we made an agreement together—along with several other people—to take part in a national campaign of students at the time to change to continual assessment. In the exams at the end of the year, you weren't allowed to leave for thirty minutes, in case somebody was late arriving and you gave them questions; you had to sit there for half an hour whether you did the exam or not. The idea was that we would sit for the mandatory half an hour and then we would all stand up and make a speech about the failures of the education system, and we would be taken out.

So that's what we did—but only me and Tom. The others all chickened out and took their exams.

When I did the exam for philosophy, which I hadn't attended, I just wrote, "Happiness is oneness with the void." That was it; that was my entire essay.

For social studies, the exam question was about the education system, and I just drew a big boot crushing a young person—then I had half an hour to kill. I remember feeling so liberated. I failed terribly! Terribly! So I didn't have to pay anything back.

Only when I failed out of university did my father bring up for the first time the various opportunities he had passed up. He'd had a chance to be a full-time professional actor. But it would've meant moving to London, where a woman who was one of his mentors had started a theatre in the East End that was quite famous. But, as he now told me, he had chosen not to take this or other things that came up because he wanted to focus on keeping me and my sister safe and getting us the best education we could get. It's interesting, though, how his generation were taught to say nothing. Just swallow and ignore it.

"We've done all this for eighteen years, gotten you the best education, gotten you tutors to help you pass exams. We've done everything to make your life as productive and positive as we can, and you turn around and drop out."

I can see why that would be really awful from their perspective, and it definitely caused a rift. My father never rang me up from then until 1989. So it was a big rift.

But I had to do it.

That July of 1969, I hitched down to London with John Shapeero to see the Rolling Stones play in Hyde Park, the first show after the murder of Brian Jones. They were fucking terrible. It's true what they say in the documentary: there were about half a million people at the beginning. But what they don't tell you is that something like four hundred thousand had left before the end of their set. When we first got there, you couldn't get anywhere near the stage; it was this little, tiny thing in the distance. By the end, you could walk right up to the front and touch the stage—there were that few people. Fucking terrible.

That's when I met Buttons from the Hells Angels. He had started the first officially chartered Hells Angels chapter in Britain, with a license from

America. The Angels were asked to do security, because the Stones were still into using them as security at that point.

After the Hyde Park concert I had nowhere to sleep, so I fished out the little piece of paper I'd been given by the Exploding Galaxy and rang them up. They told me how to get there by Tube. Then I walked up Islington Park Street and found the house, covered with scaffolding, and knocked on the door.

A man and his wife answered. They were renovating the house, and even though they seemed pretty straight, they allowed remnants of the Exploding Galaxy to live in the place. It was very much a camping out, as most of the walls had been knocked down. I had a sleeping bag, my diary, my violin, and the clothes I was wearing. The first rule was all your clothes had to be given in and put in a communal box; in the morning, the first person up got first choice of what to wear.

So I surrendered all my clothes into the large wooden tea chest, along with everyone else's.

And that was where everything really began in terms of setting myself on the path to being a wandering bohemian artist.

18.

Upon waking each day, you went to the chest and selected an outfit to wear. As it was first-come-first-clothes, if you were the last one up, you got what was left, regardless of whether it was "gender appropriate," attractive or ugly, or your size. We all learned that you could use what you wore as a language, as a creative act that spoke of your mood, your improvisational abilities, your ability to subsume your personal self-image to a random outfit, and, most importantly, that every "look" was a costume and spoke for you as a being.

What we wear, no matter how unassuming it may seem, can be a story you tell visually to the world around you.

I learned that I could and must control my own life's narrative.

As Lady Jaye put it much later, "There is no reason to run out of new people to be every day."

There were only a few other live-in Galaxy members at the time. There was Gerald Fitzgerald, who went by "Fitz," an Irish painter and a real fanatic about mixed-media improvisation and breaking down social norms. There was Fitz's girlfriend, who was called Paella Mahoupe. Don't ask me why. That was Fitz's name for her; her real name was something ordinary. Then there was another young guy called James, who very quickly became "Lemon." Along with me, that was basically it for a while. Hermine Demoriane was part of the gang but lived elsewhere with her husband. She became well-known for tightrope walking and doing a dance of the seven veils on a tightrope—except she never got naked! Derek Jarman was also a loose affiliate; at the time he was primarily painting, doing very minimal, slightly surrealistic paintings, and only just starting to dabble in film. A lot of the peripheral people or people who were involved but living elsewhere after it fragmented would come round, so there were quite a lot of visitors, but only four of us lived there all the time.

All the food they ate was vegetarian and organic, and they ate brown rice—all of which was new to me, having come from the suburbs of Birmingham. The first time I ever had whole wheat bread was during the same period, at the Arts Lab. The Exploding Galaxy house was where I learned to make risotto by watching the others. And I also started to make "density bread," which was unleavened bread made from whole wheat flour, water, and salt. When still hot from the oven, with a bit of butter and honey, it was totally delicious. Once it got cold it would get so hard you'd have to saw it.

I started to be absorbed into that way of life. Amongst the things they did to earn money was making toys. We used to go out "scrudging," which was what they called dumpster-diving and scrounging things that were free in the street. In a nearby garment district we recovered piles and piles of the discarded hangers. We would take loads of them back to the house and create these articulated spheres that you could turn into all different shapes. A lot of my time during the days was spent making these hanger toys. We would stain them with different colors so they'd be green, red, blue, yellow. We'd try to sell them to people who came by. We'd let people play with them, and we used them in performances.

Fitz was more or less in charge of the remaining faction, and he was convinced that he would get a patent on that toy in particular and make lots of money selling them to children. It might well have happened if he'd known how to do it, but he was useless at doing official documents. There's a picture of me, the only photograph I have of me and Fitz, doing a spontaneous performance with them on the green in Islington, arranging them to look like some kind of rocket—because of the recent moon landing. They were quite versatile.

Making them took up a lot of time, though. It was really a slow process to hammer and a drill the hangers, and it used to drive me up a wall.

Another job was making rain shells, which were essentially tubes of polyethylene. Somewhere Fitz had found a very bendable but strong kind of plastic with characteristics somewhere between a cord and a wire. We sewed these cords to the polyethylene tube—which took forever, because you had to sew it with a special device that transferred heat without melting

the polyethylene, and you had to go all the way around this fucking tube with it just right and then put this cord in as the spine.

When they were done, they were brilliant, because if you wanted to go to sleep anywhere, you just threw it out, crawled into the tube with your sleeping bag, tipped down both the ends, and you were completely protected from the weather and heated by your own body. And the tubes collapsed down into about a foot round and weighed only a few ounces. The idea was to sell them to people who were on the hippie trail so they could always have shelter and be able to sleep anywhere. We did sell quite a lot to hippies who came through. People would turn up and Fitz would go into his sales pitch. I kept one for years and used it all the time. If I was hitchhiking, I could just walk into a field and throw it down and climb in and sleep. It was a really brilliant invention. They looked great, too—like some weird larvae lying around in the field, semi-transparent things with shapes in them that moved every now and then. Little chrysalises.

Living at the Galaxy house meant constant discussions. Fitz had a big thing about how I fiddled with my fingers when I was thinking. I still do it, but it used to drive him mad. Every time he saw me start to do this, he'd say, "Why are you doing that? That's wasted energy! You could use that energy for something creative; you don't have to use it on your fucking fingers, you know?"

And I was, like, "I'm sorry, I'm sorry, I'm sorry! Yeah, you're right! You're right!"

We played a game called the Stop Game, which I later decided probably had been adapted from the Armenian mystic George Gurdjieff. You would say "Stop" to somebody, and then you could just harass them or interrogate them: "Your hair's the same as it was yesterday. Why is it the same as it was yesterday? Have you got no imagination? Why do you want to have it the same? Are you really so lazy that you can't think of something else?"

It went on and on: "Why are you wearing the same outfit that you found in the box yesterday? Why aren't you wearing shoes? Do you need shoes? Have you got shoes? Why don't you make your own shoes?"

Everything and anything could be challenged, constantly. Everyone was doing this continuously to each other.

Lemon, who arrived after me, had been part of an arts lab somewhere south of London. He came from a quite well-off family, and at some point we all hitchhiked to his family's huge, beautiful farm. I'd never had milk straight from a cow before, still warm. It was delicious. Lemon had turned up at the Galaxy because he'd read about it in *International Times*. The questioning thing sent him catatonic. One day we went upstairs and he was in the part of the house that belonged to the owners, sitting in a corner of the room, rocking and staring at the floor, unable to speak. Luckily, we had a phone number for his family. They had to come and get him and take him away because he was gone. The Stop Game broke him.

The whole atmosphere was ruthless. I flourished in it, but not everybody did. I thought it was great, and it was exactly what I wanted: to be challenged about everything. I wanted to question everything. Whether you're talking about social standards, morality, or anything else. Does anything have to exist just because it did before? Is it there by choice? Is it there for a reason? Who does it serve?

The people who took all this seriously were prepared to go as deep as possible. It felt like an amazing moment when you had the freedom to think, *What do I want to be?* I wanted to be as constantly creative and independent of other people's pressures as possible. So living someplace where it was about stripping the self to the point that allowed you to build the you that you really wanted to be was exactly what I wanted. It was like boot camp. You couldn't sleep in the same place two nights running. If you tried to, you'd get harassed. You could be eating and they'd say, "Why are you using a knife and fork?"

Round the corner from the house on Islington Park Street lived a guy who played viola and violin, and who we discovered was a member of Third Ear Band. They'd done an album called *Alchemy*, which John Peel had even played on; the record was basically tablas and a couple of other little drums and two violins playing very long, mantra-like pieces which were really nice. It was amazing music. Their next album ended up being the music for Roman Polanski's film of *Macbeth*. I used to go over to his place and spend the afternoons jamming with him.

The Exploding Galaxy changed its name to Transmedia Exploration around the time that I arrived. One of the big debates I had with other

members had to do with the new name: I never understood why they called it Transmedia, which was ostensibly meant to be about every possible form of creativity. Because there was never anything musical or even rhythmical—no drumming, no music, no chanting, no nothing. I told them it didn't make sense. If they were doing all this body movement and making these environments and improvising in all these other media, why wouldn't it include music, too? It didn't have to be ordinary music. You didn't even have to be able to play an instrument. But if it was truly *transmedia*, why was there no sound? Why was there no music? It became a major bone of contention.

Some members of Exploding Galaxy had left to form Stone Monkey, a mime troupe that danced with the Incredible String Band for a while. I had been listening to the Incredible String Band since school. The surrealism and FREEDOM of the lyrics were what engaged me: combining absurdity and spirituality. I feel the Incredible String Band were probably the lyrical geniuses of the 1960s and beyond, far more than the Beatles or Dylan, who became predictable and never really extended the form of the song as an open system in the same way. Once you get the Incredible String Band, all other music falls into place. They were the true troubadours of the last two centuries. SUBLIME! Here I am duty-bound to confess I have at least twenty Incredible String Band albums. Never, ever, on any day, in any mood, do I feel less than joyous to hear their voices and humor, their grand metaphysics and acid-drenched morality plays. "A Very Cellular Song" from *The Hangman's Beautiful Daughter* album, from 1968, is probably my favorite song of all time. Full of whimsy, weirdness, and surreal lyrics that insist they are profound when you know they are more likely just found. When it gets to a sequence which describes the feelings of an amoeba, you know that you are in the presence of genius.

Fitz, on the other hand, had no grounding in anything to do with sound or music and had no sense of rhythm. God knows what his sex was like. He was trapped in this little, tiny fine-art loop where he thought kinetic art as a concept made everything totally new and incredibly vibrant and inevitably would create change in the wider world—none of which was true.

In the end, it was one of the factors that led to my break with the Exploding Galaxy. When I eventually left, I was yelling something along

the lines of "Well, if you're not going to have fucking music, how can you have all the different media?"

Though the actual split came because of a rather more mundane disagreement. Fitz's girlfriend, Paella, came home one day wearing a pair of really beautiful, bottle-green Victorian-style ankle boots that looked brand-new. So of course I went, "Stop! Where did those come from?"

"Why?"

"Just tell me where they came from. Where'd you find those shoes?"

"I'm not going to tell you."

"But you have to tell me . . ."

It went on like that until eventually she admitted that Fitz had given her some money to go buy them for herself for her birthday.

"But you're not allowed to do that!" I said.

It was house policy to pool all our money in a common pot. "You can't use money for yourself! You have to get it green-lit from everybody first. That's wrong!"

And then she got really upset and went off and complained to Fitz that I was being mean. He came and tried to come up with a reason I should shut up.

Not long afterwards, I noticed that Fitz and Paella had moved in together into one of the bedrooms upstairs and were sleeping there every night—on a bed! I went up there and said, "What the fuck is going on?! You're not supposed to be in the same room every night! You're not really meant to be on a bed at all! Why are you? Stop! What the fuck is going on? This isn't what we had all agreed. Why are you doing that? You're destroying the whole point!"

Fitz blustered and got really angry. He called a meeting where the people who owned the house and the people who were there all agreed that I was being disruptive to the whole project and I should not be spoken to ever again. Or fed. Or anything. So I was suddenly an exile inside the house, and they wouldn't give me food, they wouldn't give me money, they wouldn't speak to me. I was a nonperson.

That was when I decided I would become a nomadic member. I took my sleeping bag and diary and violin and gradually hitched back up

north—though not before assembling an application for them to get grants from the local arts council.

It seemed like I was in Exploding Galaxy for a lot longer than I was—because it was just so intense. But in terms of linear time, it was only four or five months, because I was back home before the end of 1969.

Even so, the Exploding Galaxy is one of the two things—along with cut-ups—that really solidified my direction to this day. The stripping down of the personality, of any habits, of any loops, of any laziness in terms of how you relate to things or respond to things or analyze things. Constant devotion to change and to analyze one's own behaviors and character traits and adjust them in great detail towards some idealized idea of what you want to become.

We still think about that time. In fact, we've been thinking about it ever since.

19.

My parents had moved once again, this time to Shrewsbury, where my father had opened a business of his own. The company he had worked for did everything from supplying all the towels in public toilets to painting every phone box in Britain to cleaning the insides of chimneys in power stations—you name it, they did it. He was an area manager, so he had several towns that he was responsible for, and Shrewsbury was being closed because they said it wasn't profitable. He insisted it was:

"You're just not running the company right."

So he quit to take over that business and prove his point, started again from scratch. And he did indeed make it very profitable, eventually selling it back to them in the end.

I knew he needed help, so when I left the Exploding Galaxy, I hitch-hiked towards Shrewsbury, stopping in Bristol, Cheltenham, Bath, going wherever, hanging out with people with long hair.

Eventually I got back to Shrewsbury, where I helped out for a few weeks, typing up all the invoices and estimates for jobs. During downtime, I'd go to the church graveyard and play violin.

One afternoon my father said, "Do you want to go for a drive to Wales?"

Shrewsbury's right on the border of Wales, right on the river Severn. There's a castle built to keep the Welsh from invading England.

While in the company car, with my dad driving, I leaned my head on the window. I closed my eyes. Suddenly I was thinking about molecules and atoms, thinking about all the gaps between the particles that made them up—meaning, theoretically, you should be able to pass through anything, because most of it is just empty space. And while I was thinking that, it became a psychedelic vision, a trip, where I was actually outside the car, flying through the hedge, and it wasn't touching me. I flew through birds

in the hedge—actually experiencing the spaces between particles. I started to hear voices and words and phrases and see images that were clearly extrapolated from what I'd been doing in London. I realized only very recently it was a flicker experience, like Brion Gysin described having on a bus in France. It had never crossed my mind, for all these years, that I'd had a flicker experience like Brion.

But that vision changed everything.

When we got home, I started writing everything down before I forgot it. Most people don't realize "COUM" stands for something. It stands for "Cosmic Organicism of the Universal Molecular." Which basically means that everything is particles and everything is part of everything else; there's no separation between what makes everything. We're all space and we're all dust. But I thought, *Oh, God, that sounds so hippy-dippy.*

That's why I didn't tell people what "COUM" stood for. Because it would sound corny.

Though to me it was profound.

So going forward, I insisted "COUM" didn't mean anything.

My vision created a spiritual sensation. It felt as if I'd found my life's job—to explore this idea and try to find ways to add it to the culture in a positive way. It was messianic, a true revelation. I decided I needed to get started right away, so I hitchhiked back to Hull to see friends there and proselytize about what I'd seen and heard in my vision.

Before I left Shrewsbury, I got a postcard printed, which was like a pillar with a sphere on top. The sphere was made up just of the letters *C-O-U-M*, and the sphere said "cosmosis" over and over and over. The word "cosmosis" denoted the equivalent of osmosis, only between people, the transfer of positive creative energy from one human being to another. This was what I ended up calling Cosey when I met her not long afterwards: Cosmosis.

Upon returning to Hull, I first stayed with Doug Houston, the local hash and acid dealer. He let me crash under his kitchen table.

Doug had a roommate called Geoff Pettifer, who was very tall and gangly, wore big, thick glasses, and truly believed himself a beatnik poet. Geoff was really good fun until he got drunk, at which point he got terribly

aggressive. One particular evening they came back late, and I was already asleep on the floor beneath the kitchen table. Geoff turned on all the lights, making lots of noise and rambling and yelling.

I said, "Shut up, Geoff."

"Oh, you're under there, are you?"

"Yeah, I'm under here."

"Well, I've got news for you," he said.

"What is it?"

"Your name isn't just Genesis."

"Oh? What is it, Geoff?"

"It's Genesis P-Orridge. And the *P* stands for 'willow.'"

He was so aggressive that I said, "Okay, Geoff, yep. I'm Genesis P-Orridge."

When he was sober again the next day, he claimed the name was the result of his only ever seeing me eat porridge. And it's true: that was my staple diet then. I would buy a big bag of porridge and keep myself from being hungry for a week or so. I used to make porridge the normal way, but I'd also make porridge buns, porridge bread, porridge crisps. I'd do anything I could think of to change it a bit, but that's what I lived on. I never found out how "willow" came into it. Because he was so drunk, Geoff couldn't remember the backstory.

So that's the official, original surname. It would be pronounced Genesis Willow-Orridge, even though it's P-Orridge. The hyphen was there because in England double-barreled names, as they called them—hyphenated names—were associated with aristocrats and the rich and powerful. When two blue-blooded lineages joined, they often kept both names by use of a hyphen.

Something about Geoff's version of my name tickled me.

And I enjoyed the looks of bafflement it elicited.

I mentioned the new name to another friend, and he sent me a little note saying, "I know what the derivation is of your name. It's actually originally from the duke Dulage in Normandy—which means 'lord of the tempests,' but it got corrupted by the English, who don't speak French very well, and became 'P-Orridge.'"

So it built this whole sort of life of its own. People threw ideas into the pot, and there came a point when I decided, *Why the hell not be Genesis P-Orridge? I feel comfortable in that character. That's the one I'll wear.*

So, God bless Geoff.

I adapted it and adopted it straightaway. I felt more complete. And now that I felt complete, the things that I then manifested—including performances and music, or whatever—seemed to have more purity. Because I was trying to build a completely new world—perceptually, at least. Seize the means of perception and change reality.

I'd already decided that Genesis was an artwork.

Why can't there be living beings that are artworks?

It was conceptualized to go beyond the whole Factory thing, the superstars. I thought I'd like to be a hyper-real character and see what happened if you consciously injected a new being or a new creation—a human—into the cultural mix. What would happen? The process was originally meant to be observed by Neil, but it didn't work out that way, because it took over and Neil ceased to exist.

We can't think like Neil at all.

We've tried.

But he's gone.

20.

I started playing in folk clubs and pubs around Hull together with John Shapeero, who had been one of my really good friends when I was still at university. We stayed up nights talking. I ranted that life had to be a constantly created process. That nothing was fixed. That there were no rules and there was nothing that had to be the same as it had been before. Everything was up for change, and should be. And he just took to it like a duck to water. John had worked on our magazine, *Worm*, so it was natural.

Soon enough I moved in with John, who was living with another John: John Krivine. It was a pretty minimal flat, just two bedrooms and a grotty kitchen, a student-type thing.

John Shapeero was my first full-on convert to this hypermedia extravaganza called COUM—the idea that everything is everything, that playing music, and making art, and dressing, and writing can all be changed. He got a violin, so we started to play violin together, and we also had a couple of tablas and African drums. And then we thought, *Why don't we do that in public?* So we'd go to different folk clubs and pubs, and we'd go around and we'd say, "Can we come and play? We're called COUM."

There were still pubs where leftovers from the folk revolution would sing sea shanties and fake Bob Dylan songs. We would get booked to do basically a kind of rip-off of the Third Ear Band, with me on violin and John on tablas, and sometimes on another violin. It was just him and me being weird. John and I would sit and play for half an hour—both of us on violin, or me on violin and him on tablas—and read poetry at the same time. In the beginning it was primarily music and poetry—the two things that had been missing from the Exploding Galaxy experience, basically. Kerouac had given me an awareness of the music within words and experiences of all kinds with his insistent bebop rhythms and references. And much to our surprise, people quite liked it. You know, it was very simple, but it worked.

Sometimes we'd get other people to come, and it just grew. Slowly but exponentially.

Next I learned how to play my violin through amps by using wah-wahs, voice boxes, and Echoplexes from borrowing them from other bands—real bands. We'd play my violin through that, and we started being invited to do solos with other bands. Most bands did a long jam at the end of each set, and they'd invite me to just play my violin over it to add an extra layer. So I would add in a weird ten- or fifteen-minute violin solo through the effects pedals. I did that quite often.

In November of 1969, I was invited to help with an event at the university. One of the main king hippies had gone to Morocco and got busted on the way back through Spain, and he was in jail. He was the first person anyone knew who actually got busted. He'd had, I think, a kilo of hash, so it was serious. The people in the Spanish prison said, "The only way you're getting out of here, mate, is if you pay us." So we were raising money for him. We felt obliged to help.

For the benefit, we organized an acid test—as far as we knew what they were like—in the university student union, in the big hall. We didn't really know exactly what they looked like when Ken Kesey did them, but we imagined. Everybody who had an amplifier brought their amps, and anybody who had instruments brought them, and they plugged into the different amps. Anyone who wanted to could sing, or play music, or not. There were tin baths full of Jell-O to sit in when you were tripping, light shows, projecting slides and films, and old movies, lots of polyethylene, a DJ—just a general attempt at a sensory overload. Of course, everybody got a free tab of acid when they went in. I can't remember what the ticket price was, but it wasn't much, five pounds or less.

Before the party, I'd gone over to student housing, and the people in the house had made hash brownies. We all ate the hash brownies. Then we had some hash coffee, where they ground it into the coffee. I was having an out-of-body experience, it was so strong. On the way back to the student union to the acid test, I saw this massive branch that had blown off a tree—it was like a twenty-foot-long, huge branch—and somehow started dragging this to the acid test, thinking, *This'll help decorate the place.* I dragged this

massive branch all through the university grounds, and the buildings, into the student union, and then we stopped for a moment to take a breather. I looked up, and standing against a wall was this girl who was the epitome of a flower child. Yellow tights, purple silk miniskirt, big sleeves, soft satins, velvets and lots of colors, straight brown hair—just like a minstrel, just as you'd imagine the Incredible String Band looking, the classic look of the time.

Wow! I wonder who that is!

As I stared at her, in my head I thought, *That's the girl you're supposed to meet. That's Cosmosis.*

During my visions, there was the word "Cosmosis," which we took to be the name of the person we would meet eventually who would be the perfect partner in everything: creation, love, sex, ideas, and so on. In the aftermath of the vision, one of my great weaknesses was assuming everybody I met was Cosmosis.

Cosey told me, from the other side of this—she was already tripping—she looked up and saw this crazy man dragging a huge branch, and when I stared at her with big, big eyes, the elastic in her panties snapped and they fell down. Not all the way, but enough that she noticed. And she thought, *Who's that? Who can do that? Who's this weird magician person with the big tree branch?* She took that as some kind of signal that there was a connection. Then we both went in and forgot all about each other for the rest of the party.

A few days later, I remembered this girl. Of course, I had no idea who she was or what her name was, but I couldn't get her out of my head. So I started to ask people if they'd seen this girl. "Do you remember the girl that was dressed in all that velvet?"

Of course, lots of girls were, so that didn't help that much.

"She had long, straight hair. Yeah, yeah . . ."

They were. like, "Long, straight hair? No idea."

So I just kept asking people if anyone knew who it might be. Because I didn't have her name, I kept saying, "Cosmosis. Have you seen Cosmosis?"

Everyone went, "What's Cosmosis?"

I went, "It's the positive transfer of energy from one human being to another," in my fanatical way, and I said to everybody, "If you see her, and you think it's her, could you tell me?"

A few weeks went by, and I was at some dance or event, just to see music or to hang out with friends, when we saw her again, on the other side of the room with these other people you could tell were townies. In that era, students would look down on them for not being intelligent enough to go to university, and townies looked down on students as being privileged snobs. There was definitely tension of that kind. Even in the Pink Floyd books, you hear about that—the townies and the Floyds, the students. Townies couldn't come to a lot of things at the university because you had to have a student card. So unless they knew a student that had a card and they could come in as a guest, they couldn't go to a lot of the concerts. There wasn't much interaction between the two groups at all. What became the leveler was drugs, of course. It broke down because of everyone wanting to score drugs from the same people—meeting each other at different drug spots or different houses where drugs were—and it spread out that way.

It turned out Cosey grew up on Bilton Grange, which was this large council estate outside Hull. Her father was a fireman. Her mother was a housewife. She'd left school at age sixteen and become a lab technician. That was her job. She wore a white lab coat and worked at the local secondary modern school. If they were going to have a science class and do an experiment, she would put one Bunsen burner on each desk, and one dead frog to be cut apart. Just lay everything out and then clean it away afterwards. Not the most exciting job in the world. Cosey hung out with the musicians, the bands. Mick Ronson used to mow the lawns and the grass around the council estate. In those days he was still in the Rats, with Woody Woodmansey; only later did he become one of the Spiders from Mars. There was another band called Nothingeverhappens, who had a singer called Snips, who later sang with Chris Spedding and then Baker Gurvitz Army, Ginger Baker and the Gurvitz twins. Snips ended up doing jingles for adverts after that. His real name was Stephen W. Parsons, hence "Parsnips," then "Snips." John Bentley was the bass player; he went on to join Squeeze later. So she hung out with those people who were with her at this dance.

I said to Sam, "That's her. That's that girl I was telling you about the other week."

And he said, "Why don't you go and speak to her?"

I went, "Oh no, no, no. I can't do that."

"Should I go and talk to her?"

"I don't know."

So he said, "I'm gonna go and speak to her."

So he went off, and he apparently went up to her and said, "Hey, Cosmosis," and she turned around. Later she told me she was thinking, *Why am I turning around? What does that word mean? Who's that?* So it could have just been pure curiosity, but she was puzzled.

Sam said, "Genesis wants to meet you. He really likes you." Just classic crap, youth club boasts. But nothing else happened that night. Sam told me, "I told her that you liked her."

"What do you mean? She doesn't know who I am."

He went, "Oh, I'm sorry."

"Did you get any contact info?"

"No, I forgot."

So all I knew was that he told her that this person called Genesis liked her.

After the dance, I don't know how many nights after, there was a knock at the door of the flat. Nobody else was in that night, for whatever reason, so I went to the door and opened it, and there was Cosmosis. And she said, "I hope you don't mind me coming over, but Sam told me where you lived, and I . . . I just felt this tremendous urge to come and see you. I don't know why. I just kept thinking, 'I've got to go and see Genesis.'"

She'd gotten on a bus and come from miles away, at least from where she was in the council housing estate.

"Well, I'm glad you're here. Come in, Cosmosis."

She came in and I closed the front door, and we immediately started kissing like crazy, and then made love instantly. Just like that, without knowing our real names. Fast. Like in those Hollywood movies, where they come in and you're both just tearing at each other—it was like that.

After Cosmosis turned up, we saw each other a few times. God knows how we used to stay in touch, because there were hardly any phones around then, and at the same time I moved: John Krivine got the lease on an old Georgian fruit warehouse. The place was down by the pier where the ferry

went across to Grimbsy and Lincolnshire, one of the last of the steam ferries with wheels—a beautiful old ship.

The building had only an outhouse, no bathroom.

We dubbed the place the Ho Ho Funhouse.

The reason John Krivine was able to find the space was because he was rich, though we didn't know that at the time. He always made it look like he'd just pulled a miracle of some kind with no money. A few years later I was reading a magazine and ran across an article: "The Three Most Eligible Bachelors in Britain." Number one was Prince Charles. I turned over the page, and number two was John Krivine. Turned out his family owned most of Westminster. Massively rich. I thought, *That bastard used to scrounge money for a fucking cup of tea when I had nothing*. Very strange. I never totally understood how he could have such a split in his way of socializing. John actually lived at the Funhouse very rarely, though I only thought about that afterwards. He was probably off in London, living it up with the Royal Family.

Along with all the king hippies from campus, Krivine offered John Shapeero a room at the Ho Ho Funhouse, too. Some of them, like Paul Frou, I knew quite well from my year at the university, though he was older than me, part of the previous generation. Even so, we'd done a lot together; there were photos of us waving banners in demonstrations against the members of Parliament investigating student unrest and so on. So I was already friends with some of the Funhouse occupants, but it took the older group of freaks a while to accept me. They'd already agreed how to split all the rooms, and there wasn't one left for me. It didn't help that I had no income bar a few pounds here and there from playing music. But John Shapeero said, "You can stay in my room. We're doing all this stuff together, and it'll be the room that we both share."

The room we were given had no window and was situated right at the top. When the winter wind came off the estuary, it was fucking freezing in there. A staircase in the middle of the building split it in two, branching off to the sides; you couldn't walk across—you had to go down and back up the other side. We didn't go over to the other side of the house much. The lone toilet was downstairs in the backyard.

Somehow, John Shapeero got hold of money from his family and put in a window. It was one great big square window with no struts in it, and it looked right out onto the river. You could see the ferry going back and forth, and all the ships going past. We built in a loft bed, and I slept under it. We painted a big sun on the wall, sort of art deco–style, so when you woke up in the morning there was always a beautiful sunrise and the river. Basically that was it—a place to sleep and a bookshelf. Pretty minimal, but a great spot. And we were content. John and I wrote poetry together, passing it back and forth, and occasionally did little pub gigs, and proselytized the ideas of COUM Transmissions to whoever would listen.

It came to Christmas, and everybody went home because they wanted to see their families and all that crap. I didn't want to go home. I'd already burned those bridges by quitting university.

On New Year's Eve, with the house still empty, there was banging on the door outside.

It was Cosmosis again.

I went down and let her in, and she said, "Please, can I stay the night? I've got nowhere to live."

"Why haven't you got anyplace to go?"

"Well, I lost my job . . ."

Her father was the head of a fire station and very strict. He believed in conservative values. She had one older sister, but to him, Christine Carol Newby was a disappointment: he had thrown her out of the house for being unemployed for two weeks. At Christmas.

I was unsure about even letting her in. Part of me was wary of the way things had transpired. You know, whether this was just convenience.

"You can stay a few nights," I told her, "but I have to make this clear, we're not boyfriend and girlfriend. I'm too busy with COUM and things to have a girlfriend. You can stay, but we're not attached, and if I want to go off, I'm going to go off."

She said all right.

I spoke to her again the next day and explained again: "What I do as COUM Transmissions is always going to come first."

Being a bohemian artist held the top spot in my life, and everything else came afterwards.

So in the beginning it was very casual, very spontaneous. It was never planned to be a relationship, but it developed into one over the next year, bit by bit. She did end up sleeping in the bed all the time, which I didn't mind. I relaxed some of my principles to a degree. There was a small room opposite our room that had been left empty because it was very tiny and damp at the beginning, and had a sloping ceiling—basically a cubbyhole—and eventually she moved in there, to honor the idea that we weren't "together."

At that point she had her own little room with a mattress. In other words, somewhere else to sleep. Sometimes I would be invited across, and vice versa. She also had a sewing machine in her room, and that's where she started sewing costumes for people. We used to make these little orange plastic patches with the COUM symbol.

There was never any talk at that time of being in love or anything romantic. It was just an exciting, additional experience, living in parallel. She spent a lot of time out before we'd met. At the beginning, when we'd started seeing each other, she'd hung out with the townies who were in bands in Hull. Early on, very near the beginning of our moving to the Funhouse, I can remember her saying there was a big argument amongst the boys in these bands at that time. She'd been going out with a guy called Steve, whose uncle was a king hippie and was living in the Ho Ho Funhouse at the top on the other side from us. Steve was still coming around, trying to get her to go back with him, so there was pressure on me via his uncle. Meanwhile, since she wasn't going out with Steve, others in the same social circle—including Snips and John Bentley, the bass player in Snips's band—wanted to go out with her. She told me she'd be out for the weekend with all these guys jostling for her attention, saying negative stuff about me to try to get me out of her life. It was weird, like being back at school. Here were all these musicians squabbling about her, frustrated that she still kept coming back to the Funhouse.

Pretty much every weekend she'd go out with her friends, the townies, the people who became Spiders from Mars, and all those people, and drop

acid. Which was something we had a debate about. They weren't doing anything different from our parents getting drunk on the weekends. They were just going out for a good time, getting out of their heads, and then going back and continuing to be normal. This was the critique process from Exploding Galaxy. "Why the hell are you still doing that? Why are you doing it all the time?"

21.

The first time I ever got arrested, I was living in Hull, in the Ho Ho Fun-house, after Cosey had moved in. None of us had an income. We got into a routine where we would shoplift food. On this particular occasion, myself and Cosey didn't actually take anything because the shop was really well lit and there were a lot of people in the store. John Shapeero, however, had dropped a piece of cheese in my bag surreptitiously without telling me as we were walking around. I didn't notice, but the store detective did. I could have fucking killed John.

A police car came and took the three of us to the local police station. Fortunately, when we were asked where we lived, we were all clever enough to say, "No fixed abode."

There was no way we were going to say we lived at the Ho Ho Funhouse, because then they would have had grounds to raid it, in which case they would have found all these stolen books from my trips to London, as well as quite a lot of other stolen goods and drugs. So we were listed as homeless and put in the cells—John and I in one, Cosey in another—pending a visit to court the next day. It was pretty filthy in the police cell. They brought us a cup of tea before we theoretically were to go to sleep, but none of us could go to sleep. I noticed the floor had old cigarette butts on it, so I started to mix the ash from the cigarette butts into the leftover tea to make a sludgy paint. Then I used the cigarette filters as brushes and started doing a mural all over the cell, all night long, until it was floor to ceiling. All these tight little swirls and slogans. I really got into it, giggling and laughing. At about six in the morning, the cops came to give us another cup of tea and a sandwich for breakfast. Of course, they were really angry when they saw what I had painted. They didn't hit us, but they screamed and yelled and swore at us, and then they brought us a bucket and a mop and cleaning things. We had to scrub everything down and clean the whole cell before going to court.

Much to my surprise, I discovered my parents in attendance. I found out afterwards that because the cops had my name, and because I was supposedly homeless, they rung my parents and said, "Your son is in jail on really serious charges and he's in court tomorrow morning."

Of course, my parents panicked. They thought I might have stabbed somebody again. So they drove all night to Hull, completely freaking out. When they got there and looked at the actual court listing, they saw that it was for a lump of cheese. We pled guilty—there wasn't much choice. We got fined two pounds each. My mom and dad paid my two quid, because I didn't have any money. Then they took me for a cup of tea and something and to eat with Cosey.

All a bit of an anticlimax, because it didn't cause any issues. John didn't seem very embarrassed about it, and it didn't spoil our friendship or anything. In fact, I remember thinking that I didn't want to become self-conscious or fearful about shoplifting just because I'd been caught. I decided I needed to do it again, to "get back on the bike." So I went right back out and stole the double album of the Grateful Dead, *Live/Dead*, with the long instrumental "Dark Star," to get my nerve back. And I carried on stealing books in London.

I made a classic mistake. I'd gone to Doug, the dealer I'd been crashing with before I moved into the Funhouse, and told him I wanted some acid.

"Don't fucking say no this time."

So he agreed and gave me a hit. I took it and then walked back to the Funhouse and sat around for about half an hour and nothing happened. So I went back to Doug's and told him, "That was a dud. I want another."

He gave me another. Still nothing happened. So I took a third.

Then I went back to the Funhouse and sat down in an armchair. Suddenly I started to experience all the sensations I'd had back when I went into a coma and nearly died: the strange numbness, the feeling that I couldn't breathe, losing all sense of my body. Deep, deep trauma. And it scared me.

Am I going to go into another coma?

I grabbed Cosey: "We better go to the hospital. I don't want to be a dead corpse here with you."

At the hospital, a doctor came to see me in an examining room and said, "What's wrong?"

"Well, I've taken LSD, and I'm feeling pretty weird, and I have these pills I have to take to stay alive, you know. And I'm a bit concerned."

He checked my blood pressure and everything and said, "You're fine. You're gonna be fine. I'll give you some Valium."

So he gave me a Valium. And while he was talking to me, we were looking at him, and suddenly it came on properly.

Before it had been just weird, physical things—then the visuals came, and it was AMAZING. All the veins in his skin turned electric blue and were flashing, and it was like the surface of a strange fluorescent planet. We just stared at him with my mouth open. I thought, *AHHHHHHHH*.

He just looked at me and goes, "I think you're all right," and left me.

Then I remember playing hide-and-seek with Cosey in the hospital, in a really good mood and being all giggly. Then we walked back to the Funhouse and everything looked like a Hans Christian Andersen cartoon, everything all made out of marzipan and sugar. And the Funhouse looked like it was made out of candy. It looked fantastic. It was all bright because it was all painted, all plastic and colors and prams on the ceiling. We had pianos in the kitchen that were painted blue so you could play the blues. Everything was perfect. Without knowing it, we'd decorated the Funhouse to be the perfect place to trip.

Acid was still rare in Hull, though Cosey used to do it a lot when I met her, as I mentioned. I don't know what her source was, but she and her friends used to do it like some people go out and get drunk; they would go and drop acid just to have a fun time. I never thought of it like that. I always looked down on the idea that you were taking it just for fun. I always thought you were supposed to take it for serious reasons: to expand your conscious-ness, think things through, and explore things you'd normally never see. And because I'd had such a powerful experience with it, I stuck to that and didn't do it a lot. I wanted to try to make sure I always had everything set up to be as positive as it could be.

For me, it always remained much more of a ritual than a pastime.

22.

In August 1970, all the hippies decided to go to the Isle of Wight rock festival, where Bob Dylan was playing in Britain for the first time in years. They all went off and left me and Cosey behind in Hull; we didn't have any money to go to the festival. Plus, it didn't fit in with my philosophy: Why would I want to go and see somebody else make music? Everybody should be doing it themselves.

One night, while everyone was away from the Funhouse, we were asleep in our room at the top of the building when we heard banging on the door. We looked out of the window and there was a guy shouting, "Genesis, Genesis, come on out!"

How the fuck do these people know my name?

Soon there was a whole load of Hells Angels at the door. Cosey knew a few of them from the council estate where she'd grown up. She had pointed out a couple of them to me before. One in particular she'd identified as the most dangerous.

"He's only small, but he's really vicious," she had told me.

Now a bunch of them were at the door, shouting.

I went downstairs wearing a Victorian nighty and went outside and closed both of the front doors behind me. There was a door to our side of the building, and another at the front of the entire building, and both doors were pretty big and thick. There were a lot of bikers, at least thirty. Some of them were from down south, the Freewheelers, from Redding.

Somebody yelled, "Warble him!"

I later found out that was Manny Dodds, whose favorite expression was "warble him," which meant "Beat him up."

Looking around, I saw the little guy Cosey had said was the most vicious, and I walked over and gave him a hug and said, "Hey! How are you doing?"

He was so taken aback, he didn't do anything. Then they all thought that I'd shown class, as they say, so they decided not to beat me up.

"Why are you doing all this yelling?" I asked. "What d'you want?"

"We want to party."

"Well, why didn't you say so? The building's empty right now. Everybody's gone to the Isle of Wight. Come in."

So they did.

"Just don't bother us," I told them. "We're at the top, at the left. Don't bother us; we want to sleep."

So they partied all night and into the next day.

There were two "Mammas," as the Angels called them—girls who had sex with all the Angels. They were on the other side of the building from us, partying and having sex all night and most of the next day. When I eventually went down, I was talking to them, asking, "Do you enjoy having sex with all of them?"

"Oh yeah, it's great!"

"Really? They just stand in a row and take turns?"

"Yeah, it's great. I love being with the Angels."

And I said, "Oh, okay. Good for you."

The Angels turned out to be nice, somewhat crazy, working-class boys, which was fine with me. As long as they didn't hurt any of us, it was all okay.

We didn't realize until later, after they'd left, that they'd gone into the room of a girl called Bronwyn, who used to make clothes out of velvet. I don't know why they took a dislike to her, but they painted a really crude version of a naked woman on the ceiling, over her bed, with a very graphic vagina. They stuck real hair on the vagina and wrote next to it, "Bronwyn pulls a train."

When she returned from the Isle of Wight, it frightened her so much that she moved out the next day. In fact, most of the Funhouse occupants moved out pretty quickly after they got back from the Isle of Wight, because they were just petrified of "these people," as they called the Hells Angels.

How do you know these people?

That was when I realized how middle-class the hippies really were. Since we'd already run into the Hells Angels at the squat in Drury Lane, we knew

they weren't all horrible if you were just sensible. They were a bit rowdy and always had a short fuse, but if you cared for them and had respect for them, they weren't a problem. I guess it came naturally to me. My instincts for survival were good.

As the Funhouse emptied out, the Hells Angels became friends. It became their occasional clubhouse from then on. They started to come round, the ones higher up: the president, the sergeant at arms. They'd come round on their bikes quite often. Sometimes they'd even bring us food and milk and things like that. He had a 750cc bike, really fast. He asked me— challenged me, basically—to get on the back while he rode it. I was fucking petrified. I didn't say it, but I was.

Cosey started to embroider their colors, their patches—beautiful Hells Angels emblems with the big wing going off the skull. She did really beautiful embroidery. Some guys paid her to do it.

One night we were in the room that had belonged to Baz Ward, and for some reason the Angels wanted to have a séance, so I said to them, "Okay, we'll do mirror staring."

I'd learned about mirror staring from reading Burroughs and Gysin, but I'd never done it prior to that night with the Angels.

An Angel named Gypsy and at least one other could see the mirror. The others were sat around and we started. We put a cross on the mirror first, then we started to stare at it. We didn't know what was going to happen. After about fifteen minutes or so, my face went smokey and sank down, and then this other face came through that was demonic looking. The Angels flipped.

They were fucking scared.

In fact, they were so freaked out that it surprised me.

Somebody was looking out of the window and suddenly yelled, "Who's that? Somebody just came out of the front door."

So we all went and looked, and there was a man who looked to be in—I know it sounds corny—but he looked to be in Edwardian dress, a cape and a long coat, emerging from the front of our building, where the door was. He crossed the street, went around the corner, and vanished.

"I don't know who that is, because no one else is in the building and both of those doors are locked."

At that point the Angels refused to go home. They stayed until dawn because they were too freaked out to go out in the dark. They stayed in that room all night with the lights on.

The lease John Krivine had signed was for six months. After the Angels came in and everyone moved out, John didn't renew the lease. Cosey and I were the only people left in there, and we couldn't afford to take on a new lease for the whole place. Luckily, we didn't have our names on the expiring lease, and we figured we had maybe a month or six weeks before we would get kicked out. We ended up staying there for an extra two months without paying any rent. Nobody came around about it.

During that time we started going in circles, looking for anywhere else we could go. There were lots of empty and derelict factories, amazing buildings, but it would have cost a lot to fix them up to be lived in. They didn't have electricity or water; many didn't have windows.

There's a park by Holy Trinity Church (now called Hull Minster) in Hull, and then there's a big square where they used to have a market every weekend. We knew some of the people who had stalls in the market and started asking them where we might find a place. One woman who originally didn't like us—she disliked hippies and lumped us in with them, but eventually changed her mind because we were polite and well-spoken—told us, "This guy Jim has buildings down the alley there."

She motioned towards the very Victorian alleyway beyond the market square.

"He's very difficult, but he might have something you could rent because he's got extra buildings."

So we went down the alley and found a really cranky old man. Almost a caricature of a cranky old man—over-the-top nasty, hated everybody, hated life, hated us, hated the people that told us about him, hated everything. But we asked whether he had any spaces for rent.

"I've got these two buildings next door," he said. "I live in this one but I've got those other two. It's where they store some of the trolleys from the market when it's not on."

The bottom part of the buildings, at street level, were full of market trolleys.

"The upstairs isn't used, and you could rent that."

"How much?"

"Two pounds fifty a week."

For two buildings—a total of nineteen rooms.

We moved straight into what became the second Ho Ho Funhouse.

23.

The first Funhouse had lasted a little more than half a year, from December 1969 through to early fall of 1970. Life in the new Funhouse, on Prince Street, was very minimal at first. The electricity didn't work, there was no bathroom—just an old stone sink with one tap. Of the nineteen rooms, only four didn't let the rain in; all of the rest did.

It was pretty miserable when it rained or was cold. The only rooms that were really viable were at the very front upstairs. Cosey and I had the room with a bay window. I built a sort of wooden frame so it became a sofa, and you could lift up the top and store things in there. We built a bed. We made our own mattress. Cosey sewed up a great big pillowcase out of canvas, and we filled it with expanded polystyrene granules that we got for free from a plastics factory; we would lie on that and it was great, because it would just form around you and you'd float on it.

The first person to turn up at the new place was Spydee. We'd always gotten along really well, just banging ideas together, back and forth, and speculating. He was always a very interesting, intense person. He had been expelled from the school when he put an image of somebody smoking pot on the cover of the school magazine, which he had kept going after I graduated. Then his family threw him out for being expelled. So he'd hitch-hiked to Hull and turned up on the doorstep of our place. Aside from our room, there were only three rooms that were dry: two spare rooms and the costume room. Spydee moved into the little room next to ours, and he got the fireplace working.

One of us got the toilet working, which was a real boon, because up to then we had to go and find toilets in pubs, and, of course, people didn't like letting us in, the way we looked.

After me, Cosey and Spydee, we added another one of the townies—John, a notoriously strange character. His main income was from working

on the trawlers, which, at that time, still went from Hull into the North Sea to fish for cod. This was just before the Second Cod War with Iceland, which eventually killed off the trawler industry in Hull completely. John lived in one of the rooms that was a bit damp, though he was almost never there. More characters soon took up residence as COUM and the Funhouse grew.

Behind the new Funhouse stood the town vegetable market; at one end of that was the church, and at the other end a strange, mysterious shop that never sold anything but had clothes inside. Next to that place was the Gothenburg Coffee Club, run by a West Indian guy named Omar. It was an after-hours drinking club where the really cheap prostitutes worked. Across from the club was the Freemasons' meeting hall. Apparently the women in the kitchen at the Freemasons lodge noticed we had a dog. Packages of leftovers turned up on our doorstep on weekends, and once the Good Samaritans added a note. It said that they hosted big banquets for rich men at the lodge and ended up throwing away lots of meat and fish, so they'd decided to leave it for our animals. They left us chicken and turkey and fish and mashed potatoes. Of course, we would pilfer it for ourselves. They pitied us. But we stole off our animals to eat. We were starving. That's how we ate.

We had no stove, no way of cooking. We would go into the open market, where they had a fish-and-chip place in a caravan. They would heat the fat to deep-fry the chips and the fish with coal—it was that old-fashioned. At the end of the day, they'd take all the coal and throw it behind the caravan and pour water over it so it couldn't keep burning. When it got dark, we'd take the coal back to our house down the alley and put it on newspapers that we'd picked up from the street and dry out the leftover coal. That was what we used to cook in the one fireplace that worked. It was a little, tiny fireplace and we had one pan, so everything we had was a stew, because that's all we could do with one pan.

Eventually, a guy I'd gotten to know while still at university, Alan Worsey, managed to get a stove for us. Alan made his money as a junkman. He would get stuff in thrift stores or at auctions and then sell it really cheap to hippies and students and so on. Alan came over and got the electricity working as far as it ever did, and he also brought us a junked electric cooker.

Our building shared a wall with the Dockers' Club, the union club-house for dockworkers. On the weekends they'd get a band in to do covers of hits and sing "Stand by Your Man"—that one song in particular—every fucking week. They'd get drunk and take turns singing pop songs. "Tie a Yellow Ribbon Round the Ole Oak Tree"—all those songs make me flash straight back to that time and place. It would come through the wall, and there was nothing we could do to dampen the racket.

At one point, because of the Cod War and other disputes about conditions, the dockers went on strike. It became quite a famous strike at the time. They demonstrated and marched, and the police beat them up. The police in Hull were really vindictive and intolerant. They were the representatives of a prewar order that no longer existed. Not unlike what's going on now in certain places.

Round the corner from us was a pub. The young son of the family that owned it was a skinhead. The skinheads took an instant dislike to us because we were considered hippies. At one point I was walking back towards the Funhouse and bumped up against four of them in the street, including the son of the landlord of the pub. Clearly they wanted to beat me up. Fortunately, I was next to a derelict lot and grabbed a large piece of discarded wood.

My attitude in those days was to hit them before they hit you.

So I whacked the nearest one on the head with this piece of wood. I split his head open, and he collapsed unconscious.

They'd been yelling, "Fucking hippies! Love and peace!"

But suddenly one of them's felled and they had to drag him off. Afterwards, of course, when I was past the adrenaline, I thought, *Oh shit, what if I've killed him?*

The next day there was a knocking on the front door, and when I looked out, there were three skinheads, including the one I'd whacked, complete with a big bandage around his head like in a cartoon.

Oh God, they've come to get me. What am I going to do?

I figured the best thing to do was to go down and see what happened. We used to keep a hammer on the back of the front door, so I grabbed that and held it behind my back as I opened up.

"Yeah?" I said.

"I've come to apologize," said the skin with the bandages.

I dropped the hammer behind the back of the door.

"Really?" I said.

"Yeah. I'm really sorry. I understand why you hit me."

"Oh, well, come in, then," I said.

It was very similar to how I made friends with the Hells Angels. It all comes from improvising and through reading people. All the different disciplines and experiments I'd done helped me read people even when I wasn't aware that I was doing it.

My dad used to have a terrible rage. He never hit us that I remember, but he petrified us. It took years to get over his rage. Also, because I was taking these pills, I released extra adrenaline, and it's fight or flight. It can go either way—it can either make me want to run away or it can make me want to just confront things—which is how I dealt with things for a long time.

So I got to know the skinheads, and it got to a point where they started getting quite freaky. The different groups of skinheads in different towns would usually support the local football club, and our friends supported Hull City, of course. They had all these football chants they did. They called themselves the Mental Kempton Clockwork—from *A Clockwork Orange*, which they loved. They used to wear Doc Martens and paint the edges gold; I painted the edges of mine gold as well. I started to wear skinhead jeans with my hippie clothes, which was a strange mutation. And the skinheads, too, started to do really weird stuff influenced by our street theatre. In one phase, they all started wearing makeup and carrying handbags, even putting dresses over their skinhead outfits. Another time, they went on a train to cheer on Hull City at Stockport County, and they sprayed themselves gold from head to foot. About a hundred of them got off the train at Stockport all sprayed gold, and there was actually newspaper coverage of the "golden horde" that came and wrecked the place.

I was very proud of them for doing the golden horde thing. What a beautiful art piece!

We had created this environment where you were able to live and subsist, and we started to turn the building into an artwork, too. Like a maze,

a psychedelic maze. Somewhere during that period, Peter Winstanley— "Pinglewad" from the old Solihull crew—turned up, having also left home. He moved into a room across from Spydee, which was always a bit damp. He painted mushrooms and things on the walls, in a real hippie way. We were also decorating the inside of the house all the time when we were scrudging up stuff. Old prams, shop mannequins, anything that looked weird or wonderful—we would just fill the house with it. We put the prams and rows of mannequins on the ceiling.

Then Gypsy, the Hells Angel, moved in along with another biker named Rick, a Freewheeler from Reading down south. Gypsy was originally from New Zealand and had a big drooping mustache and a tassel of hair sticking up. He looked great. Real swagger. He was on the run from the police in New Zealand because he and another Angel there, whose nickname was "Animal," had been pulled over by a cop somewhere in the countryside and supposedly Animal had beaten the cop to death. Wanted in connection with this murder case, Gypsy left New Zealand and ended up with the Hells Angels in Hull, and eventually living with us.

Rick died while he was living at the Funhouse. The two of them went on a run down south and on the way back, on speed, he went straight into the front of a truck while trying to overtake a car. Only Gypsy came back. Gypsy went on to start his own small inner circle, a club within the Angels, which he called the Gypsy Jokers. He gave me a set of colors as an honorary member. Now I had a set of Hells Angels colors and a set of Gypsy Joker colors for our services to the biker community.

At the time, it didn't seem like we were skirting the edges of survival. It felt like we were just improvising as we went along. I didn't analyze or moralize the way they behaved. From my perspective, we were all rebels, we were all outlaws; the establishment wanted us to attack each other instead of attacking them. That suited them fine, so what we needed to do was be unified in being different, regardless of our various styles.

24.

The godsend for everyone in Britain was the dole, which I hadn't thought of or known anything about when I left university. But a friend of Cosey told me about getting the dole. And the Hells Angels did it, too: they used to talk about "going to the bank on Monday."

"What's the bank?"

"Oh, it's the dole. We go down and get our money and that's it for the week."

"Could I get that, too?"

"Yeah, of course."

So I went down and signed up. This was around the middle of 1970, just when the first Ho Ho Funhouse was disintegrating.

It was only around three pounds a week, but it was enough.

When you read the story of all these bands—Manchester bands, especially, but loads of bands in Britain—many only exist because they got the dole. Same is true for a lot of artists as well. God bless the dole. But of course they've tightened it up so much now that it's no longer a true option. It's a real tragedy, because it's bound to be crippling creativity.

Back then you could also get free food. If you went to the bakers after 5:00 P.M., they would give you free food because they weren't allowed to sell it the next day. Now they have to throw it away. The law changed so they *must* throw it away. Just so people like us couldn't get free food.

Woolworths had a food park where, amongst other things, they sold cheese. They used a wire tool to cut it, and there would always be crumbs, bits that fell off. They kept all these crumbs of cheese, and you could go and get that for hardly anything at the end of the day. You could put it on a piece of bread and make toasted cheese sandwiches. They also sold broken biscuits. Back then, biscuits still came in a big container and were wrapped up for each individual customer. As with the cheese, there was a constant

supply of crumbles and shards, which they sold by the pound in paper bags. The butchers also gave us free food. They used to give us "lights," which was a euphemism for sheep lungs. Very few people wanted to eat sheep lungs, even back then. They stank to high heaven.

As long as you didn't mind a modest level of living, it was fine.

You had to go down to collect the dole every Monday, reaffirming that you were still unemployed. There'd be all the Hells Angels and all the hippies and freaks, so it was like a big party. It really did feel like going to the bank.

"And where are you off to?"

"I'm off to the bank."

Then one week I got called into the manager's office. I can't remember how he initiated the conversation, but he was basically saying, "How come you've not got a job and you've never had a job?"

"Well, I don't know what to do. Being me is my job. I already do what I do, which is making art."

He got very angry.

"If you really think you can't be employed, then you must be mentally ill."

"No, I don't think I'm mentally ill, I'm just unemployable because there's nothing you can offer me that would be of any interest."

"Will you give us written permission that we can send you to the local mental hospital to have you assessed for whether you're insane or not?"

"Yes, of course," I said. "I'll go."

Then he started rambling on, and at some point he asked me what my religion was. For some reason I said Hindu, just plucked it out of the air.

He went crazy.

He started screaming, and spittle came out of his mouth. He was shouting at the top of his voice: "I know all about you Hindus! You believe God comes out of FUCKING YOU UP THE ASS!"

I was like, "What?"

I don't know, perhaps something terrible had happened to him during the war, but he really flipped out, and the assistants had to come and take me out of the room and try to calm him down.

Then I made the trip to the mental hospital.

When I was nearly there, I suddenly thought, *Oh shit, they could just say I'm crazy and lock me up. Will I be allowed out again?*

But I wanted to remain on the dole.

They administered all these tests, some written, some spoken, and then I had to talk to the main psychiatrist. We spoke, and I told him about COUM, and even showed him some event posters. And at the end of it he said, "Well, I have to agree with you. You are unemployable. And I'm going to write that down. So you won't have to worry about getting the dole anymore. Here's your classification as unemployable. But you're not insane. In fact . . ."

Here he paused.

"When you're doing your next event, could you possibly tell me? I'd like to go. And can I get one of those posters, 'COUM are fab and kinky'?"

He went on to say what I was doing was much more important than getting a stupid job, or words to that effect. Which was just wonderful to hear. I didn't have to worry about trying to find a job anymore. And I felt vindicated: I was indeed meant to exist as a creative force.

At some point I decided it would be so much more fun if, when I collected the dole, they had to call out "Genesis P-Orridge."

It also struck me as a necessary next step: to actually change my name legally and see what reverberations happened when I become someone else.

Does it reinforce the new being, this creative force? What does it do?

It was that classic method of operating: *See a cliff, jump off.*

That's an approach that I've always used, to pursue these things right down the line, rather than simply think about them.

Changing my name upset my mother more than my leaving university. She cried when I said I was going to change my surname because she saw it as a rejection of her and our family—which I guess in a sense it was.

But for me it wasn't so much a rejection as an addition, a move to another level, where having a more fully resolved character gave me the basis to operate from a stronger center. We were moving to a level where everything was much more integrated, with a clearer vision. We knew exactly what character we were now.

I went to a local lawyer—we've still got the paperwork—and I said, "Can you actually change my name? My first name and my surname?"

"I can change your surname legally," he said, "but your first name is just the name that you're known by—by other people. So if people start to call you Genesis, then that's your name."

I can't remember how much it cost, but it wasn't much. The lawyer was amused. He'd never done it before for anything other than "traditional" reasons: people who were living together but weren't married, or criminals who wanted to change their names. It was still very novel back then to create a name. It still hadn't really struck the mainstream that people were playing with identities that way. I think it was at the time a reasonably unique way of doing it: to actually shed everything possible of the old identity and decide to build a new one from scratch.

So that was it. On January 5, 1971, Neil Andrew Megson changed his name by deed poll to Genesis P-Orridge.

The music aspect of COUM started to grow over time. Pinglewad played a little bit of guitar; Spydee wanted to be involved. And another new occupant of the Funhouse, Hayden Robb—we always called him Hayden Knob—was a bass player whose claim to fame was he'd played on the Rattles' hit, "The Witch." So we actually had someone who could play bass. Soon we had a regular vocalist in Ray Harvey, a legend in Hull even then, covered in various tattooed from head to foot.

The Hull police were horrible to anyone they didn't like, and they hated Ray Harvey with a vengeance. Simply because he was black. Ray was quite literally the only black person in the whole town. He'd grown up having to fight everyone, a real brawler. He loved to get drunk and have fights in pubs. So he was always getting busted. One night Ray was just wandering around somewhere in our area where there were lots of abandoned buildings. He wandered onto some derelict ground and—probably stoned—he picked up an empty milk bottle, looked at it for a while, and then put it down again. The cops arrested him for attempted theft of the milk bottle. Technically it was private property, owned by the milk distributor. Ray didn't even take it, but they put him away for six months for "attempted theft."

As more people got involved, my drum kit arrived from home. One of the big rooms in the house was nicknamed the Drum Room, and the kit remained permanently set up in there. In the middle of the room was a four-foot-diameter hole that was the result of the rain coming through; the hole went all the way through the house, down to the bottom. It was very dangerous. But for some reason, we never thought of doing anything to protect people from falling through. In three years, we never did anything to make it safe; practical things like that never crossed my mind for very long.

Miraculously, nobody ever fell through, and when it snowed or rained, it continued to fall through to the kitchen. The kitchen housed two upright

pianos. Gradually we installed speakers all around the Funhouse, hidden in walls and behind plastic sheeting. We even had small speakers hidden outside so we could whisper to passersby, having great fun creating aural confusion. We also had various decaying tape recorders in the kitchen, and we would record things as well as pressing "play," retaining previous sonic layers and breaking down, as best as I could, the linearity of the sound and voices. The overloaded sound of the recordings was also heightened by the weird delays, textures, and tinniness of the multiple speakers bouncing back and around all the rooms before returning eventually to the kitchen.

Our visibility on the street made people interested in coming to see us. We made an itinerant preacher's stand with dolls and different toys on it that were sprayed gold, and I would read my poems from it, like a priest stands with their Bible for sermons. We would go in the street and put that somewhere, and I'd read poems and the others would just sort of act out various characters. People would stop and ask what was going on.

In 1971, COUM Transmissions often invaded weekend shopping and other "normal" activities of the Hull population, improvising surreal street theatre in our bizarre homemade costumes and props from repurposed trash. We became the notoriously weird but fun eccentrics of Hull culture. As a result, COUM were soon "discovered" by the local paper, the *Hull Daily Mail,* which came round and did an article about us—a full page.

It was easy to find out where we lived. One just had to ask, "Where are the weirdos living?"

We were the only ones.

After the local paper, we then got approached by the guy who ran the Hull Arts Center, which was funded by various government programs. He turned up at one of our street things and said, "I really like your performance art. Have you thought about doing it in a theatre setting?"

"No," I said. "It's not art. It's just what we do. It's COUM."

He said, "Oh. Well, you know, I could give you"—I think it was two hundred pounds—"to do something."

And I went, "Yes, it is art. It's performance art!"

That was when it shifted out of the street to arts festivals and events.

The Yorkshire Arts Council sent us a grant. It wasn't much, maybe a hundred pounds. We used it to buy an old three-ton post office truck at auction. We named it the Doris Austin. It had a separate cabin with an old square box on the back, and it was red, of course, because it came from the post service, and all their vans were red. We painted it black in honor of Charles Manson's black bus. The inside of the box we painted pink and silver. Then we built a four-poster bed in the back, with a curtain across if people wanted to crash, and we put a rocking chair in there, too. The vehicle had really good doors at the back—you could open up just one or two or three or four—so we could open just the middle one, for instance, and you could sit in the rocking chair and look at the traffic and the countryside. People would lie in the bed and sleep or fuck or whatever.

"Biggles" became the name of the driver—the pilot, actually, in keeping with his character. When we took road trips, we took turns keeping him company. Because there were no windows through to the cabin, we put a wire through and had walkie-talkies. So Spydee would be in the front with his Biggles helmet on, and in his character saying, "We're now travelling at forty thousand feet," meaning forty miles an hour. We could also tell him if we needed to go to the bathroom, and if he said it wasn't possible, we had a bucket in the back. That wasn't fun, especially if somebody kicked it over, which did happen.

We drove to arts festivals all over Britain in Doris Austin. When we got invited to a festival, we put all the stuff in the back, people and costumes and props, and trundled off.

Buying the truck proved important. It's how we developed beyond the weird stuff in the street and beyond Hull. COUM became a mixture of anarchic musical experiments and strange, surreal theatre.

At a Southampton arts festival, I climbed a tree in a latex body suit, taking up cheap dolls, mirrors, streamers, chains, and various objects that had no business being up in a tree. I positioned myself at the same height in my tree as passengers in the double-decker city buses that drove past. People staring idly out of the bus window, thinking of nothing, would suddenly see a grotesque black creature with chains dangling around it apparently nesting in a tree, playing abstractly with odd items. But as soon as their

brains began to register all this, the bus would move away and they'd have no proof they'd seen it.

In October 1971, Hawkwind played a benefit concert at St George's Hall in Bradford for some commune that got busted for drugs. As a prank, we wrote and asked to support Hawkwind—and they put us second on the bill as "Edna and the Great Surfers."

For the show, we assembled the biggest drum set in the world. It was during the era when all the bands wanted to have the biggest drum kit. If you look at the cover of Pink Floyd's *Ummagumma*, for example, you can see how they laid out all their equipment. We were making a joke of that. We borrowed all kinds of drum kits and set up this ridiculous sea of drums, behind which I sat down. I couldn't even reach the drums; it was just a spoof. Tony Menzies, aka Babbling Brook, whom everybody thought was a dwarf because he was very young and small, played guitar for the first time in his life. And Cosey was dressed as a classic English schoolgirl and wandered around firing a starting pistol at people. At the end, we threw sacks of polystyrene granules everywhere, like a snowstorm. Hawkwind were actually quite amused and very courteous to us, even when they had to clean granules out of jammed-up effects pedals.

For a while in that era, there was a whole network of universities and arts festivals. That was how we got better known and started doing things that were a bit more considered. We started to network with other performance art people in Britain, and even went abroad occasionally for events as well, taking the ferry across and driving to Belgium and Holland.

We weren't getting paid much. What money we took in usually just covered small expenses, like upkeep of the van, buying food, and minor repairs on the Funhouse. Anything left over we shared. No one was getting rich off of it, that's for sure.

26.

While living at that second Funhouse, on Prince Street, I had found out about *Groupvine*, which was an arts council dossier: loose pages in a ring binder that represented a sort of encyclopedia of all the active groups doing alternative theatre, performance art, ballet, mime—anything performance-oriented.

I had started putting pages in *Groupvine*, making up different fake performance groups to maximize our chances of getting something to do. Then I'd started contacting people at festivals. At various arts festivals we participated in, I met people like Michael Scott, Jeff Nuttal, and Robin Klassnik, whom I corresponded with and sent collages to; Robin even ended up participating in a couple of COUM actions. In fact, Robin came up with the "Fanni Tutti" part of Cosey's name—he mailed us a postcard from London addressed to Cosey Fanni Tutti and it stuck.

David Mayor, who was running *Fluxshoe*—which was the British end of *Fluxus*—was also in touch with us. He started inviting us to all of their events and exhibitions, and we toured around Britain with *Fluxshoe*. David had a book publishing company called Beau Geste Press, and the group lived on a farm that was owned by his family, somewhere in the countryside in the south. I went and stayed there a couple of times and met artists from Japan and Argentina who were staying there and who were into "mail art."

From those initial connections we got connected to *FILE*, a magazine produced by a small group of gay artists in Toronto who called themselves General Idea. *FILE* mimicked *LIFE* magazine, but with the letters changed around. *FILE* was printed the same size as *LIFE*, on the same kind of paper, but it had weird articles—about other mail art people, and *Fluxus*, and the real fringes of the art world that were not concerned with art galleries. They also invented various imaginary projects that they would end up doing in

reality. In Vancouver was another group, called the Western Front, who were also involved in mail art. They did a yellow insert in an issue of *FILE* called the "Image Bank Request List." They were collecting an archive of all the alternative artists in the mail art scene, and it included artists' addresses and their image requests.

Using that information, I started writing to people around the world. One of them was Anna Banana. She was a Canadian artist who listed her image request as "anything to do with bananas." Her lover was a guy called Bill Gaglione, and the two of them moved to the Bay Area and nicknamed themselves the Bay Area Dadaists. They started doing re-creations of the Cabaret Voltaire from World War I, and the Dadaists' sound poetry and futurist events. In one of her letters to me she wrote, "We met this really horrible awful man, Monte Cazazza. We were at somebody's apartment and he came in wearing a dress, really crazed, carrying a little briefcase. He opened the briefcase and there was a dead cat in it, road kill. Then he sprayed cigarette lighter fuel on it and set it on fire, and pulled out a great big magnum revolver and told us we couldn't leave the room. The smell of burning flesh filled in the room and then he left."

She added, "He's the most awful human being that we've ever met, stay away from him. You don't want to know people like that, I'm shocked at how awful he was. There are some crazy people here."

And, of course, I immediately wrote to Monte and we became friends.

It was all very organic. I just sort of meandered into what was a global mail art scene, and my interest grew the deeper I got into it.

It all made intuitive sense. We weren't trying to make art to sell, anyway. We were making art for the sake of making art. It was a drive, an obsession, a passion. So why wouldn't we just share it with each other? Fuck all the people in the art world. It was none of their business, and it wasn't made to be framed and stuck on some rich person's wall. These people made up names, fake organizations, and built an alternative art universe that was outside the whole careerist, museum, gallery thing. I took to the concepts like a duck to water, as it dovetailed with my own rejectionist attitudes. I was collaging, making drawings, writing letters, using my little typewriter, and gradually extending out to these different, active people.

I made contact with Blaster Al Ackerman. He used to send really bizarre, whacked-out letters and very odd collages. He'd been a conscientious objector during the Vietnam War, so he became a medic. The trauma of what he saw was so disturbing that he subsequently found it really hard to fall asleep because he had such nightmares. He worked as a nurse in a hospital in Isle of Portland on the burn ward because he was really the only one who could cope with those injuries, having also dealt with them during the war. One of his patients he nicknamed "the Hamburger Lady." The words to my later song "Hamburger Lady" are exact quotes from his letter about the woman, who had been in a car crash and been stuck in the car while it was burning, leaving her eyes and ears burned, blind, and deaf. She was trapped in this mutilated body, unable to speak or hear or see, not knowing what had happened to her. She just woke up, trapped in this body, in the dark, in pain, for the rest of her life. Trying to get my head around what that would be like resulted in the song. Al was truly and genuinely disinterested in being recognized, or in galleries, or anything else.

Another person I reached out to was Scott Armstrong, who had a group of weird and woolly, wild L.A. freaks. Los Angeles had a very particular kind of weirdness. Scott had collected several people under the umbrella term of Science Holiday. And they made Super 8 movies and collages and did performances. He's an incredible painter. He's one of those people who just has to paint every day to be alive. He did a wonderful series of paintings on tree bark that look like Egyptian hieroglyphs, but upon closer inspection revealed themselves to be about Charlie Manson. Really interesting, strange stuff. And again, like Al Ackerman, Scott didn't give a shit about art galleries or being recognized. His life required him to be creative. Those were the kind of people I always felt drawn to. Scott introduced me to Martin Denny. When I visited L.A. a few years later, we spent two or three days going all over L.A. to secondhand record shops and thrift stores, digging out Martin Denny records. I got loads. And those records ended up being what we played at the end of Throbbing Gristle gigs.

And, of course, I first met William S. Burroughs through mail art when, much to my surprise, I found his address in *FILE*, under a listing seeking "Ideas and Camouflage in 1984." He was living very quietly at the

time—he'd become almost invisible. Most of his books were out of print, and though *The Wild Boys* was soon to be published, he was in a kind of backwater with his career. He hadn't started doing lectures and readings at that point. He made extra money writing columns for different magazines, including *International Times*, *Penthouse*, and other soft-core porno mags. He was struggling.

From then on, Burroughs and I kept writing back and forth regularly. He sent me postcards from different places. He had a lot of postcards of the British Museum. He had postcards of different shamanic things that he was obsessed with at different times. One year he sent me a little bundle of postcards, tied in a little ribbon, as a birthday card, which was really sweet.

Burroughs became one of the invisible supporters of COUM Transmissions.

27.

From 1970 until 1973, when I eventually moved there full-time, I hitchhiked down to London often. I knew the people at a newspaper called *Friends*. In particular, I was close with one of the typesetters who worked there, Nicholas Bramble, who was gay. I started staying with him up Portobello Road, in Golden Terrace, and went to meetings of the gay liberation movement when it was really, really new.

Nicholas and I had a fling. He could look like Marilyn Monroe in drag. And we were just really attracted to each other.

Originally he'd been a ballet dancer for the Sadler's Wells Theatre. He also worked for Madame Tussauds, making wigs for the different waxworks, where he would actually use real human hair, and put the hairs in one at a time on all the different waxworks. Really, really intense, detailed stuff. And he'd do some of the casting as well. He had a studio in East Anglia, in Yarmouth, where he made porcelain dolls—beautiful, beautiful porcelain dolls. Each one was unique, and they sold for hundreds of pounds to collectors. That was how he made his money. He was creating antiques of the future, basically.

After my initial exchange of postcards with William S. Burroughs, the next thing I sent him was something Nicholas brought home from Madame Tussauds: a cast of a left hand minus the thumb. It was actually Donovan's hand, broken. I mailed it to Burroughs in a shoebox, along with a note that just said, "Dead Finger's Thumb." It seemed to pique his interest.

Nicholas lived with a Scottish lesbian named Lindsay. Lindsay Kemp, the famous avant-garde ballet choreographer. Lindsay was well-known for having invented a sort of new, avant-garde, gay form of ballet interpretive theatre, and had a theatre troupe that did a version of *Flowers* by Jean Genet, which got lots of really positive attention at the time with critics. Lindsay was a really good friend of Nicholas's. I can remember when I was staying

there one weekend and Lindsay turned up, and Nicholas said, "This is my boyfriend, Genesis."

And Lindsay Kemp went, "How amazing! This is my boyfriend, Jesus. We got Jesus and Genesis in one room!"

And then he started talking about David Bowie and Angie Bowie, and they all started to gossip about how they'd all managed to have sex with David Bowie. There was a lot of talk about David Bowie's cock—apparently he had a big cock—and how they were always trying to distract Angie so they could get Bowie in bed.

Derek Jarman turned up once or twice at Nicholas's place. By then he was living in a loft space by the Thames. He was making films of Butler's Wharf with a Super 8 camera. He was hanging out with Andrew Logan and all these other gay liberation activists, who were, as Nicholas put it, "promiscuous as a political act." That they were, and now that it was finally legal, they were going to relish liberating anyone else who was gay but in the closet by saying it's okay, it's a healthy thing to do. So they would have sex with almost anyone.

We were in the second Ho Ho Funhouse building from fall 1970 until the summer of 1973. Jim, the landlord, would come stalking up the street, shouting. You couldn't even tell what he was saying, but he'd be yelling abuse, saying how he wished he'd never let us in and all this stuff. He had a dog called Jack, a Labrador-collie cross, fat and totally untrained. The dog would jump everywhere and run away and come back, and he'd always be yelling, "JACK! JACK! JACK!" at six in the morning. Cursing the dog, cursing the people from the market when they came to trundle their things up the street. It was a cobblestone street—still is—so when they came to get their market stalls, they had metal wheels, and you didn't sleep long with that noise.

Eventually, the social workers got called for Jim and they took him away to an old people's home.

By the time we left the Funhouse, we'd started to get involved in some pretty nefarious things. One of Cosey's friends from the council estate was nicknamed Lelli, who always had a fancy of being a vicar. Cosey made him a priest's robe and we designed business cards for him—the Reverend Lelli

Maull—complete with a biblical quote. He would go around forgiving people of their sins and getting them to confess.

By night, however, Lelli was a burglar.

At first he robbed schools and the occasional residence. With schools, he would wait until the end of the term, because he thought that if he stole things at the end of the term, they could apply to replace the stuff, and that would mean they'd get better equipment—that's how he justified it to himself: "I'm stealing it now so they can get a better record player next term."

Whether that really happened, I have no idea, but that was his rationale.

At some stage, he started to consider burglary more as a performance—which led him to steal only from policemen's houses. He got really into creepy-crawling policeman's houses. He would go in and find their packed lunch in the fridge and sit at their table and eat it, knowing they were asleep upstairs, and then leave the remains on the table. Sometimes he would just go and stand in the bedroom and look at them asleep and see if he could be so quiet he became invisible. He would move things around as well. He got really twisted.

The police even set up a special squad to catch the police burglar, because it freaked them out and pissed them off that someone was robbing them deliberately.

Lelli would also just steal stuff—mainly musical instruments or other things he could sell easily. Clocks, watches, musical instruments, and typewriters—those were his big things. At some stage, he had too much stuff to store at home, because he lived in a small room at his mom's place. Fencing it was the difficult part: he just couldn't shift it quickly enough. So he started storing it at the Funhouse. Then he made a connection with Jack Pepper. Jack Pepper was a fence. He had a stall in London on Portobello Road, where he would sell junk. On Fridays, Jack would come to the Funhouse, and we would load up whatever was there that week, then he would take it to London and sell it. At the end of the weekend, he'd come back with money for Lelli.

One night during the last year we were living at the Funhouse, I suddenly had this incredibly strong feeling that something really bad was about to happen. I said to Cosey, "I know you probably think I'm being

stupid, but I don't want anything that Lelli's brought to us in the house. It's gotta go."

I persuaded her to help me get rid of it. We took it all to the docks and threw it into the sea. Alongside the typewriters and watches, there was even a sword. And lo and behold, the next day the cops came round, looking for stolen goods. They had arrested some teenage burglar who'd said, "If you don't prosecute me, I'll tell you who's robbing the police."

So they'd nabbed Lelli and Jack Pepper. Lelli got five years for his first offense. And luckily, we didn't get dragged in.

Not long afterwards, I was outside the Funhouse, up a ladder, painting a mural on the outside of the building. Suddenly somebody started shaking the ladder: it was two cops in suits.

"Come down."

"What is it?"

"We know about you," they said. "We know who you are."

They pulled out a notebook and folder, and they had photographs of the door of the house, photographs of us in the street, photographs of the COUM logo of a dripping penis.

"That there, that's obscene, for a start. You know we can bust you for that."

And on and on.

"We've got your people already"—I think they had three friends of ours in prison at the time—"and you're next."

At nearly the same moment, in April 1973, we got the Experimental Arts Award from the Arts Council of Great Britain. That's what allowed us to plan to move to London. It was our first proper grant from the Arts Council. It came pretty fortuitously when we needed to leave. So, in May, Cosey and I packed everything we needed into the back of the truck, along with three cats and Tremble, our dog.

Before we left the house, we booby-trapped it. The bottom left side of the house was really starting to collapse. It had been shored up with various bits of scaffolding and wood. We removed as much of that as we could without it collapsing, and then we took the lock out of the front door so that anyone could come into the building. But if they went to the left and

opened the door, it would hit a piece of wood that would fall down and cause everything to collapse, including the two floors above. We were resentful of being threatened, so we rigged the place to fall down. When I look back now, I think that was a bit naughty—we could have killed someone. But at the time, it seemed like the right thing to do.

Then Cosey and I drove to London.

I was glad to get out of Hull that second time.

28.

Robin Klassnik, someone I'd become close to via mail art, and Cathy, his girlfriend—who became his wife—had an artist's studio in an old garment factory at 10 Martello Street in Hackney, which later became the place we called the Death Factory. Living in the building wasn't permitted, although people secretly did. I'd already been asking about how to get a place in this building, because I was thinking I was fed up with Hull. Robin said there was an empty place in the basement. "It's really bad, though," he told me. "It's totally damp, and there's no electricity, and there's no running water."

But these were conditions we were accustomed to.

"We'll take it."

We saw Spydee a few times socially because he eventually moved to London, too, but he was no longer involved in COUM. He moved into a grotty little flat in Earl's Court, while he learned computer programming. He realized instantly that computers were going to be a big thing, and they became really interesting for him. He got it straightaway. We went around to visit with him, and had a group grope for old times' sake. We took color slides—because I wanted to figure out what made pornography seem taboo or dangerous. Was it the way it was presented and photographed? So I took these slides while they were fucking, and it looked really boring in color. Then I developed them in our darkroom in black-and-white, and doing it so they gradually decayed, so you had to really look to see what was going on. As they got more decayed, they got, in a different way, more taboo, because it was as if they'd not been intended to be photographed. Spydee was funny because he could be quite reserved, but he was always up for a fuck. It was almost like this little ritual we'd all developed together.

Pinglewad moved to a cottage in Northumberland, way up in the north, and started doing batik. He'd taught me how to do batik when we were at school together, and we did two shirts for myself like that. Even now, he

still does very elaborate batik silk scarves that he sells at Selfridges and other high-end stores. He still lives in that same cottage, doing exactly the same thing as in 1973.

Fizzy followed us down to London—he even lived in our house. Reverend Lelli turned up for a while, too, when he was released from prison. He brought his prison boyfriend with him to London, and we put them into one of the squatted houses we eventually controlled in Beck Road. They stayed there for a little while, but they just didn't take to London. They went back to Hull. Lelli's an amazing person. I feel proud that he thinks I'm worthy of being a friend.

As for Gypsy, I don't know, because he was a full-on outlaw.

Others just faded away.

The Death Factory that we were offered was appalling. It was so damp and moldy that the floorboards had turned to powder and been covered over with linoleum. If you walked across it less than gently, your feet would go through it and you'd actually hit soil. It had no electricity, no water. It wasn't legally occupiable, but we improvised.

One corner still had enough surviving floor to support a box about eight by five feet that we built using random bits of wood and plywood. We made a tiny hidden doorway so you could get inside, and that's where we slept, in that box, for quite some time.

Next door lived a huge Australian called Bill Meyer, a giant of a man who did silkscreen printing. He had a friend who was an electrician and an inventor of strange gadgets. We paid him to come in and get the electricity to work. Now we had light and a tiny box to live in, and that was about it.

We were right at the edge of a park called London Fields, which had originally been where the plague pits were. Because we were below ground level, we were at the same geological level as hundreds of dead plague victims from the Middle Ages. So we nicknamed the building the Death Factory.

We would cross London Fields and go to Broadway Market, which in those days was very run-down. When we were there, there was an old-style butcher and a place that did jellied eels and horrible cockney seafood. A couple of miles beyond, in Bethnal Green, was the Blade Bone pub, which was at that time the headquarters of the British Movement—the neo-Nazis.

And also column Eighty-Eight, named after the eighth letter of the alphabet, which is *H*, with the double *H*'s standing for *Heil Hitler*. Hackney was a really run-down, really dodgy place to be.

It was dangerous.

One day a few months after we moved there, Cosey walked across to the market to get some bread. As she was standing in line at the baker, she heard some younger people in front of her talking and recognized they had a Hull accent. Of course, she said, "Oh, hey, are you from Hull? I'm from Hull, too."

"Yeah, we are."

"Oh, I'm Cosey."

They told her they were in a band called Rinky Dink & the Crystal Set. They'd just been signed to a major label. They'd been told they'd be the new Beatles. They were really excited, and they'd bought a house in Muswell Hill because they liked the Kinks and they'd decided they wanted to live near Ray Davies. They did record an album in the end, but it was never released.

As Cosey was chatting to them, they said, "We've been living in this squat just around the corner, and we're moving out on Monday. If you want, we'll give you the key and you can take over the house."

So that's what we did.

We went around there on the Monday morning, very early. They'd already left. We went in with the key. The first thing I did was barricade the back door with nails and wood. Then we started to look around this empty house.

While we were looking around, we suddenly heard all this banging and crashing at the back. It turned out that people in the IRA were living next door in another squat. They had decided that when this house was empty, they would take it over. So they were outside in the backyard yelling at us, "This is our house! Let us in!"

"No, you can't come in! Forget it. We got in first. This is our house!"

Then we just stayed in, because we knew we couldn't leave the house empty or they'd break in. Later that evening, one of the IRA guys from next door came around again, banging on the door. This time we opened the door, and there he was with a sawed-off shotgun.

"We're having this house. We've decided this is ours, and if you don't move out we're gonna kill you."

"If you're gonna kill me," I said, "do it now. And if you don't do it now, you're bullshitting."

He left with a lot of swearing and cursing. It turned out he was the only one living next door at that moment, so why he needed two houses, who knows. But for at least a year or a year and a half, he still lived next door, and it remained tense between us. If you went to the outside toilet, he'd be there, giving you the glaring eye. We always used to have to look—*Is he out there or not?*—before we went for a poo or a pee.

This is what was called a "two-up two-down" house. They were originally built in the Victorian age for workers, and two families would live in these houses. Upstairs there were four rooms: a small room right at the back, a small living room, and then two more small bedrooms. A family would live up there and go up and down the landing, as it was called. There was no hot water, no bath, no shower. A shared outside toilet served as the only facility for cleanliness for both the upstairs and downstairs families. To reach it you had to go out of the back door, through the small back garden, and around the corner.

Once again, there was no electricity. Eventually we got to know some other squatters who knew how to turn the electricity on. You had to forge a letter from the council and go to a particular shop where you could get the special mains—electricity fuses that you put in the first box inside the front door. Then you got electricity. Next you had to tell the council that you were living there, and they would have to make it legal. Then they would start to charge for the electricity—and in that way you were allowed to live there.

There were no fireplaces, no heat of any kind, but there was a gas stove. A few years after I moved in, I had some spare cash from Throbbing Gristle, and I got a bath put in the kitchen along with a small gas hot-water heater. I built a top for the tub, so it looked like a big worktable for doing your cooking on. Later, when Caresse was born, in 1982, I used to wash her in the kitchen sink. Boil the water on the stove in a pan and then put her in the sink and bathe her. And I couldn't afford what they call "diapers" here,

so I used old-fashioned towel nappies. I had a bucket with stinky nappies that needed to be cleaned and sterilized all the time. So it always stank of shit once she was born. That shows you how long it was before I got basics.

After a few months squatting in Beck Road, I got to know a new group of people through Robin Klassnik: Anne Bean and the Kipper Kids. Anne Bean was living in a squatted pub in the East End of London that was administered by a group called Acme Housing Association. Acme turned out to be two ex–Redding University art students who set up a housing association. They did all the research and paperwork, and they started their housing association with the idea of finding derelict houses and buildings that normal people would not be interested in but artists would be happy to live in. Acme would get them legalized so the council who owned those buildings wouldn't evict them.

A squatters movement grew in Britain in the 1960s, especially in London. Squatting proved a boon for the homeless and for alternative culture—for former hippies, artists, and radicals. On the street we squatted, Beck Road, not only did we have the IRA next door, but Ulrike Meinhof was hiding in one of the houses down the street, too. And so were some of the Angry Brigade, who were the British equivalent of the Baader-Meinhof Gang. That particular block was notorious in London, and the police came and raided it all the time.

There were about thirty buildings on our street. A lot of the ones that weren't squatted housed old people who'd been put there by the local council before the war. The council were gradually moving them out because the housing was now substandard and taking them to new "estates"—big tower blocks of apartments they didn't want to live in. They were moving people out into horrible "new towns," as they were called, and it was destroying all these old communities. Because we were friendly and would talk to the old ladies, they would come over to our house and knock on the door when they were told they had to move out. They'd say, "We're being moved out. Here's the key—we'd rather that you moved in than those Angry Brigade people" or whoever.

So I started to get more and more houses on our street. By then I'd gotten to know the people who ran Acme—they were big fans of William

Burroughs. One of the two guys who ran it said to me, "I hear that you're close to William Burroughs."

"Actually, he's my uncle."

Because he was such a fan, and he actually believed me—because we called him "Uncle Bill"—he agreed to make our house legal. Acme went to the local council in Hackney and told them that I was living there, that I would maintain and improve the building, that we were very responsible, and it would be great if they gave me a license so that I was actually there legally and couldn't be kicked out by the cops, et cetera. And that's what happened.

After that, whenever I squatted another house, I'd ring up Acme and they would put it on their list of houses. So I started to have a whole series of houses in that part of the street: number fifty, which we were in, fifty-two, forty-six, forty-nine . . . I ended up with about eight houses on the block squatted by friends, musicians, or artists. When I ran out of friends to give houses, I said to Acme, "Every time I get a new house, you can have it. And we would like it if you would put in artists with families." And that's what happened. I went on to donate between ten and fourteen houses to the Acme Housing Association.

The local council was so pleased with how well-behaved we were that they legalized them all. Eventually, in the mid-1980s, the council gave everybody a grant to have a new roof put on and to renovate them so that they had proper running hot water. The houses are still there: they've all been renovated and modernized, and they're still going strong.

In the beginning I wasn't paying for the Death Factory, so I kept that space in 10 Martello Street, too. One day, driving around in Doris Austin the truck, I saw a building site where they were demolishing some houses. I parked and told the workers I worked for a charity for underprivileged children and I really needed some wood: Could they donate the wood from the demolished floorboards and beams? They donated as much as I could fit in the truck.

I drove it all back to Martello Street, lugged it downstairs, and built a stage. First I screwed beams in both sides and put proper floorboards across, then I built a stage that was about two feet off the ground and that wouldn't

ever sink because it was fixed to the concrete walls. That became the famous "studio" where all the pictures of Throbbing Gristle and the speakers onstage were shot. You had to be a little bit ruthless to survive when you were squatting and living on zero budget. After Hull, where it rained inside the house, a dry house with an outside toilet seemed luxurious.

As far as I was concerned, I was doing good.

29.

When we went to London, no one knew who the fuck we were. It was a lot bigger than Hull. I remember somebody back there saying, "Oh, you're kind of famous, but you'll be a tiny fish in a great big pond in London and no one will be interested in what you're doing."

I didn't care.

We weren't trying to be big fish. We were just having fun and exploring things.

A lot of my time was taken up with doing mail art. My network continued to spread really fast. I'd get up in the morning and walk across the park with the dog, Tremble, and then make collages and write letters to artists in other places.

I very quickly got signed on the dole using the address of a studio directly above the Death Factory in Martello Street; we'd been declared unemployable in Hull, so we just needed an address, which the artist in there let me use. So our steady income came from my dole, but it wasn't enough to survive and continue to make art and pay the rent for the space on Martello Street.

Cosey started go-go dancing. The audition was in the King's Road. She asked me to go along because she was so nervous. She had to dance to one slow song and one fast song, and she was good—really good. Of course they hired her. At first, it was just topless, then it was everything.

Again through Robin Klassnik we'd gotten to know Roger Shore and his girlfriend, Nanny Rigby. Nanny's nickname derived from the fact that she'd been a nanny to rich people's children. But she had given up that job to do porn. Though a lot of the artists in these circles were meant to be cutting-edge, breakthrough artists, they were kind of prudish about what Nanny did. But, really, what was the difference? If you were doing the same things in an art gallery, the only difference was who was watching.

Nanny made decent money at porn. She suggested Cosey do some modeling with her. "We can do something really easy, like girl-on-girl, or pretend fake sex. I'll introduce you to everyone."

Cosey said, "Oh, I don't know if I could do that."

She hadn't really done much naked work with COUM at that point. That started more in London.

Cosey began with very mild soft porn, as they used to call it. Then there comes a time when the publisher says, "Well, why won't you do it with a man? Just pretend."

The Throbbing Gristle song "Persuasion," on *20 Jazz Funk Greats*, is about this process. "Well, why not?" "What does it matter?" "You could be anybody." And so on. After a little thought, that was the next thing she decided to do. It was the classic process of a little bit, a bit more, a little bit more.

One of the people she ended up working with was named Dave Sullivan. He'd gone to Swansea University to study business. The story goes that he finished his degree when he was in his early twenties and said he was going to be a millionaire by the time he was thirty. He decided the best way to do it was porn, so he started to do porn magazines and had a really good team of lawyers. He managed to somehow exploit British law so that he was the first person to publish magazines with erect penises in them. Then he was the first person to publish magazines with penises going into vaginas. He eventually started his own national newspaper. So he did become a millionaire, and he had a whole series of magazines. If you got to work for him, you could do one photo shoot, but it would appear in two or three different magazines. He was one of the kings of porn, and in order to get good jobs with Dave Sullivan, you had to have sex with him. Cosey told me that when she went to do her "audition" at his big house, he played Barry White, and he had this big, huge bed and white shag carpets and the whole thing.

My feeling was that it was a form of rebellion against her authoritative father who had suppressed her and bullied her and thrown her out of the house when she was nineteen. Whenever she said, "Well, what do you think?" I'd say, "If that's what you want to do, then do it. Don't build up new barriers or reinforce old barriers. Go where you feel you really want to go. It's your body."

30.

COUM Transmissions were doing a series of ritual performances in an experimental theatre called Oval House in Kensington, in London; it was one of those places that always let us do whatever we wanted.

For the performance, we got something like thirty cassette recorders and put a tape in each one and then switched one on every two minutes until all thirty of them were all going out of sync with all sorts of sounds and noises, forming a piece of experimental music. At the end of one of those evenings, I had been waiting for the Oval House audience to clear out of the main theatre space so we could begin the always arduous and largely unwelcome phase of tidying and packing away various props and costumes and lights and—always the most soul-destroying chore of all—untangling and winding the seemingly endless electric cables into super-neat figure-eight infinity loops. Right at that moment, as I sighed, resentful at my fate, wishing COUM had our own road crew to do this, a remarkable being I'd learn later was Peter Martin Christopherson came edging up to me, sidling sneakily closer and entering my personal space.

I feel pretty sure he could sense I was in a cranky mood. I recall very sharply that I was staring down at the floor, trying to marshal some really basic physical reserves of strength so I could jump-start clearing up. I was truly exhausted. This slim young guy in casual style, off-white, creased corduroy trousers that were a little baggy over his gangly legs appeared in front of me, seeming quite awkward—like a boy who has reached puberty at around twelve or thirteen years old and had a sudden growth spurt but hadn't quite figured out where to store his arms and feet when stationary. It felt like he had cascaded out of a washing machine at a launderette, entangled with all these other optional clothes, limbs, even personas, but was unsure if the body and look he was now inhabiting was correctly assembled.

"Genesis," he said, mumbling at the floor as if slightly embarrassed, "my name is Peter, and I believe you know William S. Burroughs."

"Yeah, I do, he's a good friend of mine."

"I've always wanted to meet Burroughs. Do you think you could help me get in touch with him?"

"Well, maybe, but I don't really know who you are. Why don't you come round and have a cup of tea and we'll get to know each other and then, yeah, probably we'll put you in touch with William."

So Sleazy, as he would come to be known, came to see me, and he showed me photos he'd been doing, incredible photos of young boys in medical situations, looking as if they'd been beaten up, really enigmatic and somewhat disturbing, which I loved.

His parents were titled aristocrats, and he'd had a fairly privileged upbringing and had gone to a private Quaker school.

His father had been along on the *Enola Gay* bombing mission as a British observer, and it just seemed significant that the two children born afterwards were blind. Sleazy was the first able-bodied son. After his A-levels, he had had a transfer scholarship to a university in New York. After university he came back to England, and he had already hustled himself a good job with the firm Hipgnosis, which designed all the early Pink Floyd album covers. They became renowned for ever more extravagant budgets, ever more extravagant photos, surrealist imagery that was actually shot as opposed to using software the way they can now.

Sleazy had started off his career with Hipgnosis by loading cameras and moving lights around according to what they wanted. But he had a knack for lighting, especially. He was brilliant about where to put lighting. He was a genius, in fact. He very quickly became indispensable at Hipgnosis, and they offered him a partnership, which meant sharing the money. That demonstrated how dependent they became upon Sleazy's skills and ideas. Sleazy was always pushing them away from benign psychedelia to a much more weird and warped, darker version of psychedelia and surrealism.

In fact, when we first met Sleazy, after asking to meet Burroughs, he said, "You don't mind being naked, do you? If you want, I got a job for you."

Me and Cosey were to be models for the cover of UFO's *Force It* album. They built a fake bathroom in a derelict house, and Cosey and myself were supposed to be enjoying forced sex in this bathroom with the shower on. She and I both had long brown hair at the time, in ponytails. In England, it showed the straight photograph, in the typical Hipgnosis style. In America, they faded us out so we were just faint ghosts, because it was too sexual.

Hipgnosis had an office in Soho, in London, on Denmark Street above where the Sex Pistols rehearsed. We'd see them quite often, going in and out. They would be doing their methedrine alcoholism with rhythm-and-blues garage rock, and we'd be upstairs, plotting the destruction of all rock and roll. The Sex Pistols thought I was weird, but Malcolm McLaren commissioned Sleazy to do some outrageous photos of the band. He asked for Sleazy to come up with something really shocking, and Sleazy did some shots that were for him very tame. I know John Lydon was in a straitjacket. A big deal. One of them was handcuffed to a toilet; one of them looked like he'd been badly beaten up. McLaren turned them all down as too outrageous, too heavy.

Sleazy told me that he'd always been gay, from his earliest memories. He often wrote down his fantasies—there may even still be one or two in my archive. He gave me some that he had written at school, and they were *heavy*. They always involved castration and torture, often of Sleazy himself. I remember once going to his house in Chiswick, and I noticed he had a vise in the kitchen.

"Oh, what's that? What are you working on?"

He kind of giggled and he said, "Me!"

"What do you mean?"

"I put my testicles in it and then I see how tight I can do it."

"What? Why would you do that?"

And he said, "I like it!"

He would do it until he said he could get his testicles like half an inch thick. It was terrifying to think of.

It was Sleazy who in 1980 would discover Mr. Sebastian, without whom myself and hundreds of TOPY individuals, Psychic TV fans, and readers of the book *Modern Primitives* wouldn't have been pierced. But the reason

Sleazy got in touch with Mr. Sebastian, at the very beginning, wasn't just because Mr. Sebastian was the only person he could find who did piercings. Sleazy was obsessed with the idea of being castrated, and he'd heard rumors that Mr. Sebastian might be prepared to castrate people. In fact, that wasn't true, and Mr. Sebastian was adamantly against it, but people did write to him on a regular basis saying, "Will you castrate me?"

Sleazy was one of them.

When we met, he was already doing a lot photography and was starting to make photographic imagery that mirrored the fantasies he had written about. He would pick up young boys at Playland, a classic game arcade out near Piccadilly, where the boy prostitutes hung out. It was a classic game arcade. Sleazy was young, of course, but he had an old mind in terms of sex; already by his early twenties he had a very well-refined, perverted mind. He would pay the boys to be in his photos, which would be simulations of violent situations. He'd make it look like they'd been disemboweled and were trying to hold in their intestines. That's one I distinctly remember. Later, he got Monte Cazazza—the San Francisco performance artist I'd met through mail art—to do one where he had big crocodile clips on Monte's nipples going to a car battery, which he actually did use to electrocute him. Which, to my surprise, Monte enjoyed. He just got more extreme, and eventually his big thing became shit. You can see why I called him "Sleazy."

I think he was trying to impress me in the beginning, because he wanted me to introduce him to William Burroughs. He wanted to seem as perverse as William Burroughs might expect or wish, based on his idea of what William would like. I wrote to William and said I'd met this guy who does really beautiful photos that I think you'd like because they're kind of "wild boys" in a way. I got Sleazy to send William about eight photographs, and originally they were going to be used as illustrations in some book project William had in the works. William wanted to use the photos, but his publisher refused. That left Sleazy a bit deflated. His dream was to be the man who did photographic images for a Burroughs books. William knew better. William had been through an obscenity trial. He knew it wasn't fun, and he knew that it could backfire terribly, and you could end up in prison for a ridiculous length of time. It wasn't romantic. It's a bit like those people

who think that if they shoot up and become junkies, they'll write a novel like *Naked Lunch*. They never do.

The world is littered with fake Burroughses.

But Sleazy and I got on really well, really fast. His references and mine were the same. Cosey hadn't read any Burroughs or the Beats; she was a party girl. Sleazy soon wanted to apply the tape recorder experiments in Burroughs and Gysin's book *The Third Mind*, and he helped when a few years later I convinced Burroughs to let us compile *Nothing Here Now but the Recordings*. In London, COUM had become in essence just Cosey and myself, which worked well—male-female archetypes, stereotypes, sexual taboos, censorship of our bodies, these sorts of things could be explored. Sleazy supplied a sounding board for my analysis and projections of where COUM needed to go next. I really needed a like-minded individual. His being gay, and perverse by nature, added another layer of performative speculation—not an addition to the male/female archetype, but an additional, counter perception. Sleazy arrived at the perfect time, as he was a perfect foil and understood my ideas instantly as well as supplying new, non-heterosexual scenarios—and, of course, the ever more convincing wounds.

Around the same time, John Gunni Busck became peripherally involved with COUM Transmissions. He was the son of Bruce Lacey, who was quite well-known in the British art world of the 1960s and 1970s for making animatronic robots that were sort of cobbled together. Bruce exhibited in art shows and got a lot of publicity because his works were considered weird and wonderful at the time. Bruce Lacey was the caretaker of 10 Martello Street, and both he and his son John used to come down to our Death Factory studio space to hang out and talk and share ideas. In return for being caretaker at Martello Street, Bruce had a free studio space to make art and do performances. As we pondered moving towards some form of radical new music project, we were talking to John about it. John said, "I have this friend, Chris, who makes modular synthesizers. Why don't you meet him and see if he could help, or be part of it?"

John and Chris Carter had been doing little weird multimedia performances together with light shows, and sometimes doing them for straight rock bands. At the time I knew nothing about Can, Neu!, or Faust. I didn't

like Roxy Music, so I didn't listen to Brian Eno. But Chris had about thirty Tangerine Dream records. We used to make fun of him: "Ick, you have synth bands."

But when I saw what Chris was doing, and got to know him, I asked him to get involved with COUM Transmissions. He first used his modular synth at the Royal College of Art, alongside John, when we did *Music for Stocking Top, Swing and Staircase*. He stood in the background on the stage with this huge, lumbering modular synth, doing ambient background music. So he kind of filtered into the projects that way.

As we began experimenting more with music, we would meet on Fridays, go over to Martello Street, build equipment, build speakers, build effects, and then just make noise, jam, record everything on a TDK cassette recorder.

Meanwhile, COUM's reputation was expanding. In January 1974, we got invited to put on a work we'd conceptualized with Paul Woodrow from Calgary, Canada, whom I'd met back in 1972 in Nottingham at a postal arts exhibition at Midland Group Gallery. He and I corresponded and became friends. We met again in Nottingham in June 1973, and that was where we started discussing an idea of a piece of music based on bicycle wheels. So we brainstormed back and forth and it developed. Paul had a group of performance artists in Calgary called W.O.R.K.S., so we called the resultant piece *Marcel Duchamp's Next Work*.

Now we had been invited to put *Marcel Duchamp's Next Work* on in Ghent, at the electronic music festival, and also at the Palais des Beaux-Arts in Brussels—which was a really big deal. For this performance, COUM was just me, Cosey, and Paul Woodrow. We went over in the truck, and with student volunteers created twelve bicycle wheels in different colors, and then performed the piece in both locations.

Marcel Duchamp's Next Work consisted of twelve ready-made bicycle wheels, each one painted a different color and arranged around the twelve points of the clock. The scores were also circular, with spokes like a wheel, and in each segment, like the segment of a cake, were instructions for things to do to the wheel. Play it with a violin bow, play it with your fingers, pick it with this, do that. All of them were mic'd up with contact microphones.

Some of the segments had colors as well. Each of these scores was the same color as one of the bicycle wheels, but not every section had the coloring. We had slides projected, and we used the twelve colors of the bicycle wheels. Sometimes there would be only one color, sometimes lots of different colors, sometimes two, but you could play your bicycle wheel only when your color was on the screen. So it had a double score. If your color came up, you looked at your bicycle wheel score, and if it was a color there you did one thing, if it was just a gap, you did a different thing to the wheel. It would say how long you did it for as well. It was elaborate and carefully thought-out, for once. To the second. It was also a conceptual piece, which was a big shift.

We got rave reviews for the bicycle wheel piece. The classical music critic of the Belgian national paper said it was genius, that it was one of the most important new scores of modern music, was over the moon and just waxed lyrical about how incredible this piece was. Even Brian Eno showed interest in COUM, attending a performance at the Architectural Association.

31.

We used to have what we called acoustic do-dahs at the Death Factory. They were basically parties where anyone who was visiting joined in; my drum kit was up on the stage that we built, and people had the option of playing any of the musical instruments lying around, or singing, or screaming, or talking, or running around. It was hard for many guests to resist playing the drum kit—badly—probably because it was the loudest thing in the room. And we recorded everything.

Our acoustic do-dahs were our version of being on the bus with the Merry Pranksters, where they recorded everything, too. Most of that wasn't worth recording, and likewise, with most of what we did, it really wasn't worth recording, but the energy there was moving us towards the big shift. By 1975, we were all coming to the same conclusion, which was that we couldn't get much further with corrupting the culture towards real change by continuing what we'd been doing with COUM. That sentiment was just in the air.

By the time I created theatre pieces like *COUMing of Age*, I was aware that tickets would be sold for seats, imposing far more traditional structure on what could be expressed and seen. I personally never really felt comfortable with that level of formality. My preference had always been for random, informal interactions with a public that had no preconceived notions or expectations of the stereotypical audience-performer relationship.

With the formation of Throbbing Gristle, our approach to an audience became more consciously anti-entertainment and confrontational.

The idea to form the band came from an unlikely source: an old World War I veteran I used to sit with in the pub near our squat in Hackney.

This old man had been gassed in the trenches and had a really hard time breathing all the time. He would tell me about the war. What it was

like having this poison gas coming across towards you and not having a way to get away.

One day he said to me, "I understand why you are doing this stuff, because I know you. But would the other people in this pub get it if I tried to explain it right now?"

"I don't think they would," I answered.

"So why don't you do something that communicates with the maximum number of people?"

"Like pop music, or what?"

"Yeah, like pop music," he said.

And I thought, *Hmmm.*

The art world were starting to accept COUM as a formula, and they liked it.

They *wanted* us to be naughty.

It's lost its impact.

Back at the Death Factory, I looked around. There was the drum kit and an old Burns bass with no strings or pickups. Maybe we could fix it up and that could be one of the instruments?

I began to think: *What don't we want in a band, if it is to be something modern, a new kind of band?*

We definitely didn't want a drummer, because they immediately limit the way the music evolves: you get trapped by the beat. After all, what is rhythm? Just one clap followed by another, at which point you're stuck in time. Most drummers play in western music patterns, and they'll do particular patterns that rarely vary, and those in turn demand and create and make almost inevitable the response of the other musicians. Since I'd been the drummer before, I did think we needed *some* kind of rhythm. That old Burns bass guitar—it turned out to be a really valuable prototype of the classic Burns bass—had been left there by somebody. It had no pickups, no strings, no knobs, nothing, just the body. Chris took it away and put knobs on and redid the wiring and everything. He put in humbucker guitar pickups—incorrectly, since humbucker pickups were actually for a lead guitar. But we didn't know anything about guitars. And the use of the wrong components turned out to be brilliant. That became my bass for TG,

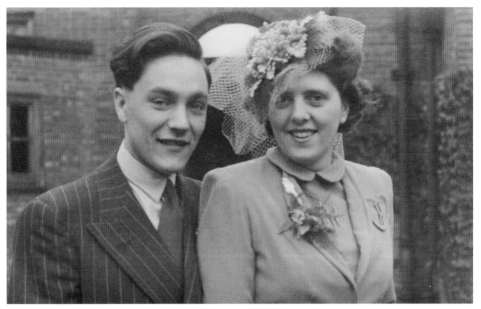

Ronald and Muriel Megson, June 30, 1944

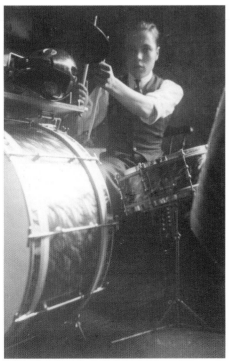

Ronald Megson playing drums, 1936

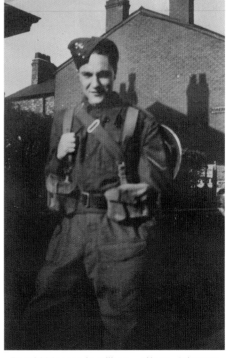

Ronald Megson in military uniform, July 1942

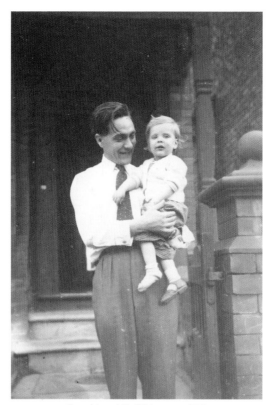

Ronald and Neil Megson, 1951

Cynthia and Neil Megson, 1951

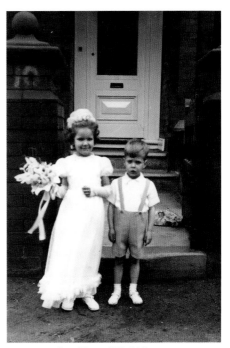

Neil Megson in cowboy costume,
Victoria Park, Manchester, 1953

Cynthia and Neil Megson
at Cynthia's christening

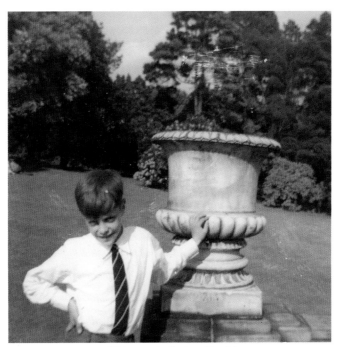

Neil Megson in Gatley, Cheshire

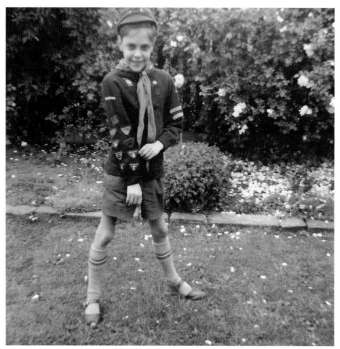

Neil Megson in Wolf Scouts uniform, 1960

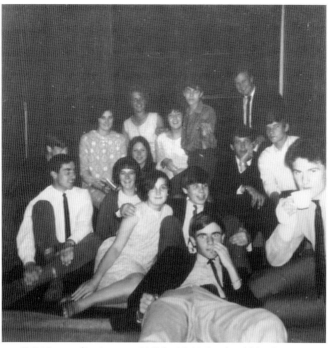

Neil Megson (back row, middle) with high school friends, 1966

Genesis P-Orridge playing violin
in COUM Transmissions, early 1970s

Genesis P-Orridge playing drums
in COUM Transmissions, 1971

Genesis P-Orridge in London, 1973

Genesis performing "Omissions" Action with
COUM Transmissions in Kiel, West Germany, June 1975

Genesis singing in Throbbing Gristle at Centro Iberico, January 21, 1979

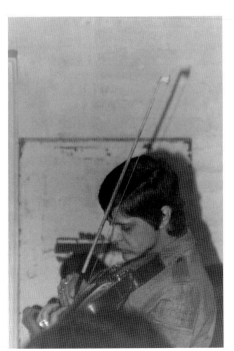
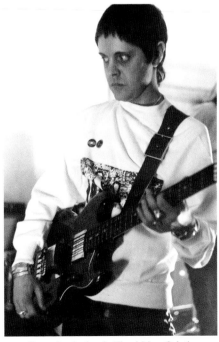

Genesis playing violin in Throbbing Gristle
at Centro Iberico, January 21, 1979

Genesis playing in Throbbing Gristle
at Butler's Wharf, December 23, 1979

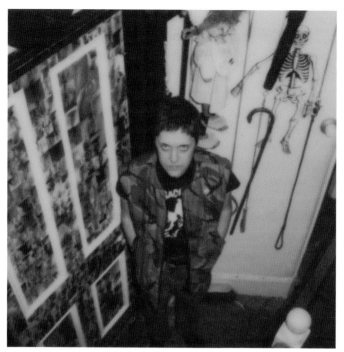

Genesis in the hallway at Beck Road, 1979

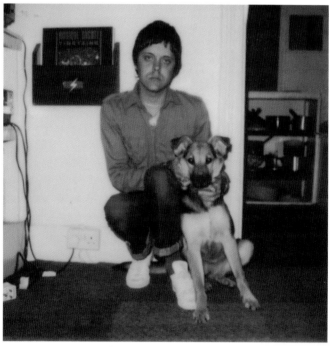

Genesis and Tanith, 1980

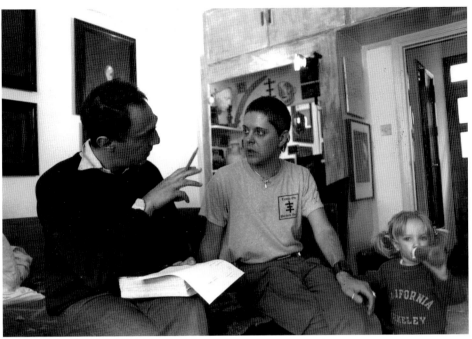

Derek Jarman with Genesis and Caresse P-Orridge, 1984

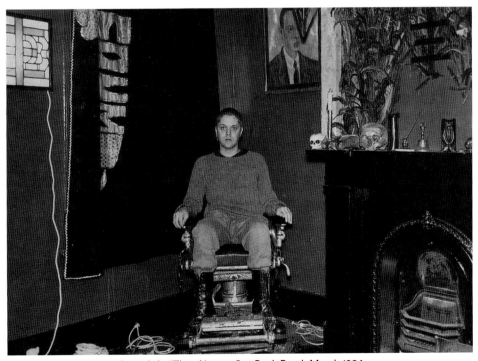

Genesis in "Thee Nursery" at Beck Road, March 1984

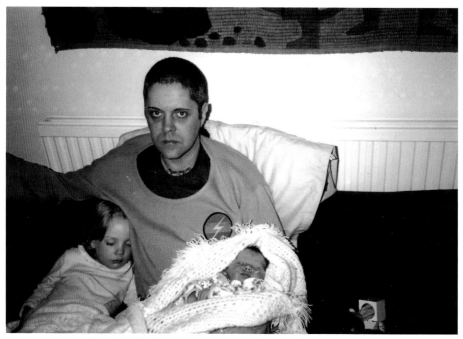

Genesis with Caresse and newborn Genesse, Beck Road, 1985

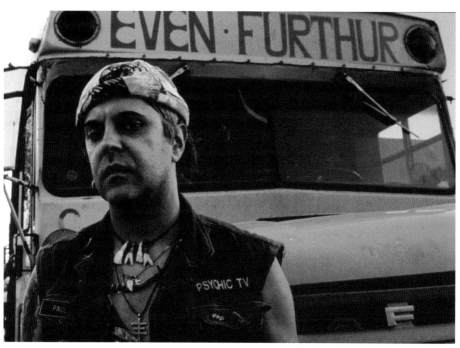

Genesis with "Bussy," U.S. tour, 1988

Genesis post-ritual, Brighton, 1989

Genesis performing with Psychic TV,
late 1980s

Genesis and Glen Meadmore,
Ventura, California, 1989

Genesis and Genesse P-Orridge on horseback on Himalayan trek, Nepal, 1991

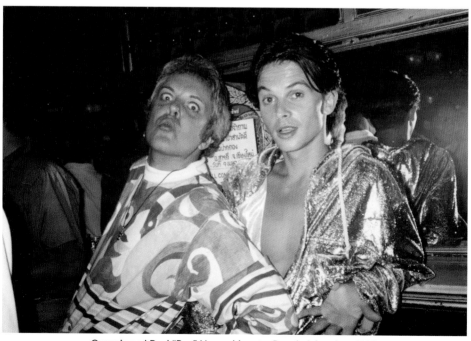

Genesis and Paul "Bee" Hampshire at a Bangkok boy bar, 1992

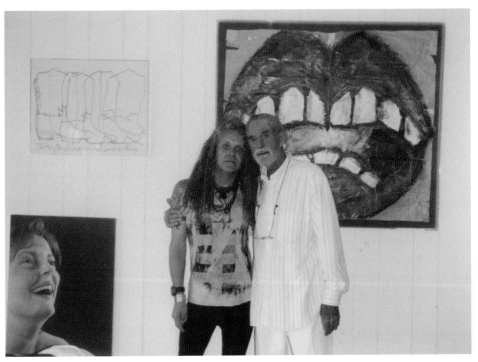

Genesis with Timothy Leary in the latter's studio, August 1994

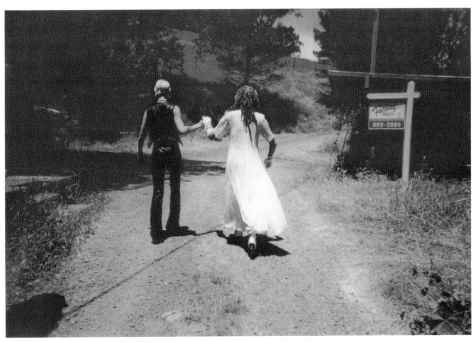

Genesis and Jackie's wedding, June 13, 1995

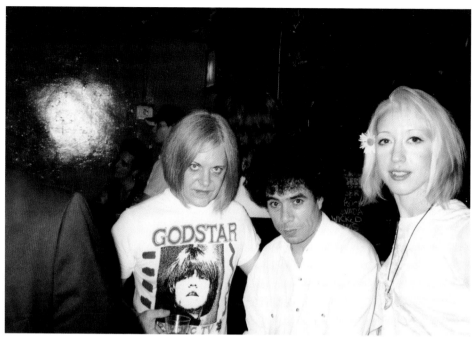

Genesis and Jackie with Bachir Attar of the Master Musicians of Jajouka, New York City, 1997

Timothy Wyllie, Genesis, and Jackie, San Francisco, 1999

Genesis and Jackie, Kathmandu, Nepal, 2000

Genesis Breyer P-Orridge at "Thee Gates Institute," Ridgewood, New York

Genesis and Jackie, 2003

which had a very particular sound. And since I didn't know any notes, I would hit it in rhythmic patterns, percussively, with my right hand wearing a leather glove.

When it came to guitars, I always found that guitarists were constantly trying to riff, and eventually it just became boring prog rock. So we needed somebody who couldn't play, so they would do something unique and original, even if only every now and then. Plus, it was always men on guitar—always cock rock—so it would be great to have a woman on lead guitar.

"Cosey," I said, "you don't like guitars. So you can be the guitarist."

We went and got her a Satellite guitar from Woolworths, the cheapest thing available. It cost fifteen pounds.

She put it on.

"Oh, it's heavy," she said.

So we just shaved off the wood, sliced off all the wood we could, and gave it back and said, "What about now?"

"That's much better," she said.

Then we just painted it black, and it retained that design that later on everyone made, the really narrow guitar.

Sleazy was really into Burroughs and cut-ups, and we talked a lot about ways that could be applied to rock music. We'd been listening to lots of John Cage, Stockhausen, and so-called modern classical electronic music. We were convinced there was a way to cross fertilize a sort of post-*Fluxus* electronic art vision with popular culture and rock music. But what would that look like? Sleazy recently went to Japan for a job with Hipgnosis and came back with six Walkmans, this new thing. They allowed him to explore his interest in tape recorder experiments, and he started messing with those. He bought some special parabolic microphones so he could listen in on conversations in the park, and from his window he could record boys playing football from his window. He was doing a lot of espionage field recordings.

Chris had already built his massive modular synth the size of a coffee table. He was a real electronics nerd. So he had this massive device as big as a fucking coffee table. He and Sleazy liked going through electronics magazines, and at some stage they found these circuits to build, which would

eventually become the Gristleizer. Of course, the circuits came out wrong, so it sounded totally different to what was meant to happen.

But it was perfect.

At that point we each had something to play.

Okay, this is the band.

It's what we have.

Not *Whatever this makes is the music we make.* No, the other way around: *This is the solution.* It didn't matter what the usual band was like. This was ours.

Sleazy started to doodle with all of his Walkmans. Chris was on his synth. Cosey was learning to make sounds on her lead guitar. Because we couldn't play, there were certain tricks you could use. Echoes and delays, for instance. Anything that had echoes on it became psychedelic and intriguing. So we said to Cosey, "You gotta have an echo."

So she had an echo delay, and that was pretty much it for a while.

I had echo delay on my bass, too, and we had a Fuzz Face and a Cry Baby wah-wah, like Jimi Hendrix—and a space echo. A really good example of what all of that could do is the later Throbbing Gristle track "Six Six Sixties," which is just me on bass guitar playing a kind of counter-rhythm to the rhythm that comes off the echo deck.

We decided our sound would be whatever evolved from the skills—and lack thereof—of the four of us combined. Whatever we ended up making as a sound would be the new sound. Every Friday and Saturday we would go to Martello Street and play for an hour or two and record everything on a cassette deck. I'd take it back to the house afterwards and listen. If there was anything I liked, which at first there wasn't much of, I would dub it across to a new cassette until it was filled up. We called that our "best of." We would listen to the "best of" and decide whether we could possibly re-create bits of it. How had we made that sound we liked? We would try to re-create it and record that. And then we would listen to the subsequent "best of," and so on.

It was a mixture of reduction and improvising with whatever was available. People, their instincts, their impulses, and whatever was lying around.

Of course, that approach to music was based on the same process I was doing with the Exploding Galaxy. Why do you have to wear what you always

wear? Why is your hair the same as it was yesterday? Why are you using a knife and fork? Why were we doing things the same as before?

Everything needed to be challenged.

That attitude always stayed with me; it's almost an automatic thing now. It's just: what's there, what's it meant to do, what might it do, what happens if you do this the wrong way around? It's sort of a theoretical process. I look at a situation and strip away anything I don't need. What is there that I'm only assuming should be there because it's usually there? And what can I take away? Whatever is left is the essence.

In our old age, we've come to tolerate certain habits and routines—our cup of tea has to be just so, for instance. Of course, we'd be in shit for that with the Galaxy. That would be an absolute no-no. But by and large, outside of our tea, we often still stop and think, *This is a routine.* We like it because it's comfortable. It's like an anchor. But is it actually *useful*, or are we just being lazy? We do still do that. Always thinking of new ways to do things. Staying fresh. Staying flexible and able to improvise in the moment—which can be applied to survival as well, of course. And will be, we bet, in the next twenty years.

With TG, we were saying, *Let's do this band that way.* And once again, with music, too, this approach worked.

The initial sound was abstract and nearly all instrumental, sort of orchestral and swirling and symphonic. Over the course of a year or so, we gradually refined in a very methodical but totally nonmusical way to a new sound, one that we could re-create enough for it to seem convincing. At some point during this period, it became obvious that while we enjoyed doing instrumental music, it was too "easy." That is, it didn't challenge the status quo enough. At the outset, I expected the band to be more like the Sonic Arts Union, a kind of post-*Fluxus* rock band. But it soon became obvious that for it to be convincing enough to get people's attention or to allow us to perform in public spaces that were not art-oriented—pubs and rock venues and so on—we would have to compromise by having vocals sometimes. So we needed a voice. We needed stories. We needed words. We needed lyrics.

Everyone turned to me and said, "Well, that's what you do."

I'd been writing poetry forever. I had been determined to try every style and read every book of poetry I could find and then strip it down and try to find out how it worked, and why it worked, and why certain things were touching and other things weren't. To this day, I write something every single day. The thing that I've spent the most consistent and serious attention to throughout my life is poetry and words. Everything else sort of flowed from that. If I hold anything sacred, it's that: language.

When we had an idea for a subject and a sound—which is much closer to what we did, rather than saying "We are going to write a song"—we'd make a sound we liked and they'd say to me, "Do you have any stories you think you could tell over this?"

And I'd talk about something I'd been mulling over.

So I was in essence voted in as vocalist.

A vocalist I admired was Frank Sinatra. I really loved Frank Sinatra's phrasing—especially on the song "Laura," where he sings "Laura is the face in the misty night." The phrasing is everything. People are often surprised, but I would later bond with Ian Curtis of Joy Division over long conversations on Frank Sinatra and his phrasing. His phrasing was a little bit like jazz or like the alto in medieval music, meaning that it's in the space that's not traditional. You have high notes which are the melody, the low notes which are reflective of the rhythm—they hold it down, the foundation—but the alto is kind of moving back and forth between accenting it. It's the accent of the story and the lyric. It's the punctuation, the exclamation marks. We just love the way that words work against music, the way you can stretch where they are placed. If you make it too mathematical and everything is exactly where it's expected to be, it becomes sterile. Where is the emotion? The emotion's hidden in those stretches and the strange conjunctions that are not logical, but emotionally speaking, they are exact. It's finding those emotional places that no amount of rigid conformity or traditional skill could ever take you to.

With Throbbing Gristle, the music was so different that I had to look for voices that fitted this new sound. That was a whole extra experiment, which could only happen by improvising and letting go and not feeling intimidated or embarrassed, just making noises with my throat and seeing how it interacted with the other noises. I'm not even sure the rest of the

band realized to what degree I'd actually had voice training, but I found it all much easier than I expected. Having grown up on the Velvet Underground and Bob Dylan, I knew that a deadpan voice could work—that you didn't have to have a clear melody, that it was the delivery that mattered, and the phrasing that was important.

So I developed my own style.

There was a German sound poet, Ernst Jandl, who played me a lot of sound poetry tapes, and they were highly influential on my approach to vocals with Throbbing Gristle, too, in terms of freeing up the idea of what it could be. It didn't need to be literal sense, and it didn't need to be melodic in any traditional rock and roll way.

I'd done some work with gestalt and also some with Gurdjieff techniques and the Tibetan technique of finding your true voice by getting stones to resonate with your voice. So I started to incorporate those ideas into the microphone, and I made friends with the microphone, discovering it was possible to make the microphone vibrate and resonate the same way stones or metal did. And once that happened, I realized there were no limitations at all except . . . inhibitions.

As far as the lyrics, there was a whole new landscape available, populated with different characters. And each character would sing its own separate songs. Even now, I experiment with a song lyric or an idea for a song until I get a voice that goes with it. So in a way each, one of them has a person that talks—and none of them need be me. Just as none of them has to be the voice I usually speak with. They can be all kinds of people. I always found it odd that people would sing every song, no matter what the subject, with more or less the same voice. The song is a story, a compact message, and hopefully a communication that will be recognized and have some kind of resonance and empathy with other people you've never even met. So each can have a storyteller. That's also why we're so fascinated with troubadours; as time goes by, we've got more and more interested in troubadours in France, and how they would travel around and were responsible for what became history. Whoever records a song is the one who tells the story that is going to be accepted as canonical. So it's a huge responsibility as well as being a fascinating thing.

One of the reductions we made was that we refused to put on fake American accents—and we wouldn't do fake blues-rooted music. We were trying to get away from all the old systems that rock music had been based upon, which was rhythm and blues, jazz, deep blues, and so on. We wanted to get away from that and make music that reflected our experience—or really *my* experience, in that I wrote all the essays about what it represented or what to imagine when you were listening.

Take a piece I wrote for a press release for a gallery show: "Imagine all the people have gone, the city's empty, and there's rats running around, and there's papers blowing in the wind, and things are crumbling in the background, and the apocalypse has obviously happened, and you're suddenly stranded, lost." That's what we were trying to convey.

The very first song lyric I ever wrote was "Very Friendly," which I still think is a good song even now.

I'd just read the book *Beyond Belief* by Emlyn Williams, about Ian Brady and Myra Hindley. I was born and raised in Manchester until the age of fourteen. I can remember, quite vividly, when the Moors murders first hit the papers. All of a sudden, I couldn't just go out when I wanted. Up to then I'd always been able to get on my push bike and go off to the park, or play in the fields behind the housing estate, or whatever. I could just go out and come back whenever I wanted, and no one was ever concerned. Everybody left their doors unlocked, other people's mums were called "Auntie." It was all very open and safe, secure, very much like the old BBC police show *Dixon of Dock Green*. If you've never seen that program, it's one of the first English police programs, and in the beginning the title character would stand there, and there'd be this really corny harmonica music and he'd go, "Evenin' all." He was your down-home nice bobby who always solved everyone's problems, and there was never any violence—just arguments or somebody stole a bottle of milk, and that would be a whole episode. That was the mood after the war: there was this nostalgia for their imagined world before the war, which never really existed, but they all had this weird nostalgia for the prewar moment. Suddenly, with the Moors murders, people completely freaked out. We were all told we couldn't go

out after five o'clock. Our lives were subject to all sorts of restrictions, with no explanation of why.

Eventually Ian Brady and Myra Hindley got caught, and it became a big cause célèbre, because there'd never been a serial killer of children before. What really freaked people out was that Myra Hindley was helping. She would drive the car, and she would pull up and say to this young boy, "Oh, hey, do you need a ride home?"

Nobody thought to be afraid of a nice lady, so children would get in. Then they would drive them to their house and entrap them. They were very modern: they made tape recordings of the torturing of the kids before they died. And they took photographs of them as well. They were documenting it all, almost like an art project. Ian Brady, it turned out later, would record Hitler's speeches on a reel-to-reel off the TV and then send them off and have them turned to acetate albums so he could play them on his record player. He would learn them all by heart while he drank German wine with Myra.

That's why the chorus of the first song I ever wrote is, "Ian Brady and Myra Hindley, very friendly."

Then the rhythm begins and it's like, "It was just an ordinary day in Manchester: Ian Brady, drinking German wine." The "German wine" and the "very friendly" became repeating patterns. And the rest of it is the story, a bit like "Lady Godiva's Operation" on the second Velvet album in that it's a true story unfolding to a minimal backing. That was definitely a reference in the back of my mind—that you could tell the story in a very straightforward way, without leaning either way emotionally with the voice. Also like the Velvet's song "The Gift," where John Cale did the voice in his Welsh accent, very flat again. So, definitely, the Velvet basically gave permission to tell stories that could be much more unpleasant than had been told in pop music before.

Whatever can be in a newspaper or on the TV news and is considered newsworthy and dramatic and sensational enough for them should also be fair game for the lyricist of a song. Of course, it turned out that other people didn't agree with me. But that was one of my positions: that from the very beginning, from pre-medieval times right on through, it was always about

storytelling. Greeks songs and theatre were ways of preserving stories, and some of those are gruesome and vicious, as is Shakespeare. In a sense, it's the return to the origin of the lyric. It needn't be reduced to clichés about unrequited teenage love—there is so much more going on out there. I took that sense of "permission" from Lou Reed and Bob Dylan, and then took it right back to the concept of the songwriter as troubadour preserving the stories of the time that have universal import. And part of that message, as far as I'm concerned, is just how corrupt and fucked-up human beings really are and what they will and won't do given the opportunity and the belief that they'll get away with it.

When it came to the name of the band, I wanted to have a stupid name. I was aware that, after a certain point in time, if a project keeps going, people forget the original meaning and just imagine the project when they hear the words. With Throbbing Gristle, for instance—or, as Burroughs misremembered it once early on, Throbbing Member—people would no longer picture a squirting penis. They'd just go, "Oh, that band."

And it worked. People said it without blinking.

On September 3, 1975, I went for a walk in London Fields in Hackney, London E8, with Monte Cazazza. We were talking and trying to come up with a name not for the band but for the *music* Throbbing Gristle was making, and we kept using the word "industrial."

Industrial music.

One reason for my obsession with things "industrial" was because I saw "industry" as a symbol of the previous way that Britain was—the Victorian era. My experience of Britain growing up had been very much decay. Then we got to the 1960s, where there was a moment of apparent prosperity and the realization that young people had money and could be exploited to spend it, which gave a brief respite from the decay and the collapse. I realized the vast majority of people had been tricked into imagining they were taking part in a great moment. After a brief, beautiful solar flare in the 1960s, society very quickly sank back into itself, into skinheads and the British Movement and punk. To me, it was always obvious that in fact we lived in a new version of feudalism. It was just like the Middle Ages. We're

serfs. We're raw material. They'll use us as long as they use us, and then they won't care at all.

Forty-five years later, however, industrial music is still a global phenomenon.

It's become like jazz; there's lots of subgenres, and there's shops and clothes and T-shirts and DJs and clubs and thousands of bands. That's what matters: not whether you made a piece of art that's on somebody's wall or in someone's record collection. It's about the impact it has in liberating other people.

These days you can go literally anywhere on the planet and find a community of people making music based on our ideas. It's incredible. And they don't even have to know I exist, which is even better.

32.

Walking along Kings Road one day in 1975, someone called out, "Genesis!"

I'd nearly walked into John Krivine—the secretly wealthy bachelor from Hull University who'd gotten hold of the very first Ho Ho Funhouse, at the ferry pier.

"What are you up to?" he asked.

"Well, I've got this band called Throbbing Gristle. We're living down in Hackney."

I asked what he was up to.

"I've got a shop down here. It's called Acme Attractions."

"Really? What kind of clothes do you sell?"

"Mod."

So he took me there. Inside was a Lambretta scooter and lots of mod clothing, suits and retro. Don Letts, who would go on to make *The Punk Rock Movie*, was the person selling the clothes. We hung out, got on okay, and stayed in touch.

Then one day John rang me and said, "You know all about music, don't you?"

"Not really. I know some."

"Oh, well, I'm trying to get a band together."

"Why do you want a band, John? You've never shown any interest in music before."

"My main rival is this guy Malcolm McLaren. He has this shop called Sex across the road. He has a band to advertise his shop called the Sex Pistols."

"Oh yeah, I've heard about them."

"I want my own band for my shop, to advertise my clothes."

"What you gonna call it? Acme? That's terrible."

"No, no, no," John said, "we're gonna call it Chelsea, because the shop's in Chelsea."

I wanted to tell him it was a crappy name, too.

"Well, that's a bit better, but I don't know."

He said, "Would you come down? I'm auditioning for this band, but I don't know how to pick anyone."

"All right."

When I met him, he took me to an archway under the railway. It turned out one of his side businesses was selling antique jukeboxes from the U.S.A. He refurbished them and sold them at exorbitant prices to rock stars for their houses. So he had all these jukeboxes everywhere, and there was a little stage set up with some amps and a drum kit—the Damned rehearsed there as well. And a bunch of young kids had gathered to audition for this band.

There was to be a drummer, a guitarist, and a bassist.

John already had a singer he was insisting on: Gene October.

"Why him?" I asked.

"Well, he's a hustler in Piccadilly. He's a male prostitute, so he's real street. I thought it'd be really good to have a hustler as the singer. That's really punk."

"Is it? If you say so. But can he sing?"

"Well, yeah."

"Are you sure?" I said.

"Uhhh, no."

"Then he can't really be the singer—even in a punk band."

"It doesn't matter how you sing if you're punk."

"I don't think that's a good idea."

"Gene's the singer."

So the kids there to audition were backing Gene.

We sat there in these two chairs, and different poor little boys came on and started playing. And John would go, "What do you think?"

"Eh."

And John would say, "Okay, sorry."

Then in walked a kid named Bill Broad, who wanted to audition to play guitar. At the time, Bill had black hair with pointy Mr. Spock sideburns. He looked really good, and he had a very interesting way of moving onstage

when he played, with his legs moving in a weird way that I thought was really interesting. I said to John Krivine, "You gotta have him. He's a star. He's amazing."

As drummer, I picked John Towe.

Then Bill Broad said, "I'm not going to be in the band unless my friend Tony can play bass in it."

This was Tony James, who was later in the Sisters of Mercy. He went out with a woman who did children's programs. And it was obvious from the start that he was an asshole. I said to John, "That's up to you. I've done my bit. I found the star. I'm out."

So John had his band, Chelsea—with this awful singer who just bellowed. Which was crazy, given the presence of Bill Broad. Not surprisingly, the band I actually picked—with Bill singing—went on to have success. Bill changed his name to Billy Idol, and the band became Generation X; I actually get mentioned in their official bio, for what it's worth.

Next thing John wanted was to change the look of his clothing shop to make it more punk. So he rang me up again and said, "Could you design a shop for me? I want a really wild, weird, outrageous shop."

My first suggestion: "You should have a shop, John, where there's only one item for sale, and nobody knows what it is. They buy a token for the price of the item and they put it into a machine, and they get a mystery box and that's what they get. And it's whatever we decide it is."

I thought it was a great idea: the shop that makes you buy things that you don't even know you want—sounds pretty much like the world. But John didn't think it would be a big success. He thought it was too arty.

So I got Sleazy involved, because he was really good at design and graphics. John didn't have a new name for the shop or anything. In fact, it was Sleazy who came up with the new name, Boy, which is still going around the world to this day. It was genius name.

Then we came up with another idea: we would pretend that as the shop was being designed and prepared to open, a skinhead boy had broken in and accidentally set the place on fire—and died in the fire. Basically all that was left of the skinhead boy was a Doc Marten boot with a bit of his leg sticking out. Sleazy was incredibly good at doing fake injuries and blood and gore.

He created body parts and installed them in glass display cases that became the window display. Inside the shop were all these front pages of different newspapers with headlines about boys dying, which I'm guessing Sleazy had saved for himself, because he had them ready to go straightaway. He must have had a collection. Then we made one corner of the shop look all burned out, and it looked amazing. My other contribution was the Gary Gilmore Memorial Society T-shirt. John Krivine added zips and all that kind of crap to make it punk. It was the first T-shirt Boy did.

The shop opened and attracted a big crowd of the new punks. And, of course, the police came. They seized the three display cases from the window, absolutely convinced they were real human remains. I don't know why I got so pissed off at the cops, but I pulled out a big, thick knife and had to be dragged away before I got arrested. Don Letts was there filming the whole thing.

Do you know how much John Krivine, the multimillionaire, paid me and Sleazy? Sixty quid for the whole thing, with no royalties for the T-shirt, which went on to sell buckets and buckets. I mean, I was glad to get the T-shirt made, because I thought it was a funny idea. And I've never been any good at business. But still.

That was my first real adventure with punk.

The only time I went out and saw many punk performances was later, in 1978, three years into Throbbing Gristle, when Soo Catwoman took me to see bands like the Jam, the Lurkers, the Clash, the Damned. I remember seeing a Crass gig with a support band called the Nipple Erectors, with this fabulously crazy singer named Shane MacGowan, who went on to form the Pogues. Ironically, I never saw the Sex Pistols actually perform—Soo was already bored with them by the time we met. But she took me out two or three nights a week to see other bands who hadn't even been signed to indie labels yet.

From the time I lived at the Ho Ho Funhouse, I didn't have a record player for years. And there was nothing I really wanted, anyway. I got the Stooges' first album, 1969, because it had John Cale's name on the back. I tried to follow the Velvet Underground but stopped at the third album. By the fourth album, I just wasn't interested anymore.

One of the reasons I did Throbbing Gristle was because there was nothing out there that I wanted to listen to. On the rare occasions I went into a record shop, I bought Tibetan ritual music or John Cage or whatever it might be. There was nothing current I was interested in. There was glam and the leftovers of prog. And so I followed the lessons I'd learned: If there was nothing that you like being done, do it yourself—invent something.

In the end, Throbbing Gristle took a year of collating and condensing the noises we were making until we had a sound that we felt expressed our feelings of alienation at the time. It was a long distillation between deciding to do Throbbing Gristle and then finally feeling ready to attempt to do it in a live situation. We'd been booked by the Winchester Hat Fair to do a COUM Transmissions performance. We rang them up and said, "We're doing something new; it's experimental sound. Do you want us to do that instead? We're happy to come and do that."

They said yes, so we played at Winchester Hat Fair. There were a few other small arts festivals that had booked COUM. We rang them all up and said, "Look, we have this other project called Throbbing Gristle. Would you still like us to come?"

Surprisingly, they all said yes.

Sleazy didn't come onstage at the beginning of Throbbing Gristle. He took some 16mm black-and-white film of some of that first gig. I'm wearing a really silly, full-sleeved black top. Chris has on a ski mask, and Cosey is wearing a leather jacket with nothing on underneath. At the beginning, Sleazy used to put his tapes in from a table in front. After a few gigs I said, "Why don't you just come onstage and do that?"

Next we were asked to do something at the Air Gallery. We did a TG performance there in a basement. It had really thick concrete walls. There were two rooms in the gallery. The second room could be closed off with this big door, so we closed the door and played in that room while people listened from the other room, because we thought that'd be more like the sound of a factory at night. It caused a lot of frustration; people were banging on the door.

"Why can't we come in and listen?"

We were trying to make it feel as if you were trapped in a city of the future and you were mystified by these noises that were coming through the walls. We used the building itself as part of the piece.

We also played at the Architectural Association, where they had a courtyard between these four buildings, so we built a scaffolding cube with a platform and put all of our PA speakers on the ground around it facing straight up. We went inside the cube, which we'd covered in tarp, and we had little cameras in there. Throughout the Architectural Association were these TV screens we patched into. So if you wanted to see us play, you had to be in the building, but then you couldn't hear anything. If you wanted to hear us play, you had to be on the roof and look down, and all you saw was a tarp and speakers. There was a riot. They threw toilets down at us. Smashed toilets and hurled them down!

It provided an interesting revelation, that people's desire to stay in a traditional situation of having to stand and look at the stage was a desire so ingrained that people would literally riot for the right to stare at you onstage. That's pretty weird.

We did another show with mirrors in front of us so people who wanted to listen could only see themselves. We once played behind a screen and they threw chairs at the screen and tried to push over the PA, and there was a big fight. To this day, it doesn't really make sense to me that people are so addicted to seeing the making of the sound. Why does it matter? Why do you have to see it being done? But it's an addiction, and when we're breaking systems, you have to break all of them.

And after a while, we played other games. We always played first, even after we had a following, because the headliners traditionally played last—so we went first instead. We played one gig where there were two thousand people, and we went on at 7:30—before the support acts—and we were out having cups of tea by 9:00. There were still two hours of the show left. There was something really satisfying about that. But the fans knew, they worked it out, so the real fans would always come early, and the poseurs, as they used to be called, would come late.

Everything we did was based on breaking preconceptions. Because we wanted to do away with habits and formulas and traditions, all of those

things that make us feel comfortable. We didn't want to be comfortable. We didn't *feel* comfortable. We felt uneasy with the society that we were part of, and we didn't get any pleasure from the sonic information we were receiving from other people, so we decided to look at that particular issue and change it.

Mainly, the reaction was somewhere between hate and bafflement.

It was odd, because we got rave reviews from certain music journalists, but we couldn't find anyone in real life who liked it. We would get thirty people at a gig and be really happy. Luckily, the journalists were so into it that they just kept writing about us and doing feature articles and saying that this new "industrial music" movement was the next big thing.

Most of the early gigs were legendary as much for the assaults and frustrations we imposed on audiences as for the music. Perhaps the most interesting was when we played the London Film-Makers' Co-operative: two women said they'd had spontaneous orgasms.

33.

At about 10:00 A.M. on Saturday morning, January 17, 1976, we were awoken by a banging on the door at 50 Beck Road. I was still in bed in the same 1890s Victorian nightgown I'd had on when the Hells Angels came around at Ho Ho Funhouse.

I went downstairs and opened the door. Outside were two guys with suits on, and they had a big envelope with them.

"Scotland Yard," they said, and asked me my name.

"Genesis P-Orridge."

Then they pulled out two postcards from the envelope and said, "Did you send these?"

In my stupidity, I said, "Yeah, why?"

"We are from the Post Office Special Investigations Unit. You are under arrest for sending indecent mail in the post."

We always had a camera on hand to do a bit of documenting. Cosey came down with it and took a snapshot. She didn't seem aware of what was happening.

They took me to the police station to give a statement. It still didn't seem a big deal. After all, it was *postcards*; I'd been sending them out for years, all of the world, hundreds of them. So it just didn't seem to make any sense that this could augur any serious trouble.

Then I started receiving letters demanding I appear in court. It started to become more real. The threat was that I could go to prison for a year per card or something like that; it was heavy. That's when it dawned on me: this was a serious matter that I had to really get my head around. It also started to dawn on me that they were targeting me in some way. It wasn't just about censoring my imagination.

I panicked a little bit then and thought, *What am I going to do?* I didn't have a lawyer. I didn't know what to do.

I started to ask for advice. Amongst others, I wrote to Burroughs, in part because I knew he'd had problems with *Naked Lunch* in America. It had gone to court, which was grueling and expensive to fight. Luckily, he had the publishers helping. He had been in jail for drugs and, briefly, for shooting his wife in Mexico, so I thought he'd be a good person to ask. He was really supportive. He didn't go, "Oh, who is this young troublemaker that I befriended?" Straightaway he was, like, "What can I do to help?" Burroughs knew Lord Goodman, and Lord Goodman had been involved with the Arts Council of Great Britain and was also a lawyer. I also wrote to people like Bridget Riley and Sir Norman Reid, who was then the head of the Tate, and Gerald Forty, who ran the British Council: people who were "establishment," but who had supported me already in the past. I asked them to write letters in my defense, which they did.

Next I sought advice from Dave Sullivan, the guy Cosey had been modeling for. Dave had also been prosecuted for obscenity, after he became the first person to publish erect penises and images of actual fucking. Dave put me in touch with the lawyer who actually ended up defending me, and who had also defended other censorship cases, like the Linda Lovelace case, and won. Dave found us a Queen's Counsel, one of those guys with the white wigs on and everything. It turned out it wasn't a jury trial; it was three magistrates, which is worse because they're all old, biased fuddy-duddies: the magistrates were part of the system that had just come down on me.

As is my wont, I decided to turn the trial into an event as well, and play with it. One thing I did was make Xeroxes of one of the postcards, the one with the Queen and Buckingham Palace with a bum, I think. I sent two of them out to all the people I corresponded with and wrote, *Please decorate them and send them back*. So I got about a hundred postcards that had been banned already, which were delivered without them being stopped, from people all over the world.

I also went to a local printing place and got wedding invites with silver frills around the edges and silver printing inviting everyone I could think of to my trial. The fancy invitation listed the address and the time: "You are cordially invited to the Magistrate's Court by Genesis P-Orridge." And a lot of people came. There's a photo including Richard Cork, who was at that time

the top art critic and curator in London. He had written articles saying the postcards were real art. In the end, many people came along to support me.

The trial itself started on Monday, April 5, 1976, at Highbury Corner Magistrates' Court. I wore a sharkskin suit. I had my hair greased back, trying to look normal, or at least my attempt at normality. I forgot that I had nail varnish on. We all sat down. When they said, "Rise!" in came the three magistrates.

My Queen's Counsel whispered, "Oh no! This is not good."

One of the magistrates was a woman, and two of them were from Scotland and known to be religious.

Everyone sat down and then they called the first witness. In walked a man from the Post Office, from the sorting office, and he was sworn in. The prosecution asked him if he was offended by these postcards. He had a look at the three postcards and he said, "No, I wasn't offended."

And they asked again, "Weren't you offended?"

That turned out to swing the whole thing.

They were charging me with indecency rather than obscenity. The difference is, obscenity has to do with being likely to "deprave or corrupt" the population, or a large part of it. It's an *active* thing. But charges of obscenity weren't brought anymore. It had failed so many times that they stopped bothering to charge people with obscenity. Indecency is more a matter of opinion. Somebody can just say they were offended, and that makes it indecent, even if there's only one person in the whole population. So when he admitted he wasn't offended, the case collapsed. There was a little bit of whispering, and then the postal worker said, "But I thought somebody *could* be offended."

The magistrates accepted that. Even though he wasn't personally offended, somebody might be, and then they passed the postcards to the magistrates, who said, "Oh yes! I'm offended."

Then I was culpable again; you see, because the magistrates, looking at them said the right words. It was set up.

That was basically the extent of the prosecution. They asked me if I'd sent them, and I said, "Yes."

I had already admitted that.

It turned out the act that made it criminally indecent mail was when I put it in the postbox. That's why they asked me if I had *mailed* them. I didn't know this until later, but if I hadn't said I mailed them, if instead I had said only that I had *made* them, they could not have done anything. It was the act of posting them: that constituted publishing them, which then meant I could be charged for indecency.

Then my Queen's Counsel got his turn.

He stood up, with his wig, and started to make a basic opening speech, and the magistrates told him to sit down. He said, "Your Honors, I'm supposed to be the defense—"

"Sit down, or we will charge you with contempt of court."

You know: *How dare you speak when we already told you not to.* Which meant I couldn't have a defense. So obviously I was going to be guilty!

They sentenced me to a year in prison or to pay the maximum fine, which was three hundred pounds. I had thirty days to pay the fee. Of course, I had zero income at the time, so the prosecution's hope was that I couldn't pay and I would instead go to prison.

When I came out of the court, the two detectives came up to me with the same envelope they'd originally presented to me and said, "Come talk over here for a minute."

We walked off to the side and they said, "Look."

They pulled out five more postcards that I had done.

Then they said, "This is just so you know that we can put you in prison whenever we want by charging you again."

Fuckers. They had held them back deliberately.

I wrote to John Armleder, a Swiss *Fluxus* artist and friend, and asked whether he could make a book of all the trial documentation. I thought it was important people knew what had happened: mail art was a big thing in our network, and people needed to know that they were in danger, that the authorities were turning on them. So he did. He made a special edition book entitled *G.P.O. versus G.P-O*, and between money from that and a few donations, I managed to pay the fine and didn't go to prison.

Supposedly, if the postcards had been in sealed envelopes, they wouldn't have been indecent. But then, of course, they wouldn't have been postcards;

they would have been bits of art in an envelope. The fact that they were postcards was important to me. They had to have the stamps on them, and the postmarking, and get bent and on occasion get lost. That was all part of it. I had to be much more careful with what I did from then on, though I was still pretty dismissive of the dangers. I took it as it was: part of the job, really. I knew Burroughs ended up going up against the status quo and day-to-day moralities for the expression of the imagination in books, or art, or whatever it might be. Aleister Crowley, too, had been up against similar things, as had Oscar Wilde. Many of the people I found interesting had gone up against that brick wall at some point, to varying degrees and with varying degrees of success or failure. I always told people I was working with that there was always a danger of the door being kicked in one day.

It's not just all fun, not just tickling the belly of the beast and hoping to get away with it. This was serious stuff, and yet I remained committed to taking it as far as it went, even if the door got kicked in.

34.

In 1976, we got invited to be part of a big retrospective on British modern art in Milan, Italy. They chose Stuart Brisley, Gilbert & George, and COUM as the three representatives of the best of British performance art. We had gone from street jesters to the global museum world in three years. When we got there, we went for dinner in an amazing gilded palazzo with the minister of culture and all these aristocrats with all their medals and Freemason outfits; it was quite incredible. We were hobnobbing with all these immensely rich people while we were living in a squat in Hackney.

Gilbert & George were great—so funny—and we got on really great with them especially. I used to get drunk with them, and we would waltz, dance, and tell jokes. And they were very disparaging of the art world, too, even though they were millionaires by that point. They were fun. When Richard Cork, the art critic of the *Evening Standard* newspaper at the time, reviewed the Milan show, he wrote all about COUM Transmissions and said we were the most important, amazing thing to come out of the British art and performance art world.

As for the piece garnering all this praise, it was all based on a dream: I literally dreamt the performance. I've still got the notebook with the drawing. Originally it was a circle in a square, which is obviously an alchemical idea. The square became a cube of scaffolding. The cube was painted black, and to one side was what looked like a solid piece of steel, bigger than two refrigerators on top of each other, taller and wider than that. And the circle was white. And within it was another square that was white. That square was filled with white milk. We had made a special box, about a foot or two deep, and then I spent ages screwing little eyelets in every inch, all the way around, until it was filled with them, and then added in steel chain, so that there was nearly a mile of steel chain in there. I gave myself really bad blisters

building it. But it looked amazing when the light caught it: it really looked solid from a certain distance.

The performance began with Cosey dressed in a silver body stocking, and her task was to get into the square very slowly and then gradually disappear. At the last minute, the mayor of Milan said we couldn't use milk: there was a big strike on, and the union said that they'd disrupt the show if it used milk, because there were workers who needed food and didn't have enough money to buy milk. So we filled it instead with little tiny polystyrene granules—which actually worked better. When Cosey got in, she would disappear into it at different amounts in different ways. Dressed in black, my task was to emerge as slowly as possible and gradually climb through the scaffolding to the top, where there was a plank with a camera. Then I took pictures from directly above her; vanishing in and out of this white tub. She looked amazing. We did the piece at lunchtime—I think we did it on three different days—and it was packed with people who were riveted by this weird, surreal, meaningless thing that was happening. Of course, it seemed meaningful somehow because it was being done with such care.

While we were there in Milan doing all of that officially, we were also invited to do something at a private gallery. For some reason, Cosey didn't want to do anything there, so I did it solo. I did a really intense piece with wire, nails, and roses, which I actually tried to shove up my ass, which was very painful because of the thorns. It was a way for me to see how far I could take my own body. It was sort of an internal test of what I could do and what would happen in a certain mental-physical state.

During those more physically challenging performances, I had visions and spoke in tongues, going into altered states similar to psychedelics. I was doing fewer of such things because they were so draining. Around this time, it dawned on me that the shamanic effects were so fascinating that I wanted to keep going, but in private. It was no longer of interest to me to do it in an art context, but I wanted to explore it as research into what made certain things happen in the human mind when you did certain things to a human body. I wanted to do it in a much more controlled, private way,

that had nothing to do with showing it to other people or it being entertaining or interesting or anything else. It was purely about mental states and physical states. That's actually where the rituals that became Thee Temple ov Psychick Youth grew from—from those private things that we did starting around this time. The results became the central ethos of TOPY. It became something that was much more serious, and much more private, and much more important.

I had a very unresolved relationship with the idea of physical death at that time. Having been clinically dead when still at school, and told that I could drop dead at any time, I tended to be very existentialist at that point: *it doesn't matter.*

There was nothing to be afraid of, because there was nothing.

Seeing how far I could go seemed much more interesting than being afraid. I'd read about Tibetan monks and the amazing things they were capable of doing with a focused, trained mind, and Hindu sadhus, and the Naga and Aghori sects. There was plenty of evidence in the world outside that so-called primitive cultures had very sophisticated techniques for out-of-body consciousness experiences. I wanted to see if there was a way to design a contemporary version of that for Western Europe. Not just to colonize an old way, but try to develop a contemporary way of doing something similar. My nature's always been to use myself as the guinea pig, because why should I expect anyone else to do it?

I didn't sit down and think, *Let's shock people.* I just thought, *This is interesting—I wonder what would happen if . . .* And for some reason I kept striking nerves, especially in British culture, revealing its double standards more blatantly. Like the fact that they were trying to make BDSM illegal while the Royal Family and their friends were aficionados of BDSM. What did that mean? Did it mean you're only allowed to explore a dungeon and S and M if you're a rich aristocrat? Why did they feel they should keep it as an exclusive activity? Was it because they knew something about its potency and didn't want to share that secret with the rest of us? What would happen if we took those rituals and used them instead of letting them be the province of the rich and the bluebloods? These ways of thinking were so carefully policed. In my mind, that meant somebody had a belief that they

had some kind of social potency, some kind of rebellious effect. That they allowed people to "short-circuit control," as Burroughs put it.

But I had reached a point in my art actions where slash and burn was literally and metaphorically just not doing it for me anymore. I had no more inhibitions to smash. I had masturbated on a satin cushion while dressed as an English schoolgirl at the RCA, used roses and syringes, dildos, chains, clips, and mortified my flesh and bones in every way possible using every orifice, but it was not working or waking anymore.

Of course, sacrificing myself in a vain hope that my distress would shame humanity into nurturing and preserving itself had only one finale: my death in action.

That, however, seemed pointless.

I considered the lives of artists as significant as what they produced. The excitement was the fact that LIFE and ART were inseparable. Unfortunately, as I'd seen in miniature form back at Hull University, again I began to see the "art world" for what it really was: a service industry to the rich. A descent into careerism and celebrity, a new stock market. The gallery and the museum system "added value" to select artworks and artists.

It's no mistake that art becomes valuable after an artist is dead.

I needed to redirect my efforts back into a non-elitist arena where the public decided on the level of engagement, meaning, amusement.

Outside the frame.

Art was an exchange between one creator and another. Like-minded individuals who refused to accept a status quo without first questioning it. Confronting it. Challenging it. The more we refuted the status quo, refused to accept inherited systems and societal structures, the more behavior seemed a key.

HOW CAN WE CHANGE BEHAVIOR?

35.

At the height of COUM's notoriety and following appearances all over
Europe, Ted Little at the Institute of Contemporary Arts in London had
invited us to mount an exhibition. Ted had previously been the head of the
Birmingham Arts Lab and had booked COUM a couple of times. He was
one of our champions in the more straight art world. Sometime during
1975, he'd become the curator of Downstairs at the Institute of Contempo-
rary Arts, or ICA, in London. The ICA was a beautiful Georgian building
owned by the Queen and the Royal Family. Another one of the buildings in
the complex housed the Royal Academy of Arts, which was where Austin
Osman Spare had his first solo show and was declared a genius at a young
age. So it had a good history. It's between Trafalgar Square and Buckingham
Palace. If you walk out of the front doors of the ICA and turn right, you can
see Buckingham Palace—that's how close it is.

We told Ted we didn't want to do a COUM show: by that point, in
1976, we felt we really did have to finally stop doing COUM Transmis-
sions. We'd already set up Throbbing Gristle and had been rehearsing for a
year, as well as appearing at a few events that had originally been booked
as COUM events.

Instead, we suggested the idea of a COUM retrospective, which Ted
actually thought was a great idea. The exhibition was set to open in Octo-
ber 1976, and we decided to use the occasion to sort of officially unveil
Throbbing Gristle, with the intention of then taking it beyond the art world,
where we'd been playing our only gigs so far.

The question was, what would a retrospective be like? If we weren't
actually going to do anything, what would a show consist of? I daydreamed
about what it might look like. Well, it was in a really posh museum, and
COUM Transmissions was this amazing, modern, influential art movement

that had changed the world, so everything had to be beautifully framed. So that's what we did.

We called the exhibition *Prostitution*.

And the world exploded.

My sculptures with used tampons caused particular outrage. But there were also lots of pornographic images, many of Cosey, who was still working as a stripper and posing for low-rent skin mags. The exhibition became a sensation in the tabloids and even on TV, and a Conservative MP called COUM "wreckers of civilization" during a session of Parliament.

Ted was brilliant. He supported us 100 percent.

We only really had photographs that had been taken by passersby, strangers. We came up with an idea that on one wall would be just black-and-white photographs of COUM taken by people we didn't know, or at least we hadn't known before they gave us the photos. The point was, the images were based on *their* idea of which bits they'd deemed photoworthy, interesting, or significant. It was their interpretation of what we did, not ours.

Then, for the opposite wall, I had a brain wave. I'd been collecting every single magazine that printed photos of Cosey doing porno. I'd walk all over London to get the magazines, and I'd always buy two copies if possible, so that I could have both sides of the page if any photos were back-to-back. I was really obsessed with documentation. I kept everything, even the tiniest little press cuttings, and I'd mount them and keep them in booklets.

Cosey would ask, "Why are you keeping all these magazines?"

"They're going to come in useful one day."

And now they were.

There was a British conceptual artist, Steve Willats, who clipped photos from magazines and put sound to them and diagrams—all apparently very meaningful. He was very precious. He had a friend who did similar stuff: photographs and captions. Something about their work really irritated me. So I thought it would be great to make a satire of that.

I decided to frame the porno mags and add captions—but all fake, because they were about a person who didn't exist.

This is Scarlet, a typist, and she likes to get fucked up the ass.
This is Carol, and she likes this . . .
All of these fake people, fake stories.

So we framed them all so it looked just like the precious work of Willats and his friend: beautifully presented photos and text in these big, sterile silver frames. And I said to Cosey, "Just sign them and they'll become your art." So she did.

In the end, they wouldn't allow us to put the framed magazine pages up on the wall as they were; they built these weird wooden boxes and slid them in. They had a security man sat next to them, and you had to ask his permission to look. You had to join it as a private club, the ICA of the Month, and pay a nominal fee, like a pound or something, and sign a form that said that you understood it was adult content. That way, if you were offended, it wasn't ICA's fault as you'd chosen to see it. And they weren't liable for publishing porn and made sure that people didn't complain that children who were underage would see it. All these different legal things made it more exciting, and more forbidden. When it opened, everybody wanted to look at the photos they weren't allowed to see in the open.

Those boxes filled the other wall, opposite the photos of COUM taken by strangers. So it was people we'd never met and their version of what we were. And the other wall was fake versions of who Cosey was, none of which was true.

Then I thought we needed one other wall: one that would be how the press saw us, which was also not true. That in fact, all media, no matter how close or how specific, never tell the truth of who you are. And as the exhibition went on, the third wall filled up with more and more ridiculous and outrageous stories about the exhibition. It was perfect. They fell right into the trap: a third wall of fiction. I was proud of the concept.

As for the rest of the show, in one corner we set up a pyramid of the "Orange and Blue" sticks of wood with all these objects, a piece we'd done for a previous show. There was a chain piece that we'd done in Milan that looked solid but wasn't. There were vitrines with different things like walking sticks with tampons attached, and rubber suits, nails, et cetera. All sorts of stuff like that.

There was still one more area that didn't have anything planned for, and I thought, *Hmm, gotta put something there.* I went home and had the idea to make sculptures out of used tampons; they were a last-minute addition. On the left was a statue we just found in the street, and we attached two used tampons and called it *Venus Mound.* In the middle was an old art deco clock with a month's worth of used tampons, and that was called *It's That Time of the Month.* Another one was a tampon with tiny little doll arms and legs attached, lying in a small plastic dollhouse bed, and there was a little picture framed on the dollhouse wall. I titled the piece *Living Womb* as a pun on "living room." Little *Fluxus*-type jokes with a sarcastic English twist. Together the group of tampon sculptures were called *Tampax Romana.*

I considered the pieces throwaways.

But precisely those pieces ended up driving the world crazy.

You were supposed to fucking laugh! But instead there were questions in Parliament, and they threatened to take my passport; there were front pages of newspapers and editorials—"Is This Art?" There were calls to put Genesis in a cage and throw away the key.

Insanity.

But that was all after the show opened.

With hindsight, the way the publicity worked was really important. They had a screen-printing shop upstairs, and these young guys who did the screen printing were just beginning to get a name for doing, sort of, psychedelic punk posters. They did a poster for us, a kind of classic-at-that-time photo of Cosey inside a cage, looking up, naked, and then they broke it down into dots, so it was like a pointillist, multicolored image that was almost abstract, and it had candy-colored writing on it. We thought, *Oh, that's really pretty*—and we wanted it to be psychedelic, because it was going against the mood of the times—but we decided that we didn't think it would get noticed. In the run-up to the opening, I thought we should really push things. So I started to look at all the newspapers and write down the names of people in the news departments along with the address of the papers and magazines until I had about forty contacts. And then I made up an alternative invitation to the opening. In one of the porn magazines

was feature called "Curious." It claimed to be an article about Victorian prostitution, but they'd used images of Cosey as illustrations, and one was a picture of her with this blindfold on, reclining on a chaise lounge, and underneath it said, "Prostitution." I thought, *That's it. That's the image.* So I had invites and press releases made with that image at the top and sent them out to all the press contacts. I sent them out secretly, without telling Chris, Cosey, or Sleazy. I sent out extra ones to all the newspapers and magazines, just to see what would happen. I didn't realize they would go as nuts as they did.

For the opening itself, we wondered what else we could change. What happens at openings? Normally it's all very hoity-toity, and people drink wine and go, "Oh, look at the art, oooh." So I thought, *We're going to have kegs of beer.* Ted said, "Brilliant. Kegs of beer it is."

What else could we do to rile things up? Usually they made speeches at these types of things. *Let's get a dirty comedian instead—a blue comedian.* So we invited John Smith from Bridlington, who came and told dirty jokes. Next we thought, *What else is really working-class and will annoy all the hoity-toity people? A stripper!* So we rented a stripper. She didn't know where she was going, and arrived to find this massive circus going on, with punk rockers, which no one had seen before, and all of us, and then the posh art world people on top of it all. As for security, Derek Jarman told me about a group of transvestite security guards.

"They're all six-foot-six and they wear drag!"

"Let's get them."

So we did.

Overall I just thought, *Let's mix the soup and see what happens.*

It was going to be chaos.

Then, of course, this was also a coming-out party for Throbbing Gristle, so we needed a support band.

Now we got back to John Krivine, who'd opened the shop Boy.

Chelsea, the band I'd helped John put together, were doing early rehearsals at this point, and we had asked if we could come round and see them, because we planned to use them as our opening band.

They were rehearsing at John's tailoring shop, which was on Portobello Road. When Sleazy and I rolled in there—along with the rest of TG, because they were all curious about this project—the band were just finishing a bad run-through of "(I'm A) Roadrunner." Every punk and garage band did that song back then. The band came into the room where we were with John Krivine. Billy Idol and I exchanged some words, and then Tony James said, "You have a band, too, yeah?"

"Yeah, yeah, we do," I said.

"Yeah, what's it called?"

"Throbbing Gristle."

"Yeah, and what's it sound like?"

I tried to describe it, and Tony goes, "Oh, I had a band like that when I was about twelve."

"Oh, really?"

"What does *he* do?" he said, gesturing at Sleazy.

"Well, he uses a lot of Walkmans."

"Oh, he's a tape twiddler, is he?"

And then he said something else that really provoked me, and I said that he'd better apologize.

Tony said, "Why should I have to apologize to you? You going to fucking hit me?"

I hit him so hard, he flew backwards through the air—I'd never hit anybody like that before—right over this great big table where they would cut out patterns. He flew right over it, through the air, and hit the wall at the other side. I'd never done such a good punch before or since.

Tony ran out crying, "That fucking bastard hit me! I've lost a toof! I've fucking lost a toof!"

I could hear him in the landing going, "Genesis hit me. Genesis hit me. Make him say he's sorry."

All I could think was, *This is supposed to be a punk band?*

Then John Krivine came in from the other room to try to mediate and said, "I understand why you did that, Gen, but it would be really good if you'd apologize."

"No. I did that deliberately because I was pissed off, and I'm not going to apologize. Just tell him don't be rude to people, and don't push people's buttons if he's not prepared for the consequences."

"Gen, you gotta say you're sorry to Tony."

"That's not going to happen. He's a fucking idiot."

"He won't play the show," he said.

"Go tell him I'll do it again if he comes back in."

He's had two false teeth since then. He went on to be in the Sisters of Mercy and Sigue Sigue Sputnik. I'd see him on TV and just smile and think, *Two false teeth.*

The band played the opening anyway, and even though I thought it was okay to have what was now being known as a punk band play, I didn't want them to have a punk name. Not to mention that Chelsea is a boring name. What would be a really un-punk name? LSD. They all hate hippies, so let's call it LSD, then. So they played as LSD, and apparently they were terrified of what we were going to do—they thought we were going to hang Chris by barbed wire and God knows what else. We did spit fake blood, and we were all topless in leather jackets. I think I shaved a bit of hair on my head and had a fake wound that was done by Sleazy, complete with leaking fake blood. I guess it was pretty radical for that day and age.

The opening night finally came. The guards were brilliant, stomping around in their high heels and bustiers as the security detail. It seemed like every journalist in town showed up. You know how sometimes there's a buzz and every media outlet decides to do a thing on it? It was like that. They just couldn't believe their luck in terms of a story: tall drag queens, people playing weird music, strippers, people getting drunk on beer and slobbering around. And, of course, the porn magazines.

Some interesting things happened during the night. There was a lull towards the end of the evening, and a guy started talking to me and saying how he'd written a book with Brion Gysin called *Here to Go* but he couldn't find anyone to publish it. His name was Terry Wilson. So I'm talking to Terry, saying I thought I could get his book published by another friend of mine, and we start to swap information, then suddenly, *boom!*

I saw stars and wondered for a second what had happened? *Did I get hit by lightning?* Then I fell over.

Somebody had come up with a pint glass and whacked me on the back of the head as hard as he could. It turned out the guy who'd hit me was a reporter from the *Evening Standard*. Ted Little, with one of the security guards, dragged the reporter outside. Once outside, the reporter turned around and kicked Ted in the balls, really hard. Ted had to go to hospital: his testicles swelled up and he nearly had them taken, poor guy. That journalist was up in court the next day, in front of a magistrate, and got fined. He then wrote a piece saying how it was an awful, terrible exhibition, and that we were all evil, horrible people.

I thought, *Who is immoral in this situation?*

During the second week we were told that one of the commercial TV channels wanted to do an interview with me and Cosey, from the room at the ICA with the exhibition in it, and it would be broadcast live on a Friday night between 6:00 and 6:30 P.M., which was absolute prime time. With all the publicity in the papers, we knew that millions were going to watch, so we agreed to do it. Back at university, I'd had a friend named Tony who ended up working for the BBC News. I rang him up and said, "Look, we're going be doing this live TV thing. What do we need to know about what tricks they'll pull?"

"Well, the main one is this: When they ask you a question and you answer it, if they say 'What do you mean by . . . ,' you repeat exactly as possible exactly what you said the first time. Because what happens is, if you change it to explain it, the audience won't remember the first answer and they'll think you don't really know what you're trying to say. But if you say exactly the same thing, it looks like the interviewer is really stupid because he didn't understand it the first time."

I've remembered and used that ever since—it's the most brilliant trick.

And, sure enough, they did try it, of course, straightaway. And I just repeated the answer for the whole half hour, live. This was Bill Grundy, who a few weeks later interviewed the Sex Pistols—when they swore and cursed and became very famous. We didn't swear and curse, because we didn't want that kind of notoriety. We just wanted to be heard, and it

seemed to me it was counterproductive to push it too far. We wanted to leave it ambiguous enough that we could still get people asking questions. I'd say our strategy was much more effective in the long term. Maybe that's the difference: having a long-term plan as opposed to an instant, immediate one.

The wall with the press clippings—what was being said about the show—just kept growing and growing, bigger and bigger. It started to get scary. We were on the Tube going home to Hackney from the ICA one evening, strap hanging, and I looked down the length of the carriage and suddenly realized all these people were reading their evening paper, and about 80 percent of them had *me* on the cover. They were reading about me, and I was in there with them.

If they realize it's me, they're going to kill me.

But they didn't put it together. That's when I learned something interesting, which is: if it's in the newspapers it's a cartoon, like reading *Superman* or *Batman*. And you don't expect to meet a cartoon on the subway going home. The news is a fantasy that you never expect to intersect with your real life.

That was a seminal moment I remember very vividly.

Maybe a week or so later, John Lydon got attacked and slashed with knives for being one of the Sex Pistols. There was an antagonism in the air towards this sudden influx of new information.

To his credit, Ted Little never backed down when people tried to get him to pull the exhibition. At one point, the Queen herself—bless her—sent three law lords. The law lords are sort of like the equivalent of Supreme Court judges, but they work specifically for the Queen, and they have almost unlimited power. The Queen's law lords came down to talk to me and Ted and said they wanted us to close the exhibition: it was causing too much embarrassment to the Crown.

"She's just up the road. You can see her palace from here. There's pornography here in her building. Everyone's upset and it's all in her building, giving the appearance that she's given tacit permission. We have to close it down."

Ted said, "We're not going to close it down."

"You must."

"If you try and close it down," I said, "we're going barricade ourselves in, paint the building pink, and start a siege. You can come in and get us."

They did not want that kind of additional publicity just down the street from Buckingham Palace. The Queen continued to get flack for permitting the show.

36.

After the *Prostitution* show, I didn't want to do COUM Transmissions with Cosey anymore. She did one or two things solo, which, from the pictures I've seen, were very similar to her part in the other rituals we'd done. And I went to Belgium, because I'd already agreed to do a solo performance I called *Scenes of Victory* at Antwerp University.

This is the last thing I'm doing as COUM Transmissions, I thought, *so I'm going to go for broke.*

I drank a good half-bottle of Scotch and then used a rusty nail I found on the university grounds to carve a Union Jack in my chest. They had a botanical garden, and it had certain poisonous plants and bushes. I got a branch of a poisonous bush and chewed on it and swallowed the juice. And then *whammo*, I was out of the body, vomiting, speaking in tongues, a really bizarre, strange language. It was like I'd been given a very strong psychedelic. I ended up in the university hospital medical center because I was puking so much that I was very dehydrated, and I lost something like ten pounds in four days from vomiting.

It was a good ending to the public work.

At some stage early in the process of creating the band, I'd made a call to Burroughs and said, "Hey, William, even though TG is a music thing, we want it to be really non-technological. We want it to be kind of anarchic, low-tech, guerrilla action. And so what would be the best kind of cassette recorder to record with?"

He had recommended a TDK recorder, which was what he'd been using in London. It was a flat one, about ten inches square, with a condenser mic. So I'd bought that cassette recorder and put it on a table on the other side of the room and just started to jam, and the cheap condenser microphone leveled everything out.

All of TG's first album was recorded on that cassette recorder.

It was totally low-fi, content-driven, and concept-driven. And that's something people haven't really realized yet: *The Second Annual Report*, that recording—which has been available in some form all the time since it was made, always, every year, for over forty years—was recorded direct to cassette. I think that's really significant. It's almost the *most* significant thing: the ideas you have, and the ways that you deconstruct the overriding reality of the time, are always so potent and powerful that they can destroy the status quo and the establishment with minimal technology and resources.

Ideas ultimately win.

In terms of its effect on people who've never heard it before, it can still really rattle people, despite having originally been released in 1977. Most people grow up with a sense of form. They have jingles on the TV; they have pop songs playing on God knows how many different satellite stations. There's always a basic form. There are certain 4/4 rhythms; there are certain constructs: verse, chorus, verse. So, from birth, people are conditioned to expect certain forms. And in other cultures, too, although the standard might be different, there's always a basic cultural norm that's thought of as the song. When you come in and take away any time signature, and take away any melodic backup, and take away the idea of singing in the sort of official, operatic idea of the voice, and you do it as a certain being speaking a message, you change *everything*. And no matter how long it's been, if someone's never heard that before, they'll be surprised. Their mind will be tickled.

I tend to look for a point to make, and so *The Second Annual Report*, in a very real sense, wiped the table clean in terms of what was possible with music in an electronic, youth-culture setting. It said anything could be part of the music, any sound could be included in the music, silence could be part of it, the sound of the people listening could part of it. It was very much a post–John Cage approach to the idea of sound. But we were also fascinated, again, partly through Gysin and Burroughs and their cut-up experiments, with the idea of using the tools and the toys of the military-industrial complex that filter down to the public. We wanted to see what we could do to utilize relatively cheap or unique instruments and tools and gadgets, what we could do to play with them in a way that subverted their original intent, which was, of course, control.

In order to do something that seems new, you have to strip away everything that's traditional, take away all the things that give it its formula or its identity. You have to get everything that's normal and break it. And even then you still are at the mercy of having grown up thinking of music a particular way, and that's where the cut-up process came in, because you could then break your own preconceptions and actually end up with new comprehensions that you would not otherwise have.

The question was: How can this machine kill music? And what happens when you've done that, when you've murdered music? What's left? That's how I saw it. And we still want to murder music.

The most common response to our sound was: "That's not music. That's just noise."

I'd respond: *That's what music is—noise. You make noises and organize them a certain way. We just didn't organize them in familiar ways, but it's all noise.* That simple message was something that was really hard to get across.

We liked the idea of calling our label Industrial Records, because we were thinking of the Hall of Records. You know when you go and try to find your birth certificate? That's the Hall of Records, and all of our Western societies are built on data. Everything is records and record-keeping, recording things that have happened, or people's physical states, or their medicines, or their wage earnings. or whatever. So in the case of the label, it wasn't *records* as in a piece of vinyl or a CD. I was thinking of information—stored information. That's why we did the seven-inch singles all looking the same. I had the idea that when they were in a rack, you'd flip through them like looking at library cards. They'd all be the same structure, and you'd know where the title would be, you'd know where the image would be; you'd flip through and recognize it was all "industrial." Because they were just documents.

There was a difference between information and product.

We weren't making product.

We were making information.

An industrial record was a piece of stored information on a project in the process of evolving. There were always multiple versions of things

we did because there's more than one version of everything that happens. Information is interpreted through the prejudice of those who read it or hear it. So there are no definitive, finite versions of information.

You're taking away the idea of entertainment; you're saying: These are lumps of information in an ongoing process of stripping away this cultural opium to see what works, why it works, and whether it can be subverted. And here's three or four versions of the conversation we had with ourselves. They are just topics and files in the databank of Industrial Records.

We also started an Industrial newsletter, and people started to send us cassettes of their music, and then we'd print all the addresses of people who'd sent us their music, allowing them to start swapping amongst themselves as well; we encouraged people to set up networks and exchange cassettes—a musical equivalent of mail art.

As TG started to play out, people misunderstood the band logo. Still do. The red and black is the anarchist flag, and the lightning bolt on it is actually an electrical sign of the British Rail. It meant "Danger: High Voltage Electricity," which I found amusing, since we were using electronics.

Danger, we're anarchists!

Also, rather naively, I thought it a clever way of expressing the idea behind our music: high-voltage electrical music as opposed to rock and roll. With hindsight, of course, you could see how it might be accidentally or deliberately misinterpreted—though mainly deliberately.

Everyone was all "Fucking Nazis."

And we were, like, *No, no, that's not what we were thinking at all.*

TG did a concert once at the London Film-Makers' Co-operative, and we set up our own PA system. We just stacked it up both sides, and then somebody did a review claiming we'd set up the PA as two *H*'s for *Heil Hitler*. That was a total lie; they were just in square stacks. I'm not even sure how you *could* make it look like *HH*. There's probably a way, but that would certainly never have crossed our minds. Basically, the press caused us years of having to re-explain that we were *not* right-wing.

Looking back now, people often talk about how the way we made the first TG album—all on our own—really inspired people to realize they could do a lot more outside the existing systems; at the time—unlike the first wave

of punk bands—we were alone in not trying to get a major record deal and instead doing everything ourselves.

When we did that first TG album, the pressing plant rang us and asked us how many copies to make. We just told them how much cash we had on hand and they said, "Okay, that'll get you 785," or something. My estimate was that it would take three years to sell them all, between mail art people buying them, selling a few at performances, and maybe some word of mouth through friends. That was one of my big miscalculations. When reviews started to come out, suddenly the Virgin Megastore on Oxford Street was on the phone: "Can we buy two hundred albums?" And I took them over, on the Tube. Then maybe a week later they rang back: "Can we get some more?" And then the indie shops came aboard, like Rough Trade. I couldn't believe it: the initial seven-hundred-odd copies were actually dwindling quickly.

I will say, it entailed a lot of work. The whole bottom of our house in Hackney was eventually given over to Industrial Records. Right at the back were stacks and stacks of shelves with all these cassettes and records on them. Then on one side was a desk we built for machines that duplicated cassettes at high speed so we could do six at a time. Chris and I would go down to the record plant and watch them mastering it on the lathe and everything. We would watch them make the plates. We would go back down and listen to the test pressings and take some home and listen on different record players. When they were ready at the factory, he would rent or borrow a van, and we would drive to the factory and pick them up, load them ourselves onto the van, and then drive them to Beck Road, unload them all, and carry them into the back. We would put them in their sleeves, put the stickers on, and put the things inside each copy, do the mail orders, and drag them in a big bag on our backs to the post office. I would do all the invoices.

Oh, God, it was a huge undertaking.

But I was still so happy and proud the first day we went into a Virgin Megastore and in the racks, for the very first time, was one of those dividers that said *Industrial Music*. There was only one record in there—ours. But they recognized it as a genre. Soon enough, there would be an entire section for industrial music.

Later on, the industrial music section would include Cabaret Voltaire. We wanted to release their first album on Industrial Records, but we didn't have enough money to press the vinyl. So we did a cassette of their music that sold pretty well, and then I took the cassette to Rough Trade—because they were thinking about starting a label at the time—and said, "You should really work with these people."

We were always networking—as opposed to competing. That was one of the big differences between that point in time and now. No one was competing. We were just trying to get the music made and available. It didn't matter who did the actual thing. It was just an attitude of *Let's get it made.*

Whoever could do it, did it.

That was a couple of years, that life. It was a really fun time. I felt part of this underground opaque family that the world above didn't really know about yet.

Of course, you can also see why bands and labels gave up doing it that way. They just get tired of doing everything. We were also the band. And also playing gigs. And releasing stuff by other people.

Somewhere at the end of 1977, *New Musical Express* or *Melody Maker* did a big spread on Throbbing Gristle, talking about how we were gaining an international audience. Soon after, I got called into the dole office.

"Is this you?"

All I could say was "Yes."

That was another reason a lot of people in punk bands used different names: so they couldn't be caught out like that by the dole. It wasn't always just to have fancy names; a lot of it was to avoid being spotted. Stupidly, I'd used my real name, which was strange and recognizable.

"I guess that's the end of my dole," I said.

I'd been on the dole since 1970.

"Yes" was all he needed to say.

And that was the end of the dole for me.

37.

Over time, you start to think that you're in love. And you are in love in a certain way. You love each other but you're not in love—like, *big* love. Maybe it's just comfortable.

Cosey was so good to collaborate with. She grew ever more open-minded and willing to push the envelope as far as what could be done. Over a period of time, she became a really good partner in creation, and that held us together.

Sometimes, all people need is permission.

From the time she joined the Ho Ho Funhouse, she had somebody who always responded, "Yeah, why not?" instead of what she had been getting from her family: "No, you can't."

It was "yes" from the new family.

That could be enough for someone to start to expand and grow and become closer to their true potential as a being.

We were very young when we met, twenty and nineteen, respectively. We were growing up together in what became an ever more intense, creative project, without all that much time to really investigate what we were as a relationship. It just became an essential part of being in COUM Transmissions. That was why it was so devastating initially to think that she was going to stop doing that, because I'd assumed that she was Cosmosis, and therefore I must have failed the vision. I felt the gods would be angry with me because I failed.

It wasn't *Oh my God, I've got to be with this woman.*

It was *Oh my God, I fucked up the project.*

The spiritual side of the project.

That was what really disturbed me. What did I do that fucked up this idea? How does it continue from here? How do we repair it? And repair ourselves and evolve and mutate so that we can do things more

effectively with fewer mistakes? That's what was going through my mind at the end.

At the beginning, it had just been really exciting to find someone who would say, "Yes, let's do that." I would be thinking, *What if I went like this? Now I've done this in public—what if we took it further? So we're all naked. If we're all naked, what do we do?* She would always go, "Yeah, okay, let's do that."

Sleazy would do it, too. He would say, "Yeah, let's do that."

Those are great people to work with. It was very much in my head at the beginning, coming up with concepts and ideas. But they would then initiate some of the dynamics that had to happen to me to make it effective. That was what glued it together, that made COUM Transmissions work on a really good level. The fact that it's still respected shows that what we did manage to achieve by that closeness was valuable. As they say, the band that lays together, stays together. When you are that close, intimately, even for just a little while, it gives you some sort of connection that is beyond most people's expectation. It gave us this really strong, loyal connection for a long time.

The beginning of the end in terms of our living situation would have been January 1978. It was Chris Carter's birthday, and I said, "Why don't we give him a really good birthday present? Why don't you dress up in sexy lingerie and stockings and high heels, and in your fur coat. You could go over there with a whip and say *you* are the present."

And she said, "Okay!"

So I put her in a taxi, and she went over to Chris's place. She says that's when they fell in love—that night. Big love.

It was around then that I started to go out with Soo Catwoman. When the Sex Pistols did a spoof newspaper, the back cover had two buses with "no future," and on the front cover was Soo Catwoman. She had two bits of black hair that went up like Batman's ears, and really extreme makeup.

At the time, Soo was the girlfriend of Mark Perry of *Sniffin' Glue*, the famous punk fanzine. Mark was in a very early version of Alternative TV with Alex Fergusson. Sandy Robertson and Alex Fergusson used to live in Glasgow and briefly had an alternative band they called the Nobodies. They

would play, every set, just one song: "European Son," off the first Velvet Underground album, the noisy one. They would just play that endlessly. Sandy Robertson also had a fanzine called *Piss Factory*, because he mainly wrote about Patti Smith, and was a big Aleister Crowley aficionado, too. They decided to move to London, where the punk action was. Sandy Robertson very fortunately got a job at *Sam's*, the music paper, and was writing features and reviews. Because of him working there, we used to go around to give them copies of records and press releases. Sandy gave us five stars out of five for *The Second Annual Report*. He loved it because he totally got it—because he'd been doing that noise thing with his best mate, Alex. He became a real champion of Throbbing Gristle, and, eventually, of industrial music more generally. Sandy and Alex Fergusson were living in a squat, an awful place, really filthy. That's how we got to know Alex, who then ended up in Alternative TV, Mark Perry's experimental punk band.

Mark needed a drummer, so he asked me to be his drummer—because I had a drum kit set up all the time at Martello Street. He and Alex would come over and jam, trying to become a band. Then they started to get actual gigs, and were invited to a punk festival in Birmingham that they wanted me to go to with them. I realized I couldn't be in two bands.

"I can't go. I'm in TG. I can't be in both. You'll have to find someone else." Which he did.

But that's how we all got to know each other. And that's how I got to know Soo, because she was Mark's girlfriend. I didn't really see her very much at that point. Then I heard from Mark that she was in the Hackney hospital with some unknown illness. She was in tremendous pain in her stomach area, and they thought that it could be infected ovaries or something really nasty. When she was in there, in agony and alone, most of the punks couldn't be bothered to go all the way to Hackney and visit her—including Mark, who never once went to see her in the hospital. So I thought I should go. It was only a ten-minute walk or so. I went over and sat with her and chatted.

Then another day I was visiting with Jules Baker—who was one of the people who helped us get the space at Martello Street, made monsters for *Doctor Who*, had made the crown with fire for Arthur Brown, did

armadillo tanks for ELP, and made huge, bizarre inflatables covered in knobs and warts. He gave me a lump of his discarded latex that looked like a pool of vomit.

And I thought, *Soo she needs a get-well-soon card.*

So I wrote "Get well soon" on the back of the pool of vomit and took it to the hospital and gave it to Soo.

Evidently she fell in love with me, and I had a tremendous crush on her anyway. The first time I went around to see her in her flat after she was out of the hospital, she was in the bath and called, "Come on in, I'm in the bath."

I went in and she was lying in the bath with her knees spread. As I came up to say hi, she sent a jet of bathwater into my face from her vagina. It was brilliant.

Sex with Soo was the best sex I'd ever had in my life. She was incredible. We used to have sex everywhere. We mutually masturbated on a subway in the rush hour. We were going up to Hipgnosis, where Sleazy worked, and the ground floor is where the Sex Pistols rehearsed, and we got halfway, we got up the first flight of stairs, and there was a little toilet, and she just pushed me in and closed the door, and we fucked. It was like that everywhere we went: we were like rabbits. An extremely high-libido person, and so was I at the time, because I kept up with it, by all means. Must have been pheromones.

She started to take me around to meet all the other punk bands that were just beginning. The Jam hadn't had a record contract yet, but she took me to see them a couple of times. Their bass player, Bruce Foxton, was just incredible. I don't know what happened to him, but he was the fastest bass player I've ever seen. We saw the Damned a few times, the Lurkers. She knew everyone—you name them, she knew them. She was a superstar in the punk scene. At the beginning of us being together, she was doing a lot of photo shoots for music magazines and that sort of thing. At that time, there were only about ten people who looked like that, and she looked the most extreme of the ten, so she was always asked to do photo shoots. On occasion I'd go with her, and sometimes they'd ask me to join in, because I had a leather jacket and jack boots, so I'd be in the back, just pad it out as an extra. It was tremendous fun. It was just so liberating for me not be the one leading but to just be sucked into this incredible experience.

Soo also started to wear military clothing: army boots and fatigues, and green, the whole thing. She shaved her head and had a soldier boy's haircut. A lot of people thought she was a soldier boy because she did it so well. They'd be really freaked when we started snuggling and kissing and canoodling. Soo was another one who was up for almost anything. She was really fun, and also really smart.

Soo Catwoman's real name is Sue Lucas. She got sick of the whole punk thing and of being a celebrity in the punk world. When Malcolm McLaren made *The Great Rock 'n' Roll Swindle*, he asked her to play Soo Catwoman and she refused. So he got some young kid who was about fifteen to pretend to be Soo Catwoman in the film. Then Sue reverted to her original name, got a normal job, and dressed in really normal secretary clothes—a blouse and a sensible skirt—and disavowed the whole scene. She'd had enough. She refused to admit that she'd even been Soo Catwoman. Not to me, but to most people.

Later, when we did the cover photos for *20 Jazz Funk Greats*, it was Cosey who suggested renting a Range Rover so it would look as if we had lots of money. And I always thought that was a little bit odd. But the idea of a Range Rover was funny, because it was so not TG. Originally, Range Rovers were something the Royal Family had, and Margaret Thatcher's son repped them to rich people—until he was busted for corruption in Africa. So it was seen as a symbol of upper-class power and wealth in Britain at that time. I always got the feeling that Cosey was thinking, *I wish I had a Range Rover.*

I've never wanted a Range Rover.

I knew she was seeing Chris, because we were all together. And that didn't bother me at all. It was just par for the course. I was seeing Soo Catwoman and was having an affair with a Japanese journalist named Akiko Hada. And then I had Kim Norris on top of that. I had three girlfriends who were all really fun, and everything was fine. Then Cosey finally said, "I think I don't—I don't think I—I don't want to live here anymore. I don't think I'm in love with you anymore. I think I want to move out and be with Chris."

"Oh, okay."

Then we talked a little bit, and she said, "I'm going to go away on my own for about two weeks, and then I'll try and decide who I want to be with."

"Oh, okay. Okay."

Off she went, and every day or two I'd get a postcard. It would say things like, *My darling Gen, I miss you so much,* or *I'm so lonely,* all this lovey-dovey stuff. Those came about every three days. Then she came back and she announced, "I'm gonna live with Chris."

"Ah, okay."

I cried a bit, because I felt that I had fucked up the COUM thing. And, of course, I was attached to her—I did love her. Somehow, within a day or so of that, however, I found out that Chris had gone with her on the trip. So the whole time she'd been writing these bogus postcards, she was with Chris. I thought, *Why didn't you tell me?*

Why did she have to keep lying and make up this deception? Especially after I'd already said okay?

Ultimately, Cosey wanted the car, the stability, a family—something much more domestic. There was no stability in my vision. That definitely bothered her. I remember clearly a point when Cosey told me probably one of the truest things she ever said: "Sometimes, I feel like I'm just dissolving in you, in the intensity of what you are. I'm just vanishing into it. I'm drowning in it."

Larger-than-life Genesis just sucked her in, and she didn't want to be a puppet anymore.

She couldn't deal with it, didn't want to, which was fine. That wasn't what I was asking, but that's how it felt to her. She made the right decision to go. I just wish she'd have been more honest.

That was when it broke, in 1978.

38.

It was following that split that we made *D.o.A: The Third and Final Report of Throbbing Gristle*. By that point, Chris's wife had caught wind of his affair with Cosey, and she and Chris were separated but not yet divorced. His wife was leaving a series of more and more hysterical and enraged messages on my answer phone—she's the one yelling at Cosey on the song "Death Threats." She blamed everything on him being in Gristle. There's another message where she actually said she had paid some East End hoodlums to come and throw acid in Cosey's face. We got crank calls quite often. But when I got a call from that bloke, I got a bit paranoid at first. Then I realized that seemed really stupid to put a threat like that on tape, knowing what you're saying was being recorded.

The song "I.B.M." used sounds from a yellow plastic cassette that we found in the street near the gutter outside an IBM branch office. The tape was labeled IBM. We just picked it up and went, "Oh, I wonder what's on that." What was on it was computer code. They usually wiped them off, and indeed most of it was blank, but there were sixty seconds left on, which, fed into a computer, spewed out everybody's monthly pay. We left it as it was for the first bit, and then we added other noises as well, so if you put it back into the computer, it might have started off churning out paychecks, then God knows what it would have started doing. But apart from the computer, "IBM" also stood for "intercontinental ballistic missile," too, which also had sound connotations—blips and noises, like radars and scanners. So the track was computers and missiles, and it was the only track that wasn't emotional or human, really—it was sort of electrical and cold. Usually bands put their most commercial track first, to draw people in. But what we did was say that if you could cope with this and you were still interested, then you might genuinely want to listen to this album. It was a test, in a way.

Suddenly, anything and everything that could be recorded was game. It was no longer about chords or structures or keys or harmony or whatever. Suddenly, anything and everything that had ever been recorded could be included.

It's one of those things—the right thing at the right time, and having the nerve to let go of all the preconceptions and saying, "This is how we feel comfortable making sounds, and if you don't like it, tough."

That's the difference between punk and industrial right there. The other thing was just lyrics: we took the lyric to its final extent, which was dealing with things that we were experiencing. Anything and everything is capable of becoming a lyric, whether it's a piece in the newspaper or a documentary film you've watched or some theory that somebody's proposed. We took away the limits.

At the time, there was a big split in Britain between punk and what we called industrial.

There was that classic quote about punk: "Learn three chords and form a band."

But I thought, *Why learn any chords?*

That was the difference.

Why learn *any* chords? As soon as you learn chords, you've surrendered to tradition. We weren't trying to please anyone except ourselves, and if we were confused by it ourselves, even better.

Punk rockers still wanted to be rock stars. Just through a different strategy. They got managers first, like Malcolm McLaren. Then they tried to get major labels vying to offer them deals. And they took deals, all of them: the Damned, the Jam, the Sex Pistols, the Clash. They could not wait. They all wanted deals with major labels, and they wanted to be on the music chart show on TV, *Top of the* fucking *Pops*. None of them refused. It was kind of pathetic that they were so easily seduced. That was the strategy the industry had been using since the end of the 1960s: Co-opt it, corrupt it with money, turn it into entertainment, and emasculate it. And that's what happened to punk, too.

I can't speak for Chris, Cosey, or Sleazy, but I was fanatical about the destruction of rock and roll and the prophesying of an entirely new, far more

relevant expression of the contemporary experience. I remember doing an interview when we re-formed, and the journalist asked about the lyrics, and immediately Chris and Cosey went, "We were never listening to the lyrics. We don't know what Gen's singing about." And I thought, *God, how disappointing*—and I wondered if it was true. Had they really not cared? Is that why I could get away with everything that I did? Maybe it was true. And if so, what a pity. Because it meant a lot to me, what I was writing about. I really don't believe TG could have worked without the lyrics. I think the vocals and lyrics were essential. The sound was very powerful and strong, but I think those made it truly revolutionary.

The track that followed straight after "I.B.M." was originally just called "Hit by Rock," not "Hit by a Rock." It's about transistor radios in the morning, kids sitting in the kitchen, trying to eat their breakfast with Radio One on or whatever, and comparing that to being belted over the head with a brick. A lot of the lyrics were very simple, but to me they conveyed about six levels at once, the banality of the radio at breakfast time, then a joke comparing heavy rock to actually being belted over the head with a rock, killed by it: "Hit by a rock / Spoiling my breakfast / Hit by a rock / Blood and brains on my marmalade." I always liked the idea of using marmalade; it's such a silly word.

For *D.o.A.*, we also decided each to do a solo track. Sleazy did one that was basically a collage of tapes that he'd made. Cosey did one about childhood called "Hometime." Chris did one that was like ABBA without singing.

Mine was called "Weeping," and it was about loss, but also about feeling wounded by deception. I thought I'd play with the idea of wounding. If you're burned or wounded, if your wounds leak, they're said to weep. And if your heart is hurt, or if your ideas are hurt, then you also weep.

I had letters from Ewa, describing to me the time when she got divorced, and I just slipped in certain sentences as I was making up the lyrics to "Weeping," combining her thoughts with how I felt about my personal relationship at the time. And when I went to record it, I also took a load of Valium, because I wanted the song to be like a suicide. I didn't want it to be technically well sung; the voice sounds like somebody who really is about to overdose, leaving this as his final message. And I was feeling pretty

much like that, so I captured it while I was still in that state. "Weeping" was a description of how I felt, and yet at the same time, the exact parallel of someone else in another country and how she felt.

And after working on the song, I actually tried to commit suicide, because I thought I'd really blown the COUM Transmissions concept.

Cosey had moved out of Beck Road at some point in 1978. Fizzy Pete had come down from Hull and was staying with me. Fizzy Pete was sort of a very strange, beautiful person—still is, probably. He was living downstairs, and this particular weekend he decided he was going to go away with one of his boyfriends for the weekend. We thought, *Oh, that's good, so I won't get found, I can just do what I'm going to do, and then no one will find me—a nice, clean exit.*

I'd gone to the doctor and said I was suffering from depression, and saved up Valium and Mogadon. I took fifty Valiums and ten Mogadons—which is stronger—and then drank a bottle of whisky. And I also took all the prednisone pills I had left because I thought that might fuck up my metabolism, too. Then I lay down on the bed very quietly and went to sleep.

Suddenly, somebody was shaking me and shaking me, and bloody Fizzy's come back because he and his boyfriend had an argument. I don't really remember any of that part except little flashes. We didn't have a phone at that point, so Fizzy ran across the street to the door of Helen Chadwick. She called an ambulance, and she and Fizzy shook me until it arrived. The ambulance took me to the hospital, which I don't remember at all.

When I woke up, I found myself in the hospital and went, *Fucking hell. Why am I here?*

On the little table next to the bed was a bottle of pills. So I just opened it and swallowed all of them. Don't know what they were. They didn't do anything . . . that I know of.

In those days, in Britain, they didn't really bother at all with things like psychiatrists and psychologists or therapy. Afterwards, I was taken to a room, and a guy sitting there in his white coat said, "So, why did you try and kill yourself, Genesis?"

"Because I was fed up."

"Oh, okay."

And that was it. That was the whole interview. My entire therapy. And then they sent me home.

But, for about a year, I don't remember anything. I must have burned out some serious memory receptors or something. I don't really know much of what happened in the next year, 1979. It's a blank.

Luckily, Kim Norris was taking care of me a lot of the time that year. I'd met Kim while I was still on the dole. At some point I had received a letter: "You have to report to the unemployment office for a follow-up interview to see if you've become capable of work." *Oh, fuck.* I hoped they wouldn't say I had to work. So I put on my skintight leather trousers, my jackboots, my leather shirt, and my leather jacket. Went down there thinking, *This should freak them out.*

I had to wait for a while, and then somebody came and said, "Come in."

We go into an office, and there was a very prim and proper woman sitting there with glasses who said, "Oh."

"What?"

"So you're Genesis P-Orridge?"

"Yeah."

I was determined to be really obnoxious, so I went and put up my jackboots on her table.

Then she said, "I got taught all about you in my art class at school."

"Oh, was it interesting?"

"Yes, it was, actually. I thought it was really interesting."

So we started talking about art and Throbbing Gristle, and she was a fan!

Then I said, "So what's going to happen now?"

"Well, obviously, I'm going to say that you're unemployable, and you should keep getting your money indefinitely."

Then she said she wanted to show me something.

"Come with me."

We went to another office that was empty, and there was a safe, which she opened, and inside were various folders, files, and things. She pulled out a thick one. It was my file. Normally, when Kim got handed a particular case, she was handed a little folder. But when she was assigned to my

case, it came with this massive thing that was kept in a locked safe. They had stuff going back to my primary school, copies of all my school reports, all the times I'd been questioned by the police, photographs of the Ho Ho Funhouse, everything. It was really spooky. Someone, somewhere, had the master copy, presumably some section of MI5 or Scotland Yard, who knows. She showed it to me just as a warning.

"Look, they've really got their eye on you."

It was pretty amazing. I always wished I could have gotten a copy.

The police in Hull had a big file, too, with photos and everything. They probably passed it on to whoever was keeping the master file. In university, when I was doing fake sit-ins and demonstrations, I was bound to have been put on a list of radicals. One of my really good friends at university had gone on from there to work for the IRA as a legal advisor. So to anyone looking at the jigsaw, it seemed like I was involved with all these different things and therefore must have been doing something wrong, radical, and bad.

And, of course, I was, in a way, but not in any way that they would understand. It was more surreal than it was political.

Maybe three or four days later, there was a knock at the door. Monte Cazazza was staying with me at the time. I'd been over to see him in Oakland in 1978, where he was plugged into the underground culture all over California. Which is how I ended up getting to know the Dead Kennedys and X and Fear and Flipper, as well as Claude Bessy from the L.A. fanzine *Slash*. I actually liked the music of American punk bands better than the English ones. I also remember Darby Crash of the Germs showing me copies of their first record, fresh from the factory, talking about what an inspiration TG had been and excitedly pointing out that their drummer, Don Bolles, was wearing a TG button on the back of the record. Anyway, from then on, Monte was around a lot.

I went down, and it was the postman with this big cardboard box.

"It's for Genesis P-Orridge."

I signed for it, took it in, and looked at it—and for some reason, both Monte and I got really suspicious of the parcel, because there was no return address.

Monte and I decided it must be a bomb.

The IRA people next door had threatened me. I'd also had arguments with the National Front, the Nazis, so there were a lot of people who'd threatened me at that point. I thought I'd better not open it in case it was a bomb.

After a lot of discussion, Monte and I very gently carried it outside into the backyard and filled up a metal container with water. Then we put the parcel into the water and left it there for two or three days, so that hopefully it would make it stop working. Finally, I threw it over the wall behind our house, and then forgot about it.

A few days later, Kim came around, and I told her about the bomb.

"Gen, are you serious?"

"Yeah. But we buried it in water and then threw it away."

"That was a food parcel I sent you from work. That's why I didn't put the return address on it. It had a loaf of bread, some cornflakes, and butter."

That's how far out in my fantasies I'd gone at that point. I do take my fantasies very seriously. I immerse myself in them, but that was an example of being stupid.

In any event, Kim started to come around, and we started having an affair. Which was fun. She lived in the suburbs somewhere. Sometimes, when her parents were away for the weekend, I'd go over and spend the night, and she'd cook me a really nice meal and then we'd have lots of sex. Then she'd get me home the next day. It was a very sweet relationship. We became really close.

Fizzy Pete, who ended up living with me for quite a long time at Beck Road, rang me up one day, and said, "Gen! I've been watching the TV news and that guy that I went home with, he's just been arrested for murder!"

He was a serial killer of young gay men, whom he would take home and murder and then cut them apart, keeping the heads in the fridge and boiling bits of them. He would get the flesh off the bones by boiling them. Then he would pour the soup down the toilet and flush it. In the end, the human fat had blocked up the pipes, and a plumber had been called to have them unblocked. They found human remains in the pipes, and so he was arrested. Then they found out that he had killed all these people.

Fizzy was actually in tears, saying, "I went home with him, and I thought it was strange. I could've been murdered, Gen! I could've been murdered!"

"But you weren't."

"But I feel like I was! I'm so scared!"

He's not going to come get you now."

Then Kim told me that the killer had worked with her. When we first met, Kim was working at the dole office, but later she worked for the job center when they made it more yuppified. This guy worked with her at the job center. He always seemed a little strange, but not in any particularly extreme way. But when he appeared in the news, she said, "God, that guy worked with me!"

And then she said, "Oh no, last Christmas . . ."

"What?"

"He brought this really good meat stew to work and we all had some."

And we looked at each other and we both thought: *It had human meat in it.*

* * *

I found myself increasingly disillusioned with everything to do with the band. I hated TG's increasing critical acceptance. The dilution of integrity. Even the "cult" acclaim. And I felt no respect for the other three members of Throbbing Gristle. I had to call a TG band meeting and say, "Look, I am doing almost all the daily work now. I can't do everything, write all the lyrics, come up with new ideas and titles, copy cassette tapes, and I am living on about eight pounds a week while you've all got houses, money for cars, luxury goods. I am feeling used and exploited."

In the end, they agreed to pay me thirty pounds a week for running Industrial Records and for the use of my home and studio. It was clear the other three members of TG became more and more torn between comfortable lives and the hip status of the band.

I knew Monte Cazazza was right when he told me Cosey, Chris, and even Sleazy would be happy to see me die onstage.

"You'd be their gravy train," Monte said.

I was convinced that I had become perceived as a wild onstage spectacle. Exciting the insatiable, voyeuristic appetites of public and bandmates

alike by risking my sanity, my life, my physical freedom, and my emotional disintegration in order to speak more clearly of alienation.

"Weeping" was not only my own first "official" solo track within the confines of Throbbing Gristle; the song was meant to be my suicide note. I chose to kill myself in public at a club in London called the Crypt. I thought a club that smelled like piss and used to be a desanctified church would be the perfect ironic spot to end it all. I drank a bottle of whisky laced with Mogadon and Valium onstage and violently threw up halfway into "Hamburger Lady."

It didn't quite work.

To this day, I consider that the last true Throbbing Gristle gig.

39.

My feeling, looking back at my brief but precious friendship with Ian Curtis, is that he and I were intensely similar. We were both born in post-war, bombed-out Manchester, and we both viewed our experiences in a minute-to-minute way, seeing life as a metaphor for an ultimately fatalistic destiny. We would often express this futility in self-hatred. For failing to make people understand, failing to make them really SEE the hypocrisies and the betrayals, the pain of existential dilemmas.

Ian would usually call me late at night. Perhaps it was from Jon Savage, or perhaps someone else, but he got hold of my private telephone number and began to call me. He would call me at odd hours to talk about Throbbing Gristle, to talk about my anarchic ideas on popular music. I had, after all, named a totally new genre of electronic rock, which imbued me with some serious credibility.

Ian was a great talker on the phone, and smart. He turned out to have been an aficionado of Throbbing Gristle from as early as 1977, when he bought our first album, *Second Annual Report*, mail order directly from us. Apart from any common drive to subvert and inflame popular music, we would also talk about militaria, transgressive acts, Nazis, William S. Burroughs, suicide, sociopathic tendencies, and, needless to say, depression and isolation.

When *D.o.A.* came out, Ian loved the track "Weeping."

It turned out I wasn't the only one who thought he was being used by his band. Ian felt the same way about Joy Division. We understood each other's hopeless situation completely. We wished we were somewhere else with a group of our own, a new group.

"Weeping" remained Ian's favorite song of mine. Sometimes he even scared me with his devotion to it. He'd play it to me over the phone and

softly sing the words along with my vocal. Joy Division released "An Ideal for Living" in June of that same year, 1978, and he gave me a signed copy.

People ask me years later what Ian Curtis was like. What did he dress like? What kind of drugs did he do? What were his political views? What kind of music did he listen to?

He dressed scruffy. Pullovers. Jeans. Unremarkable.

He drank beer. Smoked a cigarette now and then.

He didn't have any political views. Couldn't have cared less.

We both loved Frank Sinatra.

Listen to "Closer" sometime, really closely, and you can hear the Sinatra influence. The careful phrasing. Sinatra's phrasing blew Ian away. One time I can distinctly remember the two of us sitting in my squat in Hackney, listening to "Laura" sung by Sinatra. It must have been the middle of the day, because I remember turning up the stereo to drown out the sound of traffic outside. Ian was staring at the jacket of the LP as if it were some holy document.

He liked Jim Morrison, too. And the Velvet Underground's nihilism. But he liked Sinatra more.

Some afternoons we'd kill time in a Nazi memorabilia shop called Call to Arms, run by Chris Farlowe in an Islington antiques mall. Chris had had a hit single covering "Under My Thumb" by the Rolling Stones, using the resulting windfall to indulge his Nazi passion. I had bought one of Hitler's table knives from the Berlin bunker silverware there for just ten quid.

Ian would paw around some of the uniforms, try a jacket on. A Hitler Youth belt. He thought the Third Reich had the best uniforms, that Speer had a really sophisticated sense of style. Most of the time, we walked right back out, empty-handed.

The rest of his band was always into getting drunk in some pub somewhere. They didn't get him. Never would. They'd tell him to have another beer and shut up.

Do you think he'd ever dare tell them he'd been listening to Frank Sinatra?

There were only two people he really confided in by late 1979 and early 1980. One of them was Annik, this beautiful Belgian woman who worked

for the record label Factory Benelux; he'd met her on tour, with her perfect pouty lips shaped by speaking French in that super-seductive way. He was so in love with her. He was still married to Debs, and they had a baby daughter, Natalie, too, but there was no going back.

I was the other person he confided in that fatal year. I was his father confessor, in a way. I was ten years older. It was never a matter of having some deep conversation, some tearful heart-to-heart. He wasn't like that. In fact, I remember the silences more. Long silences. So much guilt filled those brooding silences. His eyes lighting up when he suddenly had come to some firm conclusion deep in his mind.

Once he reached for his pack of cigarettes, then remembered I didn't allow him to smoke in my apartment. I hated the smell. We'd been talking about the upcoming Joy Division tour of America. The conversation had dropped off earlier. But now he'd circled back.

"I'm not going," Ian said.

"Then don't go," I said.

"They keep telling me I'm going to be on tour," he said. "But I'm not going to do it."

It seemed as if a weight had been lifted. Decision made. He had a sense of invisible, relentless steamrollering behind the scenes, and this was compounded by feeling he had ended up exactly where he didn't want to be. Feeling obliged to take part in a truly dreaded American tour. He spoke of a sense of betrayal, of being used, of claustrophobic relationships, his fear of flying, letting Deborah and Natalie down, disappointing Annik, who he truly loved, of being eaten alive by everyone and destroyed. He felt weak and trapped. Sucked dry. It was a toxic combination.

He believed that his own lack of courage had created this situation. Commercial blackmail and misplaced loyalties had destroyed the integrity of Joy Division. Matters had somehow been shabbily manipulated in such a way that, despite his cries for help, he was scheduled to fly to the U.S. on May 19, 1980.

"Shall we listen to 'Laura'?" I said, reaching for the Sinatra LP. He nodded his head, in a mildly better mood suddenly. "Cheer you up?"

"Laura is the face in the misty light . . . ," Ian sang, smiling at me as I

set the needle down. A few seconds of static and then that perfect, gem-like phrasing.

A few weeks went by before I heard from Ian again. It was one of those late-night phone calls. We were talking about Throbbing Gristle again, and he told me he wanted to be as irreverent, innovative, and provocative. He'd seen a small pressing of our single "We Hate You (Little Girls)" backed with "Five Knuckle Shuffle," which had been packaged and designed by Jean-Pierre Turmel of Sordide Sentimental. Ian loved all the artwork and the concept of a limited edition seven-inch single.

I'd met Jean-Pierre through the mail, because he'd ordered a copy of *Second Annual Report* and went head over heels for it. He felt it was the next step in culture, the next move. He sent me a copy of what was then a fanzine, *Sordide Sentimental*, and in a subsequent issue, he wrote a deeply philosophical six-page review of the LP. He sent me that, along with a translation, and I was pleased someone took us seriously: unlike most of the English music press, that, if they initially liked the record, liked it just for being "weird." Anyway, Jean-Pierre and I became pen pals, and he wanted to transform his zine into a label—a label that wasn't just releasing records, but was releasing packages that were sort of cultural anarchy, strategies to change the way people perceived things. Of course, he wanted TG to do the first, because we'd inspired the shift in his perceptions and his aesthetics. Then he invited Loulou Picasso to do the cover art, because he wanted to have different artists do the covers of the things he released, so that he was also engendering support of the art world and showing that that, too, was in flux.

"Do you think Jean-Pierre would be interested in doing a Joy Division single, Gen?" he asked, seemingly unsure.

"I know he would, Ian. He is already a great admirer of your band."

He seemed surprisingly unsure that their music would be interesting enough. I told him I'd connect him with Jean-Pierre in Rouen. And that's how "Atmosphere" happened, released as a limited single by Sordide Sentimental: Joy Division's most valuable musical artifact and, in my opinion, still their most perfect song.

The experience with Jean-Pierre had planted a seed in Ian's mind.

Smaller instead of bigger. Taking risks instead of staying trapped in a band that had become stale to him. The same way that TG had become stale to me. It was during those late-night phone calls that we hatched a mischievous plan: we were going to organize a joint show in Paris where TG and Joy Division would perform together. Ian, Jean-Pierre, Brion Gysin, Joy Division's manager, Rob Gretton, and I would agree to keep things secret for now. The usual groupies would be there, the other six members of our two bands just going through the motions, waiting for their two lead singers to get over their little art kick and become the usual moneymaking spectacles again.

Ian was laughing on the other end. He didn't laugh much, so I knew this was really amusing him. He could really picture it.

"Then we all come back onstage and have a little jam," I said.

" 'Laura,' " he said jokingly.

"They wouldn't get half way through it," I said. "How about 'Sister Ray'?"

It was one of our favorite Velvet Underground songs. Joy Division sometimes played it live as an encore.

"That's perfect," he said.

"And then *we* come back onstage—just you and me," I said. "And we announce that we're quitting our bands and you and I are forming a new band together."

Looking back, it's bittersweet. Brion Gysin arranged for me to talk with a booker at La Palace, who loved the idea. Rob, the Joy Division manager, gave the show a green light. I had even traveled to Paris to confirm everything.

But it's the show that never happened.

It's the band that never was.

It's this empty page that haunts me. The songs that aren't. I would love to hear what it would have sounded like. Two Frank Sinatras. I know it would've been something else. I know it would've saved Ian.

That's how close we came. Can you feel that almost erotic sense of purpose and that exquisitely tormenting sensation of irrevocability that devoured us?

We wanted to build something, in this case an aesthetic "jihad" that was

not already publicly desired, that nobody in their right mind could possibly want, and then to relentlessly prove that they did want it after all—indeed, leave them feeling that it always existed.

All the while we were converting the outside world to our inner aesthetic, Ian and I were depressingly aware that in the end, the audience and critics understood nothing, respected nothing, and protected nothing of our vulnerability, our genuine pain.

We explained so much, we appeared silent. We moved so many, we appeared still.

I am forced to believe that Ian recognized a great part of himself in the role I was compelled to act out in Throbbing Gristle: careening, searingly adrift, and isolated. During more extreme performances, often bitter, suicidal, and callously nihilistic.

There were two more calls from Ian.

One night, it was short and to the point. He asked me if I was coming to a Joy Division gig at the Pavilion in Hemel Hempstead. I said I would.

The show was a mess. He had an epileptic seizure during the second-to-last song and they had to carry him offstage. Tony Wilson, that prick, was smiling at me. The houselights had been turned back on, making him look even more demonic.

"You're killing him," I said. "You know that?"

"Well, then," Wilson said. "Even better publicity. We'll really clean up."

I wanted to punch him, I really did.

The last call from Ian was on the night of May 17, 1980. An abject Ian phoned me for the last time. He was singing "Weeping" again, but his voice seemed farther away, strange. I was scared for him, because I could sense what was in his mind. I had tried to kill myself to a backdrop of "Weeping," too. He was distraught and severely depressed. He was alternately bewildered and angry. Sick of it all. Sick of not being heard when it was inconvenient for others. With his own personal contradictions and problems on top, I knew that there was not much time.

He felt that somehow he'd let matters slip out of his grasp and control; that nobody around him cared what he wanted, what he needed, and more

importantly at that moment, how much he did not want to tour the States with Joy Division.

I listened to him sing "Weeping" and stayed silent.

He wasn't drunk. He wasn't deranged-sounding. He was concentrating on every word. The phrasing as important as ever.

"You didn't see me weeping on the floor / You didn't see me weeping on the floor . . . ," he sang.

I was just listening. I had a terrible feeling. But in hindsight, anyone can say they had a terrible feeling.

"My arm is torn open like a wound," he sang, his voice getting even softer. "My universe is coming from my mouth / I spent a year or two, listening to you / Discrediting myself for you . . ."

When I see myself sitting in the corner of the couch, with the phone pressed tightly against my ear, I can't do more than just listen to him sing. The singing is where it began and ended. Maybe the darkest song I ever wrote could help him begin again.

He was singing me the final words.

"I don't want to carry on / Except I can't even cease to exist / And that's the worst."

He put the receiver down, and it disconnected.

I just knew something was wrong. I rang people I knew in Manchester. My calls went unanswered.

But why didn't I call the police?

The last thing I wanted was for Ian to be suddenly invaded by emergency services and perhaps carted off for more medical and even psychiatric evaluations. Perhaps this was just an extreme version of his usual motive for ringing me up. Perhaps he was just desperate for company and support, to be heard by a person he believed felt the same things just as intensely. I intended to travel up to see him that week if he managed to cancel the American tour.

I phoned someone else in Manchester and told them that I thought Ian was really going to try to kill himself and that they should get to him immediately at home. When I got a curt reply and was asked how I knew,

I said I just knew. Somehow the person I spoke with succeeded in putting me into an almost hypnotic holding pattern, persuading me that everything was going to be fine; it was just a prima-donna tantrum and that I should not interfere directly and call anyone else or the police. They promised they'd do something anyway, and they never did. They thought he was just winding me up.

"Just Ian being dramatic," they said.

"*No!* I really think he's going to kill himself tonight," I pleaded.

It fell on jaded ears.

I was assured that if anything really serious was going on, the Joy Division inner circle would take care of it in their own way. They were used to this kind of thing.

A sense of awful inevitability still overwhelmed me as I hung up. I cried into the night until the Valium kicked in. I wept. The kind of weeping that wracks your body with sobs and screams so deep that they feel like spiritual convulsions.

I could have called the police, but I didn't.

In the end, I convinced myself, just like the rest, that nothing terrible had happened.

They found him the next morning. I'm not sure how long after we spoke he actually hung himself in the kitchen in that very working-class Manchester manner.

Years later, long after Ian's death, I saw Annik at a Psychic TV show in Brussels and we fell into each other's arms. We'd both been his secret friends at the time he most needed to feel he was being heard. The hidden, heart-torn Ian. We were wiping away tears, holding each other. Even after so much time had passed, I could sense, without her saying a word, how much she still loved him.

40.

With Throbbing Gristle, our approach changed a lot over time. To some degree, we got more skilled. I could *almost* play the bass. Mainly it was better recordings.

We did everything on our own, but we did it through discussion. That's how we came up with things. Discussion. Our main goal was, whatever we did last time, we had to do the opposite this time. We had to contradict ourselves. That was the strategy, so that, whenever possible, people's expectations were confounded.

The idea was always to change.

We did what we did in the beginning, with *The Second Annual Report* and *D.o.A.*, and everybody started to get that. Then with *20 Jazz Funk Greats* we fucked with their heads and got lots of abuse for it. Now everybody says it's a classic album. But when we did it, it was like saying: *Don't relax, keep awake, don't just do things because that's what you did last time and it worked last time. Look for new solutions, new answers, new ways to say something. Don't stay in one formula. Don't have a fucking brand.*

There's an article in *New Musical Express* where they got us together with the Human League and a few of the other early people, using machines and synthesizers in order to have a conversation about what industrial music actually was. I came across as really angry. I was like, "You're all just using these sounds to make the same kinds of songs everyone was making before. Why are you turning it back into a variation of what was done before? Can't we let go of those structures? That's not the way to come up with something new."

I despised most "industrial" music personally. It was the classic case of the commercial labels cashing in on something by ultimately mutating it into a commercial venture. The fact that there's still industrial music clubs and DJs and labels and bands worldwide speaks to the success of commerciality rather than the innovation of music.

It's almost like having invented jazz or something, then years later seeing it result in something like Kenny G. You think, *How did that come out of what we did?* So there's all these different subgroups now, and they're all valid if they've got reasons to exist. That's the real question: What is the reason you're doing it? Are you trying to tell us something, or are you just trying to make music? If you're trying to make music, why? Is that to sell? Is that to get girls or boys or drugs or what? What's the reason? And if it's not about telling us something, preferably something, we didn't know before, then it's not really worthwhile. It doesn't mean you can always do something original—to some extent, we just got lucky. It must have been in the air; but I was also very stubborn.

It's incredible to think that a handful of people in England, primarily ourselves and Cabaret Voltaire, could change the concept of what music could be and invent a whole genre of music. We heard rumours David Bowie was at a couple of TG shows; I do know for a fact that Bowie bought *The Second Annual Report* when it came out, as did Lou Reed and Peter Gabriel, because they ordered it through mail order. Peter Gabriel used to ring up Sleazy and ask him about the latest electronic equipment. Gabriel also bought out an engineer we used to work with.

We think one of the great contributions we made with industrial music, particularly with our lyrics for Throbbing Gristle, was to break down any limits on what we could discuss. Anything can be part of a song: Why should it only be the provenance of journalists, philosophers, or economists?

There would always be sections that were untitled and just a rhythm— and that's when I would make up lyrics, like "10 pence for a packet of cigarettes" and "discipline" and so on. Even at the last gig, "Looking for the OTO" I made up on the spot. When I was walking into the venue, I saw a dog get run over by a car, so I talk about that in the beginning of the concert. But at that point, I was really interested in trying to find out more about the OTO—the Ordo Templi Orientis, Crowley's outer order—because it was very mysterious, and I was already planning Psychick Youth. So I was wondering how the OTO did things. That's why I did the song "Looking for the OTO." It was actually an invocation. The other three members of TG had no clue what I was thinking and doing. They gave me the freedom to make up lyrics.

During that time, I was having an affair with Laurence Dupré, the sister of LouLou Picasso—the leading visionary of a punk fine art community in France and the artist who'd done the cover of our Sordide Sentimental single. LouLou's collective called themselves Bazooka and became very well-known in France in certain areas of culture as the most revolutionary designers, graphic artists, painters, and performers. LouLou is color-blind, which means that he did lots of beautiful oil paintings in black, grey, and white. That's why the cover of the seven-inch vinyl single of *We Hate You (Little Girls) / Five Knuckle Shuffle* is just yellow and blue and grey, because it was just black-and-white, and then Jean-Pierre Turmel added a bit of color to it for the design.

Jean-Pierre thought LouLou's sister, Laurence, and I would be mutually attracted to each other. So much so that when I went over to see him at some stage, he moved out of his apartment so that Laurence and I could stay there together. It was fun.

Laurence is a most incredible seamstress. She's worked with all the top couture design houses in Paris. She can sew and embroider to a degree that's uncanny: she can make it look like it had to have been done by a computer, all by hand. I had always shied away from fashion—partly because I could never afford any clothes I liked, and partly because it seemed a contrived system to define elite groups from those less fortunate, working-class demographics. Fashion signaled aristocratic superiority. So I always dredged army-navy surplus shops, found jeans for fifty pence (ten shillings back then), got surplus suede desert boots, then hand-died them in psychedelic patterns. I liked the utilitarian qualities of military gear: "Function before fashion," my T-shirt said. There were pockets galore to store equipment, clips of bullets, and maps, making you a walking self-contained warrior. We imagined TG as sonic warriors. And with thoughts of Psychick Youth already in my head, I was picturing a kind of paramilitary organization, and perhaps adherents would wear a big belt like a cop would wear—perhaps containing a Walkman, a miniature camera, flashlight, film, notebooks. Basically it would be an artist's version of a survival kit, so you were always ready to document, to capture images and words and sounds. I was already practicing what I preached; I had an old military leather pouch that fitted

my Polaroid camera perfectly, and I kept that, along with clips of film, on my belt.

One of the things Laurence and I had in common was a fascination with camouflage. Military camouflage was intended to make you vanish, not stand out. It used different colors *not* to be seen, whereas most fashion was about being seen. Camouflage had all these wonderful contradictions because of its different functions. It was improved by dirt and mud, becoming more invisible and authentic. Also, camouflage was about functionality instead of aesthetics. Laurence was into it for similar reasons, and we would have long talks about camouflage that were very, very obscure, and we'd go looking in bookshops together for books on camouflage. Then we started going to flea markets in Paris looking for obscure bits of camo wear, and got some great stuff.

We became camo buddies—and lovers.

After a while, we started thinking, *We love camo because it's the opposite of high couture. What about making high couture that's camo?* Laurence thought it would be a great idea to twist it back on itself and make hand-done, beautifully embroidered camouflage clothing. Camouflage was originally about hiding in forests and in the countryside in traditional warfare, but, more and more, fighting was urban. Wearing normal camo in a city made you stand out and become a target, when it was supposed to be helping you stay hidden. So urban camo should be greys and brick color, and weird angles like buildings, instead of floppy leaves. There were lots of really good, sensible reasons why we wanted to completely redesign camo together. There are some letters back and forth with all the theories we were discussing at the time. We were planning to do a book together, in fact.

She decided to make a custom set of camo clothes for me.

"Do you need me to send measurements?"

"No," she wrote, "I never measure anyone."

"How do you know it'll fit?"

"I've never made a mistake."

And sure enough, when she came to London, she had made me these amazing outfits: trousers and two reversible jackets. She had silk-screened canvas with images she found in an archeological book—of early human

skeletons and skulls found in a dig somewhere—and broke it down into white and grey.

Then Chris, Cosey, and Sleazy started nagging me: "We'd like some camo, too. You think Laurence will make some for us?"

"I don't know. She's not in love with you. And you're not in love with her, so I don't know if she's going to make you any clothing."

But I mentioned it to Laurence, and she thought it would be a really interesting project to do an outfit for each of us, so that TG would be in her new kind of camo.

Again she refused to measure anybody and made three more outfits, one for each of the others. Each is different, all of them hand-printed, all of the badges hand-embroidered. It was a beautiful set of outfits, and she gave them to us for free.

41.

I had remained friendly with the members of Alternative TV. The band had become a four-piece, with Mark Perry, Alex Fergusson, the drummer, and another guitar player. Mark got more and more avant-garde and started to prefer the Throbbing Gristle approach to the punk approach. He started doing weird experimental things. One of the albums was called *Vibing Up the Senile Man (Part One)*, and I played percussion on it.

Because of his music writing gig, Sandy Robertson got well off enough with his income that he could afford to move into a flat, which meant that Alex—his former roommate in the rotting house they had squatted together—was all on his own. I told him one of the houses we controlled on Beck Road was empty.

"If you want, you can live next door."

So he and his best friend, whose name I can't remember, moved into number 52 Beck Road. And it was Alex who ended up introducing me to my kids' mum. One day he said, "I was in the Tesco's around the corner, and there was this really cute girl working there. She's there on Saturdays."

"Yeah?"

"Yeah," he said. "Oh, guess what? They sell United Biscuits, by the way."

"Yeah, so?"

He started singing the United Biscuits jingle. He found it hilarious that the biscuits shared a name with a classic TG single.

"Alex, for fuck's sake!"

He kept pleading, "Come with me, come with me! She's really cute. I think I might try and go out with her. Let's at least go, and we'll buy some United Biscuits and have it with a cup of tea."

"Shit, Alex," I said. "Sometimes you're really weird."

So we went around to the Tesco's by Broadway Market, and we got some United Biscuits so that we could go to the checkout so I could see this girl. When I actually looked at her I thought, *Oh, she is cute! He's right.*

So I said, "Do you want to go out tomorrow?"

Alex gave me a really filthy look.

She said, "No."

"Oh, okay," I said. "Well, we just live around the corner on Beck Road. If you ever want to come and see us—you know, for a cup of tea or anything—you know, just come around."

I was thinking that was the end of that.

But then, a few days later, there was a knock on the front door at one in the morning, and I went down. It was the girl from Tesco's.

It was like when Cosey turned up at the Funhouse. It sometimes seems like my life is a series of loops that keep reoccurring.

"Come in," I said.

I made her a cup of tea and a grilled cheese sandwich, and she told me about her stepfather and how she hated where she was living. Her name was Paula, it turned out, and she was seventeen, still at school, and she hated her life. She was supposed to get engaged to a boy she'd gone out with for the last two years. He worked on the railways, painting fences.

"Is that really going to be my life? That I marry someone who paints fences, and have babies, and that's it? I don't want that."

"Well, you don't have to have that."

"I don't? Why?"

"What would you really like to do?"

"I just want anything that's not that. I want to travel. I want to learn things and see things."

So we became friends, just chatting, cups of tea and stuff. She'd been stuck in a horrible little house in Hackney all her life, and now she would come around quite often—at one, two, three in the morning—and just talk. We came to really like each other.

One day when she came around, she said, "I'm getting engaged tomorrow to that guy, at my birthday party."

The next day, her birthday, would be February 23, 1981.

"Oh! That's a surprise. I didn't think you wanted to do that."

"I *don't* want to do that."

"Then why are you, then?"

"I don't know. Everybody expects me to get married to him. His family is friends with my family . . ."

The guy was little bit older, probably twenty, and he was in the National Front, meaning he was a Nazi. He was not what she wanted at all. So she invited me to the birthday party—at a local pub. I tried to get out of it by saying, "Oh, I can't get there until about 11:30," thinking it would be closed, because the pubs all closed at eleven then.

"That's all right," she said. "We're going to lock the doors, but the party will keep going."

I went to the pub about half past eleven, pretty scared, because her stepfather used to work for the Kray brothers—notoriously famous British gangsters. There was a phase in the late 1950s and early '60s when all the celebrities wanted to hang out with the Krays. They were very brash, living openly and saying "Fuck you" to the police. They eventually got life in prison. One of them was gay, it turned out, and he ended up in Broadmoor, the mental prison, with Ian Brady. Her stepfather is mentioned in books about the Kray brothers, because he was the guy who did tortures. He was notorious for having nailed somebody to the floor, crucified him on the floor. Not a nice man. In fact, really scary. Later on, I went around to her house a few times for cups of tea and met her mum and her stepfather, who just stared at me. All I could think was that the guy who did these horrid things to people was giving me the evil eye.

Anyway, I arrived at her birthday party. There was the Nazi rail worker, who'd just given her the ring, and her stepfather, who tortured people, and a load of smaller-time gangsters. Nazis, criminals, and me. I did not feel at home there at all. It was a scary atmosphere. I'd given her an antique Victorian dress, a beautiful old dress, as a gift one day. I had it out in the house, and she said she liked it, so I said, "Oh, you have it." And at the party, she was wearing this dress I'd given her, which I thought was sweet.

I didn't stay long. I had one drink, and then I made excuses and left, as one does. That was so spooky. Then, about three in the morning, there was a knock-knock-knock on my door, and it was her.

"Can I stay the night? I don't want to go home."

"Yeah, if you really want to."

A couple days later, I came out of the house with my German shepherd, Tanith. Paula's fiancé was standing there, and he was a big guy. He was with his sister and a couple of other people from the National Front. He got aggressive: "You've been touching my woman!"

Then he hit me on the head with a brick, and they kicked me a few times. While I was on the ground, half-conscious, they grabbed the dog and ran off with it. Stole the dog. I was freaking out, thinking they were going to kill the dog.

After I'd recovered from being hit with the brick, I got in touch with Paula and said, "They've got my dog. Do you think there's any way to get it back?"

To his credit, her stepfather went around, beat the fiancé up, and got the dog. I was so glad to get Tanith back, but I thought, *This is not a scene I want to be a part of. This is too fucking heavy.*

About a week or so later, there was a knock on my door in the middle of the day. I went down and there he was: Paula's stepfather, Jim. He had on a big coat, and he stared at me. I don't remember exactly what he said, but the gist was, "You better not fucking see my daughter anymore . . ."

Then he pulled his coat aside to reveal a sawed-off shotgun in his other hand.

". . . or I'll fucking kill you."

"I'm standing here and cannot defend myself. If you're really going to kill me, Jim, go ahead. But I don't think you want to go to prison."

Like I'd said to the IRA, to the Hells Angels, to the skinheads. It was my standard response. Not consciously; it was just my instinct. Because I wouldn't live with the paranoia. I didn't want to sit around thinking, *Is he going to do it tonight? Can I go out?* So I just dealt with it on the spot. He probably had some weird, begrudging respect for the fact that I stood up to him. He never really ever spoke much to me again, apart from the odd

grunt over the next few years. I would go around to their house and sit with Paula's mum—sometimes just talk to her mum on her own, or her two sisters, whom I was worried about for obvious reasons.

This was all in February 1981. As Paula and I became lovers, she was still going to school; I would even go pick her up from school sometimes. She really had no interest in school anymore and didn't want to stay at her house, where she'd been abused so much. She needed to escape.

One night, after we'd become lovers, Paula and I were on the camouflage couch in the living room upstairs. I'd let Chris, Cosey, and Sleazy keep their keys to the house, because everything downstairs was Industrial Records. Paula and I were in the middle of making love when we heard the front door open and close. We both just sort of looked at each other and wondered who it was. It was Cosey. She came up the stairs, all dressed up, very glamorous with makeup and everything. As she came to the top of the stairs, she looked at us both and said, "Oh, that's how it is."

Then she went back down and left. Paula turned to me and said, "I think she came round here to have sex with you. I think she's trying to control you with sex."

"It *was* a bit weird, wasn't it?"

"Yeah, it was very weird."

At some point, I said to Paula, "TG are going to America."

"I don't want to be on my own. I'm scared of what's happening at home."

"Come with me."

"Really? I can come?"

"Well, it's up to you, but if you want to go, I'll pay for you to come with me. We'll get you a passport at the post office. Get away, see the world from a different place."

She had to decide what she wanted to do. She could stay at school and do her exams, or she could take this opportunity to change her life—which she did, to her credit.

Her mother was actually quite okay with her decision. Paula's mum was submissive towards Jim, but when I went around to ask if she could come to America, her mother just said, "Yeah, she can go with you. Just look after her, and be nice to her."

So, in May 1981, off we went with Throbbing Gristle to the United States.

We flew to Los Angeles, where TG played a gig at Veterans Auditorium with SWA and 45 Grave—which was the new band of Don Bolles of the Germs. The morning after the gig we were having breakfast at Norms with Don, Stan Bingo, Scott Armstrong, and Jerry Dreva of Les Petites Bon-Bons. I had met Jerry through mail art, and he was in a big exhibition just then at one of the university galleries. We were hanging out together, and I'm pretty sure it was Don who said, "Let's all go to Tijuana. We can get flick knives and all kinds of good stuff."

I thought, *Why not?*

Don Bolles, his girlfriend—whose name, sadly, I can't remember—Jerry Dreva, Stan Bingo, Paula, and I got in an old transit van and drove to Tijuana. On the way, we all took a hit of acid. Tijuana was fabulously bizarre. As we were walking along one street, we looked up and saw a sign that said: *Mr. Martin. Weddings Quick, Divorces Quicker.*

I said, "Mr. Bradley Mr. Martin, the character from *Naked Lunch*! That's pretty funny!"

Then Don said, "One of us should get married!"

"Why don't you get married to your girlfriend?"

"Uh, no," said Don. "Why don't *you* get married?"

And then Jerry, Don, and Don's girlfriend all started saying, "You should get married. Just get married. It'll be fun."

So Paula and I said, "Oh, fuck it. Why not?"

We all went up and saw Mr. Martin, a Mexican guy with a nicely trimmed moustache. On the wall behind him was a picture of John F. Kennedy made on a typewriter, using the letters to make a picture. We went in and said we wanted to get married. I can't remember how much it cost, but it wasn't a lot. Even so, we had to club our money together to pay to get married. Don Bolles was the best man, and his girlfriend was the bridesmaid. And we got married. I've still got the marriage certificate. It's beautiful, all colored in purples and pinks.

We went back in the van all laughing our heads off. We thought it was just hilarious. We drove back to the motel. As we were all going up to our rooms, we were talking about going to Don the Beachcomber in Huntington

Beach for our wedding feast, which was a beautiful, old, kitschy tiki bar. As we were going up the stairs, we saw Chris and Cosey coming out of their room, walking towards us.

Stan Bingo said, "Guess what Gen and Paula did? They just got *married* in Tijuana!"

Cosey just said, "Oh, I suppose that means I've got to change my name now from P-Orridge to something else."

That was it. That's all she said. Then she and Chris went back in their room, pulled the curtains, and didn't come out for twenty-four hours. She was really pissed off, angry that she would have to change her name. She just assumed that Paula would call herself P-Orridge. It was a really odd response. Cosey hardly spoke to me for the rest of the tour. She sulked.

After L.A., TG were going to play in San Francisco. But while we were still in L.A., we were invited to do an interview on one of the college radio stations. Monte Cazazza was there. I'd already confided in Monte that I was going to quit the band. I had realized that, despite all the tricks TG pulled to stay unpredictable to our audiences, in the end, the only option left was to confound and disappoint our fans—to stop playing and retire the band. Monte thought it was a great idea.

"But don't tell them," he said. "Just do it. Just spring it on them. Don't give them the pleasure of knowing."

When we got to the radio station, Sleazy, Chris, and Cosey went into the studio first. I was hanging back with Monte, and he said, whispering, "Go on, do it. Do it."

"Really?"

"Yeah. Go on, do it."

So I went in and sat down and we started the interview. The radio host turned to me and said, "So what's in the future for Throbbing Gristle?"

"Oh, it's finishing. I'm leaving the band and we're stopping. The band's over. San Francisco's the last gig."

You should have seen their faces. It was a wonderful moment. I looked through the glass and saw Monte killing himself laughing. He was celebrating.

"Yes! Yes!" he mouthed.

42.

Monte had told me: "Stay alive out of spite, because they would love you to die so they could make all this money out of you being a dead rock star."

So when I decided in 1981 that I just couldn't stand being in Throbbing Gristle any longer—or really, that I couldn't be in it with Chris and Cosey, basically—I was quite happy to think I just wouldn't do music anymore. I'd never wanted to be a musician anyway, and it left such a bad taste in my mouth.

At that point, I was finished with industrial music. It was doing just fine. I was a bit sick of all the people thinking they just had to yell about serial killers and make a lot of noise. That wasn't what I'd meant at all. It was more of a conceptual aesthetic, not a formula.

The experience of Throbbing Gristle had left me feeling taken for granted and exploited. I'd run a great deal of the day-to-day grunt work of our DIY label, Industrial Records, which allowed the other members of the band to enjoy their money from unrelated, lucrative occupations while I remained in a squat with an outside toilet, no bathroom, no hot water, and one gas fire for the whole building, barely surviving.

So I just thought, *Fuck that*. I decided I'd focus on being at home with Paula, have a baby, and try to find a way to get hot water in the squat on Beck Road.

I also had something else in mind, too: I was going to make the occult trendy again.

I'd already started doing the psychic youth propaganda with Monte. If you look on the "Discipline" single, it says "Marching Music for Psychic Youth." If you look on the flyers of the last few TG gigs that I did, it says, "from the headquarters of psychic youth," and things like that. They've all got mentions of "psychic youth."

None of the other three members of TG asked me, "Why are you putting 'psychic youth' on there?"

But I was prepping the ground for what would become Thee Temple ov Psychick Youth, which I was already envisioning as my next project. What I really wanted to do was have thousands of people having orgasms at the same time. No one had ever done that before.

People laughed at me at first and went, "What?"

Of course, in the meantime, there are loads of people in music and fine arts dealing with the occult.

When we got back to London, I started seeing Alex Fergusson of Alternative TV regularly again—just because we were living next door to each other. He would come around almost every day and have cups of tea, and we'd sit around and talk about ideas, and he would say, "Why don't you do some more music?"

"No, it's a horrible scene. It's fucking awful. I don't ever want to do that again."

"Oh, you should."

"Oh, no."

"Yeah, you should."

"No."

I'd written a note to Paula and stuck it on the first water heater we ever got, a gas heater that hung on the wall. After the better part of a decade, the house finally had hot water. The note was a sort of poem that I'd written, which became the song "Just Drifting." I've still got the original piece of paper in my notebooks, which is pretty amazing.

Alex was on his infinite rap: "You should do more music. You write great lyrics. You should write songs." To which I always said no. Finally he said, "Look, give me something. Let me just prove it to you. Give me something to turn into a song, and I'll prove to you that it could be a really good song."

So I pulled that note off the water heater and said, "There, take that, then."

Just to shut him up.

He came back the next day and played "Just Drifting."

I thought, *Oh, wow, that actually is good.*

It was also totally different from Throbbing Gristle. Poetic, a ballad. *That's more like it. That's different.*

Alex was a genius. I could give him anything on a scrap of paper and he would make it into a catchy song. It was uncanny. It was incredible.

Basically, he persuaded me that it was at least a possibility to do something else musically—with him. One of the nice, unintentional symmetries of this was that Alex was in Alternative TV, and since I was working on my Psychic Youth movement, we ended up adopting the name Psychic TV. It was like the two of us split the title.

Around the same time, I had started to get phone calls from Stevo from the record label Some Bizzare. He'd had a fluke hit with "Tainted Love" by Soft Cell and now had a lot of money. He was basically trying to collect his favorite bands, and he was a massive Throbbing Gristle fan. He wanted Throbbing Gristle, he wanted Cabaret Voltaire, and later on he wanted Einstürzende Neubauten and Foetus. And Stevo was a persistent creature, so at some point I agreed to meet him and discuss possibilities.

Stevo kept saying, "Why don't you do Throbbing Gristle again?"

"No, it's over."

"Well, why don't you just carry on doing Throbbing Gristle, but with new people?"

As we chatted, I mentioned that I'd started writing songs with Alex and had secretly seeded teasers and clues in TG materials about the transmedia combination of video, sound, books, and manifestos that would be the public propaganda for a paramilitary occult association to be revealed as Thee Temple ov Psychick Youth. By that point, I had designed the Psychick Cross logo, the TOPY haircut, and the grey military-style non-uniform uniforms and embroidered patches.

Stevo loved it.

So he went off and got us a deal with Warner Bros. He got the money to record *Force the Hand of Chance*, and they would have first option if they liked it. Suddenly we were in a real recording studio for the very first time. TG never worked in a recording studio, except for one time to do final mixes on the singles in camouflage bags. We had recorded them on Paul McCartney's 16-track, but we discovered there was a click all the way

through. So we went into some big recording studio, and because I had the best sense of rhythm, I had to sit through each song with the erase button under my finger and memorize the click rate and then punch the record button every time there was a click. If I did it wrong, I would erase part of the song. And I did them all without a mistake. I was very proud of that. Talk about having to focus.

While we were recording, I wrote most of the lyrics at home after I heard the basic idea for each track. I would go home, write, and come in the next day with the lyrics. I knew I wanted to do something called "Ov Power." I wanted to try and make sure it had direct magical references in it; that was part of the overall idea. Some things, like "No Go," were just Alex messing around in the studio, and I'd say, "That sounds great. Let's make it a track."

Stevo got Ken Thomas to produce and engineer, and some unknown guy called Flood as the tape op. He went on to become very famous. That's when Sleazy got involved—when we started making the album.

During the time we were working on *Force the Hand of Chance*, we came across Hugo Zuccarelli. Ken had met him and told me about Hugo, because he knew I always liked to push the envelope with technology. Ken told me there was a new way of recording that was three-dimensional, and there was even a guy who used a real human skull covered in latex for the skin, with real human hair, with a weird box under it that translated the signals into stereo that was three-dimensional.

So we worked with Hugo Zuccarelli for parts of *Force the Hand of Chance*. There's a part with my newborn daughter, Caresse, crying, also recorded with the Zuccarelli holophonic process, on the instrumental version of "Just Drifting." We actually got letters from women saying they had lactated breast milk from listening to the baby cry. We produced a promotional seven-inch single of "Just Drifting" for DJs, and on the B-side is a track called "Breakthrough" that is mainly holophonic. It was the beginning of what we were going to do with the next album, *Dreams Less Sweet*. There were dogs barking at the end of the track. To record those, we actually went to Battersea Dogs Home, a big, famous dog shelter. When you walk down the kennels, of course, all the dogs start barking, so we recorded the barking there. I played the keyboards on that one, and Alex played the guitar.

Originally, Psychic TV was just me and Alex. Then, after a while, Sleazy asked if he could be involved, because he missed being in a group. He was the one who wanted to put more emphasis on it being video as well. At the very beginning, we were thinking it could be "Psychic Television," using the whole word. We had been discussing ideas with Sleazy, and we wanted it to be not just a band, but a whole multimedia project. Which we did try to do, but it broke into two halves, with Psychic Television as the video project and Psychic TV as the band.

Sleazy liked technical inventions, so holophonic recording really drew him in. But when I agreed to let him join Psychic TV, I recalled how part-time he had become with TG, and I didn't want to go through that again; I didn't want to end up feeling exploited again. So I made him sign a contract that listed twenty-three clauses. If there were ever conflicts of interest between his other jobs and PTV, he had to put PTV first. If he ever put PTV's interests second or said he couldn't do a gig because he had a job, then he was automatically fired from PTV.

As first proof of loyalty and commitment, Sleazy and I both got tattoos of a skull and Psychick Cross. My tattoo was a cross with a skull inside it, and Sleazy's was a skull with cross inside it. We got them on our upper right arms.

At first it worked. He was pretty consistently involved in TOPY at its inception, and worked with others on the ideas that became *Thee Grey Book*, which was initially a sort of TOPY bible. And he was pretty focused on the first two Psychic TV albums.

But then he began saying he *had* to do this job or that video.

So I arranged to meet him in St Annes by the studio, and over breakfast told him, "You are no longer in PTV. You broke your promise and your signed agreement."

Sleazy was fine about it.

"I told you this time it's not a hobby, this is a lifelong mission for me. I take it very seriously. No passengers on this bus!"

So it was we parted ways, but remained friends.

In a way, *Force the Hand of Chance* was the first time I was in control of everything that happened to the record. That was the beginning of making music that I had heard in my head since I was a young teen. I'd always heard

this music and never been able to actually make it because we did Throbbing Gristle, but this was a different project. This was my vision, a solo vision. I remember very distinctly when we were playing back "Just Drifting," the first track, crying with laughter, imagining the dark, serious faces frowning and then becoming outraged that we'd betrayed the industrial aesthetic.

It's a love ballad with orchestra, and everybody knows me for this harsh industrial music. What are they going to do when they hear this? The Throbbing Gristle fans are going to be so angry.

That was a real revelation. It meant doing a ballad with an orchestra could be more radical than grating, hard-edged industrial sound. Because what you're really doing is breaking expectations. You're saying to people, "No matter what you expect or think is next, I am going to confound that."

When in doubt, do the opposite.

Still, at the time, I considered the most important track to be "Message from the Temple." We asked Mr. Sebastian, the body piercer and tattoo artist, to read the text. We used to go and see him for piercings and tattoos, and he had an incredible voice. It was made for voice-overs on TV and radio. It was just perfect. We'd always thought, *One day we'll think of a way to use this voice, because it's so good.* So we said to Mr. Seb, "Will you read these two texts? Take them home and read them first to make sure you don't disagree with them. I don't want you to read them if you don't agree."

Mr. Seb took the texts and then came back and said, "Yeah, I agree with those one hundred percent." So he read them for the record, and Andrew Poppy did the music. Somebody had recommended Poppy for the orchestrations. It turned out he lived down Beck Road. So I walked down the street and knocked on his door and told him we were doing this record and would really like to have orchestral stuff. Would he be interested in helping? And he said yes, because he was still a student then. So he wrote all of the orchestral parts for "Just Drifting," as well as other bits like that on *Force the Hand of Chance*.

We had Mr. Sebastian on the record because I wanted it to be clearly about the psychic youth movement I'd been envisioning, hinting at, and starting to put into place. It was meant to be a presentation of an entire way of life, of an idea, an alternative perception of how to do life. I was

putting in all my Austin Osman Spare influences, and also all the things that I'd discovered through doing the really intense COUM rituals, and later just doing rituals on my own. I'd also discovered ecstasy in 1982, through Stevo. A girl whose nickname was Cindy Ecstasy used to come over from New York and hang out at Some Bizarre, mainly with Soft Cell, and give everybody handfuls of pharmaceutical ecstasy, which was still legal then. That became the drug of choice at Some Bizzare—and at Thee Temple ov Psychick Youth. Whenever we did rituals, we'd give everybody free ecstasy. It was really conducive to ritual work. Especially if you wanted to go out of the body, which is what I was using it for.

We often hung out at the Some Bizzare offices between sessions or whenever we were in central London for whatever reasons, and, of course, naturally we got to meet and socialize with other musicians and staff there. Along with Cindy Ecstasy, I also became good friends with Marc Almond and Dave Ball of Soft Cell, at one point introducing Marc to Val Denham at their Degree Art Exhibition, which led to Val designing pretty much every cover and T-shirt for Marc's side project, Marc and the Mambas. Marc became quite fascinated with TOPY and how I was writing almost all the songs with occult meanings and symbolism. One day at the Some Bizzare office, Marc told me he, too, wanted a TOPY tattoo. But, he added, not quite as stark as mine or Sleazy's.

"More flamboyant, less sinister," he proposed.

I asked him if he was sure, as I don't recall he had any tattoos at that point. Marc was quite sure, and so I said I would try and come up with a couple of ideas and see what he thought. I went home and thought about what sort of vibe to create that would remain strong and still have a Psychick Cross and a skull. Eventually I got my notebook and began to draw. It was inspired by Japanese Noh theatre and Zen Buddhism yet still including a Psychick Cross. I also had a Japanese mask tattoo that was red, white, and black. Somehow, all these threads blended together, and a very unique TOPY tattoo evolved. Sadly, we think Marc had it covered up some years after he got it.

With that first Psychic TV album, *Force the Hand of Chance*, we wanted to teach people to listen differently. The Throbbing Gristle era had been a

period when the politics of the time demanded anger and rage. But that can't last forever. It becomes redundant. At some point, you have to go, "What can we do that's still positive? How can we unify those people who feel disenfranchised, angry, and lost? How can we embrace them and make them feel safe?"

That was what Psychic TV was for: to set up a safe place for people. It still is. In the end, you can sing things that are really radical—and you can encourage people to be more positive with the simplest form. It's all about putting intelligence into it. We always think very carefully about that.

We spent about two weeks on *Force the Hand of Chance*, to record, write all the lyrics, and mix it. Then we made the *Themes* album, which came with the first 3,000 copies of *Force the Hand of Chance*. The core musicians on *Force the Hand* were Alex, Sleazy, and me; the musicians for *Themes* were me, Sleazy, Alex, and David Tibet, who played a thigh bone trumpet, and John Balance. Beginning in the TOPY era, I began to collect ritual materials, fetish objects, shamanic tools, sacred figures, and musical instruments whose functions surmounted their aesthetic value, like that Tibetan human thigh bone trumpet, which was reputed to have belonged to Drupka Kunley, known as "the Divine Madman." Just as my interest in camouflage clothing during TG was because its primary purpose was function not fashion, so my interest in acquiring certain talismanic objects was because they were functional; their aesthetics were secondary. I've long ardently believed that purported inanimate materials can absorb and store emotions, memories, and even energies from any sacred rituals that occur around them. I felt vindicated to learn that, for instance, silicon can store data. So I've collected objects assumed in far-flung cultures to contain, unleash, or direct specific spiritual or occult forces.

Themes was meant to suggest that in other cultures, a lot of music has nothing to do with entertainment or even pleasure. It's to do with shamanism and spiritual states, and that there should be a way to create a modern form of music in the West that serves that same function. I was curious if these ritual instruments, like the thigh bone trumpet, really did in some way generate a particular nonscientific energy, some kind of esoteric phenomena. I wanted to experiment with that and see if it was true, and if it

was, what was the effect? I still had some of the old Marcel Duchamp bicycle wheels, so we also did a piece with those. I thought that was an interesting extension of creating a non–musical instrument that was more ritual than melodic or rhythmic.

Themes was research. I was saying: Stop worrying about pop music and success and careers. The original idea of music is spiritual and ecstatic and about altered states, and that's what we were trying to re-create in a contemporary way.

This time around, I had decided to seduce the audience rather than alienate them. The audience became a trusted—and trusting—friend. I revealed my deepest thoughts and spiritual occupations with a new vulnerability and acceptance of crass dismissal and ridicule. I also wanted to build a network of like-minded individuals to share our journey with, and to include respect for their ideas and support as well. And I did. Thee Temple of Psychick Youth, a paramilitary occult association, would exceed my wildest dreams and remain a supreme achievement in my mind to this day. I destroyed as best I could the separation between performer and consumer by setting up a kind of occultural chosen family who took care of each other. TOPY would give fans positive activities and a way of life to be part of. We shared resources and ideas, developed communal living spaces, and set up book publishers, record labels, raves, and workshops.

Force the Hand of Chance said you do have ways of taking control of life and improving it, no matter whether you have resources or not. And even if the world outside is destroying itself, and fragmented, and paranoid, and fearful, the job of the artist is to embrace and hold people and say, "It's okay: Be safe here."

It was all so much more rewarding than TG's aloofness.

43.

When I went into performance art in the early 1970s, I got more and more involved in ideas of sexual taboo and social conditioning. I really wanted to explore who makes the rules of acceptability in terms of sexual behaviour, nudity, masturbation. Why was it okay to do something in a tribe in the Amazon but a crime in Alabama? Societies created rules to maintain themselves. They were an integral part of control. But the actual rules were arbitrary, flexible, merely tools to repress and intimidate. This created fear and guilt, and this controlled people. Religion clearly colluded in this, yet was also arbitrary according to location and era.

So there were NO natural laws?

Or were there?

This is where I wanted COUM to go. What controlled our bodies? Why? Who benefited from this control of our natural self. Why was there ever shame or embarrassment? Was that natural or cultural? Who decided on the arbitrary rules of what was acceptable? Since these positions change over time, they are not universal truths but socially chosen and imposed.

Who had the right to censor imagination?

This remains a key battleground if our species is ever to mature and stop being ruled by fear and guilt.

The human body and sexuality is what I honed in on by observing what happened when I did performances. Sometimes I would notice reverberations or residual effects that I didn't understand. Once I started speaking in tongues. Another time I was declared physically dead. My pulse, my heartbeat, and my breathing had stopped. I was in a hospital and they said there was no pulse, no breathing: "He's dead." But I was lying there and could hear everything that was said. I could feel everything, but I couldn't speak. I was in a zombie state. I was completely conscious but physically dead for a few minutes. I was lying there, thinking, *I've got to tell them I'm not dead!*

These types of things started happening to me more frequently, so I decided doing them in public arenas like art galleries was becoming too dangerous, too uncontrolled. It wasn't necessarily fair on me or any audience any more to expose everyone to the risks that I appeared to be taking. I thought things were getting really interesting, but also very dangerous. The phenomena that were happening were too intimate and unclear for me to really share.

Instead of doing rituals as COUM Transmissions actions, I started doing them on my own. I found that I would go into trance states and would do things occasionally like drink poison, and cut myself and it would heal without a scar, and I would have out-of-body experiences. I ended up in hospital a couple of times in intensive care because I didn't know how to repeat it in a safe way. It was very random. Sometimes the combination of sound, physical discipline, and stress would trigger an amazing alteration of consciousness; sometimes it wouldn't. I didn't know how to make it happen when I needed to.

I needed to go back and think about all of this. Who might know more about these things that had been happening? Shamanic cultures. I started to look into Native American shamans and Siberian shamans and different tribal rituals and initiation practices. I started to try to get more information about those states, to see if I could find some common threads or materials or specifics that matched some of what I'd been doing intuitively and calling performance art.

That's when I started to really look again at books about magic, all of which, in a roundabout way, led to Thee Temple ov Psychick Youth. I wanted to find out if there was a formula or a basic equation that would explain what was happening. I could then work from that with more control and understanding of what was going on. So that's how I went back to my interest in magic, and that's where the sigil idea appeared.

During the last few years of Throbbing Gristle I picked back up on some of the philosophical touchstones from my 1960s readings. Back then, I'd become aware of Emmett Grogan and the Diggers in San Francisco, the people at Haight-Ashbury who did the free food, who still inspire us to this day. They had a big picture frame they would put up, called the Frame

of Reference, and people would walk through it to change their frame of reference. Things like that really appeal to me. And the free food and the Digger Shop, where everything in the shop was free. It had a sign that said, *It's yours because it's free.*

Emmett Grogan, one of the top Diggers, was invited to a conference in London in 1967. He stood up in front of several hundred of the top flight of alternative culture and made a speech that got everyone riled up: he was getting a standing ovation and cheering and clapping and then, when they all calmed down, he goes, "Do you know who wrote that? Adolf Hitler."

Then they all started booing him and he went, in effect, "Exactly. You are all a bunch of fucking idiots," and walked out.

And I thought that was brilliant. One of the best things I'd heard about at that point. It just went to show you that the presentation could completely distort what you received, and that's a lesson to remember always.

I loved Emmett Grogan and the Diggers. Things like the Frame of Reference—the picture frame you stepped through—were so much more potent than loads of essays. If you got it, it changed everything in an instant. That's why I loved performance and song. There were ways to shift people's perception in a moment—or, as we say, change the way to perceive and change old memory—because if you give people information that changes how they see the world, then they reinterpret everything else. It's an important thing to keep in mind as a bit of a warning, as a way to keep a sense of balance and prevent overindulgence without really thinking things through.

Another thing I'd picked up on back in the 1960s was the Merry Pranksters. I first heard of them through *Oz* magazine #2. It had a psychedelic bus on the front, in pink and purple ink, and it talked about Ken Kesey, the Pranksters, the acid tests, and everything. Straightaway, I thought that would be great and wanted to do something similar. And to a small degree we did it with COUM, with Doris Austin the truck. We used to drive around in the truck with all of the people who were going to take part in events, all in costumes. We'd arrive and all pile out and do crazy things and leave again. Eventually, with Psychic TV, we got our own school bus and had our own acid tests, and we drove around America and even went to see Ken Kesey.

That completion of the circle is what makes what we do special. We ended up calling Kesey and saying, "My bus wants to meet your bus."

And we did it.

But by then, his bus had been transformed into a chicken coop!

And then there was Aleister Crowley. I had been reading about "magick" since getting hold of *Diary of a Drug Fiend*, *Moonchild*, and *The Confessions* by Crowley. Spydee had found out about Crowley back at Solihull and told me about him. And then I'd read about Crowley in *Oz* and *International Times*. He seemed interesting, but the more I had read about him, the more I thought he was a dick. He was a misogynist and a bully. There's a lot of clear evidence about him. The mistake people made in the 1960s was always the same: Crowley is interesting, so that means Crowley is great. But it also can go the other way: Crowley was a dick. But that doesn't mean everything he said was stupid. You have to pick out bits that seem relevant and practical.

At some point I wrote to the OTO, Crowley's Ordo Templi Orientis. I was curious what they would say if I wrote to them. They were very snotty. I got back a sort of list of all you had to do—learn by heart this and that poem, read all these books, get tested on the material—to become "first degree." And then you had to do more stuff to become second degree. There were even degrees within degrees, like 2-1 and 2-3. And it went up to the ninth degree, which was masturbation. Eleventh degree was the big, big secret that took all these years of work to get to: the eleventh degree was sex magic, as in fucking and orgasms, which, of course, with TOPY, we called the Museum of Magic. They were just continuing to repeat what Crowley set up, like a symphony orchestra keeps playing Tchaikovsky. They weren't writing anything new. And so, when we did TOPY, let's be honest: I was aggressive. So I told anybody who wanted to know what the eleventh degree was, to save time. And I got hate letters, and the OTO in England wrote to me saying they were unleashing the demons and so on. Cursing this and that: "You won't live till the end of the month" and all that crap, which, surprisingly, ended up with me being really good friends with the head of the OTO. He realized that TOPY really wanted to change things, and I took that as a good sign. Also, he was a nice guy.

However, my fascination didn't peak until about 1980, when Geraldine Beskin at the Atlantis Bookshop, in Museum Street in London, expanded upon my meagre knowledge of Austin Osman Spare. I used to go Atlantis to look for Crowley books and other interesting, occult things. They specialized in alternative wisdom, Magick, occult, "Oriental magic," all that stuff. Geraldine Beskin and her mother were running it when I first went there. Later on, the mother died and Geraldine ran it on her own. These days, Geraldine's daughter runs it. I first went to Atlantis when I was still in school and hitchhiking to London, but I didn't meet Geraldine or really speak to her until I was living in London. Once we got to know each other, she would have me over to her country house for dinner now and then. She was a very interesting woman, and fun. She used to tell me anecdotes about Crowley, who used to go to the shop during the latter part of his life in London. As they put it, he'd scrounge cups of tea, sit in the corner to keep warm, and ramble on. So she had all these stories about Crowley. Atlantis had an amazing collection—basically, for decades, they were the only place in London where you could get any occult books of interest. Geraldine would hold things behind the counter for me. Jimmy Page was also a client.

Thanks to Geraldine, in 1980, I purchased original copies of every book Austin Osman Spare published, plus several original paintings in a race against time—and Jimmy Page's much fatter wallet. Up to then, I didn't know who Austin Osman Spare was. Crowley and Spare were contemporaries, and I think Crowley mentioned him somewhere in his *Confessions*, just briefly, a paragraph or so. Crowley regarded Spare to be the only self-proclaimed magician of that era whom Crowley felt really was a magician.

Austin Osman Spare came from an art background; he was a precocious, incredible artist from the time he was a child. He had his first solo show at the Royal Academy of Arts in London, the most prestigious place to exhibit, when he was about nineteen. He was also a contemporary of Beardsley. Beardsley's illustrations were erotic and druggy, while Spare's were more dangerously inhumane in the forms and the implications. There were lots of mutant human demonic creatures and phalluses and vaginas. They give a sense of unknown knowledge of other worlds, with practical magic and interdimensional beings.

During the First World War, he became a war artist. The War Museum in London has an amazing collection of his paintings of the First World War, which are stunning. He is up there with someone like Salvador Dalí as far as technique. He was a genius.

Right when he was at the point of having an illustrious established art career with a real income, Austin Osman Spare decided to give it all up and focus the rest of his life entirely on magic. This meant he lived in truly abject poverty in London up until he died. He would do oil painting portraits for local shopkeepers in exchange for pieces of meat, things like that. He was living at the edge of civilization. He had a very tiny circle of friends and some shopkeepers that helped him out, and that was it. He was completely alone. Everything that's known about him is mainly through his own writings.

It appealed to me that he was so good, and yet it was of no interest to him except whether he could execute the task. He was doing it as a compulsion. He had to do it: it had to be that way to live his life. He sacrificed anything and everything material. His reputation or career or critical appreciation—none of that was of any interest. The only part of it that had any meaning was trying to go deeper into consciousness, trying to discover whether it was possible to have a relationship with energies, powers, and phenomena outside rational science, and build an interplay between himself and it to experience this universe differently. All those things appealed to me.

At the start, I just knew these vague, cloudy, diaphanous references to Austin Osman Spare, but Geraldine started pulling out all these first edition books signed by him. One of them was black-and-white drawings, but he'd colored them all himself, by hand. She charged me only thirty or forty pounds. I didn't know I wanted it. I didn't really even know who he was. Even the OTO people weren't looking for Spare's work. No one was interested at all. But I bought one of the books, possibly *Book of Zos*. It was pretty esoteric and very idiosyncratic. A lot of it was pretty opaque, hard to completely understand and comprehend. He just did small editions that he somehow paid for himself, and he didn't really care if anyone else got it. He'd make around one hundred copies and manage to sell enough to friends and aficionados to break even. Geraldine ended up with copies of all of his books.

One day I was in the shop and Geraldine said, "Would you be interested in this?"

It was a whole lot of aphorisms written by two doctors, James Bertram and F. Russell, and all the illustrations were by Austin Spare. I bought it. What I managed to comprehend of his writing was the use of the orgasm. It was through Spare that I came to have knowledge of what we call sigilizing. We took the name "sigils" from him partly as an homage. That's how we ended up with the ritual of the three liquids in *Thee Grey Book*. Even just calling it *Thee Grey Book* was a reference to Austin Spare. He became the main influence in terms of occult matters, and Crowley kind of faded away. Crowley was into being the top of the tree and having a cult that worshipped him; Austin Spare didn't give a shit.

Austin Osman Spare claimed it was possible, at a moment of orgasm, to basically post a message of a true desire or instruction for behavioral change from our mundane reality and everyday consciousness into our deepest unconscious mind. Furthermore, this message or instruction, once delivered, would infiltrate your choice-making neurological zones, insisting—without your day-to-day self being aware of it—that every decision from then on would maximize your movement towards achieving that desire. No time frame, just an inexorable, relentless progression towards realization of a changed self. This is what led to the mass orgasms TOPY organized.

The question of whether it was possible to change a person's innate, established behaviors once the neural pathways had been reinforced by societal pressures was a conundrum that obsessed me. I was always seeking and occasionally seeming to find methods to rid a self of atrophied habits, redundant behaviors, and boundaries imposed from outside.

By the early 1980s, after I'd been studying Spare's books for several years, I started to apply them in a practical way. Spare became the center of any references of what would be called a magical practice. What I liked about it was that it came from an art background rather than a pompous clique. When he wanted to do his sigil rituals, he would save his money up until he could afford to pay a prostitute. He preferred to use scuzzy middle-aged prostitutes because he didn't want to be distracted by the aesthetics. It was only about creating the orgasm and projecting a thought form onto the

person that you're working with; someone he was completely uninterested in was better, because then he could focus on an image from his mind without interference with how they really looked.

Once I started TOPY, I took it upon myself to utilize his system. The Sigil ov Three Liquids was meant to be a very simple ritual that was demystified, that was nondenominational. Although, obviously, the fact that it involved tantric or sexual magickal practice, there would be certain disciplines or groups who would understand or feel aligned to it more quickly. At the moment of orgasm, you're simultaneously annihilated and also totally united with someone else, depending on whether or not you're doing it with a partner or not. We took the concept that at the moment of orgasm, you can reprogram your nervous system by inserting what you desire in deep consciousness. It's not that you're going to manipulate reality. Rather, it's that you will always make decisions, no matter how trivial, from then on that will lead you more effectively towards that desire. That's why those desires end up happening so often. Having said that, there are times when it's uncanny the way they just fucking happen, as if you *have* manipulated so-called reality.

The simple version is that you program yourself to live everyday towards what you truly want to become.

The more complex version is that you build a relationship, as Austin Osman Spare did, to whatever this universe was created of, and there's a reciprocal relationship that's built up through repetition, through opening yourself up to it, where more and more often desires you have, ways you want things to unfold, happen exactly as you wish them to happen. What we now call the "of course" factor. Everybody has these experiences. I haven't met a human being yet who hasn't had uncanny psychic experiences. Everyone has had these experiences, but most people deny them. It's a universal skill that just atrophies through lack of use, and through ridicule and suppression. Of course, that's why Spare got an awful lot of criticism and had life made really difficult by the defenders of the status quo. Exactly what happened to Crowley, and exactly what happened to me. It happens to a lot of people who begin to knowingly and consciously and, in my case, publicly decide to explore those ideas and techniques and technology.

What I interpreted of what he did and what he said has become totally integral to my way of life, and always will be. Those ideas and those beliefs are confirmed by my experiences. It works.

I took it upon myself to promote the work of Austin Osman Spare. Eventually, I had all his books, so I had them duplicated on copy machines and made them available to the TOPY network, which expanded dramatically, with more than 10,000 active members and operations in Europe, the UK, and the U.S. Books are ports of entry to perceiving the experience of life differently, and that's as powerful as it gets—that's alchemy. In the U.S., a guy named Tom Headbanger, an anarchist at a printing press in Denver, ran off copies of the books for free at night. We spread that information, along with my interpretation of the meaning. Eventually we did the same for TOPY Scandinavia and TOPY Europe and so on. We really pushed it, saying Spare was someone who should be noted, remembered, respected, and given full credit.

At some point, Geraldine acquired a number of Austin Spare's original paintings, many of them magickal paintings. Some of them were just totally psychedelic, some were weird, a lot of them had Spare himself in them. I wrote an essay about them, "Time Mirrors," which is really the best explanation.

I said to Geraldine, "Are any of those for sale?"

"Yeah, they're only sixty pounds each."

"Oh, God, I'd really love to buy a couple."

"You better hurry up, because Jimmy said he'd buy them all."

I said, "I'll take that one and that one. Keep them for me."

She did, thank God, because the rest were all gone the next time I went in.

One of the two I bought was a pencil drawing of Mrs. Patterson. When he was young, she used to help take care of him and was renowned as a witch and a medium. The implication that I got was that she taught him a lot of things about the spirit world, or spiritism, and possibly initiated him into sex magick. If true, it would make a lot of sense. This drawing was quite uncanny. You could look at it from certain angles and see two immaculate photo-realistic faces of Mrs. Patterson. I had that for about three years on

the wall, and I would pass it every day. One day sunlight came through the window from a different angle, and I saw there were additional faces in it in this incredible pale green that I'd never seen before. They were just unbelievable.

The other piece was a painting called *The Ides*, which would be the Ides of March. *The Ides* is set in Romania. It has faces of three prostitutes. Garish makeup, lipstick, bad makeup; they look kind of scuzzy. They don't look very appealing. There are also two portraits of Spare himself on either side, in profile, facing himself, yelling at each other. He's having a big argument with himself, across the faces of these three women, and he's enraged. It's brilliant.

When Geraldine sold it to me, she said, "I would advise you not to necessarily to hang this on a wall."

"Why not?"

"They come alive, you know."

"Really, aren't you being a little bit hokey here, Geraldine?"

"I have one that's from the same series at home. For the last few years, I've had it turned to face the wall in a room on top of my house that we don't go in."

"Why?"

"Because it caused so much trouble. It's hard to explain, but it would upset people and make them angry, so I had to hide its face."

I didn't really think a picture could possibly contain anything like that, so I put it on the wall opposite the drawing of Mrs. Patterson. At some point in the early 1980s, we bumped into an Italian woman who was supposedly a psychic and medium. She seemed more convincing than many, so I befriended her and she would come around for cups of tea sometimes. The first time she came around to our place, when she came up the stairs to come into the living room and passed *The Ides* and Mrs. Patterson, she went really white and started to shake. She sat down on the sofa, and I thought she was having a heart attack.

"Those paintings, cover them up, they're alive!" she said.

She started to tell anecdotes that she'd received from the paintings. She had no idea who Austin Osman Spare was, I hadn't said his name, and

she knew nothing about the paintings, so it was completely an authentic experience.

Later on, *The Ides* was involved in the disintegration of TOPY when Paula and our daughters, Caresse and Genesse, and I had moved out of London to Brighton. We managed to buy an incredible Georgian house on a curving terrace, with all the original windows and floors, high ceilings, and a view of the sea. The children and their mother sometimes came on tour with Psychic TV, and when they did, we left what we used to call "the TOPY boys" in the house in Brighton. They did the mail orders and watched my dog, and in return they got to live for free and have some spending money. At the top of the house was a room I'd turned into a nursery, which is where I'd put *The Ides*, now facing the wall. I said, stupidly, that they could use the nursery if they wanted, but not to turn around the Austin Spare painting up there. I told them, "It's a window, and it's not to be messed with. I'm not joking." I gave them every warning I could think of.

While we were away, they were taking acid every day. They were being macho, seeing how far they could go. When we came home, there was red paint splattered all over the sinks in bathroom. It looked like someone had been slaughtered in there. Everything was trashed. When I went up to the attic, on the altar facing out was the Austin Spare painting.

"Oh no, they did it."

They fucking turned it around when they were on acid. No wonder they all flipped out. Who knows what entities came out and walked across to them. Then we learned that they'd used the TOPY printing accounts and spent all of the credit for themselves. I didn't understand quite why having the run of the house turned into an aggression towards me, but who knows what the spirit was that was in them. I can't hold them personally responsible because they were occupied. So please don't play with Austin Osman Spare when you're taking acid. As for *The Ides*, I ended up eventually selling it to Chris Stein of Blondie—he wanted to put it near his H. R. Giger—for a plastic shopping bag full of cash that he had to retrieve from Island Records.

I carried on doing sigils and different types of self-designed rituals and rituals based on things that I read all the way through the 1980s. My rituals

were very much about sensory deprivation and using bondage to force me to travel outside the body. In one experiment with sensory deprivation, I was wrapped in wolf skins inside a coffin suspended on chains. I'd had eight hits of ecstasy before I was put inside. I was in there about eight hours, apparently. My first words when I was let out were, "Now I understand time!"

One of my ideas was that if you did magickal ritual or sigils, in a way you were cutting up your normal behavior and expectations and programming, just as Burroughs and Gysin had done cut-ups with language. That's where I started to apply the cut-up, breaking linearity over and over and over to create new spaces, new collisions, new perceptions, that you couldn't get to any other way because we're so trained by language, culture, society, family, education, economy. We're so trained and so sucked into this material, solid, established form of living and life and being; the hardest thing of all is to break it, truly break it.

Just as Burroughs would say you cut up a book to see what's really there, if you cut up your own social imprinting and took yourself into other dimensional realms, would you also see what was really there inside yourself? Would you really learn the most detailed and scarily honest version of what you really were made up of, and could you then engineer your own character and behavior pattern from inside back out to become what you wish to be?

And I would say the answer is yes. Though slowly. There is a cumulative effect of anything. Any ritual done with sincere commitment and repeated with honor and sincerity over any long period of time appears to have a cumulative effect. The orgasm appears to be a very powerful portal for transferring messages to areas of the consciousness or the DNA structure, which then continue to amplify the will. These things seem to happen.

I take an anthropological approach to it, and I have great respect for systems that appear to have a lineage and a sincere clarity of intent. I assume I know nothing, and I'm glad to learn everything I can. Sometimes I discover that things work.

There was a group in the west country in England, very much a Thelemic group. They published the English Kabbalah; we did a ritual with them at Stonehenge. We worked with Wiccans in London, as well as OTO groups.

We've always had great respect for other people's systems. In Nepal, we worked with Shiva sadhus and in northern Thailand with animist sorcerers.

One of the things that was really vivid in Asia was that sacrifice, ritual, and devotional activities were as commonplace and equally as important or unimportant as cooking, working, and sleeping. There was no separation at all. That's where we were coming from. We like everything to be practical. We like the idea that magick enhances and amplifies the best parts of life and gives blessings to those who are serious about having an integrated system of life.

If we don't end the idea of separation between everyday life and magickal work, then we're going to continue being at the mercy of those who wish to control us. So for us it's very much a political thing, too.

Control can divide and conquer.

We don't believe in any either/or maps of reality or behaviour. Never have. Improvising, exploration, pressing one's own limits—that's how we discover what might really be going on. Cut-up everything. Body, mind, flesh, identity—relentlessly break and short-circuit any form of control you can reveal or locate.

I saw magickal ritual as a cut-up of behavior. That's why I didn't want the banishing rituals and naming the names and all the frippery and baroque nonsense. In a sigil, the orgasm opens up the deeper mind and the other minds so at one moment they are all open and interconnected and you can post a message in it.

You can call it magickal, you can call it neurolinguistic programming, whatever you want to call it.

But it works, and that's all that matters.

Or at least it seems to work a lot more than it should.

44.

I'd become friends with Jordi Valls of the World Satanic Network System and Vagina Dentata Organ art and music project in the late 1970s through his enthusiasm for Throbbing Gristle. In 1984, Jordi approached me to say he was certain he could get a Spanish national TV channel to create a whole program about my band Psychic TV and Thee Temple ov Psychick Youth. Turned out it was true, and Paloma Chamorro, the presenter, agreed I could have full editorial control of her very popular alternative music and arts program, *La Edad de Oro*, for ninety minutes, mostly live: an amazing opportunity.

I wanted to include two or three short pre-created films shot in 16mm film stock, including one called "Moonchild," dedicated to my new daughter, Caresse, who'd been born at home on Beck Road in 1982, her name inspired by Caresse Crosby, the name assumed by Mary Phelps Jacob after she married Harry Crosby, the Lost Generation poet and society figure.

The title "Moonchild" came from a novel by Aleister Crowley, in which he describes a magickal order performing ceremonies focused on the moon as goddess in order to have a human initiate fall pregnant with a divinely evolved chosen child. Everything used in the ceremonies was to be in direct ways connected to the moon.

I decided to make a film taking this further, implying that the film was documentation of a ritual to manifest a "pandrogyne." By fusing a physical male and female being into a "third being," the pandrogyne would be created—a theme that has been recurring in our magickal practice and evolutionary theories since that time.

We first coined the term "pandrogyny" back then, in a magickal journal. It was clear to me that pandrogyny was inevitable: that a breakdown of the normal binary idea was going to happen, and that it would be revolutionary.

I wanted a word that encapsulated as many interpretations of personal bodily sovereignty as possible and that did not carry any conceptual, political baggage from the start of its use. "Pandrogyny" serves perfectly. It's meaning is the total sum of everything done under its umbrella by whoever does it.

One of my main issues with the way people perceive what we call reality was that they still fell into the traps of either/or. This either/or dichotomy means that somebody can call something different. Which in turn means there's a minority that can be attacked and used as a scapegoat to distract the rest from the fact that they're oppressed. What we should be saying is: *This is the bio-body I happened to be born in, but I am not this body; I am this consciousness that resides in this body. The body is not me.* That said, we can use the body as propaganda and as a form of leverage within society to confuse those who disagree. These days there's an ongoing discussion on gender, which is important, but the real problem is that it shouldn't matter at all. "Male or female" shouldn't even be considered for a second: they're irrelevant, biological constructions that should have been swept away hundreds of years ago.

Pandrogyny, we've felt ever since the mid-1980s, is inevitable. It's part of the evolution of the human species. And it's not finished. Evolution is a long-term process that keeps going. Mutations happen—sometimes slowly and sometimes suddenly. A pressure to a sudden, radical, evolutionary mutation is building. The ageing old guard are resisting with ever more blatant strategies culled from shameful internecine conflicts of their past. Thousands of years of slaughter in war—oppression of anything "other"—at the expense of the thinkers, proponents of change, philosophers, artists, and, of course, racial, ethnic, religious, and sexual variants. They say "deviants."

For the short film, John Gosling volunteered to represent the male half of a pandrogyne, while Paula represented the female half. In the film, you see these two halves in a coffin, representing sacrifice and the self-chosen death of the previous state of existing, overlaid to symbolize a pandrogyne—a perfecting being where the split corporeality of

Adam and Eve is finally resolved in a fusing back together, but with self-awareness, knowingness.

Until the Moonchild is formed, with intention, our species can no longer mutate—and, as we say in one of our lyrics, "Mutation is a law."

Mutation is a law of evolution.

We are a species frozen in stasis, yet within us all, if we sacrifice our SELF, there is, *in potentia*, a path forward where we are all perfecting. *Perfecting* because to believe that we are already *perfected* human beings—immutable, inert, complete—would mean our road as a species is over. "Moonchild" said that all must be constantly in flux, a chaos of possibilities and impossibilities.

Evolution requires mutation.

Creators and innovators are the mutation triggers for humanity.

When control suppresses art, creation, new ideas, experiments, it is blocking evolution.

Viva la Evolution!

The Spanish TV broadcast was shut down at gunpoint.

For some reason, we seem to be able to pick up on undercurrents in the overriding culture more quickly and precisely than a lot of other people. It's enabled us to be ahead of the curve in terms of saying what's going to happen next and what it might look like. To shape it and to hopefully make it available to people before it gets commercialized, before it gets controlled by corporations.

We were right about industrial music when we said there was another kind of music that was inevitable. We predicted a resurgence of contemporary magickal forms. We predicted pandrogyny and radical new visions of the body and gender. We also said piercing and tattooing would be a global phenomenon, and helped push it along with the *Modern Primitives* book in 1989, as well as proselytizing about body modification—and leading by example—through TOPY.

A magazine back in the 1980s asked me to sum up my occupation in two words. Without having ever knowingly thought of the words together before, we blurted out, "Cultural engineer." Perhaps now we'd substitute

"*Occultural* engineer." None of that means we thought of it first necessarily, though a few times we have. We prefer to believe these changes and shifts are in the zeitgeist. They are INEVITABLE, and somehow we've developed very sensitive antennae for spotting these very early. And, once seen, we feel duty-bound to strategize how to manifest them out into this cultural matrix.

45.

In 1985, Psychic TV played a gig at the Haçienda in Manchester. After the show, Terry McLellan, who was functioning as our manager at that time, came up to me in the dressing room, really excited, sweaty, eyes bright with the light of greed of some unknown source.

"What was that new song you played tonight?"

"What song?" I replied.

"The one about Brian Jones!" he insisted.

I felt bullied, my personal space perverted as he crowded me against the wall in the tiny room. I could feel his perspiration soaking through my T-shirt as it oozed down the white painted brick wall.

"Oh . . . I don't know, I just made it up spontaneously onstage. I don't remember what I said except 'Godstar Oh Oh Whoa.'"

I loved Brian Jones and believed he got a raw deal in the history of the band.

"Shit! That's a hit single if we record it. SHIT!"

Terry was visibly deflated.

"Maybe somebody recorded it?" I offered hopefully. "We can ask around and ask to borrow it so I can write the words down and Alex can hear what he played, too."

Which is what happened.

I bustled and shoved my way through the crowd, asking if anyone had recorded our gig, stressing that we didn't mind and actually *wanted* someone to have a tape. Eventually I found a fan who cautiously admitted to having a cassette of almost all of the gig. Once I explained my dilemma, the person handed me the cassette tape, which I promised to return as soon as I had located and duplicated the "new song" we'd played that night. I carefully wrote down the name and address on a piece of scuffed-up paper I picked up off the floor, fully intending to keep my promise and return the cassette.

Thus was our single "Godstar" channeled, and its improvised bare bones preserved. To this day I have pangs of guilt, though, as, perhaps inevitably, I lost the fan's name and address, stupidly breaking what had been my sincere oath.

Anyway, here and now, let me take this opportunity to say thank you, dear anonymous concertgoer. Thank you for sneakily recording that crucial set in Manchester and for your generosity and trust, albeit triggered by your shameful confession to me.

I remember playing the demo for Muff Winwood at CBS, since they'd released our previous album, *Dreams Less Sweet*.

"Listen to this; it's just a perfect little pop song. And I've got these other psychedelic songs I really want to do."

He looked at me and went, "I want *Dreams Less Sweet*."

"But we've done that, Muff. This is a great little song, and it could actually be a hit record."

He didn't budge.

"When you've got a deal with us, you're renting my brain," I told him. "But you can't afford my brain, Muff. Even an ape could sell this record and make it a hit, and I'm going to prove it to you."

So I started Temple Records and released "Godstar" that way, as I'd done with Throbbing Gristle. Because of Industrial Records, I knew about manufacturing and other aspects of putting out a record.

Because I was obsessive, I ended up finding the woman who ran the Stones fan club; she worked in a children's clothing store somewhere in London, and I went down to the shop and said, "I'm doing this record about Brian Jones. Do you want to hear it?"

I gave her a cassette. She loved it. I asked her if she had any photos we could use on the single. She had all these pictures that she hadn't even developed. And I said, "Look, I'll go and get them developed in the best possible quality and give you a full set and the negatives if I can use the prints."

She said yes. So I had all these beautiful publicity photos.

The key to the song's success, it turned out, was to have a list of the chart return shops, which is all the record stores whose sales count towards the charts. I managed to get a list of them, and then I wrote to the TOPY

network and said, "If you're going to buy 'Godstar,' buy it at one of these shops." We knew where most of our TOPY people were, so we sent the names of the shops in their area that counted. And once it was going up the charts, it got played on the radio; we also made a video with Akiko Hada, my former Japanese girlfriend. And we did the video for basically nothing—all we had to do was pay for renting a goat. The black-and-white newsreel footage we got from a company that shot tons of that stuff in the 1960s, and they let us use it for the cost of developing the film. So we got the Stones in our video as well—previously unseen footage that hadn't even been developed. In the footage, they were hitchhiking on the street. And then we put ourselves hitchhiking on the street and blended the two together. And then as Brian Jones played his teardrop guitar, Akiko somehow made him move to the rhythm of the "Godstar" riff. Where I sang, "Where are all your laughing friends?" it shows Mick and Keith laughing in an airport as they run through. That was the reason Mick didn't like the song—because it implied that he was involved in the murder of Brian Jones, which at the time I thought he was. Now I don't think he knew in advance, but I think it suited him just fine. The Stones owed Brian Jones a million dollars for agreeing to leave the band, and they were due to pay it within a month of when he suddenly died. Allen Klein had taken over at that point as their manager, so I'm sure he had him done.

A video chart show had recently started on TV, and they put our video on for the indie chart; it went to number one. The show was on every Friday night around 6:30 P.M., and on came our video. Just like that.

Not long after the song came out, I was at a gig with Psychic TV when a guy came up to me and said, "I got a gift for you."

"Oh, wow, that's nice. What is it?"

He handed me a jacket.

"This was Brian Jones's jacket," he said. "I was their roadie for a while. They didn't like wearing these jackets, so he was going to throw it away. I saved it."

It was black-and-white herringbone with a little bit of velvet. And it fit me so well, it was spooky. Then another guy turned up at a gig with a box containing every single press cutting about the Stones from when they

first got mentioned to when Brian Jones died. The guy had been working for the *Daily Mail,* and the paper had moved offices. They were getting rid of files where they kept all the cuttings on different people; he gave me the whole lot on Brian. It was incredible to read—from an unknown band to a threat to the whole of Britain.

And "Godstar" reached number one in the indie charts, where it remained ensconced for sixteen glorious weeks, which was a big deal back then.

46.

By the end of the 1980s, I was making acid house records with Dave Ball of Soft Cell. Our *Towards Thee Infinite Beat* album sold around 40,000 copies for Wax Trax! Records in the U.S.; Psychic TV toured extensively there, eventually playing all forty-eight contiguous states. At the same time, TOPY was picketing a cruel dolphinarium in Brighton, where I lived; after two years of picketing every weekend, TOPY effectively exerted sufficient political pressure to shut it down.

I had quite a comfortable life: I owned a car and a house where I lived with a family that consisted of my wife, Paula, and our two young children, Genesse and Caresse; I had a publishing company, a record label, shops, and market stalls.

In fact, we had five houses in Brighton where TOPY people lived, and we tried to evolve loving, compassionate, alternative ways of living that included magick, shamanism, and creativity rooted in COUM ideology and Austin Osman Spare's techniques. It was communally agreed that whatever sexual explorations took place in the TOPY houses were never taken outside—no jealousy, no sexual preconceptions, no gossip or recriminations. Surprisingly, it worked.

As always, there were people who threatened us and slandered us. Having been the primary founder of this network of autonomous social experiments, I was the central scapegoat, the media icon who was victimized.

In fact, I was growing weary of being in a "leadership" role. Also, things were starting to go strange; for instance, I noticed that our mail was being opened and resealed. A local post office worker in Brighton—a TOPY sympathizer—even warned me that I was being investigated, and that we were considered "Satanists" by the authorities.

One afternoon in the car, I passed a traffic sign that said: CHANGED PRIORITIES AHEAD.

Yeah, I thought, *changed priorities ahead.*

I had always prided myself on maintaining a sort of state of flux. Had I stopped? I could never live with myself if I chose comfort over continuing to evolve infinitely. I can't trade comfort for giving up. I just can't.

There were people who had an inkling; they knew there was something else going on. They'd seen the light in the crack around the door. They knew there was something else in that other room, and they were curious, but they'd been told to be afraid of what they didn't know, what they weren't familiar with. They were wary. They needed someone to say, "Hey, it's fine." Someone to open that door. That was *my* job. To open the door wide and pull people through.

Come on, it's okay.

I decided to visit Samye Ling, a Buddhist monastery in Scotland. I'd started going there in the late-1980s after a TOPY member in Sheffield told me about it. He'd gone there to get off heroin, but he knew I'd been interested in Tibetan culture for ages. Since then I'd gone several times.

Lama Yeshe, the head of the monastery, wanted to speak to me during my visit.

"You're not really enjoying what you're doing anymore, are you?" he said.

"No, not really. I'm kind of tired of having to run TOPY and the band and the raves, of dealing with all the pressure, the press, being public enemy number one."

"You should go away. Just go away."

This fit with my basic plan since childhood: I wanted to do the things I read about; I wanted to be able to travel and be a wandering bohemian, making stuff and learning from wise people and sharing it when it made sense. That's all I ever wanted to do. And now, it seemed, was time for another shift in direction.

I had no trepidation about taking Caresse and Genesse someplace new. Throughout their young lives, Paula and I had tried to raise them with as few cultural biases as possible, consciously avoiding giving them definitions, dogmas, and clichés. We wanted to leave them free to observe and think, because that was the tool they would most need in life. I remember when

Caresse was about three, when we were still living in Hackney, I had her in the back of the car as we drove home towards Beck Road. She saw a statue of Jesus on a cross outside a church.

"I know what *that* place is!" she said excitedly.

I thought, *Oh shit, who's been telling her about religion?*

We had deliberately not mentioned religion, Christianity, or the church dogmas adopted in contradiction to the actual teachings of a Christ.

"Oh?" I said. "What *is* it?"

"That's the place people go who are afraid of dying!"

"Exactly, Caresse."

I was very impressed.

Language was the key, trying not to include any prejudice in the way we described things. And we always talked to them on the level, intellectually speaking—no baby talk.

At this point, they'd been taken out of the local Steiner school in Brighton. Caresse had told me they kept talking about religion and made the kids pray. I think it was just bad luck—the one Steiner school in Brighton had some weird evangelical Christians in it, and they were twisting it to suit their own wishes. I yanked the kids out as soon as she told me that and told the school, "You can't have my satanic children in your school!"

Which, given the investigations percolating in the background, might not have been so clever.

The other thing we did with the kids was not leave them behind. When I went on tours, I took the kids. Twice they went around America with Psychic TV on a school bus. They'd gone all over Britain and Europe, even to Japan. In the summer, we sometimes rented a camper and drove around and camped; we'd go to sacred sites and dance circles and hang out. There was no staying at home watching cartoons for Caresse and Genesse— though they did have videos of the Care Bears, which drove me up a wall.

The kids had even been with me the very first time I visited Samye Ling monastery. On that first visit, we had picked up a hitchhiker in grey robes on a desolate road while searching for the monastery. The hitcher had suggested we take a right at an unmarked crossroads—which turned

out to be crucial in our finding the place. Then, in the middle of nowhere, he said, "This is where I get out."

I had stopped the car, and he hopped out without a word and closed the door. When we all went to wave goodbye, he was nowhere to be seen. And when we pulled into a parking lot up the road, hoping we could camp there for the night, a woman came running out to the camper.

"Oh, sir, thank goodness you are here."

"What?"

"We've been waiting for you. Lama Yeshe wouldn't let us start dinner until you got here."

I had never met Lama Yeshe before and didn't even realize we had reached the monastery. I believe the hitchhiker must have been some projection of him, but I can't prove it. From then on, I had visited Samye Ling regularly, and Lama Yeshe became one of my teachers.

When he told me I should go away during that visit to Samye Ling, I asked him where I should go.

"Nepal. We've got a monastery there. They will look after you. You can get teachings and meditate. They also run a soup kitchen you can help with."

I'd been doing this phase for ten years.

Fuck it.

So, in 1991, in need of rest and a change of pace, I moved the family to Kathmandu.

And just before we left, I sent out cards that looked like wedding invitations that said *Changed priorities ahead* in gold. I sent them to everyone on our mailing list, and that was the official end of TOPY.

47.

We arrived in Kathmandu with a great big bale of warm children's clothes, because we had learned that refugees and beggar children froze to death in the winter. We checked into a hotel where we'd arranged to get a discount rate for a long-term stay.

I ended up using my life savings to finance the soup kitchen at Boudhanath Stupa, the sister monastery to Samye Ling. Twice a day we fed up to three hundred lepers, beggars, street kids, and refugees from Tibet with rice, dahl, and fresh drinking water. Preparing the first meal meant rising at six in the morning and cooking the food over an open fire in big pots. Genesse and Caresse helped carefully feed lepers with no fingers or hands. The lepers were the most difficult to get used to, but the kids helped every day and never freaked out. They were really great with everyone. And the people who came were so glad to get something to eat; it was a great experience.

Something that concerned the monastery was that they had to cook and heat the place using wood, which had two disadvantages: it meant the wood had to be carried up to the site, and it meant the surrounding woods were being depleted. They'd learned of a new process—basically a turbine that could be positioned in a mountain stream—that would make enough electricity to light and heat the monastery, but it cost $5,000.

Before we'd left England, I had gotten an American Express gold card— as a backup for emergencies—that allowed me to get exactly $5,000 in cash. I went into Kathmandu to a dodgy banker and said, "You can have this card if you give me $5,000."

And he did it.

So I took the cash to the monastery and told them to buy the turbine system.

We had return flights booked for February 1992, but for some reason, I wasn't ready to leave yet. My wife looked at me not long before the

scheduled departure and said, "You don't want to go back, do you? You really like it here."

"Yeah, I love it here," I said, looking at our half-packed suitcase.

"So let's not go back," she said.

"What about the tickets?"

"Oh, fuck the tickets."

So we all agreed to forgo the flights and remain in Nepal.

Then, the day we were scheduled to have arrived home, a telegram was delivered to us at the hotel: CALL HOME BIG TROUBLE.

I walked to the only international phone in the area.

The news from Brighton: Scotland Yard detectives from the Obscene Publications Squad had raided our family home, armed with a search warrant and video equipment. They'd seized candles, African drums, a cast-iron Victorian dentist's chair, videos—including the home videos of my daughters' births—all our family photos, artworks, digital audio tapes of music, and the only existing print of a film I'd made with Derek Jarman in 1982 featuring William S. Burroughs and Brion Gysin. All in all, they confiscated a large amount of material from my two-decade arts archive and private family memorabilia, amongst it every photo, video, and slide.

One of the TOPY people was staying in the place, Alice Trip de Gaine, and another one who lived two doors down was there during the raid, and they wrote down every single thing that was confiscated. They followed the cops around. So we got a list. It's great, because lots of it was things like the names of specific videos, like the Care Bears, or "incomplete stuffed dolphin"—Caresse was trying to sew a cuddly toy. The worst part, really, was that they took many family photos of the children. They didn't even find any hash, because that was a period when I was really anti-drug for a while. I'd been a born-again psychedelic for a few years and then needed a break. Also, the house in Brighton was a no drug house, because I knew the authorities were looking for something to pin on me. Of course, later, when I met Jaye, that went right out the window.

Following the initial reports of the raid in early February—and a TV special purporting to show we were Satanists—came the press onslaught, with headlines such as "Video offers first evidence of ritual abuse" and

making reference to supposed "bloody satanic rituals." The footage in question was later screened on Channel 4's *Dispatches* program, where the reporter claimed it showed "abuse of young adults in what is clearly a ritual context." His claims—"the trappings of black magic are obvious," "sex and blood rituals"—were backed by the testimony of what was presented as a former "cult" member. The woman said the grainy footage was of a forced abortion of a fetus to be used in sacrificial rituals.

The footage shown on TV, it turned out, wasn't even from my archive at all—and was staged, not real. And the ostensible former "cult" member was a plant from the religious right who had no connection to TOPY. But none of that, it seemed, mattered. TOPY and I were front-page news: serial killers, baby eaters, Satanists.

Apparently an officer who'd headed up the raid had said, "We must eradicate the scum who have hidden in the art world for far too long."

My lawyer told me that if we returned to England, we'd be arrested by Scotland Yard and held indefinitely for questioning; our daughters would be taken into custody and state "care." Scotland Yard told my lawyer that our physical safety could not be guaranteed if we came home.

"You may be killed," my lawyer told me.

I had never imposed any of my ideas upon anyone, but I had paid a price. Overnight, my children had no belongings, no photos of their childhood, and could possibly never see their friends and relatives again. They had no home. It was all gone.

I would never be charged with anything, not so much as a parking ticket. But I would be unable to return for seven years. We would lose our house. And nothing the police confiscated would ever be returned, despite the illegal seizure it was part of.

All of this followed the arrest, in 1987, of Mr. Sebastian, the tattoo artist and body piercer, on fourteen counts of "grievous bodily harm," based on an apparently random selection of clients found in his appointment books. Sebastian had been tried at the Old Bailey, known more for trials of spies and murderers, and the case had resulted in the criminalization of piercings if it could be proven they had played a part in sexual activities. The year before that, authorities had tried to charge a London bookshop under

the Obscene Publication Act for selling *Modern Primitives*, the landmark compendium on body modification that included extensive photos of my and Paula's genital piercings. It was hard not to see these cases and the raid on my place as part of a concerted effort—not to mention that the ruling in Sebastian's case had made our piercings illegal.

It's very strange to suddenly realize that the people who have the most power in your home country—the rich and, in the case of Britain, the aristocratic establishment—are prepared to destroy you using the media as a weapon. That you are no longer welcome in the country of your birth, and that, if you go back, your life is threatened.

I went to see my Buddhist teacher.

"I'm a refugee now, too. Where would you advise me to go next?"

To my surprise, he replied, "America."

"I hate America; that's the last place I'd want to go."

He just laughed: "You're supposed to go there."

As we pondered what to do, the owners of the hotel where we had stayed told us we could stay on for free because of all the work we'd done for the Tibetan refugees. I started going through our things, looking through papers related to our home in England—bills and whatnot. *Guess I don't need these anymore.* Then I stopped, holding a large brown envelope that I'd forgotten I had in the suitcase for all these months. It contained the last of our mail that I had just thrown in the suitcase as we were leaving. Inside was a smaller envelope from Michael D. Horowitz.

Michael ran the Fitz Hugh Ludlow Memorial Library, the largest archive of drug and drug-related literature and manuscripts in the world, in San Francisco, California. He had hidden Timothy Leary's archive while Leary was in jail. He'd been hounded by the FBI. His partner was Cindy Palmer, and Winona Ryder is their daughter. I had hung out with Michael a couple times during Psychic TV tours.

I'll open that, I thought.

The envelope contained a postcard. On it: "Dear Gen, we were all at your gig at Dingwall's, Winona, too. It was the most psychedelic thing we've seen since the acid test in '66. If you ever need a refuge, call this number."

Wow.

To think I had kept it around all these months and opened it that day, of all days.

Again I walked to the international phone in town. I rang the number.

"Hi, Michael, I need refuge."

"Oh, what's happened?"

I told him the whole story.

"Can you get to San Francisco Airport?"

"I think so."

"If you can get there, just tell us. We'll meet you."

Next I called Psychic TV's U.S. label, Wax Trax! Records. They'd never paid out our royalties, despite the sales of *Towards Thee Infinite Beat* in America.

"Listen, you owe me money. Instead of holding the royalties, would you buy me one-way tickets to San Francisco for two adults and two children?"

They agreed.

We were now in exile: the first British citizens persona non grata since Quentin Crisp, Oscar Wilde, and Aleister Crowley. Good company.

48.

At that point I wasn't making choices, I was going where things took us. I didn't have a plan. It was just impulse. But if I hadn't have come to America, I wouldn't have met Lady Jaye, Psychic TV wouldn't have gotten better than ever, and all these other things wouldn't have happened. They were right to tell me to go to America. There was nothing left for me to do in England except be aggravated—which was proven by the fact that I got detained when I went back even years later.

As promised, Michael met us at the airport in San Francisco and drove us to Petaluma, where we spent the next three months in exile in Winona Ryder's old bedroom. Just downstairs was his library, and I'd get up when I felt like it and go down there and read. Incredible material.

One afternoon while reading, Michael called to me.

"There's someone on the phone who wants to talk to you."

I picked up the phone.

"Hi, Genesis, it's Timothy Leary."

He went on to tell me he loved my music and what I'd been saying.

"It happened to me, too," he said. "They tried to destroy me, tried to shut me up. You're going through what I went through. You should come visit."

He said we should come stay with him in Los Angeles. I told him unfortunately I had no way to get there. We were broke at this point, having spent all of our money in Nepal and lost everything in Britain.

"There's a car of mine out back. You can have it."

He stored what was I think an old Volvo on the premises of Michael and Cindy's place.

The license plate, which is now amongst my papers at the Tate, read HI-ORBIT.

Throughout 1992, I ended up working as a part-time assistant to Leary, driving down to hang out with him in Beverly Hills every few weeks. We

began to do a lecture series together called "How to Operate Your Brain," on the nature of control, and discussing why authorities had attempted to seize both of our archives. In addition to speaking engagements with Leary, I still dabbled in music.

The truth about the false and malicious accusations against us came out—the British establishment's attempt to destroy TOPY and suppress our global network of liberationist ideals and tribal support systems—but it was too late to save our home or get our possessions returned. So we were basically back at square one, and I think Paula had a minor form of breakdown. She struggled from her terrible upbringing. Her mother and stepfather lived on the dole. She had escaped hell. Then suddenly it was all taken away by the police. And she was on the other side of the world. I think that probably did a lot of psychological and emotional damage that she never really expressed.

I had a different approach to that sort of thing. Sure, I would have liked to have kept the house in Brighton or sold it. But I didn't have those options. People get attached to societal norms and financial security, but they've always struck me as traps; they're not useful in decisions about what genuinely enhances life and what doesn't.

In the end it didn't matter that I had no money; it all worked out. It was proof of the theory. Because of the recent experience of dealing with people who had less than nothing—at the soup kitchen—my personal experience didn't hurt as much as it might have. I knew that all those pretty things we'd lost really meant nothing; what mattered was that we were alive and healthy.

Unfortunately, there's been a whole movement in recent years to try to close down exactly what the United States was supposed to be: a place where everybody would be given a chance to live a positive and reasonable life no matter what they believe, no matter what language they speak. The U.S. is supposed to be a refuge based upon true tolerance. No judgement. No expectation. We believe that was a lesson our exile was intended to teach us. Of course, we're white and middle-class and well-educated, so we're privileged. My heart bleeds for those who have nothing. But when we first arrived here, we believed they really meant it in the U.S.—it wasn't bogus, like in the UK. It wasn't fake democracy. People forget that Britain is a monarchy, which

means there is no real democracy there. To see all of that—the good fortune and the freedom to say whatever we wanted—destroyed and corrupted by those now in power is about as depressing as it gets.

Back in 1992, the Bay Area rave scene included many TOPY members, and they helped us as soon as we arrived in the U.S., organizing benefit raves for us, like Shiva's Erotic Banquet and Thee Cyborganic Be-In. There was a lot of incredible energy swirling around San Francisco at the time, and I saw great possibilities for cultural engineering.

The P-Orridge family took up residence in Northern California, first in Monte Rio and then in Cazadero. I had asked Michael and Cindy about a good place where we could go to lick our wounds and the kids could go to a school where they wouldn't feel ostracized. They suggested a school in Occidental, where Tom Waits's kids also went. The town of Occidental was a little, picturesque village where there were still two surviving 1960s communes. So we looked for a place to rent in that area; the cheapest place was in Monte Rio, up the road towards Bodega Bay. I didn't know it when I rented the house, but it was an area where a lot of Hells Angels and fucked-up retired bikers lived. There was a joke that you could smell when the next batch of speed was being made, and you really could. Later we moved further up the road to Cazadero, which was beautiful. We had ten acres, redwood trees, and a creek with a waterfall.

At some point in 1993, the children's mother and I divorced. Things had been deteriorating for some time, and she was spending all her time with a new lover while I was caring for the girls and trying to make money. The kids were old enough to realize something was wrong; Paula moved out, and I was awarded full custody of both kids. When they were at her place they would call me, crying. I had messages on my answering machine that were entered into the family court records with their mom yelling and screaming and the girls pleading, "Don't hit me again, Mummy!" There even came a time when they called me from a public phone box, asking me to pick them up under a bridge, where they were hiding after running away from their mother's house.

In August of 1993, after the children's mother had moved out, I wanted Caresse to have a nice birthday, so I arranged for her to fly to New York

City and have a wonderful holiday with "Auntie" Terence—Terence Sellers, a close friend who ran a professional dungeon called the Whip Shack on West Twenty-Third Street in Manhattan. I'd been visiting Terence regularly, spending long weekends partying and blowing off steam during the slow implosion of my marriage. When Caresse returned, she had a photograph of somebody lying on the beach at Fire Island—a woman with a towel draped over her head. Caresse taped it to my bed above where I slept.

"I met this really nice girl who looked after me when Terence couldn't. I think she'd be a really good girlfriend for you, Papa."

Her name was Jaye. The connection, however, wouldn't occur to me for several more years: I myself had yet to meet Jaye at that point, and I couldn't see the woman's face because of the towel.

Later that year, in the autumn of 1993, I took another trip to New York to relax, crashing with Terence as usual. Rather than waking her after my three-day bender on pharmaceutical ecstasy, I slept in her dungeon. My eyeballs had gone totally red: I looked in the mirror before falling asleep and thought, *God, I look like I'm in a Dracula movie or something.*

Next thing I knew, I was awoken in the dungeon by talking. When I looked at the open doorway, an incredibly beautiful woman walked past in 1960s clothes and a Brian Jones haircut.

I found myself saying—aloud—"Dear Universe, if I can be with that woman for the rest of my life, that is all I need." As I spoke, I wondered, *Why am I saying this?*

The woman walked back and forth, gradually changing into a black fetish dominatrix outfit. Took my breath away. The person she was talking to was saying, "Don't go back there: one of Terence's friends from England is in there. He's bad news."

Lady Jaye—for it was she—immediately thought she wanted to meet this person. She invited me out to an S and M club called Paddles. She dressed me up like a little doll, in a green velvet bodysuit of hers; it symbolized a lot, in a sense. It was an immediate recognition. She dressed me up androgynously from that first day. Her instinct was immediately to recognize, reinforce, and honor the whole aspect of my being that had been either suppressed or sublimated or hidden because it was so

inappropriate to the culture I was in. She wore skintight black leather with five-inch heels, standing well over six feet tall. I stood holding her hand. I noticed at some point that she was gently moving. I looked down. Lying sprawled fully naked was a slave, whose hand was under one of her heels, which she was grinding into his hand as hard as she could while otherwise ignoring him.

I was smitten.

Lady Jaye Breyer was a registered nurse as well as a professional dominatrix. Being forced to wear a corset for scoliosis for long periods as a child had made her hyperaware of pain and both a body's limitations and its pleasures. She and I fell in unconditional love quite literally at first sight. Our independent journeys into stressors and near-death experiences cemented our fusion.

We became inseparable, though still bicoastal at first. We visited each other as often as we could, and we spoke on the phone almost daily. When Jaye and I hung out in New York, I often wore her clothes. We found we were the same size, and her things fit me nicely—plus my rave clothes didn't suit the scene in New York, where Jaye was a fixture in the underground. In New York, I could be more or less anonymous and let Jaye lead the way, whereas when she was with me in California, I was the one everyone knew.

From then on, when I came to New York, I stayed with Jaye at her place on East Eleventh Street. Terence was upset that I now stayed with Jaye, because up to then I'd always stayed with her. She also thought she was sort of the mother of all the doms and considered me a special friend. So in Terence's mind, I was betraying her in two ways: by not staying at her place and by distracting one of her "chickens," the name she liked to use to refer to the coterie of young, cute dominatrices that worked for her.

And though Jaye and I kissed and cuddled when we got together, we waited a year before we ever made love. It was wise to do that. She was disentangling from a complicated love affair with someone who wouldn't accept it was over. I was still going through a nasty divorce, and it was unclear what exactly was going to happen. So Jaye and I agreed to keep it at a certain level, no more.

When we finally did have sex, however, it was like no sex I'd ever experienced before. What was so fabulous with Lady Jaye was that she was way more perverted than I was. As she used to say, "You weren't ready for me until now."

She was totally right. It took me forty-two years to be ready.

Sex with Lady Jaye changed my universe and rearranged my inner being.

49.

The divorce papers were dated February 21, 1994, and I received formal notice on my birthday. I opened it and rang Jaye.

"I just got the best possible birthday present."

"What is it?"

"My divorce came through today."

As Jaye got to know Caresse and Genesse a bit, I always remember that she sat them down and said, "I'm your evil stepmother. It's your job to hate me. It's quite all right for you to hate me—I don't mind. Feel free to hate me as much as you want, in fact, because that's what you do to stepmothers."

Then she organized punishment: "If you're really naughty, you get a cream pie in the face."

I have Polaroids of Caresse running around, being chased with a pie and then getting it in the face, and laughing her head off. Then Genesse would say, "I want to be naughty so I get a pie!"

Jaye was very smart with the kids.

Later that same year, Martin Atkins, the Chicago-based organizer of the industrial supergroup Pigface, got in touch with me. The connection may have come via Helios Creed of Chrome, who lived up the road from me. Martin invited me to go on tour as part of Pigface, which was a loose collective that had at times included members of KMFDM, Skinny Puppy, Ministry, Swans, Dead Kennedys, My Life with the Thrill Kill Kult, Tool, and PiL, amongst others.

I thought, *Why not?*

I would get paid every day, and for once I wouldn't be in charge of making it all happen—no worrying about merchandise, nothing. I'd be a paid hand, using my sampler and doing vocals on a few songs. Easy peasy.

It made good use of being the godfather of industrial. And it was one of the first tours where we had a bus with bunk beds. Up to then, I'd always been on a school bus.

We had a gig on Halloween night at the Limelight in Manhattan—an old church converted into a club. And I had an idea. Lady Jaye had done performances at Jackie 60 and also with Blacklips Performance Cult, which included a lot of the East Village alternative drag and performance art scene people like Anohni of Antony and the Johnsons, Hattie Hathaway, Howie Pyro, and RuPaul's roommate Flloyd. The Blacklips orbited a club called the Pyramid, on Avenue A. So I asked her if she would want to get some people together to perform onstage while Pigface was playing. Just to appear, with no explanation, and be weird.

"Oh yeah," she said, "I can do that."

She put fake latex skin over her own and appeared to have a pregnant belly. At one point during the performance, she slashed open the belly—she had forks on the ends of her fingers—and out gushed pig entrails and fake blood, along with toy guns and baby dolls. It really freaked people out who were tripping in the audience, because it looked so real when she ripped away the skin and all the blood came out. The other girls she brought along did similarly disturbing things.

After the show, we packed everything away and were standing with Jaye by the band's bus.

"Last call! Fifteen minutes before we leave!" called out the tour manager.

"I don't want to go," I said. "I don't want to leave you behind."

"I don't want you to go, either. I don't want you to leave me behind."

"Well," I said, "why don't you just fucking come along?"

"Have I got time?"

"You have fifteen minutes. Can you do it?"

She hailed a taxi.

"I'll be right back!"

She jumped in the cab still covered in blood and gore, took it home to East Eleventh Street, got a little overnight bag, and came back just as they were saying to me they were going to have to leave.

Jaye and I climbed aboard. There were no spare bunks, so she and I had to share one—they were so small, they were referred to as coffins. It meant we more or less had to have sex to fit into the bunk together.

In those days, I had all these little Tibetan bells on my scrotum piercings. So whenever we had sex, the bells would tinkle. The guys in the band started crying out, "The bells! It's the bells!" pretending to be the Hunchback of Notre Dame. It went on to become a big band joke. But we went happily down the freeway, fucking all the way.

The next day, around midday, when the bus stopped at a gas station for a piss break, snacks, and cigarettes, we all got off and were milling around.

Suddenly, Jaye said, "Shit! I'm supposed to be at the dungeon today! It's my shift today."

"So give Terence a call."

"I can't. She'll go nuts."

"What? She won't go nuts."

"Oh, yes she will."

"Okay," I said, "I'll call her, then."

I went to the phone box.

"Hi, Terence, Gen here."

"Hi, Gen, how was the gig?"

"It was great, really great."

"Sorry I missed it."

"That's all right, Terence. We had fun."

"Do you happen to know where Jaye is? She's meant to be here now, and she's not. It's not like her to be late."

"Yeah . . . about that," I said. "She's with me."

"Well, tell her to get in a fucking cab and come over here right now."

"No, she can't. We're somewhere out of state."

"But Jaye's working here today."

"That's why I was ringing you. She can't do her shift. She's with me."

At that point, Terence lost her rag. She went crazy, screaming about betrayal. A truly psychotic side came out. *No wonder Jaye wanted me to call*, I thought. Fortunately, my money ran out just then and the phone cut off.

So we carried on. I remember the show in Atlanta, because a TOPY girl turned up with a whole load of acid. Everybody dropped acid before the show.

"I want to dance tonight," Jaye said.

"Sure, nobody will mind."

Jaye stuck tufts of hair all over her naked body; in her mind she was an acid-tripping goat. The TOPY girl did the same thing. And Jaye once again built a fake pregnant belly. Only this time, some of the members of Pigface freaked out about the blood because they were tripping.

Overall, we had a wonderful time. There were psychedelics galore on the bus, and everyone was in a great mood. Someone gave us opium, which Jaye and I smoked, and then we had the most incredible sex in a motel. We were so high that we left the envelope of opium on the bedside table when we got back on the bus. We carried on for about ten days, all the way to San Francisco. Basically we eloped and became the bell-ringing opium fuck.

At that point, Jaye decided she needed to get back to New York, but Terence didn't speak to her for years afterwards.

Jaye used to describe Terence to me as a particular breed of recklessly sadistic voyeur she had dubbed a "true writer" after years of observing Auntie Terence's machinations and vicious dramas with her various chickens. Terence craved intensity, make-or-break interactions with those she chose to attach her affections and desires to. Whether her subjects knew it or wanted it or not, Terence tried to vicariously mold "reality" to emotionally stimulate her, to be more like a fantasy book she intended to write, filled with intrigue. She wrote her journals ostensibly to document life, but interfered in its natural flow because of her craving for drama.

Jaye noted how often "scenes" with clients at the dungeon would spill over uncontrollably into her "real" life. I guess this was inevitable when Terence chose to live in a small room off to one side of her rented dungeon space. Jaye said she believed Terence would casually but deliberately say something to someone, perhaps implying their lover was unfaithful, for instance, knowing it would fester and cause the person to obsess over it, becoming more and more neurotic and insecure. Once she saw her ploys had succeeded in triggering destructive insecurities or friction amongst the

mistresses or her closest friends, Jaye said Terence would sink quietly into the background, like a therapist reclining in a leather chair in the corner of her office, legs crossed primly, with a clipboard resting on her knees, making meticulously detailed notes of any volatile dialogue or emotional or physiological symptoms expressed due to her subversive machinations.

"Terence winds people up just to get material for her books," reiterated Lady Jaye many times. "She's a callous bitch; she doesn't care if she hurts people or ruins relationships. These games are her soap operas. She's a bit like Warhol that way. Why do you think she studied forensic psychology?"

At first, I felt Jaye was being a tad unforgiving about Terence. But over the years, especially after seeing for myself her mind games and psychic chess in all their blinding radiance and brutality while serving as phone girl and occasional dominatrix at the dungeon, I came to see how accurate Lady Jaye's analysis tended to be.

50.

Rick Rubin liked much of my music. At some stage he had reached out about signing Psychic TV to his label, American Recordings. They flew me to L.A. and asked me to do demos. I did a couple of tracks, and he didn't like them. But he called again, asking me to help Skinny Puppy. Back in 1993, the band had rented a big house somewhere in L.A. and had a studio, but Nivek Ogre, the singer, was having problems doing his vocals. He'd lost his confidence. So I went down and stayed with them for a few days and helped Ogre get going again. That became the basis of the *Puppy Gristle* album that was released years later. Though oddly enough, even though we had what seemed a friendly work relationship, I actually never met Rubin in person.

Now, in April 1995, he invited me—again through a go-between—to stay at Harry Houdini's old mansion in Laurel Canyon, in L.A., to see if I could activate the band Love and Rockets, who were recording uninspired demos for Rubin's label.

I arranged a gig for Psychic TV for a Saturday during the stay in L.A., but it was a disaster. Someone put a roofie in my drink prior to the show. So as I introduced our first song, I collapsed onstage. John Lydon was there, along with Wayne Kramer of the MC5, and there was no show.

The next morning, I found a very weird, very old-looking voodoo doll inside my clothes at the mansion. Very dark energy. I asked a friend of mine to bury it in the garden. That night, I rehearsed with Love and Rockets and played a bass riff that worked really well. We had a great jam. I slept upstairs at the top of the house, sharing a room with David J. We quit jamming about midnight, but David and I chatted away for a while. He was telling me about his favorite guitar, Big Woody, which he had made himself back in school. He had the guitar with him, in the bedroom.

At about seven in the morning I awoke to a voice screaming, "Fire! Fire! Fire!"

I shook David awake and went to check the staircase. There was a huge, roiling, swirling chaos of smoke coming up the stairs, cutting us off. There was black plastic mixed into the smoke from the nylon carpets—toxic fumes. I went back into our room and slammed the door.

"The place really is on fire. And we can't get out that way," I said.

The only way out was the window. We were two floors up, with concrete stairs below.

We were stuck, with the flames coming up the landing towards our room.

"Let's throw down the bedding first," I said. We threw the mattresses down to try to cushion our fall.

I went to check the door again—it was starting to melt, it was so hot— and when I turned back to the window, David had managed to climb out and drop down safely, unharmed.

I wrapped the 24-track demo masters in a blanket to save all the work, then threw them down to David. Then I thought, *Shit, I can't leave Big Woody behind—it's his talisman*. So I wrapped the guitar and dropped that to him, too. He caught it safely.

I looked at the door, and smoke was coming in through the cracks. I knew I had to get out before it blew in. I climbed out the window. The ledge was dusty. I slipped. Fell backwards. As I was falling, I saw a tree and grabbed at a branch; it snapped.

Bam—I landed on the edge of some steps.

People came running up. "Are you okay?" they shouted.

"Don't touch me!"

I had broken my left wrist, sustained nerve damage that makes my thumb numb to this day, cracked my ribs, and broken my elbow so badly that it exploded into thirty-six pieces. I was in agony.

"The firefighters are coming," they said.

Firefighters arrived and told me to wait; they had to cover me in case the windows blew out. They put what felt like a lead blanket over me. The windows above exploded outward, and glass rained down on me.

A woman from the house—someone from the label or the band's management—came up to me and whispered, "If anyone asks you, just tell them you have insurance."

It was already eight in the morning or so by the time they tried to drive me to the hospital in an ambulance. Rush hour. Morning traffic in Laurel Canyon refused to move aside.

So much pain.

Eventually, I passed out.

I woke up in the hospital. It turned out it was Cedars-Sinai, in Los Angeles, where all the stars go—it just happened to be close to the site of the fire. A pit bull of a woman came up to me as they wheeled me into the emergency room, waving a clipboard and shouting, "What's your insurance? What's your insurance?"

"Look," I said, "I'm in pyjamas, I don't have anything with me. And anyway," I bluffed, "I don't deal with that sort of thing, with money or anything like that—it's all handled by my manager." I continued to bullshit until they were convinced I was some rich rock star.

Then it was off to the operating theatre.

Given the extent of my injuries, most hospitals would have amputated my arm, but this hospital had one of the most prominent orthopedic surgeons in the world. They rebuilt my arm.

At the end of a long day—most of it spent unconscious, in surgery—I put on the TV in my recovery room. On the news were helicopter shots of the fire and of me being wheeled out on a stretcher to the ambulance. That was a very peculiar moment.

The next morning, the nurses told me I should try to move around to avoid blood clots. So I got up and went to pee. Coming back to the bed, I couldn't breathe. It felt just like the moment before I went into a coma in 1967. I fell to the floor. I crawled, in my massive cast, towards the emergency call button. I just managed to reach out and push it and say, "Oxygen . . . dying . . . ," before blacking out.

When I came to, I was in intensive care with a morphine drip.

The doctor came in and referred to me as "TLG."

"Sorry, did you say TG?"
"No. TLG: Tough Little Guy."
The doctor explained he couldn't believe I was alive.
Turned out I'd had a pulmonary embolism—a blood clot.
I had died again.

51.

Lady Jaye heard on a newsflash on MTV that I was in an ICU. She imme-diately jumped on a plane to Los Angeles and tracked me down.

The first thing she did was climb in my hospital bed and masturbate me.

"I can't trust you to be left alone," she said. "I'm just going to have to move out here and take care of you."

When I was eventually discharged, Timothy Leary offered to have Jaye and me crash at his place for as long as we wished. We did for a while, then Jaye went home and packed her things to move to Cazadero to live with me.

The experience of the fire really made me reconsider everything I was doing and what was constructive versus what might not have been. With TOPY, for instance, I realized I might have miscalculated people's deep need for something to follow, for someone to tell them what to do rather than seeing it as a way to learn how to tell themselves what to do. I didn't think people were so desperate to have somebody be their cult figure. It was a wake-up call, a time to step back, consolidate my ideas and theo-ries, and to decide what I wanted from life going forward and how to go about it.

Lady Jaye said, "You never need to do anything; you've already done more than most people do in a lifetime, given more to the culture than most people ever do, so you don't have to feel as if you need to keep giving of yourself."

As she put it, "If you feel like stopping, stop. If there's something you want to do, then do it because you want to—and I will fully support you both emotionally and financially."

That was the deal she made with me.

And yet, I couldn't ponder stopping. To me, life and creativity were the same. Change—constant change—was critically important.

That summer of 1995, we got married in a private ceremony, while I was still partially incapacitated by my injuries and wearing a cast on my arm. Lady Jaye hated terms like "wife" and "spouse" and "life partner." She felt at ease only with "other half."

Our love was so intense, so total, that we literally meant it when we said, "I wish I could eat you up," absorb you, fuse and blend with you completely. Lady Jaye said we were blessed. We had truly found our other halves. Together we became whole, complete. We started thinking: Why did we feel this urge to be consumed into each other, to BE each other, look like each other?

We truly felt like two parts of one being.

Jaye, who had a nursing degree, had planned to work as a nurse when she moved to California, only to run into problems getting her New York license approved for use in California. Meanwhile, she couldn't work in the dungeons in San Francisco, either, because they were controlled by the Hells Angels, and Jaye had an ex-boyfriend who was an Angel in New York—and since she'd left him, she was a target, even on the other side of the country. When we were in New York, we also made sure never to walk near the Angels' clubhouse in the East Village, either—for years.

For a long while after the fire, I was in really bad shape physically: I could barely walk. We moved a studio into the spare room next to my bedroom so I could continue to work on a Psychic TV album that had been in the works before the fire. I would stagger over with my walking stick and record a vocal or say yes or no to the mixes and then collapse back in bed. There had been a plan to tour the record in North America and Europe, but I couldn't do it.

Then, about six months after the fire and my emergency surgery, I received a letter in the mail that said I owed Cedars-Sinai Medical Center $140,000. My lawyers said I had no choice but to sue Rick Rubin: as it turned out, the fire had been caused by faulty wiring, with the use of the house as a makeshift recording studio overloading the system and leading to an electrical fire. I didn't want to, but I also couldn't pay the hospital bill, and Rubin and his insurance company had said through an intermediary they refused to pay the bill for me.

The case ended up taking years, culminating in a court case in Los Angeles in 1998.

By then we had relocated to Ridgewood, Queens, in New York City. Jaye's grandmother was suffering from Alzheimer's and needed help at home. We decided to move to New York so Jaye could work and care for her grandmother.

I had full custody of both Caresse and Genesse at the time, and everything was set to take them with us to New York. But then their mother called me and said, "I've been in touch with the police and told them you're trying to kidnap my daughters and that I haven't given you permission to take them out of the state."

"But you did give me permission."

She had not, however, written it down. And then she realized she would no longer get any child support if she wasn't looking after the kids part-time. So she wouldn't let me take both girls to New York—for which I don't think I can ever forgive her. It really hurt Genesse, because she's the one who was left behind.

When we left England, it really hit Genesse hard to be told we couldn't go home, that her toys were all gone, that she wouldn't see her friends or relatives anymore. That we didn't have any family photos anymore. She was just a little kid, still figuring out what it meant to be alive, and then she was told all that no longer existed. And that it was my fault, because of what I said and believed. Then, as things seemed to be stabilizing, that was destroyed because of the divorce. So I figured that the continuity would suit her better; she had friends in California, a school she liked, cats, a dog, and other pets—elements of stability. Caresse, on the other hand, had been doing poorly in school in California and was just sort of drowning in nothingness. She wasn't integrated into life in California the same way.

As the court case drew near, Paula was approached about being a witness against me. To her credit, Paula told them to fuck off. Several other friends had similar experiences. My lawyers said all along that Rick and his company would settle the case; they were shocked they wanted to go through with it. I guess they figured it would be easy to go up against a starving musician living in some crappy place in Queens—Rubin's

millions against an English pauper who didn't even know the American legal system.

The case finally went to court in 1998, and Jaye and I flew out for it. Court, I found, was like a linguistic game of chess, and I don't think they bargained with how articulate I could be. Also, the Santeria priest who lived downstairs from us at the time gave us a special powder to sprinkle in the courtroom to help us win. He told me to spread it beneath the jury box seats, which I figured would be impossible. But then, on the seventh or eighth day of the trial, there was a break, and I lingered to talk to my lawyers. Then they left, and I was all alone in the court. *This is my opportunity!* I ran over and sprinkled the dust around the jury box and then wandered out nonchalantly.

At some point during the second week, I was walking into the courthouse, in a suit and tie as usual, and there was a bearded homeless man on a bench outside, wearing dirty red gym pants, an extra-large red T-shirt, and sandals on his filthy feet. As I walked past the man, he said, "Hi, Gen."

What? I looked at him and he must have realized I had no idea who he was.

"It's me, Rick Rubin."

And I thought, *You cunt, you're the reason I'm here.*

"How are you?" he said.

"Actually, Rick, I'm not doing that great."

And then I walked into the courthouse.

When he took the stand, he was asked about the fire at such-and-such address in Laurel Canyon. "Is that your property?"

"I don't know, I have so many mansions. I have five or six."

You could see the jury recoil: the jury was full of normal people, bus drivers and a woman who worked at the zoo. They did not seem to like the way he was boasting about how rich he was.

Once the case had been heard, we flew home from L.A. while the jury deliberated. A few days later, my lawyers called me in New York and said, "You won."

I had been awarded $1.6 million, plus interest.

I was speechless.

Then reality set in: most of the money wouldn't remain mine. In addition to the outstanding hospital bill of $140,000, I owed $500,000 to the firm that loaned me $250,000 to fight the case. Then there were other bills, many related to the case. In the end, Jaye and I had about $600,000 left over to use however we wished.

In the end, I was a millionaire for exactly one day.

52.

When I first met Jaye and people were talking to me about her, some people proposed to me, as far as they knew, oh yeah, she's actually really a man. They were quite adamant that she had a sex change. And that if I got her naked, I would find a penis. It didn't bother me in the slightest. I think it was supposed to put me off, but it didn't. If anything, Jaye has always been genderless in the sense that she doesn't carry any clichéd qualities or relate to any stereotype at all. Whereas I came with some clearly defined male qualities. So she probably brought about a neutrality in my way of viewing myself, or a clearer form of neutrality, which I think was important.

Though I had started to wear Jaye's clothing a lot in New York when we went out—usually the green velvet bodysuit and a miniskirt—I didn't think of it as cross-dressing so much as dressing more glamorously. Once she was living with me, we started dressing in complementary outfits; often she would dress very masculine and I'd be more feminine. It came naturally to us to switch identities, blend identities. It was fun: I'd go to PTA meetings at the girls' school in a silver miniskirt and thigh-high silver boots, a velvet top, and a beautiful wig.

The more I began passing and being perceived as female, even when I wasn't trying, the more curious I got as to what would happen if I tried. It was a cyclical process, cause and effect, observation, spectacle, round and round. And our personal dialogue just took us to a point where I was determined to really commit myself to extending gender, extending identity and consciousness, not rolling them back or isolating them.

The body is a really primitive machine. The way it functions is not that special. Lizards manage to perform just the same function except for, as far as we know, linguistic thought. Most animals that we might even think are primitive have most of the same physical characteristics in terms of how their bodies work. They just don't have the pretension of being concerned

with their bodies somehow imposing meaning on their existence. So I think what Jaye and I ended up doing in a way was removing this illusion about the body giving meaning to life. I think that's part of the trickery of organized religion. It's all part of that same deliberate brainwashing that's been going on for thousands of years to maintain economic, political, and social control.

Those are all in place not because they necessarily describe any genuine reality. They're in place because they maintain tension between one community and another, or between one community and the environment. The other, what is you and what is other. And whatever is other can always become the enemy or something to be feared.

It was obvious what we had to do. That's why we were so antagonistic to binary systems, including identity being based on gender. That just led to yet another excuse to prehistoric behavior and separation. Unification was what we needed.

As Jaye used to say, "Identity is your only possession, so repossess your self, be possessed by your self, every self, any self you ever wanted to be."

When Jaye and I had moved in together, we created a ritual symbolizing our rebirth as newborn babies, twins, two halves of one new pandrogynous whole we called the Pandrogyne. In recognition of this, our most momentous, vital, spiritual expression of unconditional BIG love, we both slowly, lovingly, worshipfully shaved every single hair off each other, from head to toe. Entwined, totally naked, we lay for twenty-three hours—wearing adult diapers—in the fetal position before an improvised TOPY ritual. We did sigils to focus on the Pandrogyne.

The Pandrogyne is a very, very important reconciliation of a closer version of what reality might be, in terms of physical reality, anyway. Basically, the universe is made up of one kind of matter—everything. There is no binary universe. So there is no binary body. It's a myth. We need to erase difference, embrace the idea of similarity, and recognize that similarity is not a weakening at all but a strengthening.

I'd first written about pandrogyny in my notebooks in the 1980s—that's how long the idea had been percolating. Back then I'd written that it is was inevitable. It was just a matter of observing the undercurrents of the

culture. By the mid-1990s, Lady Jaye and I noticed that the sex ads in the *Village Voice* had transformed over time. Originally nearly all the sex ads were heterosexual—meaning they were biological women servicing heterosexual men. But we noticed that, over a period of time, there were ever more ladyboys and chicks-with-dicks servicing heterosexual men. That seemed significant. That suggested something was going on in terms of how people viewed sexual activity.

Back then, cosmetic and plastic surgery were big secrets in Hollywood. But gradually that shifted to a point where people were boasting about it. Plastic surgery became something to be proud of. Body modification was no longer a dirty secret. Everybody wanted to get in on it.

We saw that as evidence that there was a shift away from the stereotypes of either/or, male/female, and that there was an undercurrent, no matter how unclear, saying that pandrogyny, hermaphroditism—"trans," as it became— was in the mix now, and that it was going to come through and become more visible. So we thought we'd help it along, because that's what we do.

When Burroughs and Gysin cut up words, images, tapes, and film and reassembled new creative works, they attributed these results to a combination and fusion of their two imaginations that they called "the third mind." They could not claim authorship individually anymore; the process entailed a willingness to sacrifice their own separate inviolate works and artistic "ownership," with the third mind representing an entity in and of itself, the origin and source of a magical or divine creativity that could result only from the unconditional integration of two sources. It was that very structure that Lady Jaye and I sought to apply to create the Pandrogyne, to take it a step further, just like we took the tape recorder experiments and turned it into Throbbing Gristle. Lady Jaye and I speculated that if we applied a form of cut-up to our problematic bodies, trying to end a male/female paradigm, a new being would emerge from our process of merging. We called this "the third being."

Cut-ups had taught us both that nothing was fixed, that everything was permitted. Only society's suppression of our imaginations limited us from reaching our full potential in every way, almost every day; people surrendered their autonomy for the convenience of fitting into society.

We both felt an absolute dissatisfaction with being classed as a gender-based. Genitals, we believed, were simply reproductive, pleasure, and excretory devices—flesh functions left over from our ancient animal past. The obsession with body and genitals was a negative loop that only helped those in control to maintain control. Plus, what more perfect expression of truly unconditional BIG love than to surrender body and soul into each other?

We decided in our quest to create the Pandrogyne to use various modern medical techniques to try to look as much like each other as possible. To erase our differences, to include every option. We ended up spending hundreds of thousands of dollars—the windfall awarded us after the near-fatal leap from Rick Rubin's house—on painful body modifications, including breast augmentations and facial surgery, twenty-three surgeries in all. Beginning with matching C-cup breast implants on Valentine's Day 2003.

I remember staring in the mirror the day before our first facial surgery and being quite intrigued by the idea that I wouldn't have the same face the next day. I didn't have any objection to the face I had. The face I had was just fine; I'd had that face for forty-odd years. *I'm not getting my face changed to have a face that's somehow more appealing.* I really didn't care what it looked like the next day. Within reason. I would have preferred it not to have been all bloated, swollen, disfigured, and something to go wrong. But I actually didn't care. At all.

I'd let go of the need to feel any sort of basic connection to the surface. When I looked at the face, I saw a brain with lots of little processes happening, and that brain being a brain that loved Jaye. That was all that mattered.

One culture, as Jaye pointed out, will want scars and tattoos, another will want the neck stretched, and another one modified ears or lips. Nothing at all is fixed. Nothing. Everything is completely arbitrary in the first place. So, in another way, the Pandrogyne is a reconciliation. The final beginning of a reconciliation of all that chaotic flux, which is inevitable, because we've only just gone through one phase of evolution. This is just the next container for human consciousness to move outwards to the stars and then, ultimately, out into the ether.

Jaye and I definitely both had altruistic leanings. Despite having a misanthropic aspect, in that we were disappointed on a certain level about the

state of the human species. Its self-defeating inertia into polarized bigotry and fear of responsibility. We both had that misanthropy. We also had an altruistic leaning in that we wanted to present and propose a solution. We cared enough about the human species to want it to evolve, for it to find a more divine trajectory than it had then, which would require a great deal of sacrifice by a great many.

Pandrogyny was the altruistic aspect of our individual and mutual quest for answers.

By virtue of both of us going under the knife and changing our appearance and becoming a visual symbol of pandrogyny, there's no question we generated attention which has created dialogue, which is also having an effect. The full ripples of the effect we won't know for years and years, but certainly creating the Pandrogyne as a visual icon and idea has been powerful.

You could argue that the Pandrogyne is our attempt to heal the gigantic wound that occurred when Adam and Eve were split—mythologically, at least. That the very origins of the human species are infected. The divine state was a hermaphrodite; Adam and Eve were originally hermaphrodites. But in the usual history of the species, there was this massive rift. And the Pandrogyne is very definitely, consciously, on that mythological level, about the reunification of Adam and Eve.

It seemed useful to us, in our practice, to adopt the assumption that there was no way of knowing which had supremacy: the recording device that is DNA, or the self we converse with internally that we call *consciousness* but often still imagine and identify as the living, biological body. We viewed the "I" of our consciousness as a fictional assembly or collage that resides in the environment of the body, and the body as a sort of hieroglyph for the self. We were required over and over again by our process of literally cutting up our bodies to create a third, conceptually more precise body, to let go of a lifetime's attachment to the physical hieroglyph that we visualize automatically as the "I" in our internal dialogue with the self.

It represented the liberation of the mind and perception, the liberation of the body, and, ultimately, thereby the beginning of a sort of evolution. It's an external manifestation of an inner change—just a reflection of what's going on inside.

We were each other's completion. Each other's *Other Half*. We completed, we didn't compete. "Other Half" also suggested that any project we collaborated on would necessarily be incomplete until the Other Half supplied whatever aspect of the project was going to be theirs, and it did not have to be an equal amount, merely *more*, merely *that which completes*. There is a culturally inbred, unconscious emphasis on the male/macho that leads to assumptions that a woman in a couple is inevitably less integral, less significant, a mere appendage, even implied property. We were Lady Jaye's Other Half and s/he was my Other Half, leaving a balance where neither is more consequential than the Other. We called this egalitarian integration of two artist explorers, this third being, BREYER P-ORRIDGE.

Though Burroughs was the inspiration for the third being, we also realized it might not have dovetailed entirely with Burroughs's philosophy. He believed in being unnoticed and slipping through unseen, hoping to have a long-term effect of change by tinkering on the inside. I always maintained that method had been tried and was too easily co-opted—that it was incredibly hard for one bank clerk, for instance, to change the global policies of an international bank. That the conglomerates were just so powerful and basically so inert that it was not feasible to collaborate with them on the off chance an opportunity arose to do something anarchic.

And in the end, we've always had less patience; we didn't know how much time we had, and we decided early on we'd rather do the maximum damage to control in the shortest possible time and risk sacrificing ourself in the process. That was an accepted risk.

We think that the end of either/or is essential to the survival of the species. We really do. It's the only logical progression.

Pandrogyny is not about defining differences, but about creating similarities. Not about separation, but about unification and resolution. Difference is the core problem. To us, at least, pandrogyny is one of the only options the species has for survival.

There are many genderless organisms on earth, and many others that can switch genders, though in the end that doesn't really matter. It's too literal. What matters is shifting the paradigm to be more inclusive for the sake of unifying the species. We use a simple sort of analogy: if you have

something like an amoeba and part of it gets damaged, it will marshal whatever resources it has internally to fix the injury. If we were capable of visualizing the human species as one organism, then that would be our inevitable reaction to famine or war or other crises—and we have more than enough resources to marshal. If we could achieve a state whereby we think in terms of the entire species as a single organism, then there would be no debate about ending carbon emissions, etc. We would know that it was in our best interest not to despoil the planet and to clean it up instead. It's a way of thinking, a perspective, that encourages far more positive and healing actions.

Whether or not we all become hermaphrodites is not particularly a bother to us; it's just looking in a direction that takes us away from the damage society has done and continues to do. And takes the power away from the people we keep allowing to do it to us—that handful of idiots worldwide to whom we hand power and thus control.

Just as we had predicted in 1986, transsexualism became an accelerating option for those in need, and exploded into the sociopolitical discussion. But even now, being trans is seen as *changing* gender, maintaining the either/or bastion of control. What we were doing wasn't about adopting a different gender or that horrible term people use now, "gender fluidity." Lady Jaye and I didn't wish to be defined as male or female. We wanted to fight for an end to either/or, male/female, black/white, and so forth. Confusion as to how we view our SELF is mostly because we are labeled as "trans" by media and social authorities; it's easier to dismiss us that way. Though we do feel a strong kinship with the trans community because it demonstrates an inevitable change that we predicted, an evolution in the human body and how it can be perceived, manipulated, and integrated with technology.

End gender.

Break sex.

Destroy the control of DNA and the expected.

Every man and woman is a man and woman.

53.

Lady Jaye dropped her body on October 9, 2007. Our other half died in our arms at our home in Ridgewood.

"Our bodies are just cheap suitcases to carry our consciousness around," she used to say.

That consciousness—prior to bio-body life, during bio-body life, and after entropy and dissolution (death) of the bio-body—is always connected to all other consciousness, outside time and space, in perpetuity.

In retrospect, it seems eerily undeniable that one of us would drop our body that year. Just before PTV3 set out for a European tour in the fall of 2007, Jaye and I had a Santeria reading. Afterwards, we felt compelled to alert the entire band: we'd been warned that if the tour were cut short, someone would die. Once the tour started, Jaye and I sat down Markus Persson, the keyboard player at that time, and Hannah Haddix, who operated the video projections and handled merch, and asked them to promise to help take care of the survivor were either Jaye or ourself to die. The anthem of that tour became a song called "New York Story." It's a sad song about two junkies and the need for one of them to die for the other to live.

> Your body is so cold
> Its turning blue, you look so old
> Not human anymore
> I think we've lost this hopeless war

About halfway through what was to be a two-month tour, we discovered our tour manager had been stealing money. We were faced with a dilemma. We could use the merch money to cover the expenses—the bus, backline, and other expenses—to continue, meaning we would finish the tour without

having made a cent. Or we could cut our losses and head back to New York early, where the band members could go back to their day jobs.

We held a band vote. Markus, Hannah, and we voted to continue. Eddie, Davey, and Alice voted to go home, because making nothing for two months just wasn't feasible for them. Jaye cast the deciding vote—and she voted to go home.

Nobody thought to bring up the Santeria reading.

Less than a week after returning to New York, Jaye dropped her body.

By then we were living in a town house in Brooklyn we called the Gates Institute, a living, working art commune once again. Along with others living in the house, we napped with and cuddled Jaye's body before they took her away in a black body bag. We tried to keep her hands warm for as long as possible.

Most religions in the world tend to suggest that the body is sacred. It's not. Lady Jaye was a nurse, and she loved being in the operating theatre because she said it reminded her that we're just meat and bones. She thought it was primitive—akin to being in a butcher shop.

There's nothing sacred there. Nothing.

But with the mind, there is. The mind is what can love; the mind is what can come up with new ideas. The mind is what can change language. The mind is a memory retainer. The mind is connected to all sensory inputs. The mind is what can shape culture.

The mind—not the container—is who we are.

With pandrogyny, we used to say: "Some people think they're a man trapped in a woman's body, some people feel they're a woman trapped in a man's body, but the Pandrogyne just feels trapped in a body."

Various cultures and belief systems hold that consciousness is capable of maintaining a sense of individual, self-conscious identity after the death of the body. Hence the tradition of reincarnation. We used to find this very hard to grasp and truly believe.

We remember back in 1986 when Brion Gysin was becoming ever more sick. We visited him the week before he dropped his body. At one point, he asked me to go out and have a coffee while the funeral staff came to measure him for a coffin. He was pale, as if he were literally fading away

from reality and becoming semitransparent. We took a Polaroid, one of our prized possessions.

"Gen," he said, "I can't take this pain any longer. I need to go."

Our heart faltered for a second. He was our mentor, our teacher, our engine of hope. And he was leaving.

We said to him, very sincerely and seriously, "I'm going to make sure that nobody forgets about how important your work is until it gets recognized."

It became one of our life tasks. To proselytize his works, his ideas; keep his books and artworks available and influential. This is what we've done. He deserved it. He generated the most important techniques and tools of the last century for short-circuiting control and moving the culture in a new direction.

Lady Jaye used to say, "As soon as I'm gone, they'll pretend I was never there."

But we assured her, too, that we wouldn't let that happen. There was no way we would ignore or undo the Pandrogyne, and we wanted people to realize that her contribution was ongoing. Pandrogyny is the culmination of all our previous interrelated series of projects that were always intended to follow on from each other, distilling what the previous one had revealed. COUM Transmissions was our first; Throbbing Gristle and Industrial Music was our second project; Psychic TV and Thee Temple ov Psychick Youth came next; and they all combine like threads entwining into a golden rope—reaching into I'M/MORTALITY. We knew the theories and concepts surrounding pandrogyny would be the central experiences and references that would consume us and all we created until we also dropped this body.

Jaye always said one of our special qualities was loyalty, and we remain totally loyal to the memories of both Brion and Jaye.

We remember corresponding with Caresse, our older daughter, when she was going through a crisis as to what to do with her life. We told her that as far back as we could remember, even as a child, we always viewed everything from the perspective of an old person on their deathbed, not in a morbid way, but that final day, knowing you're going to pass out of this life, looking back at your choices. I told Caresse, "We make decisions based on where you want to be and what you want to be on that last day."

Everything we've done has been geared towards that moment, viewed in a sort of preemptive hindsight. And when we picture ourselves in that position, looking back, we have to consider things like: Did the choices we made always contribute to the improvement of our way of being and the success and effectiveness of our creative life? The second question we ask ourself is: Did all the choices we've made and all the actions we've undertaken improve the lives of others in some way? Then finally we must ask: Did the choices, actions, and words we've given out to the world by living this life do any harm, hurt, or injure other people—even accidentally? Also, did we repeat mistakes or errors of judgment knowingly thereafter?

There's a checklist of ethical questions that one should always ask, over and over, almost by rote, from moment to moment. Because the last thing one would want to do is to feel ashamed or in some way to have failed oneself in the unfolding of one's life. One must always be aware that everything one does resonates with other people, no matter what forum one chooses—whether it's being a nurse, an administrator, a musician, or a laborer. There's still the same resonance, still the same responsibility.

One should be able to believe one has set the best example of how it's possible to be. It means so much to us, for our own personal gratification, to believe we have done the best possible job of *sharing* inspiration when it comes. By sheer example, we have shown it is possible to create everything necessary to remain outside the system and move forward.

All our strategies and choices in terms of art, music, writing, and life have been made in order to construct the most amenable picture of ourself from that deathbed perspective. One finds images, words, phrases, people, strategies, objects, talismans . . . all kinds of things that one gathers around oneself in order to keep reminding oneself of the discipline needed to create this final person one wishes to become. It's all about reinforcing motivation in order to become something special, something one is proud of at the end of the day, with hindsight.

Of course, one never knows how many days one has left. Every precious bit of time one has should be used in the most positive, creative, altruistic way it can be.

Lady Jaye described it very simply: "See a cliff, jump off."

54.

When we were back in Hull recently, we found it surprising how mundane some people's vision of COUM was. They seemed to see it as just making silly music, or just messing in the street. That wasn't what was like for us at all. It was a theory that was also a way of life, that was meant to be part of an evolutionary shift for the species. When people became involved and converted to that way of life for some length of time, that was proof that it had meaning. *What* we did wasn't as important as the fact that people were *doing* it.

Back then, as later, and as now, we've always tried to create a dialogue through art. We've tried to talk to people and say there's more, and you have a right to be part of it—an absolute right. People have been sold a false bill of goods. People have been offered an empty bag of what life is supposed to be. There is a universal energy somewhere that is the reason people should be making art or creating. Everyone has the potential to do it; everyone has a genius factor.

We've always found the concept of divine inspiration frustrating. Some artists refuse to admit having any influences. We think everything that happens every day is an influence—we are the sum total of everything that comes in, and then we filter it back out—and that even transcendent, seemingly divinely inspired artists like Leonardo da Vinci are always building on what went before. This immediately gives value to everybody's life as well, because it means everybody's life is full of information that can become a source of inspiration. Maybe people just haven't been told how to process that information or recognize the value it has. We want everyone to realize that they can always take their level of existence higher: there's always more potential because of this genius factor everyone has. We truly believe everyone has far more ability to process and express things than they've been told by their society.

Oh, you can't play the piano properly, so you can't be a musician.
Bullshit.

We once had a big row with Frank Zappa about that. He was going on about having all the best musicians in his band. And we said, "I have a band of non-musicians called Throbbing Gristle. And I'm telling you now, I think we're going to make a contribution that's innovative and fresh and we're going to change the way music unfolds."

He said, "Ridiculous."

We have nothing against Zappa, but we remember going to see his show and thinking, *What is this?* It was infantile, with endless fucking solos—very skillful but boring.

And pointless.

We want our "works" to be functional, to make something defined happen. So we always ask, *What is this work telling us that we didn't already know? What is this work telling our chosen tribe that enhances their understanding of being alive with sense and intelligence?* Then, finally: *What is this work sharing with all humanity that has the potential to release wisdom?* If a work doesn't answer one of these questions in a positive, then it is of no value or importance to us. In that case it is, as Brion Gysin used to say, "deceptual art."

Art is supposed to be about the constant process of change, of pushing the envelope with perception so that you get closer to understanding what existing is. It's ultimately a philosophical quest for a meaning of life and a comprehension of mortality and all of those big questions. It's not supposed to be about careers. It's supposed to be about someone who's just desperately trying to express something.

That's how art is supposed to function: stripping away the hypocrisy and saying, *That's not what life's about.*

Life is about your satisfaction in yourself each day.

We're a fanatic, by the way. We don't play the art game. We don't fraternize with people in the art world. We don't try to get into professional galleries, schmooze collectors and people with money, all that shit. We're not interested in that. We're just trying to communicate.

And as long as we can eat and stay in our little apartment, we don't need anything else. So there's no temptation. What can they give us? If they gave

us more money, we'd just use it to make more art. Which is what happened when we got the money from the fire at Rick Rubin's house. We used it for art.

We could have played it safe.

But then Jaye would have died without doing any of that.

And it's had its impact.

When we were diagnosed with leukemia, we got an incredible parcel from New Pine Wood, which is a transgender commune in Upstate New York. They'd all made something by hand as a gift and as a way to say they hoped we'd get well. And they also thanked us for the inspiration.

That's what we want: to provide inspiration.

Not the inspiration to be the same as us, but the inspiration to be yourselves. That's what gives us satisfaction. If you can help people through some stuff, if you can give someone a sense of belonging when they live in rural Idaho, or wherever, that's what matters. Not how many catalogs or records there are on a bookshelf. We have moments of cynicism towards aspects of society, but we've never become cynical, never stopped believing in the power of creativity.

We're truly an idealist.

An audience for us now is an opportunity to explain our positions and give freely of any ideas we have come across in our seventy years. Preserving and protecting those wisdoms offers the only hope for a future for our species.

This may sound awful, but recently we've been wondering: What was it that Burroughs saw in us when we were twenty years old? Why did he give us the time of day? And why from then on did he support us until he died—help find lawyers, encourage projects, write references. We wonder what it was he saw. He probably just saw that fire, that fanatical fire that you've got to have—that fire that makes you do things no matter what happens to you.

To go against the grain.

Far more people are capable of this than actually do it. That's the main point of the exercise of writing this book. It's to demonstrate (a) it's been done, and (b) it can be done again.

The materials will change and the strategies will have to adjust, but the basic premise is that everybody can be more and do more than they've

been told—and everyone can have a more satisfying sense of completion in their life as a result.

Rolling Stone never once reviewed Throbbing Gristle, but recently they credited us with one of the top thirty albums ever made. It's nice to think that it's appreciated. If the old records still work to some degree and can still inspire in any way, that's great. But they're not something that we go and listen to; they're of no interest to me now, because we're not the same person. We wouldn't make those now.

We have to think of something new in order to wake people up. Because at the moment people have become so blasé. How do you get through this miasma of complacency and make people listen? How do we break through it and slap people's faces—metaphorically—and say, "The world's collapsing around you, and all you're worried about is how many 'likes' you've got on your social media accounts. For fuck's sake, wake up!"

We used to think we were a romantic existentialist. But after all the incredible evidence we've witnessed in different shamanic traditions worldwide, we've had to adjust our perceptions. Now we are happy to be a compassionate utopian idealist. The potential of humanity is infinite. And the choices we make as a species could be either our downfall or our celebration.

That's what we think about now: *What's next?*

There is definitely a parallel between what was happening at the end of the 1970s and what is happening now. People need to be slapped awake . . . but that's not our job anymore. All of you who are reading this: you're supposed to be changing this. You must. Because what happens in the future is a direct result of what you do and don't do *right now*.

There's always a way. You don't need resources. You don't need money. You just need to have an idea that's strong enough, and that you feel strongly enough about, that you will go against everybody else to say or to put into practice.

Please go out and try to change the fucking world.

End gender.

Break sex.

Short-circuit control.

AFTERWORD

"It's my belief that one of the problems of the world so far, or one of its evolutionary states that is coming to an end, is the binary system. The either/or system. The good/bad, black/white way of perceiving everything. That's not the way the universe is built. That's not how matter is. That's not now the brain is. Nothing is like that. It's a fallacy."

—Genesis on audio cassette, sometime in the mid-'90s.

I first met Genesis back in February of 1993. I had been in San Francisco working on my book *Media Virus!*, and I got a call from Timothy Leary asking if I would bring Gen with me when I returned to Los Angeles. Gen had been chased out of the UK for that art video depicting a mock satanic ritual and was hoping to learn some strategies for a life in exile from Tim, who had spent years in Europe as a fugitive himself.

Of course, I was delighted at the prospect of spending five hours with one of my cultural heroes, a cut-and-paste artist who approached the body and gender with the same appropriative remix ethos that he (Gen identified male at the time) approached civilization itself. But I was also a little frightened. I knew Genesis P-Orridge, the pioneer of industrial music, the front man for Throbbing Gristle, and the instigator of mail-in-semen-and-pubic-hair cult: Thee Temple ov Psychick Youth. TOPY members I had encountered in America were still quite binary, with militant garb and rigid gender roles and hierarchies. If the coyote boys were modeling themselves after him, I could only imagine how fierce the original coyote might be.

But as I pulled my Ford Escort into a parking complex, I came upon the real Gen—along with reluctant travel companions Caresse and Genesse—waiting with their luggage. They piled in, and I got to know this strange

and wonderful human in a different context. A host of contexts, in fact: psychedelic adventurer; rock musician; cut-up artist; conspiracy theorist; beat, cultural philosopher; and, thanks to the occasional sister brawl in the back seat, typical father. All at the same time. But there was nothing scary or over-determined about Gen. This was not the hard-core, macho TOPY leader I expected, but a soft, squishy, open, and endearing partner in thought-crime.

Yes, Gen could talk for hours on end. But they were never egotistical. Gen didn't speak about Gen, but about influences and collaborators, friends and lovers. Their diatribes were about Burroughs and Gysin, Kenneth Anger and Derek Jarman, Cosey and Alaura, and later, of course, Lady Jaye. To the extent that Gen did have an ego and persona, well, the object was to kill it and reassemble the parts into something else.

Gen and I bonded and remained close friends and confidantes until they passed. We recorded hours and hours of our conversations over the years, with the intent of collecting them into some sort of book. These encounters were intimate and intense. Challenging, but not in the way that engaging with a strong personality like Leary challenged one's ego and assumptions with the power of his own. It was more a feeling of being taken in and invaded at the same time, where the boundary of my own individually was immediately suspect. It was like making love or, better, being possessed. It was a nondual way of relating to people. There was no other. It was like becoming one shared consciousness.

What I always really wanted Gen to do was write a book of their own. Not a TOPY scripture or collection of Thee Majesty poems, but a real chronicle of Gen's experience of life and art and power and people since the 1960s. This was history they had lived. I started nagging Gen in the late '90s and kept at it when we played together in PTV3. I saw every van ride was another chance to push the idea forward. "Would people really be interested?" they'd ask, as if their adventures applying the techniques of cut-and-paste to human flesh were already going out of style.

"People are going to want to know where all this came from," I'd reassure them. "The origin story of the counterculture, told through the eyes of someone who was everywhere that mattered."

It was only after Gen developed leukemia that they considered this option seriously. Initially, and with great cost to their health, Gen kept traveling and performing, finally canceling gigs when they lacked the oxygen to speak. Eventually I had to set up a GoFundMe for Gen to make ends meet, and they accepted that a book would allow them to maintain creative output without leaving the apartment.

Gen didn't know if they could afford to work without some income, and I had to explain that real books get real advances. From publishers. "You think I could get a publisher? Do you know one?" Again, they had no confidence that anyone would even read their book, much less pay for one. I helped Gen put together a simple proposal, introduced them to the perfect agent in Peter McGuigan, who connected Gen with brilliant cowriter Tim Mohr. And you've just read the result.

What helped me get Gen to turn the corner was when I suggested they not write their autobiography, but rather their experiences with others. Gen's eyes would light up at the thought of sharing their adventures transitioning from man to medium, as they themself transitioned from life to—well, whatever is next.

Predictably, then, this volume may seem just a bit mosaic to some readers. Well, what would you expect from a cut-and-paste artist who was no more dedicated to crashing civilization than crashing their own identity? The reading experience you just had was to my mind a bit like experiencing Genesis the person. Fluid. Changing. Self-annihilating. Nonbinary in the sense that subject and object, figure and ground merge and intertwine.

For Gen only truly existed in relationship with other people. The nonbinary ethos was about so much more than sex or gender—it was about the dissolution of individuality. Of self and other. And given that Gen lived this way, their life defied the traditional narrative structure of a protagonist moving through the world. That's why this is a book about relationships and impressions, unions and dissolutions—where the thing we call Gen serves less as the leading man or woman and more as an environment or medium through which various collective experiences could take place. Not a protagonist but a *pan*-tagonist. They'd have liked that word.

Nonbinary is less an autobiography than an antibiography. A dissolution. Gen annihilated the self—first himself, then themself, but also everyone else in the field, forcing us all to wake up. Resistance was futile. Still is.

I'm sorry Gen is gone. They didn't live an easy life, or leave us with instructions for how to live an easy one ourselves. Quite the contrary. It's to be deliciously and delightfully challenging. Embracing our nonbinary nature means we straddle the abyss. As Gen once told me during a particularly harrowing psychedelic journey together, "Come, Douglas. You know that the only good trip is a bad trip." One and the same.

Douglas Rushkoff
Hastings-on-Hudson, New York
January 2021

ACKNOWLEDGMENTS

Given the unfortunate premature ending of this memoir, the estate of Genesis P-Orridge would like to acknowledge that more than just a few very significant, loved, and influential people, as well as moments and events, were left out. Especially to these friends, confidants, and chosen family, we wholeheartedly hope you know who you are and that it is no reflection on your closeness or importance to Genesis. Instead, it is a reminder of a life that ended too soon that we all cherished. Genesis was working so hard on *Nonbinary*, and we feel so lucky to share what s/he worked on.

The culmination of this project was a collaborative effort among Genesis's daughter Genesse P-Orridge, editor Garrett McGrath of Abrams Press, and the vice president of the estate of Genesis P-Orridge, Ryan Martin of Dais Records. They worked very closely together to maintain the integrity of the story and honor the wishes of the writer as s/he passed while still working on the book. Thank you to these three individuals for the long nights and dedication to Genesis, and thank you to Douglas Rushkoff for writing an afterword that gives justice to such a profound life story.

ABOUT THE AUTHOR

Genesis Breyer P-Orridge (February 22, 1950–March 14, 2020) was a legendary singer-songwriter, musician, writer, occultist, cultural engineer, and visual artist. P-Orridge rose to notoriety as the founder of the COUM Transmissions art collective, which operated in Britain from 1969 to 1976. P-Orridge cofounded and fronted the pioneering industrial band Throbbing Gristle and the experimental multimedia outfit Psychic TV, paralleled by P-Orridge's cofounding of the communal network Temple Ov Psychick Youth. In 1996, P-Orridge and partner Lady Jaye embarked on the Pandrogyne Project, a living art concept that blended physical and psychological mediums, creating the unified "Breyer P-Orridge." In recent years, P-Orridge performed with their spoken word project Thee Majesty, which in the past included such collaborators as William S. Burroughs, Brion Gysin, Timothy Leary, Monte Cazazza, Aaron Dilloway, Merzbow, Tony Conrad, and countless others. P-Orridge also continued performing sold-out shows all over the world with PTV3, an iteration of Psychic TV that spanned almost two decades. Over the past fifty years, P-Orridge's artworks have been exhibited in hundreds of museums and galleries across the world, spanning P-Orridge's prolific career of contributions to *Fluxus,* mail art, collage, sound poetry, and conceptual art. The archives of Genesis P-Orridge were acquired for the permanent collection of London's Tate Britain in 2010.

ABOUT THE COLLABORATOR

Tim Mohr is the author of *Burning Down the Haus*, a history of East German punk rock and the role dissident musicians played in bringing down the Berlin Wall. The book earned praise from the *New York Times*, *Rolling Stone*, the *Times Literary Supplement*, and NPR, amongst others; it was called the best punk book since *Please Kill Me: The Uncensored Oral History of Punk* by Legs McNeil and Gillian McCain and named one of the forty best music books ever written by *Classic Rock* magazine. Mohr is also an award-winning literary translator of contemporary German novelists such as Alina Bronsky, Wolfgang Herrndorf, and Charlotte Roche. Prior to starting his writing career, he worked as a club DJ in Berlin.

The publisher gratefully acknowledges Tim Mohr for his editorial
contribution to this volume.

Library of Congress Control Number: 2020932353

ISBN: 978-1-4197-4386-3
eISBN: 978-1-64700-018-9

Printed and bound in the United States
10 9 8 7 6 5 4 3 2 1

ABRAMS The Art of Books
195 Broadway, New York, NY 10007
abramsbooks.com